ART, EMOTION AND ETHICS

Art, Emotion and Ethics

BERYS GAUT

OXFORD

UNIVERSITY PRESS

OXFORD

UNIVERSITY PRESS

Great Clarendon Street, Oxford OX2 6DP

Oxford University Press is a department of the University of Oxford.
It furthers the University's objective of excellence in research, scholarship,
and education by publishing worldwide in

Oxford New York

Auckland Cape Town Dar es Salaam Hong Kong Karachi
Kuala Lumpur Madrid Melbourne Mexico City Nairobi
New Delhi Shanghai Taipei Toronto

With offices in

Argentina Austria Brazil Chile Czech Republic France Greece
Guatemala Hungary Italy Japan Poland Portugal Singapore
South Korea Switzerland Thailand Turkey Ukraine Vietnam

Oxford is a registered trade mark of Oxford University Press
in the UK and in certain other countries

Published in the United States
by Oxford University Press Inc., New York

© Berys Gaut 2007

The moral rights of the authors have been asserted
Database right Oxford University Press (maker)

First Published 2007

British Library Cataloguing in Publication Data
Data available

Library of Congress Cataloging in Publication Data
Gaut, Berys Nigel.
Art, emotion, and ethics / Berys Gaut.
p. cm.
Includes bibliographical references and index.
ISBN-13: 978–0–19–926321–9 (alk. paper)
ISBN-10: 0–19–926321–3 (alk. paper)
1. Aesthetics. 2. Ethics. 3. Art—Moral and ethical aspects. I. Title BH39. G36 2007
111'.85—dc22 2006103223

Typeset by Laserwords Private Limited, Chennai, India
Printed in Great Britain
on acid-free paper by
Biddles Ltd, King's Lynn, Norfolk

ISBN 978–0–19–926321–9

1 3 5 7 9 10 8 6 4 2

For my parents
Barbara and Desmond Gaut

Contents

Acknowledgements ix
List of Illustrations x

1. The Long Debate 1
 1.1. The Controversies 1
 1.2. Disentangling the Issues 6
 1.3. A Thematic Overview 9
 1.4. Two Bathshebas 14

2. Aesthetics and Ethics: Basic Concepts 26
 2.1. The Puzzle of the Aesthetic 26
 2.2. The Aesthetic and the Artistic 34
 2.3. The Concept of the Ethical 41

3. A Conceptual Map 49
 3.1. Options in the Debate 49
 3.2. *Pro tanto* Principles 57

4. Autonomism 67
 4.1. Radical Autonomism and Artistic Acts 67
 4.2. Moderate Autonomism 76
 4.3. Aesthetic Relevance 82

5. Artistic and Critical Practices 90
 5.1. Artists' Ambitions 92
 5.2. Criticism 95

6. Questions of Character 107
 6.1. Artworks and Friends 109
 6.2. Moral Beauty 114
 6.3. Moral Beauty and Works of Art 127

7. The Cognitive Argument: The Epistemic Claim 133
 7.1. Formulating Aesthetic Cognitivism 136
 7.2. Sources of Knowledge 141
 7.3. How to Learn from Imagination 147
 7.4. Imagination and Ethical Learning 157

8. **The Cognitive Argument: The Aesthetic Claim** 165

 8.1. Arguing for the Aesthetic Claim 165
 8.2. Autonomist and Contextualist Objections 172
 8.3. Techniques and Strategies 186
 8.4. *Lolita* 194

9. **Emotion and Imagination** 203

 9.1. The Importance of Emotional Realism 203
 9.2. The Possibility of Fiction-Directed Emotions 208
 9.3. The Rationality of Fiction-Directed Emotions 216

10. **The Merited Response Argument** 227

 10.1. Versions of the Argument 227
 10.2. Objections and Replies 234
 10.3. Humour 242
 10.4. Conclusion 251

Bibliography 253
Index 263

Acknowledgements

I am grateful to the many philosophers who have commented on the precursors, partial or whole, of this book. I would like in particular to thank David Davies, Daniel Jacobson, Mathew Kieran and Paisley Livingston, all of whom read versions of the complete manuscript and provided valuable comments, suggestions and examples, many of which have been incorporated into the book. Other philosophers have commented on various papers, draft chapters, or talks, material from which has been used in this book. These include Noël Carroll, Alan Goldman, Gordon Graham, Peter Lamarque, Jerrold Levinson, Richard Moran, Alex Neill, Monique Roelofs, Robert Stecker, Kendall Walton and Nick Zangwill. Several philosophers have published criticisms of or responses to an earlier version of the merited response argument, and I am grateful to them for helping to clarify my thoughts on the subject; besides some already mentioned, these include James Anderson and Jeff Dean, Oliver Conolly, Kate Thomson-Jones and Eddie Zemach.

I would like to thank the University of St Andrews for a period of Research Leave, and the Arts and Humanities Research Board for funding a contiguous period of leave during which most of this book was written. I am also grateful to Peter Momtchiloff and Rupert Cousens at Oxford University Press, whose enthusiasm, forbearance and support during the preparation and publication of this book have been much appreciated.

I am grateful to the Louvre for permission to use Figures 1 and 2, and the National Gallery of Ireland for permission to use Figure 3. I would also like to thank the following publishers for permission to use material from published articles: Routledge, for "Reasons, Emotions and Fictions", published in Matthew Kieran and Dominic McIver Lopes (eds), *Imagination and the Philosophy of the Arts*; Cambridge University Press for "The Ethical Criticism of Art", published in Jerrold Levinson (ed.), *Aesthetics and Ethics: Essays at the Intersection*; Blackwell Publishing, for "Art and Cognition", published in Matthew Kieran (ed.), *Contemporary Debates in Aesthetics and the Philosophy of Art*; and Oxford University Press, for "Art and Knowledge", published in Jerrold Levinson (ed.), *The Oxford Handbook of Aesthetics*.

My greatest debts are to my parents, and to Morag, Suzanne and Robert. Without their support and encouragement, writing this book might have been possible: but it would have been a lot less fun.

List of Illustrations

1. Rembrandt, *Bathsheba with King David's Letter*. 1654, Musée du Louvre, Paris. Oil on canvas. Photo RMN/ © Jean Schormans 15

2. Willem Drost, *Bathsheba with King David's Letter*. 1654, Musée du Louvre, Paris. Oil on canvas. Photo RMN/ © Jean-Gilles Berizzi 16

3. Caravaggio, *The Taking of Christ*. 1602, National Gallery of Ireland, Dublin. Oil on canvas. Photo © National Gallery of Ireland. Indefinite loan from the Jesuit Community who acknowledges the generosity of the late Dr. Marie-Lea Wilson. 134

1

The Long Debate

1.1. THE CONTROVERSIES

Art has the power to upset, to disturb, to make us question our assumptions, to change us. But it also has the power to celebrate our cherished convictions, to pacify us, to be, as Matisse put it, "like an appeasing influence, like a mental soother, something like a good armchair in which to rest from physical fatigue".[1] These powers of art have made it the recurrent object of high ethical hope and of deep ethical concern. In recent years concern has been the more prominent of the two: many artworks have been publicly represented as evil or corrupting, and have been condemned or even censored on such grounds. Andres Serrano's *Piss Christ* (a photograph of a plastic crucifix immersed in the artist's urine) and Robert Mapplethorpe's homoerotic photographs became celebrated in 1989 as objects of conservative fear and hatred. Guided by the animadversions of Senator Jesse Helms, the resulting uproar led to cutbacks in the funding of the National Endowment for the Arts and a serious threat to its very existence. In 1998 in England, controversy erupted over the *Stations of the Cross* in Westminster Cathedral, sculpted by Eric Gill. Critics pointed to a biography of Gill, which had exposed its subject's unquenchable sexual appetites, appetites that had allegedly been exercised on prostitutes, two of his sisters, his daughters and even on a dog. How, it was argued, could the sculptures of such a man be set up as the vehicles of devotion in a place of worship?[2] And the Royal Academy's 1997 *Sensation* exhibition in London lived up to its title, causing a furore in the British popular press by exhibiting Marcus Harvey's picture of the child murderer Myra Hindley made from prints of children's hands. When the show transferred to Brooklyn Museum of Art in 1999, New York mayor Rudolph Giuliani denounced Chris Ofili's picture of a black Madonna that included elephant dung and cutouts from pornographic magazines, threatening to remove city subsidies from the museum and evict it from its site.

Moral anxieties have been directed not just at the fine arts, but perhaps even more recurrently and forcefully at the popular arts. Michael Medved wrote a controversial and influential book that denounced Hollywood for celebrating a

[1] Henri Matisse, "Notes of a Painter", p. 135.
[2] The biography of Gill was *Eric Gill* by Fiona MacCarthy.

culture of violence and indifference to suffering; and films such as *Natural Born Killers* and *Pulp Fiction* became the objects of considerable popular concern.[3] In the early 1990s 'gangsta' rap was frequently and vehemently denounced for its misogyny, its glorification of brutality, its crass and strutting materialism, and in 1994 became the subject of congressional hearings.[4] These fears about film and popular music, centred around but not exhausted by concerns about sex and violence, are only the most recent expressions of anxieties that reach back into the histories of these media. Film as soon as it became a mass medium was the object of moral panic; the Catholic Legion of Decency had been a major force in getting the American movie industry to tighten up its Production Code in 1934 in order to curb the industry's dangerously immoral tendencies. Rock too has been repeatedly denounced, virtually from its inception, for its supposed subversive tendencies: in Elvis Presley's third and final appearance on the Ed Sullivan show in 1957, the camera had discretely averted its gaze from Presley's wobbling hips, lest American youth be driven by their gyrations to wild sexual abandonment.

It is not just the popular imagination that has been gripped by these issues of art and morality: the Academy too has been much exercised by that question. From the late 1980s onwards the 'Canon Wars' were waged by the massed ranks of academic infantry. Allan Bloom wrote a book arguing that only a return to the august tradition of Great Books could save Western Civilisation, while the black scholar Henry Gates Jnr countered: "The return of 'the' canon, the high canon of Western masterpieces, represents the return of an order in which my people were the subjugated, the voiceless, the invisible, the unrepresented and the unrepresentable."[5] The canon also came under sustained assault from feminist writers, who saw in it a dismal assemblage of largely dead white males whose misogynous assumptions were transmitted like a virus to future generations. These scholarly controversies in turn partly reflected and partly influenced an increasing erosion of Great Books courses in American universities, together with a weakening of the membranes of the traditional canon to make it more permeable to non-Western influences.

It would be tempting to regard such controversies as so much froth on the tides of popular and academic fashion, soon to be dispersed by the next sea change of opinion. But that reaction would be a mistake. For the question of the ethical import of art has roots deep within the corpus of the Western literary and philosophical tradition. Indeed, the controversy reaches right back to Plato, whose warnings about the ethical dangers of poetry set the framework of the subsequent debate. In *The Republic* Socrates says of mimetic poetry: "Its power

[3] Michael Medved, *Hollywood vs. America.*

[4] For an overview and critical discussion of some of the controversies surrounding rap and popular music, see Theodore Gracyk, *Rhythm and Noise*, ch. 5.

[5] Allan Bloom, *The Closing of the American Mind*, and Henry Louis Gates Jnr, "Whose Canon Is It Anyway?", p. 45.

to corrupt, with rare exceptions, even the better sort is surely the chief cause for alarm." For Plato mimetic art was a double assault on reason, exalting irrational emotions and crippling genuine knowledge. Poetry "waters" the growth of the passions; and in the *Ion* Socrates says of the recitor of verses that "There he is, at a sacrifice or festival, got up in holiday attire, adorned with golden chaplets, and he weeps, though he has lost nothing of his finery. Or he recoils with fear, standing in the presence of more than twenty thousand friendly people, though nobody is stripping him or doing him damage. Shall we say that the man is in his senses?"[6] Poetry, in short, fosters irrational emotions. And, whereas genuine knowledge for Plato is universal and of the Forms, the purveyor of poetry peddles beliefs only about particulars and about the shifting shadows of mere appearances. Given the importance of poetry in general and of Homer in particular to classical Greek education, Plato's condemnation of most mimetic poetry as corrupting challenged a fundamental assumption of Greek culture, the foundational linkage of poetry to ethics. And, in placing the issues of the relation of art to the emotions and of art to knowledge at the centre of the ethical debate, it set the terms of the subsequent discussion, and indeed of the present book.

Plato's challenge to the value of art was fundamentally and ineradicably to condition the subsequent Western philosophical and literary debate. Aristotle's *Poetics*, though it does not mention Plato by name, is plausibly construed as a response to his criticisms of art, defending a proper place for emotion in response to poetry and honouring poetry as a source of genuine knowledge. Philosophical replies to Plato's objections have continued ever since, reaching down to the present day in the writings of Iris Murdoch and Christopher Janaway.[7] Likewise, the literary tradition has compulsively returned to Plato, the spectre haunting the cultural banquet, a literary genius who attacked literature. As Sir Philip Sidney lamented in his defence of poetry against its Puritan attackers, "now indeed my burden is great; now Plato's name is laid upon me, whom, I must confess, of all philosophers I have ever esteemed most worthy of reverence, and with great reason, since of all philosophers he is the most poetical".[8] Sidney had much to be worried about: subsequently, during the Interregnum in Britain, theatres were closed down by the victorious Puritans.[9]

Within the long debate about art and ethics triggered by Plato's intervention, three broad strands can be picked out in a preliminary way. The humanist strand was to be the most influential; responding to Plato directly, it sought to defend the ethical value of poetry and of art. Horace declared that "The aim of the poet is either to benefit, or to amuse, or to make his words at once please and give

[6] Plato, *The Republic*, 605c, 606d; *Ion* 535 d–e.
[7] Iris Murdoch, *The Fire and the Sun*, and Christopher Janaway, *Images of Excellence*.
[8] Sir Philip Sidney, "An Apology for Poetry", p. 170.
[9] See Jonas Barish, *The Antitheatrical Prejudice*, for a comprehensive history of anti-theatrical sentiment, which traces its Western roots to Plato, but which also shows that it is not confined to Western societies.

lessons of life", and he primarily had moral lessons in mind.[10] Sidney argued that poetry, with its capacity to delineate precise situations and its power to move even obdurate hearts was of all discourses the most suited to teach virtue.[11] Tolstoy argued that the criterion for a great work of art is that it communicate the artist's feelings of joy and of spiritual union, and so morally elevate its audience.[12] Other important defenders of the humanist tradition include John Ruskin, Henry James, Matthew Arnold, F. R. Leavis and in our own time Peter Fuller. The view for which they fought set the background assumptions of much of our culture. For if art can improve the character and refine the sensibility, then it seemed only right that the state should build museums and concert halls as repositories of culture and knowledge; that it should subsidise the arts, either directly by grants or indirectly by tax concessions; that it should encourage the teaching of literature in schools and universities; and that a culture of deference should be maintained towards artworks, their creators and their interpreters. Though many intellectuals now question the connection between art and ethics for which the humanists argued, they all too infrequently acknowledge that in their education and employment they are the beneficiaries of the very assumptions that they roundly reject.

The second strand of the debate was aestheticism, which came to prominence during the latter half of the nineteenth century. Aestheticism spurned any connection between art and ethics, 'art for art's sake' being the flag of choice under which its adherents sailed. The painter James McNeill Whistler rejected what he saw as the glum Victorian coupling of the artistic with the improving; art was about beauty and form, and to shackle it to the demands of the ethical and the utilitarian was to ignore its essence and to prostitute its power. Though it grew out of cultural revolt and artistic experiment, aestheticism rapidly acquired a more theoretical programme, and in the writings of Roger Fry and Clive Bell developed ideas of form and aesthetic emotion that were to seduce or challenge subsequent aestheticians. In Monroe Beardsley aestheticism was to find its greatest theoretical exponent, a philosopher of distinction who clarified the formalist assumptions behind the view and developed a challenge to humanism that demands a response.[13]

The third main strand in the modern period was the idea of art as transgression. Art, it was held, can be good precisely because it transgresses our moral assumptions, making us question received wisdom and challenge conventional attitudes. Agreeing as he saw it with Plato that art is a form of lying, Oscar Wilde in "The Decay of Lying" then stood Plato on his head, and argued that the decay of art was the result of the decay of lying. However we judge the seriousness of his intent, the interest and power of his position render it worthy of critical

[10] Horace, "Art of Poetry", p. 73. [11] Sidney, "An Apology for Poetry".
[12] Leo Tolstoy, *What is Art?*
[13] See Roger Fry, "Art and Life" and "An Essay in Aesthetics", in his *Vision and Design*; Clive Bell, *Art*, ch. 1; Monroe C. Beardsley, *Aesthetics*.

attention.[14] If Wilde is the court jester of the movement, de Sade is its forbidding patron saint, and his burgeoning literary reputation is evidence enough of the grip that the idea of transgression has come to exercise on modern intellectual culture. Indeed, a great deal of the self-identified avant-garde in art has taken the idea of flouting conventional morals and good taste as a central goal, codified in the slogan of 'épater le bourgeois', and having as its much-touted successes the initial scandalised receptions of Manet's *Déjeuner sur l'herbe* and Stravinsky's *Rite of Spring*. It was towards some of the latter-day products of this movement that Helms took Senatorial umbrage, but in a way the artists concerned were just as traditional as he: Mapplethorpe's photographs lay in a long tradition of homoerotic photographs that stretched back to the 1930s work of George Platt Lynes, and earlier; and Andres Serrano's *Piss Christ* was in more than one way an appropriate response to Duchamp's *Fountain*.

It is no exaggeration to say, then, that the relation of art to ethics has been a recurrent and central concern in Western culture from Plato to the present, a concern manifested not just in the writings of philosophers and the literati, but in the attitudes and beliefs of politicians and lay people who may be largely ignorant of the intellectual debate. That this is so might seem surprising, for it is easy to think of art as something marginal to our lives, as something that is not part of their main text and story. Yet such a view would be mistaken, for art, to return to our opening theme, has real power. It is a core part of culture, through which we articulate and develop our self-conceptions both as individuals and as members of society, and which through its emotional charge can imprint that self-conception deeply on us. This is perhaps most obvious in the case of the popular arts. Hollywood films have had an enormous if incalculable influence on their audiences' lives, in everything from establishing fashion and consumption patterns, to the ethically weighty matters of articulating notions of what it is to be a hero, of showing how to react to a perceived wrong, of delineating ideals of romance and love, and of otherwise conditioning our self-conceptions and emotions in ways too various to list. Indeed, it has been powerfully argued that early American films were a fundamental means by which new immigrants were socialised into the basic mores of American society.[15] Consider too the multifarious ways in which popular music genres both express and condition the styles and attitudes of their adherents—think of the attitudes implicit and explicit in heavy metal rock, say, or of Goth music, or of rap, or of country music, or of the kind of songs favoured by Sir Cliff Richard. What a person's musical tastes say about her may reach very deep indeed, may articulate more accurately and fully

[14] Oscar Wilde, "The Decay of Lying". Wilde is often thought of as a proponent of aestheticism, but, with a magnificent indifference to consistency, he managed at various points to embrace all three strands of the debate. The preface to *The Picture of Dorian Gray*, for instance, is famously full of aphorisms supporting autonomism; but, when one delves below the glittering prose of the novel's surface, it reads suspiciously like a simple morality tale.

[15] See Neal Gabler, *An Empire of their Own*.

who she is than does any other resource available to her. And what is true of the popular arts is also true of the fine arts, which, for those who care about them, can similarly express and articulate their sense of who they are, of what really matters to them. Consider the ways we would differently interpret someone's values and character were we told that her favourite modern artist were Mark Rothko, or if we were told that it were Roy Lichtenstein; if we were told that her favourite author were Jane Austen, or that it were Dostoevsky; if we were told that her favourite opera were Wagner's *Tristan and Isolde* or that it were Mozart's *Marriage of Figaro*. The arts, high and low, can express and develop our understanding of who we are and of what matters to us—a thought that Hegel developed in his idea of art as the articulation of a culture's self-understanding, even if in his hands that powerful insight was applied to generate an overly simplistic view of art's historical development.[16] Given the importance of the arts to our self-understanding and to our emotional life, it is hardly surprising that the ethical import of art should have been of recurrent and deep concern to our culture.

1.2. DISENTANGLING THE ISSUES

The debate over art and ethics has been long and complex; so it is no surprise that within its broad boundaries several distinct issues have been addressed, without always being delineated one from another. These issues need to be separated and clarified before they can be adequately examined.

The first, and perhaps most evident, concerns an essentially *causal* question: does exposure to works of art tend to affect us morally—morally to improve or morally to corrupt us? This question admits of many interpretations, depending on how broadly the class of artworks concerned is specified: the question might be asked about the causal powers of art in general, or of art that is good (or bad), or of art that has a certain content (most often sexual or violent) or that manifests certain attitudes. But, however it is finessed, it is always a question about the effects of art on its audience. Plato's objections were directed to most mimetic art (other than verses praising gods and heroes), and his condemnation of it was grounded in part on his fears about its effects—its powers emotionally to degrade its viewers and powerfully to seduce them with the chimerical appearance of knowledge. Much of the subsequent political debate about the popular arts and violence has been about the causal issue; indeed, Plato's worries about art have been tellingly compared to contemporary worries about the malign influence of soap operas, films and music.[17] The humanistic celebration of art was in contrast partly grounded on faith in the powers of (great) art to ennoble and refine its audience, to make them better human beings. The broad features of that view have been attractive

[16] G. W. F. Hegel, *Introductory Lectures on Aesthetics*, especially ch. 5.
[17] Alexander Nehamas, "Plato and the Mass Media".

to several philosophers: Kant, for instance, holds that the harmonious accord between the cognitive faculties that beauty, whether of art or of nature, produces in our consciousness "also promotes the mind's receptivity to moral feeling".[18] And more recently, the benign causal powers of art have been advocated by Anthony Savile, Anne Sheppard and Martha Nussbaum.[19] The aestheticist, 'art for art's sake', movement was in contrast at least in part a rejection of the view that art can morally affect us or that it ought to be valued as art for this reason.

A second issue that trots doggedly at the heels of the first issue concerns matters of *public policy*. What role, if any, ought the state to play in the regulation and promotion of art? The spectre of censorship has cast a long shadow over the debate, beginning with Plato's expulsion of the poets from his ideal city, down to recent accusations of censorship levelled against those who on political grounds advocate cutbacks to the arts. And wherever charges of film's and popular music's ethically corrupting tendencies are heard, calls for censorship or self-restraint are generally not far behind. Such a position is in a way the converse side of the humanistic tradition's espousal of state subsidies for art, because of art's purported powers to enhance the enjoyment of life and promote the spread of civilisation. Finally, the legitimacy of a *droit de suite*—the right of an artist or her estate to receive a proportion of the resale value of her works—is one that has been much debated, and, though it has been enacted by a European Union Directive, it remains deeply contentious.

These causal and policy issues have both been prominent in the public and political debate about art and ethics. The other issues in the long debate have less often received public discussion, but have been of recurrent interest to philosophers and literati. One—our third issue—concerns a *conceptual* question: is there an analytic connection between the notions of the aesthetic and the ethical? There is a long tradition of supposing that the two are intimately intertwined. For instance, it has often been argued that moral virtues are beauties, sometimes in the sense that moral virtues possess beauty, sometimes in the stronger sense that moral virtues are identical with a kind of beauty, beauty of the soul. In various forms, this view is widespread in the philosophical tradition, to be found in the writings of, amongst others, Plato, the Stoics, Plotinus, St Augustine, Shaftesbury, Hume and in the present day Colin McGinn. In this tradition the connection between morality and beauty has generally been held to be a priori, and some (though probably not all) of its supporters think of the connection as a specifically conceptual one.[20]

[18] Kant, *Critique of Judgement*, Ak. 197. All references to Kant in the present book use the Prussian Academy edition page numbers of the appropriate volumes.

[19] Anthony Savile, *The Test of Time*, ch. 5, sect. II; Anne Sheppard, *Aesthetics*, p. 151; Martha Nussbaum, *Poetic Justice, passim*.

[20] For instance, Colin McGinn, *Ethics, Evil, and Fiction*, pp. 97, 102, explicitly holds that the connection between the moral good and the beautiful is a conceptual one. I defend a version of the moral beauty view in Sect. 6.2.

A fourth issue concerns whether there is an *intrinsic* relation between art and morality. Is it the case that the ethical goodness of the attitudes, if any, manifested in a work of art contributes towards its aesthetic value? This question is distinct from the causal issue; for that question is one about the moral causal effects of (some) art on its actual audience: as such, its answer must draw on empirical psychological and sociological investigations. The intrinsic question, in contrast, is not about the effects of art, but about an internal relation of the aesthetic to the moral domains: does the moral value of works condition their aesthetic value? The intrinsic and causal questions are often run together, and the humanistic view of the value of art is sometimes, in part, not just an enthusiastic endorsement of the morally improving powers of art, but also a claim about the intrinsic connection: works of art are assessed as aesthetically good on this view partly because of the moral excellence of the views they display. In contrast, the idea of art as transgression returns a negative answer to the intrinsic question, holding that works can be good precisely because they violate ethical values, advocating evil as seductively attractive. The intrinsic question is also, it should be noted, distinct from the conceptual issue. For an intrinsic relation need not be conceptual: there might be some other a priori, and therefore rationally establishable, connection between the moral goodness of views expressed by works of art and their aesthetic goodness. However, if the conceptual connection does hold true, at least in the version that ethical goodness is a kind of beauty, then the intrinsic relation will be established too, for the ethical goodness of attitudes expressed will be a kind of beauty in the work, and therefore contribute towards its aesthetic value. That point, though, shows that there are rational connections between certain answers to the conceptual and the intrinsic issues, not that they are the very same issue.

A fifth issue that has figured in the long debate concerns whether there is a *structural symmetry* between the moral and the aesthetic domains. The structural symmetry view holds that fundamental aspects of aesthetic and moral values are the same: for instance, that realism (or irrealism) is the correct account of both sorts of value, or that both kinds of value are expressible in terms of principles (or that neither are), or that both kinds of value are objective (or subjective), or universal (or relative), and so forth. The question of whether the structure of aesthetic and moral evaluation is the same has been of recurrent interest in the philosophical debate about the relation of the aesthetic and the ethical. Some, such as Hume, have thought of the two domains as standing on the same footing, both characterised by subjectivity and a projection of sentiments onto their objects.[21] Others, such as Kant, have argued for a contrast between the two evaluative spheres in certain key respects; for Kant morality is binding on all rational beings, since the validity of the categorical imperative depends purely on the nature of rational agency, whereas aesthetic evaluations are valid only for beings who share a human disposition of the cognitive powers,

[21] Hume, *An Enquiry Concerning the Principles of Morals*, app. I, p. 88.

possessing both imagination and understanding. Whereas aesthetic evaluations are only subjectively universal, moral evaluations have the full force of objective universality.[22] More recently, philosophers have also addressed the issue of structural parallels: Philippa Foot sought to strengthen her argument for moral relativism by comparing moral judgements with judgements of taste, which she takes to be more evidently relativist; and John McDowell argued that the same kind of realism applies to the aesthetic as applies to the moral domain.[23]

1.3. A THEMATIC OVERVIEW

There have, then, been at least five distinct strands in the long debate about art and ethics. My concern here is mainly with the intrinsic issue, though the conceptual issue will also be addressed, since its variant that holds that moral virtues are beauties is relevant to our main topic, as noted earlier.

The intrinsic issue concerns whether the ethical value of artworks conditions their aesthetic value. In considering this question, the ethical value of an artwork is not to be understood in terms of the ethical effects of the work on actual audiences, since that is germane to the causal issue, which we will not directly address, for reasons to be explained shortly. Rather, the ethical value of an artwork is to be understood in terms of what I will call its intrinsic ethical value. Note that by this I simply mean to rule out from consideration the ethical effects of the work on actual audiences. Other relational ethical properties of the work are not disallowed, since relational properties are crucial to morality: as we shall see in Section 2.3, attitudes directed towards other people are central to moral assessment; and many relationships are themselves moral, such as friendship and certain kinds of community.

I construe intrinsic ethical value in terms of the ethical features of the attitudes that the artwork manifests. The notion of an attitude should be understood broadly here, to cover not just characteristically affective states, such as showing disgust towards or approval of the characters, but also to cover more purely cognitive states, such as presenting characters in such a way as to imply judgements about their being evil, good, inspiring and so on. Thus in assessing the ethical value of art we are assessing the ethical quality of the point of view, cognitive and affective, that it takes towards certain situations. Though

[22] See Kant, *Grounding for the Metaphysics of Morals, passim,* for moral rationalism; and *Critique of Judgment*, Ak. 217–19 for the subjective universality of aesthetic judgement. Kant's position is, however, complex; in the *Critique of Judgment*, Ak. 232, he claims that "taste is basically an ability to judge the [way in which] moral ideas are made sensible", which would put the two domains on a more symmetrical basis. For an overview of Kant's opinions on this matter, see Paul Guyer, *Kant and the Experience of Freedom*, ch. 1.

[23] Philippa Foot, "Morality and Art", and John McDowell, "Aesthetic Value, Objectivity and the Fabric of the World".

the actual consequences of works do not figure in their ethical assessment, the consequences for which works *aim* do, since a work's attitudes may be manifested in various ways, including in its aims: if a work is aiming morally to corrupt its audience, it thereby manifests an ethically flawed attitude towards them. And these aims may be to produce either cognitive effects (aiming to corrupt judgement, or to teach people certain things) or affective responses (aiming to produce certain responses). In considering the intrinsic issue, then, it is ethical qualities of manifested attitudes that are relevant. For instance, de Sade's works are ethically sick because of the attitudes they display of approving of, celebrating, making positive judgements about and aiming to get their readers to enjoy the sexual torture and multifarious degradation of the characters who suffer through their pages. The putative effects of these works in corrupting actual audiences, though evidently resting in part on the ethical features of the attitudes that the works evince, is not directly relevant, though the aim of the works to corrupt is.

In contemporary philosophical discussion broadly three approaches have been advocated towards the intrinsic issue, which correspond to the three main traditions within the general debate about art and ethics identified above. Part of what I will argue in this book is that much of the current characterisation of these approaches is unsatisfactory, both lacking in precision as well as occluding other options. Here I lay out the three approaches as they are sometimes distinguished, before specifying them more carefully and amending some of the classifications in Chapter 3.

Moralism about the intrinsic issue is an aspect of the wider humanistic tradition about art. Moralism, in a broad sense, is the view that the ethical merits of works of art contribute to or condition their aesthetic merit, and their ethical defects contribute to or condition their aesthetic demerit. Moralism comes in different strengths. Some, such as Tolstoy, hold that ethical merits in works are the sole or supreme determinants of their aesthetic merit. Less strong versions of moralism deny that ethical merits are either necessary or sufficient for works to have aesthetic merit. These weaker kinds of moralism hold that there is a plurality of aesthetic values, and that the ethical value of works constitutes only one kind of these values. The view to be defended in this book, which I term 'ethicism', is one of these less strong kinds of moralism. It holds that an artwork is aesthetically flawed in so far as it possesses an ethical flaw that is aesthetically relevant, and conversely that an artwork has an aesthetic merit in so far as it possesses an ethical merit that is aesthetically relevant.

Autonomism is a particular application of aestheticism to the intrinsic issue. Radical autonomism holds that it makes no sense to evaluate works of art ethically. A more moderate form of autonomism holds that the intrinsic ethical merits or demerits of works are irrelevant to the works' aesthetic worth. T. S. Eliot remarked of Matthew Arnold that "This is not the place for discussing the deplorable moral and religious effects of confusing poetry and morals in

the attempt to find a substitute for religious faith. What concerns me here is the disturbance of our literary values in consequence of it. One observes this in Arnold's criticism."[24] Autonomists are sometimes formalists, holding that the aesthetic value of works resides only in their form, not in their content, so that artworks' ethical content, and the ethical attitudes manifested towards that content, are irrelevant to their aesthetic worth.

Immoralism, the third approach, has as its most enduring motivation the idea of art as transgression. It acknowledges that ethical merits or demerits of works do condition their aesthetic value; but, in contrast to moralism, immoralism holds that ethical defects of works can contribute to the aesthetic worth of works, and that, conversely, ethical merits can contribute to the aesthetic demerit of works. A pithy summation is due to Oscar Wilde, who held that "lying, the telling of beautiful untrue things, is the proper aim of art".[25] This is a position from which it follows that art is good in so far as it manifests at least this moral defect. In Chapter 3 we will have reason both to question the label 'immoralism' for this position, and partially to reformulate the option.

Concerning the three other issues, besides the intrinsic and conceptual ones, I will be largely silent, though the positions defended here bear indirectly on some of them. The question of the causal effects of (some) artworks on the actual audiences who view or listen to them is an empirical issue, answerable only by carefully controlled psychological and sociological investigations, rather than by philosophical ones. The empirical effects of artworks on actual audiences may be the result of sometimes radical misunderstandings of the artwork, or of audiences' abnormal psychology (perhaps Satanic messages are heard in a heavy metal record), or of fortuitous features of a work's context of reception (a novel with commendably democratic aims might so alarm the military that it provoked a coup against a fledgling democratic movement in a politically unstable country and hence undermined the very cause it sought to promote). So if we construe the effects of a work in terms of actual audiences, the effects are potentially too various and idiosyncratic to be receptive to a general philosophical theory. However, if we construe the audience of a work in normative terms, as an audience that understands the work (including its aims) and correctly grasps its aesthetic properties, then there are some limited implications about the moral effects of artworks that flow from the arguments of this book. For instance, the cognitive argument (advanced in Chapters 7 and 8) holds that the fact that a work can teach something is, under certain conditions, an aesthetic merit of the work. To grasp this teaching, the audience must be able to understand the work, including its communicative aims, and so be normatively specified. If it does not yet know what is being taught, it will learn something from the work; and if what is taught is moral, this audience will have a moral cognitive gain, and so be morally improved in that respect. The merited response argument (in

[24] T. S. Eliot, "Matthew Arnold", p. 116. [25] Wilde, "The Decay of Lying", p. 686.

Chapter 10) holds that the responses that a work prescribes to its audience are aesthetically relevant; the aesthetic success of a work in part depends on whether those responses are merited (and not on whether they are actually felt); and these merit conditions include ethical ones. It follows from the truth of this argument that, if an audience grasps the work correctly and is sensitive to the full range of its aesthetic properties, it will be guided in its responses in part by moral considerations, and so there is a moral aspect to the effects of a work on such an audience. However, even these limited implications for audiences, specified in aesthetic normative terms, do not guarantee that such audiences will take any moral lessons learned or moral feelings prescribed by the work and apply them to the real world, and therefore be morally improved in their real-world actions. It is possible to weep over the travails of a fictional character and be indifferent to her real-world counterpart, or to be repeatedly weak-willed in one's actions. One must invoke more general norms of rationality to bridge this kind of gap. So, while some implications for normatively specified audiences flow from the views defended in this book, they do not entail positions on the empirical issue of whether actual audiences will be morally improved or degraded by their encounters with art.

The issue of censorship will also not be directly addressed. Clearly, however, there is no entailment from the claim that ethicism is true to the claim that one ought to censor morally bad works. For all that ethicism shows is that an artwork with certain moral defects thereby has an aesthetic defect, yet having an aesthetic defect is no ground for censoring art. It is true that ethicism kicks away a prop on which anti-censorship views have sometimes rested. This prop is that the ethical attitudes manifested in artworks have absolutely nothing to do with the correct appreciation of them as art, so that the ground for censoring them is never their status as art, but always some other feature they possess. But the anti-censor lobby is not well served by appealing to untenable aesthetic positions. I would instead suggest that art has no *special* grounds for claiming immunity from censorship as compared to other kinds of valuable expression, such as scientific and political speech, but that the grounds on which censorship can properly be resisted in these cases apply just as well to the case of art. The discussion of the general issue of free speech, however, is properly an issue in political philosophy, and lies outside the scope of the present book.

Finally, I will not directly address the issue of whether there is a structural symmetry between the moral and aesthetic domains. However, if ethicism is correct, so that ethical values of artworks, when aesthetically relevant, count as aesthetic values of works, then whatever features of realism, objectivity or pluralism that characterise ethical values will also characterise those aesthetic values of artworks that are ethically based. So a denial of symmetry in respect of at least these aesthetic values would prove untenable. However, fully to explore the issue of symmetry in respect of all other aesthetic values would take us far beyond the remit of this book.

The structure of the book is as follows. In the remaining section of this chapter, I discuss in detail a pair of examples to illustrate the nature of ethical criticism. Then in Chapter 2 I clarify the two basic kinds of concepts under debate: the aesthetic and the ethical. The chapter develops an account of aesthetic properties that construes them as evaluative properties of artworks that are relevant to their value qua artworks. It also holds that what makes something art is its possession of some of a cluster of properties. Two notions of the ethical are distinguished, and the narrower one is construed in terms of a sub-set of character virtues distinguished by the nature of the concern that they manifest towards other people.

Chapter 3 examines the three standard positions about the intrinsic issue, noted earlier, and argues both that they need to be more carefully defined than is usually the case and also that the best division of the more plausible positions is not in terms of moralism, autonomism and immoralism, but in terms of ethicism, autonomism and what I term 'contextualism'. The chapter also argues that the best formulation of these positions is in *pro tanto* terms, and that the formulation often employed, in terms of overall principles, leads to untenable results.

Chapter 4 examines and rejects two kinds of autonomism. Radical autonomism, the view that it makes no sense to evaluate artworks ethically, is rejected by arguing that the ethical evaluation of artworks is equivalent to evaluating ethically what the artist(s) did in the work, the artistic acts performed therein. Moderate autonomism, the view that the intrinsic ethical merits or demerits of works are never aesthetically relevant, is discussed, and several arguments in its favour are considered and rejected. Finally, a criterion for when ethical merits are aesthetically relevant is proposed.

Chapter 5 discusses the claim that ethicism bests fits reflective critical practice, that is, best fits the critical judgements that critics make of artworks, when those judgements are subject to a process of reflective testing. This argument is endorsed, but it is also pointed out that, given the sheer diversity of critical practices and the strength of ethicism relative to contextualism, this argument cannot decisively establish ethicism.

Chapter 6 criticises an argument of Wayne Booth's, that ethicism should be defended in terms of the notion of befriending an artwork's implied author. But it goes on to defend the claim that ethical merit is a kind of beauty, and that therefore the ethical merits of artworks are kinds of beauties in them. Various objections are considered to this view and are rejected; thus, the first a priori argument for ethicism is developed.

Chapters 7 and 8 develop the second argument for ethicism: the cognitive argument. Chapter 7 argues for a central role for imagination in learning about what one morally ought to do. Employing this result, it shows how one can ethically learn from imaginings guided by artworks. Chapter 8 then argues for the aesthetic relevance of this cognitive capacity of artworks, and explores some of

the strategies and techniques employed by works to achieve their cognitive goals. Nabokov's novel *Lolita* is discussed in some detail to illustrate these techniques and strategies in action.

Chapter 9 argues that emotions can be real, rather than merely imagined, when directed towards fictional situations and characters described in works of art, and also that such emotions can be rational. It is shown how the reality and rationality claims bear on the arguments for ethicism. Emotional education is closely related to the education about ethical values described in the two previous chapters, and it is real emotions that are educated, not merely imagined ones. The reality and rationality of emotional responses also play a role in the argument of the next chapter.

Finally, Chapter 10 develops and defends a merited response argument for ethicism, distinguishing it from less satisfactory variants due to Hume and to Noël Carroll. The favoured version of the argument holds, roughly, that, when works prescribe responses to the events that they represent, their aesthetic success partly depends on these responses being merited, and that whether this is so in turn partly depends on whether the responses are ethical. Various objections to this argument are considered and rejected; and the case of dark humour, which has sometimes been supposed to present a difficulty for the argument, is examined and shown not to undermine the view defended here.

Chapters 7 to 10 taken together constitute an ethicist rebuttal to Plato's basic charges against art: that art only appears to provide knowledge and that it grounds irrational and ethically bad responses. And Chapter 6, by linking morality to beauty, shows that Platonic considerations in fact favour ethicism.

The book, then, addresses one of the central issues in the long debate about art and ethics, a debate that has been of great and recurrent importance in the Western literary and philosophical traditions. The answer it returns is a kind of philosophically circumspect humanism, stripping out from traditional humanism some of the more contestable empirical elements with which it has traditionally been burdened. In the course of the argument for this reconstituted humanism, the traditional claims that art can teach us about morality and that this is aesthetically relevant are defended, as is the view that we can feel actual emotions towards fictional characters and events. And the upshot of the argument is to show that the aesthetic domain is deeply intertwined with the ethical realm.

1.4. TWO BATHSHEBAS

In developing philosophical theories about art, it is important not just to formulate them with care and to consider their general merits, but also to test them against one's responses to particular artworks. It is customary to perform this testing by marshalling a parade of examples, quickly sketched and peremptorily dismissed. But any adequate theory in aesthetics should be able to account for

complex cases, and account for them in detail. So it is appropriate near the start of this book to illustrate and support ethical criticism by examining in detail some examples. The examples illustrate the nature of ethical criticism, provide a touchstone for our intuitions about the correctness of ethicism and of its rivals, and bring out the main themes that will interplay throughout this book. They should also help retire the hoary old claim that ethical criticism must invariably be insensitive to the subtleties of individual works, and they show how appreciating that a work can convey moral understanding can enrich our experience of the work, rather than impoverish it or lead to a merely instrumental valuing of it. I consider two paintings, both of Bathsheba, both painted in 1654, both hanging in the Louvre. One is by Rembrandt (Figure 1), the other is by his pupil, Willem Drost (Figure 2).

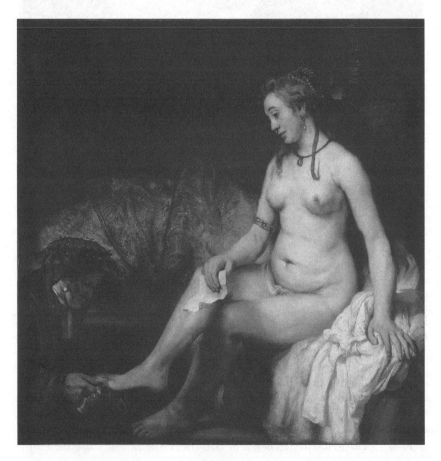

Figure 1. Rembrandt, *Bathsheba with King David's Letter*. 1654, Musée du Louvre, Paris. Oil on canvas.

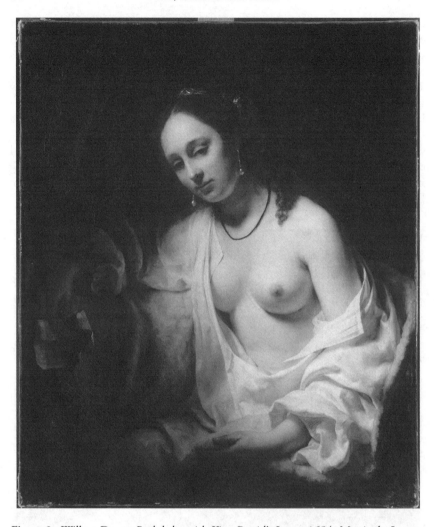

Figure 2. Willem Drost, *Bathsheba with King David's Letter*. 1654, Musée du Louvre, Paris. Oil on canvas.

The story of Bathsheba is related in the Bible in 2 Samuel 11, and its consequences unfurled in 2 Samuel 12. It begins thus: "And it came to pass in an eveningtide, that David arose from off his bed, and walked upon the roof of the king's house: and from the roof he saw a woman washing herself; and the woman was very beautiful to look upon. And David sent and enquired after the woman."[26] David discovered her to be Bathsheba, the wife of Uriah the Hittite,

[26] 2 Samuel 11: 2–4 (King James Authorised Version).

and sent his messengers to her, who took her, and David slept with her. She conceived a child by him, and David arranged that her husband, a soldier in his army, be sent into the most dangerous part of the battle to be allowed there to die.

This is a morally charged tale; David's act was one of the grossest betrayal of a faithful soldier. The details of the story pile up the sense of moral outrage: David commanded Uriah to return from the battle in order to get him to sleep with his wife who was pregnant by David, so as to cover up the adultery. Uriah refused to return to the comforts of his own home while his comrades at arms were still in tents on the battlefield; instead he remained with David's servants at the king's door. It was this act of sensitivity and loyalty that sealed his fate. David got Uriah himself to carry to Joab, David's general, the letter that effectively condemned Uriah to death. The consequences of David's sin were dire: though David married Bathsheba, God was angry, and, despite David's fasting and contrition, the child born to them died.

In the biblical story David came to realise his moral degradation prior to the child's death through a parable related by the prophet Nathan. This told how there were two men, one rich who owned many flocks and herds, the other poor who owned only a single ewe lamb, "which he had bought and nourished up: and it grew up together with him, and with his children; it did eat of his own meat, and drank of his own cup, and lay in his bosom, and was unto him as a daughter". When a traveller arrived, the rich man did not serve him with one of his own lambs, but took the poor man's lamb, and served it to the traveller. "And David's anger was greatly kindled against the man; and he said to Nathan, As the Lord liveth, the man that hath done this thing shall surely die: And he shall restore the lamb fourfold, because he did this thing, and because he had no pity. And Nathan said to David, Thou art the man."[27]

This wonderful scene, through which David came to realise the evil of what he had done, and which triggered his futile repentance, is, as Robert Sharpe has pointed out, itself an example of how one can come to learn through art.[28] For by shifting David's perspective through the telling of the parable to that of a disinterested spectator, and by telling a tale in which there was no element of sexual desire, Nathan got David to see the wrongness of what the rich man had done. And then came the devastating linking of the parable to David's situation: "Thou art the man." This cognitive mechanism, of distancing the viewer from his particular interests and concerns to adopt an unbiased perspective on the situation is, as we will see in Chapter 7, an important way in which one can deepen one's moral understanding of a situation through an artistic presentation of it. And it is striking too that it is through the emotion of anger that David was driven to see the wickedness of what he had done. The emotions are cognitively important when experienced from the correct perspective.

[27] 2 Samuel 12: 5–7. [28] Robert Sharpe, "Moral Tales".

The Bible illustrates a noteworthy way in which we can come to learn from art, but the way in which Rembrandt's painting exemplifies this point is, though related to the biblical mechanism, both artistically richer and (not coincidentally) morally more subtle. In Rembrandt's painting of Bathsheba bathing, we see a scene not mentioned in the Bible. The naked Bathsheba is holding prominently in her right hand a letter in which she presumably learns of the king's desire for her to come to him.[29] Though a servant is tending her feet, apparently drying them after her bath, and Bathsheba's eyes are cast down in that general direction, she is not looking at the servant, but is staring into empty space just above the servant's head. Her whole demeanour is of sadness, resignation, a distant contemplation of what will happen.

Willem Drost's painting of Bathsheba is very different. Bathsheba's eyes are not cast down and unfocused; rather, she is looking out from the canvas. Indeed, in the current hanging position of the picture in the Louvre, high on a wall, Bathsheba's eyes, which are slightly inclined downwards, make direct contact with those of the viewer looking up at her. There is no trace of anger or sorrow on her face or in her posture; but there is a strong element of seductiveness present, a sense of being available, ready and willing for sexual adventure.

Drost's painting is a very fine one: it is technically superbly handled and accomplished, it is pictorially arresting, it is in many ways very beautiful, and it has a great deal of chutzpah to it, being very likely a response to the version of his famous teacher. Yet, as anyone who has seen both of the pictures will testify, the artistic difference between the two paintings is immense: with Rembrandt's painting we are dealing with one of the great pictorial masterpieces of the Western tradition; with Drost's painting we have a fine work which in the end does not come even close to achieving the artistic standard set by Rembrandt's work. What interests me here is to try to capture something about why these pictures differ so greatly in their artistic worth, and what role ethical assessment might play in explaining that difference.

Let us begin by looking in more detail at the Drost painting, since its artistic qualities are easier to analyse and explain than those of the Rembrandt (which may itself be a mark of its inferior status as a painting). How does Drost achieve his pictorial effects, and what is their import? Bathsheba is cast in a silvery even light coming from a source outside the picture, up and to the left. There is no back-lighting, so that the background lies in impenetrable dark. The effect is to isolate her; yet that isolation does not render her vulnerable (the seductive expression on her face negates any sense of that); rather, it focuses the viewer's attention more firmly on the young flawless body of a woman probably in her early twenties, with

[29] Though the Bible does not mention a letter from David to Bathsheba, by Rembrandt's time there was a long pictorial tradition of Bathsheba pictures in which such a letter often figured. See Eric Jan Sluijter, "Rembrandt's Bathsheba and the Conventions of a Seductive Theme".

skin that has a pearly, almost alabaster sheen to it. Only her upper body is to be seen, and within the composition there are two central areas of pictorial interest, picked out by the cool appraising light falling on her body. The first is that seductive expression on her face, the eyes hooded and slightly heavy-lidded, cast in shadow so that the viewer can see them as always focused on him, her head turned gently to one side as if to solicit his attention and to suggest her acquiescence in it. The second focus, and but for the power of that glance, the stronger one, is her left breast, modelled by the strong shadow underneath it, cast from the single light source. The effect is to round out the breast, to give a sense of its weight and volume, to render it almost palpable, and attention is focused further by the redness of the nipple, the sole strong saturated colour point in the entire composition, and also by the line of shadow that traces itself just underneath and across the nipple. Her chemise is thrown off her left shoulder, framing her exposed body with a gentle arc that echoes closely and thus enhances the arc of the naked breast, and that curve is also echoed though more distantly by the thin necklace that hangs low around her neck. The falling translucent cloth of the chemise barely covers the nipple of her other breast, conveying the sense that the garment might be brushed away with just a touch of the hand of a curious spectator, who might thus expose her upper body completely to his view. The chemise in turn is framed by what seems to be a sheepskin cloak or throw on the chair on which she reclines; through its tactile qualities, which are modelled with fluffier brushstrokes, the throw insinuates a suggestion that her nakedness is tangible and real. In the outer darkness, in the outer circle of our attention, she holds in her right hand David's letter; the letter is reduced merely to a prop, little more than a pictorial signifier that it is Bathsheba at whom we are looking. The import of its commanded betrayal and its consequences of death and despair are all forgotten by Bathsheba, by Drost and by the implied viewer of the picture. Her left hand and wrist in contrast are picked out on their upper surface by a pool of light, and the hand is inclined upwards, passively lying on her lap, in a gesture almost of suppliance.

Of the power and quality of this picture there is no doubt; but there is also something disturbing about it, which casts a shadow over its merit. For it is clear what Drost is aiming at: this is Bathsheba as willing object of the viewer's sexual attention, a Bathsheba who is aware of the gaze on her, and who returns it with considerable interest. This is Bathsheba as seductress, not the innocent unknowing object of an unwelcome sexual attention. In short, this is Bathsheba as seen through King David's eyes, the object of his lust: willing, interested, with the promise of sexual abandon and satisfaction conveyed in her look; his attention is focused on her willing expression and especially on that breast, with its suggestion of further nakedness and of the pleasures to come. She is in David's and the viewer's eyes free of any attachments, moral or social; the intended adultery, the betrayal and death of her husband, the moral gravity of what she and David are about to do, all are swept away, consigned to the outer darkness along with David's letter to her.

Indeed, there is something more subtly disturbing at work in the picture. Bathsheba in the Bible is initially the innocent and unknowing victim of David's voyeurism: she does not aim at his attention, he observes her unawares. In the Bible's sparse sentences, we are given little sense of what her reactions were when she discovered his interest: we are told simply that "David sent messengers, and took her; and she came in unto him, and he lay with her". This could have been simple rape, it could have been based on Bathsheba's willing assent, it could have been something more complex. But there is no doubt of the reactions of Drost's Bathsheba: she returns the viewer's (and David's) gaze with a coquettish inclination of the head; all sense that she is the victim of someone's voyeuristic interest is expunged. This is a Bathsheba who is actively complicit in her own ignominy, and by implication blame is shifted away from David and the male viewer. Though the Drost painting is a particularly striking instance of this moral shift, it is not unique in this respect: both in the painterly tradition and in the moralistic literature of the time, it was Bathsheba who was often held up for condemnation, rather than such condemnation being directed primarily at David, the instigator of the entire episode.[30] And there is a further subtly discomforting aspect to this image: Bathsheba is the traditional paradigm of the object of illicit lust; yet this painting, in the way in which it represents her, aims to recreate that very same sexual interest in the viewer. It thus exhibits a kind of hypocrisy in arousing the very emotion the narrative that it illustrates condemns.

The long pictorial tradition of Bathsheba as seductress is also found at work in a painting of 1643, *Toilet of Bathsheba* (The Metropolitan Museum of Art, New York), which was traditionally credited to Rembrandt, though now it is more often ascribed to a pupil of his. But, whatever its exact authorship, there is little doubt that Rembrandt had at least some hand in the work. The painting is more traditional and in many ways less interesting than the Drost, for it shows Bathsheba in her customary setting, being preened by two handmaidens, with a peacock, that traditional symbol of vanity, in the lower right of the picture, and David's castle in the background. What links it to the Drost is Bathsheba's seductive expression, her head inclined to her right, her eyes enticingly meeting the viewer's gaze. Her left arm lies across her chest, the hand just covering her right breast, but leaving the left breast exposed and also slightly supported by her arm, thus emphasising its roundness and presence. Rembrandt, in so far as he was involved in this picture, was clearly at an earlier point in his career happy to follow the traditional line of Bathsheba as seductress.

The 1654 Louvre *Bathsheba*, which is our subject and is undoubtedly by Rembrandt, has been X-rayed, and it is apparent that the picture as first drafted was very different from the final version. For in it Bathsheba holds no letter, and she is not gazing sadly down, but is looking upward and apparently outward, her body in a much more lively posture. The head in this upward position seems to have

[30] Ibid., pp. 76–81.

been largely finished before Rembrandt expunged it and radically rethought what he wanted to convey. It has been plausibly maintained that in this earlier version Bathsheba was painted at the moment of catching and returning King David's gaze as he observed her.[31] Though the imperfections of the X-ray do not allow us to be sure, given the pictorial tradition and the existence of the 1643 *Bathsheba*, it would not be in the least surprising if the expression on her face was that of the seductive longing we saw in the earlier painting. If so, the temporal gap between the initial draft of the 1654 painting and its final form represents the point at which Rembrandt affected a radical and extraordinary rupture with the Bathsheba tradition.

The finished painting gives full weight to Bathsheba's erotic charge. Measuring 1.42 metres by 1.42 metres, the canvas is almost filled by her seated form, which is thus shown life-size and lies close to the picture plane. Her upper body, unlike her head and legs, is turned towards the viewer to reveal her breasts, and only a wisp of cloth (cut down from the fuller drapery revealed by the X-ray) plays across her lap. She is painted in a warm, golden, glowing light streaming down from the left and above her, a quality of light very unlike the cool silvery tones of the Drost painting—we see Rembrandt's Bathsheba literally and metaphorically in a warmer light than we do Drost's. Her body is subtly modelled by small gradations of tone and hue, which impart to it a quiet and gentle glow against the dark background. The brushstrokes that construct the body are carefully laid down and subtly melded into each other, being almost indiscernible, unlike the broad and coarse brushstrokes that model the discarded chemise on which she sits, the golden brocade of the cloak bunched up to her right, and the broad brim of her servant's hat. Rembrandt has lavished loving care and attention on the representation of her body, which help make it stand out in an erotic glow from the dim surroundings in which she sits. Many have found Bathsheba's body, as opposed to the painterly facture of its construction, not particularly beautiful or even not beautiful at all. The reaction is a long-standing one: a Christie's catalogue entry of 1811 labels her firmly as "deficient in beauty".[32] And there is little doubt that by modern standards she is not as conventionally beautiful as is Drost's Bathsheba. But in terms of Rembrandt's standards of beauty, this is not so: the same basic body-type of narrow shoulders, small breasts, large belly and hips recurs in other paintings by Rembrandt that are undoubtedly intended to represent a sexual ideal, such as his *Danaë* (Hermitage, St Petersburg), and indeed in the 1643 *Bathsheba*. And there is some evidence that this standard of beauty was widely shared at the time, being displayed in fashionable clothing of the period.[33] Looking through Dutch seventeenth-century eyes, then, this may have been a wondrous beauty, in full display before the viewer.

[31] Ernst van de Wetering, "Rembrandt's Bathsheba", especially p. 40. The X-ray is illustrated on p. 33.

[32] Gary Schwartz, " 'Though Deficient in Beauty' ", p. 179.

[33] Sluijter, "Rembrandt's Bathsheba", pp. 93–4, citing work by Anne Hollander.

There is a second reason for thinking her beautiful: for, in striking contrast with the Drost portrayal, this Bathsheba conveys a strong sense of being a real person, of having an inner life of her own, of being a personality whose erotic side is but one aspect of a multi-layered whole. As we shall see in Chapter 6, the notion of personal beauty is sensitive to the presence of personal qualities as well as to bodily form: seeing someone as beautiful is partly responsive to seeing her personal qualities as displayed in her bodily gestures, pose and form. This kind of beauty is well illustrated by Rembrandt's portrayal, whereas Drost's Bathsheba seems lit only by the force of an erotic power, which is itself the mirror of a sexual desire directed at her by the implied viewer.

How does Rembrandt achieve this effect of a real, rounded person with an inner life inhabiting the body we see, an effect that is so important to the quality of the picture and to the attitude it invites us to take towards its subject? Partly the effect is dependent on the nature of Bathsheba's body: Bathsheba is perhaps in her thirties, a decade older than Drost's model, and her body gives a sense of having been lived in, displaying some of its wear and tear in the carefully traced folds of the skin, particularly around her belly. Partly it is because there are many signs of her life outside the purely erotic realm: at her feet is a servant tending her and caring for her in a way that has nothing to do with the sexual interest that is the predominant and perhaps sole concern displayed in Drost's picture. The servant, though only sketched with loose brushstrokes, has her role emphasised by the implied diagonal running from the top right-hand side to the bottom left-hand side of the canvas, a diagonal that dominates the composition of the picture, and broadly down which Bathsheba's gaze runs. Bathsheba's elaborate coiffure, the beads and plaiting of her hair, together with the attention of her servant, also remind the viewer that she has a degree of social status and standing in her own right.

But most important for the conveying of a sense of an inner life, and the attitude we should take towards her, is her gaze and bodily posture. Rembrandt's Bathsheba is unaware of our attention: her gaze is lost somewhere in the interior space of her own thoughts and feelings as she contemplates what the letter has told her. The letter is prominently displayed and lit in her right hand, slightly below the centre of the picture. And what the expression on her face, shown almost in profile, reveals is a mixture of introspective sadness, tinged with a gentle resignation, with perhaps a hint of a half-smile of erotic anticipation (the latter is more obvious if one concentrates on her head alone and ignores her bodily posture). The resignation and melancholy are also mirrored in the posture of her body, bent slightly forward as if too heavy to hold upright, and also propped up by the prominent left hand, whose fingers are picked out in black lines that anchor them to the red-draped bench on which she sits.

Finally, and more subtly, there is a sense in which the viewer's experience of the painting itself recreates a sense of interiority, of entering the inner chamber of another mind. This is a painting that only slowly reveals its forms and colours:

the space in which Bathsheba sits has a structure, unlike the plain black backdrop of Drost's painting, but its topography is obscure, and details such as the arch or architectural feature in the upper right of the picture and the red curtain drawn parallel to the picture plane running just below the top of her head and onto which her shadow falls emerge only very gradually. Even Rembrandt's signature and the date of composition, painted just above the right foot, can only be discerned after long and careful viewing. Above all, once the eye has grown accustomed to the painting's subdued tonality, the initially muted colour scheme proves to be subtly powerful: the colours seem gradually to gain in hue and saturation, and almost to glow with a quiet inner light. This experience of looking at this work, of discovering hidden beauties and new forms, creates an analogue of Bathsheba's contemplation, but with a pictorial object, and it reinforces the sense of an inner, interior life at work that the painting so powerfully conveys.

If Drost's painting is Bathsheba seen through David's eyes, this is Bathsheba as seen through her own eyes: the picture conveys a real sense of interiority, of a mind well aware of situation into which she has been thrown by the King's attention, and cognisant of the moral implications of what is to happen. This Bathsheba too is sexually attractive, displayed in her nakedness before us, but she is also a woman of some standing, with people who care for her, a real person with a history and a habitat, whose life is about to be uprooted and who contemplates what is to be. There is no or little sense of voyeurism in our visual relations with her: though erotically charged, she has too much psychological presence and we are drawn too deep into her ruminations to think of ourselves as somehow peering at her merely as an object of sexual interest.[34] And as Leo Steinberg has strikingly observed, there are subtle signs of an innate modesty in her posture: her legs are carefully crossed, the wisp of cloth in her lap must have been placed there by her, the thumb and the forefinger of her left hand enclose a fold of cloth between them, as if to draw the chemise on which she sits slightly tighter and more protectively around her body.[35] This then is a view of Bathsheba that invites us to empathise with her, to imagine what it is like to be in her situation and to sympathise with her in her plight. In short, the kind of attention we are invited to direct towards her is a moral attention that is cognisant of her suffering; it is not the narrow sexual interest, reciprocated by its subject, that Drost's picture invites the viewer to share in. The sexual aspect of Rembrandt's Bathsheba is there for all to see, but it is viewed only as an aspect of her, not as her entire reason for being, and it is handled in a way that reminds the viewer of the full moral import of the narrative that we see pictorially enacted

[34] Here I disagree with Sluijter, "Rembrandt's Bathsheba", and Svetlana Alpers, "Not Bathsheba", both of whom hold that the viewer is visually identified with David's voyeuristic position in this picture. Voyeurism involves not only a kind of observation of which the subject is unaware, but also a specific kind of motivation, which in the case of sexual voyeurism is a narrowly sexual, objectifying interest. It is the latter that is strikingly absent from this picture.

[35] Leo Steinberg, "An Incomparable Bathsheba", pp. 111–13.

before us. It can be no coincidence that the model for this Bathsheba is almost certainly Hendrickje Stoffels, who became Rembrandt's common-law wife after the death of his first wife, Saskia. The sense of palpable care, love and sensitivity with which Bathsheba is depicted may well draw on the artist's real feelings for his model. Indeed, given the sparseness of the interior in which Bathsheba is depicted (itself an unusual feature in the genre, which in line with the biblical story usually depicts Bathsheba outdoors), it is not hard to see this as a portrayal of Hendrickje posing as Bathsheba.[36]

Rembrandt accomplishes a revolution in the tradition of Bathsheba-depiction by seeing the story through her eyes, and in so doing displays an awareness of the moral significance of that story, laying aside the narrow concupiscence and implicit hypocrisy of its customary depiction. Bathsheba is in a way depicted as a tragic heroine, caught up in a dilemma between the summons of her king and the demands of her marriage and of her heart, the victim of her own outstanding beauty.[37] Indeed, Rembrandt by pictorial means here performs the kind of sympathetic exploration of an acutely painful situation that Tolstoy was to undertake much later in literature for that other adulteress, Anna Karenina.

As should now be clear, it is the quality of moral attention, its awareness of the tragedy of Bathsheba's situation, its invitation to feel sympathy for her and its acute sensitivity to the existence of a fully-rounded person with an interior life that go a large way to explaining why Rembrandt's is such a great picture. Conversely, it is the moral nescience, the sense that Bathsheba is narrowly the construct of male concupiscence, the object of a sexual interest that is oblivious to any sense of the interior life of its object and indifferent to the evil that is about to be enacted, that explains in large part why Drost's painting falls short of the artistic greatness that Rembrandt's picture so effortlessly commands. And, though one might casually suppose that the quality of moral attention in the Rembrandt is something irrelevant to and independent of the artistic excellence of the picture, the painting itself illustrates why this is not so. When we try to show how the artist conveys the sense of a full, rounded personality caught in a fearful situation, and how he gets us to think about and feel about it in a particular way, then as we have seen it is to the artistic qualities of his picture that we must appeal—to the way he depicts the posture and gaze of Bathsheba,

[36] See Alpers, "Not Bathsheba". Alpers also takes up an earlier suggestion by Gary Schwartz that the painting was prompted by the 1654 summons of Hendrickje, who was five months pregnant by Rembrandt, by the Council of the Reformed Church for 'whore-like' behaviour with Rembrandt. If this is so, it adds an intriguing dimension to the painting; but, since we do not know when precisely in 1654 the painting was made, this hypothesis can be neither confirmed nor disconfirmed.

[37] This is well argued by Schwartz, " 'Though Deficient in Beauty' ". He also shows that Jan Six, Rembrandt's patron of these years, wrote a play in 1648 that sought to recuperate Medea from her stock position as evil personified into a more complex tragic and sympathetic heroine. Rembrandt produced an etching to illustrate Six's play, and Schwartz speculates that the play may have inspired Rembrandt to attempt a similar moral rescue for Bathsheba.

the nature of the light that falls on her, the presentation of the role and painterly handling of the servant, and the nature of the brushstrokes that delicately delineate her body. And the same general point about the intimate interrelation between the moral and the artistic qualities of the picture applies too to Drost's painting. Drost and Rembrandt, then, give us two quite distinct ways to think about and to see Bathsheba, and the ways they do this are intimately bound up with, and are fully understandable only by reflecting on, the ways in which they have painted their subject. And, in getting us to see Bathsheba in this new way, Rembrandt also provides us with the means for reflecting more generally on the kind of predicament in which she is trapped. For hers is a situation in which sexuality, power, adultery and loyalty are all powerfully in play, and, in presenting her situation, Rembrandt invites us to reflect on these themes too, and on how we should feel about and judge a beautiful woman locked in the vice of a dreadful situation. One can see such a woman and her sexuality in the way that Rembrandt invites us to do, or in the way that Drost suggests. Rembrandt's implied attitude in this painting extends wider than the Bathsheba story, for its themes have a broader application than to her particular predicament. The painterly expression of how to see Bathsheba can be the lens through which we view women's sexuality and male attitudes thereto. Rembrandt then has taught us to see Bathsheba and her like in a way that is closely bound up with a painterly mode of expression and yet that also allows us to view the human world anew and more accurately. And it is in large part because Rembrandt's vision of his subject is deeper, richer and truer than Drost's that Rembrandt has produced the greater painting.

Ethical criticism of these paintings, then, displays their ethical qualities in a way that also enhances our appreciation of the aesthetic merits and demerits to which they are intimately connected. And their ethical qualities are also inextricably linked to the modes of feeling that we are invited to have towards their depicted subjects, and the insights which we are vouchsafed through our appreciation of the paintings. The merits of ethical criticism and the main themes of this book are well illustrated through this intriguing pair of pictures.

2

Aesthetics and Ethics: Basic Concepts

The central question of this book concerns the intrinsic issue of the relation of the aesthetic value of artworks to their ethical value. To answer this question adequately requires us to clarify the notions of the aesthetic and the ethical figuring in it. The aim of this chapter is to provide an adequate account of these concepts. This will allow us to disambiguate some of the confusions that have surrounded disputes about the relation, and, by correctly determining the notion of the aesthetic, to form a basis for a conception that allows cognitive and ethical values to count, under certain conditions, as aesthetic ones.

2.1. THE PUZZLE OF THE AESTHETIC

The notion of the aesthetic is a frustrating one, at once indispensable and yet obdurately obscure. Certainly we seem to need it. We can view a work of art from many points of view: we can view it from an investment point of view, or view it in terms of the social status it will confer on its owner, or consider its utility for hiding that annoying damp patch on the wall. Or we can view it from an aesthetic point of view, and this seems to exclude the kinds of consideration—of money, social esteem or brute physical dimensions—that are of interest to the other kinds of view. So the notion of the aesthetic appears to be doing useful work and to be relatively clear, at least when used in contrast to these other terms. Yet, when we try to say more precisely what it is to observe something from an aesthetic point of view, we either move merely within the realm of the aesthetic (it is to take an aesthetic interest in something, or to consider its aesthetic value, etc.), the very term we are seeking to clarify, or we aim at a non-circular account, perhaps in terms of non-practical concerns, which, as we shall see, lays itself open to counterexamples.

There is at least one relatively clear usage of the term, which I will call the *narrow* sense of the aesthetic. Often when people talk about an aesthetic experience, or of something being aesthetically good, they mean simply that it is beautiful, or possesses properties that are particular species of the beautiful—the elegant, the graceful and so on. And when they talk of something being aesthetically bad, or of it being 'unaesthetic', they mean simply that it is ugly, or that it possesses properties that are particular species of the ugly—the hideous, the ungainly and

so on. Attempting to characterise this narrow sense of the aesthetic is no easy matter. Simply construing it in terms of sensuous pleasure (that is, pleasure in sense-perception) is inadequate, because there are things that can be beautiful, such as mathematical proofs and thoughts, that cannot be perceived by the senses at all (a point to which we will return in Section 6.2).

Were we to restrict ourselves to the notion of the aesthetic in this narrow sense, then it might seem that the issue of the relation of the aesthetic to the ethical is easily settled: there is none. It is a platitude that a beautiful person may be vicious and an ugly one virtuous; and more generally, since the ethical centrally qualifies a person's character, and character is not directly perceptible, then what is ethical cannot be beautiful or ugly. However, this disavowal of a link between the ethical and the narrow notion of the aesthetic is much too quick: as just noted, the beautiful cannot be restricted to the sensuously pleasing, and, as observed in the previous chapter, there is a long tradition of holding that a person's moral virtues are kinds of beauty of her character. In Chapter 6 we will examine this argument linking a virtuous character with beauty.

Though the notion of the aesthetic in the narrow sense is relatively clear, if elusive of definition, things rapidly obscure and darken when we examine the full range of usage of the term 'aesthetic', a usage I will term the *wide* sense. For this usage far outruns talk of the beautiful and the ugly. Here are some of the terms that Frank Sibley, in a classic and highly influential article that set the framework for the modern debate about the aesthetic, gives as examples of aesthetic concepts: besides the beautiful, the elegant, the graceful and the dainty, which fit the narrow use, he also gives as examples being tightly knit, unified, integrated and lacking in balance; being serene, sombre, lifeless, dynamic, tragic, sentimental; being deeply moving, exciting, full of tension; and being trite and vivid.[1] This list comprises a surprisingly heterogeneous set of properties: some are broadly formal (that is, non-referential) properties of works, such as unity and balance; some are broadly expressive, such as serenity and sombreness; some are affective properties, conceptually linked to phenomenal responses, such as being exciting and deeply moving; and some do not clearly fit any of these categories, such as being trite. Yet all are in some sense aesthetic properties.[2]

[1] Many of these terms, for instance, 'sombre' and 'lifeless', have both aesthetic and non-aesthetic uses (in the latter use, one can talk of someone's mood as sombre, or say that a corpse is lifeless). It is the aesthetic uses of these terms alone that are to be discussed in what follows.

[2] Frank Sibley, "Aesthetic Concepts". Sibley repeatedly denied that he was trying to give a definition of the aesthetic (see Colin Lyas, "Sibley"). But one might wonder what unites these terms on his account. He holds in "Aesthetic Concepts" that what these properties have in common is that their detection requires the possession of taste (since they are not condition-governed). However, if taste is the ability to detect aesthetic properties, any account appealing to this would be tightly circular. On the other hand, if taste is, as Sibley indicates, an ability acquired by training, then many perceptual skills, such as the ability to see which kinds of rock formation are likely to be oil-bearing or to distinguish chicks as male or female, require training, though they are not directed at aesthetic properties. Also, as Ted Cohen points out, an ability to identify basic aesthetic properties does not

One might argue that this broader set of aesthetic properties could be subsumed under the beautiful and the ugly: the positive ones being beautiful, the negative ones ugly. But this putative broader notion of the beautiful itself includes the normal notion of the beautiful as one of its components, so what is this broader sense of the beautiful, if not simply that of being a positive aesthetic property—the very concept we are seeking to clarify? And the other properties on the list can be possessed by works whether or not they are beautiful in the ordinary sense: a work can, for instance, be sombre and beautiful or sombre and ugly. So subsuming the full list of aesthetic properties under the rubric of the beautiful and the ugly is not a promising strategy.

What then do these apparently heterogeneous properties have in common? Two approaches to answering this question have been influential. The more historically important has been to give an account of the aesthetic attitude and then to identify aesthetic properties as the proper objects of this attitude. The second has been directly to identify some feature or features that all aesthetic properties have in common.[3] The attempts to characterise aesthetic properties are innumerable; so I will merely indicate briefly why some of the more important of them have failed.

Aesthetic attitude theories try to characterise a distinctively aesthetic way of looking at works of art and nature. In order to identify aesthetic properties non-circularly by such a strategy, the aesthetic attitude must be specified independently of the properties at which it is directed. Though Kant does not discuss the idea of an aesthetic attitude in the *Critique of Judgment*, his account of taste has greatly influenced attempts to define the attitude. His first definition of the beautiful is as the object of taste, and he defines taste as "the ability to judge an object, or a way of presenting it, by means of a liking or disliking *devoid of all interest*".[4] An interest is "what we call the liking we connect with the presentation of an object's existence"; and he adds that, "if the question is whether something is

always require any special training, such as when one distinguishes clear cases of a graceful line from a clumsy one; see Ted Cohen, "Aesthetics/Non-Aesthetics and the Concept of Taste". Sibley's later view is that that there is no one notion of the aesthetic, but "many criss-crossing ones" ("Tastes, Smells and Aesthetics", p. 254).

[3] There is a third option, to try to characterise aesthetic experience directly. Attempts of this kind, though, tend when elaborated to reduce to talk of properties that are the objects of this experience or to appeal to the attitudes implicit in this experience (or to appeal to similar considerations as do aesthetic attitude theories). For instance, content-oriented theories of aesthetic experience, such as Noël Carroll's, depend on listing the properties that are the objects of the experience. Alternatively, attempts to specify the kind of experience involved appeal either to its phenomenology (generally employing the idea of pleasure) or to the value of the experience (standardly, that we value it for its own sake, a view adopted by Gary Iseminger). These appeals to pleasure and to valuing something for its own sake are also made by some aesthetic attitude theorists, and will be criticised later. The aesthetic experience view thus tends to reduce to one of the two traditions considered above or to appeal to similar considerations. For useful overviews of the aesthetic experience view together with defences of versions of it, see Noël Carroll, "Aesthetic Experience", and Gary Iseminger, "The Aesthetic State of Mind".

[4] Kant, *Critique of Judgment*, Ak. 211.

beautiful, what we want to know is not whether we or anyone cares, or so much as might care, in any way, about the thing's existence, but rather how we judge it in our mere contemplation of it (intuition or reflection)".[5]

Kant's seminal discussion highlights two elements that have been central for aesthetic attitude theorists: the connection to pleasure and the idea of disinterest. The latter idea Kant introduces as expressing an attitude by which one cares about the presentation (or representation) of an object, but does not care about its actual existence; for one cares only about the contemplation of the object. He here marks as salient the distinction between a practical attitude and an attitude of mere contemplation. Later aesthetic attitude theorists have borne the imprint of Kant's view. Stolnitz defines the aesthetic attitude as "disinterested and sympathetic attention to and contemplation of any object of awareness whatever, for its own sake alone".[6] Scruton talks of the aesthetic attitude as involving "enjoyment of an object *for its own sake*", and defines an interest in an object X for its own sake as "a desire to go on hearing, looking at, or in some other way having experience of X, where there is no reason for this desire in terms of any other desire or appetite that the experience of X may fulfil, and where the desire arises out of, and is accompanied by, the thought of X".[7]

Different problems infect different elements in these accounts. First, the appeal to enjoyment (made by Kant and Scruton) fails, if it is held to be a necessary element of a (rewarded) aesthetic attitude.[8] For one can attend aesthetically to a work of art, judge it to be good, yet the experience may not properly be described as one of unmitigated enjoyment. Some works of art are harrowing, disturbing, disconcerting: one might well look askance at a reader who said that she had really enjoyed the denouement of *Tess of the d'Urbervilles*, or who experienced simple delight on perusing Goya's *Disasters of War* etchings, or who said that she had rarely had as pleasant an experience as watching *The Killing Fields*, a film about Pol Pot's genocide in Cambodia. So not all positive aesthetic values are necessarily the objects of pleasure.

Second, perhaps for this reason talk of attending to an object for its own sake has proved popular (as witnessed by Stolnitz, who mentions it, but who does not mention enjoyment, and by Scruton, who mentions both it and enjoyment). For one can think that something is worth attending to for its own sake, perhaps because the experience of it is somehow enriching or rewarding, without thinking that the experience is thereby enjoyable. Only an indefensible hedonism about value would equate what is valuable in itself with what is enjoyable. The notion of attending to something because it is intrinsically valuable contrasts in this usage with taking a merely instrumental interest in it. This way of characterising

[5] Ibid., Ak. 204. [6] Jerome Stolnitz, "The Aesthetic Attitude", p. 336.

[7] Roger Scruton, *Art and Imagination*, pp. 143, 148.

[8] Since Kant is concerned with the definition of beauty, which plausibly is essentially related to pleasure, this point is meant as a criticism not of his theory of taste, but merely of the subsequent tradition's application of his views to the more general notion of the aesthetic attitude.

the aesthetic attitude holds, therefore, that such an attitude is inconsistent with having an instrumental attitude towards its object. But that is false: a student may have a merely instrumental attitude towards reading a Shakespeare play, since she must pass an exam about it, yet be alive to its aesthetic features; a valuer for an auctioneer may be concerned to value the works of art in the showroom, and thus have an instrumental attitude towards them, yet have to attend to their aesthetic features in order to give a correct estimate of their monetary value; and an artist may have an instrumental attitude towards her productions, seeing them as a way to make ends meet, while also being well aware of their aesthetic features.

The attitude theorist may object that these cases have been misdescribed: what is really going on is that the student, valuer and artist are, when they are aware of the works' aesthetic features, attending to the artworks for their own sake, but that they also have a separate and distinct instrumental attitude towards the artworks. However, the cases need not be like this: these people may all be attending to the aesthetic features *because of* their instrumental concerns; there may be one seamless instrumental attitude involved and not two distinct attitudes. So the objection stands: attention for its own sake is not necessary for the obtaining of an aesthetic attitude.[9] Further, it cannot be sufficient, for one can have an intrinsic interest in something while not having an aesthetic attitude towards it: I can value learning about history for its own sake, but I do not thereby regard history aesthetically.

The third strand in the tradition of the aesthetic attitude is the contrast of mere contemplation with possessing a practical attitude towards a work, as adverted to by Kant and Stolnitz. This account contrasts an interest in merely contemplating or experiencing an object with a practical interest in it—a concern to do something with it. The contemplative/practical contrast is easy to conflate with the intrinsic/instrumental interest contrast, but they are in fact distinct. I can intrinsically value not only experiences, but also doing things, such as going for a walk; so my attitude is practical (I am concerned to do something, not merely to experience something), but I also value the activity intrinsically. And conversely I can have a contemplative but instrumental attitude, as when an archaeologist shows great interest in a battered leather shoe that he digs up: he has a merely instrumental interest in it, for he wants to know what light it will throw on the past; but his interest in the shoe is not practical: he merely wants to look at it, not to do anything with it, such as wear it.

Though the contemplative/practical contrast is distinct from the intrinsic-/instrumental contrast, it falls to the same counter-examples in respect of what is required for an attitude to be aesthetic. The student, valuer and artist mentioned

[9] George Dickie, "The Myth of the Aesthetic Attitude", also tellingly considers some instrumental cases, though he also claims against Stolnitz that these cases are ones in which people have an instrumental *motivation*, and that this need not show that they have a distinct *mode of attending* to the artworks. The latter point is untenable, however: for one way of specifying a mode of attending is in terms of the attender's motivation, as when we say that 'he looked at me with hunger in his eyes'.

above have concerns that are practical as well as instrumental, but all can attend to aesthetic features of objects. So an attitude's being contemplative is not necessary for it to be aesthetic. But matters are worse than this. For, if we insisted that a contemplative (non-practical) attitude is necessary for an attitude's being aesthetic, then any artist at all would count as not taking up an aesthetic attitude to her work while making it. For her attitude towards her work is certainly practical while she makes it: she is concerned to create it and to revise it in various ways so as to improve its quality. The contemplative criterion for the aesthetic attitude here reveals itself as rooted in the audience's perspective on the artwork and neglects the viewpoint of its maker, which has at least as good a claim to be an aesthetic one as does the audience's.

An attitude's being contemplative is also insufficient to make it aesthetic, since I may contemplate something non-aesthetically. I may let my eyes wander around the room during a boring talk, allowing them to alight where they will, merely contemplating what I see, with no intention of acting in any way, but I am not thereby attending to the corners of the room aesthetically. And in reading history I am barred from the possibility of action (nor need I be reading it in order to draw lessons for present action from it), but I need not thereby be viewing historical events aesthetically.

There has been a wide range of attempts to specify the aesthetic attitude in terms of qualities intrinsic to it, only some of the more important of which have been examined above. But, given the general problems raised with the strategy, the discussion gives grounds for suspicion about whether any such project can succeed.

The other way to specify the aesthetic attitude would be in terms of the objects at which it is directed: aesthetic properties. An important account of this form is due to Monroe Beardsley. Beardsley defines an aesthetic point of view as one in which we take an interest in the aesthetic value of some object; and he then defines the aesthetic value of an object as the value that it possesses in virtue of its capacity to give aesthetic gratification, when we are correctly experiencing it. He explains that "Gratification is aesthetic when it is obtained primarily from attention to the formal unity and/or the regional qualities of a complex whole, and when its magnitude is a function of the degree of formal unity and/or the intensity of regional quality".[10] The notion of a regional quality is only vaguely outlined, but appears to be a broad one, covering both expressive and narrowly aesthetic properties. Given this account, and the assumption that the aesthetic attitude is directed at aesthetic properties, it follows that such properties can be construed in response-dependent terms, as those in which we properly take aesthetic gratification, where aesthetic gratification is construed as above.

This account of aesthetic properties encounters several difficulties. Beardsley tells us that gratification is supposed to cover a bit more than enjoyment, but does not say in what this surplus consists. Lacking such an account, the adequacy

[10] Monroe C. Beardsley, "The Aesthetic Point of View", p. 16.

of his theory is hard to evaluate against *Tess*-style objections. More importantly, Beardsley's account is an attempt to regiment the embarrassingly disorderly collection of wide aesthetic properties by means of a fairly simple and strict formalist notion. As such, it represents a welcome advance over specifications of aesthetic properties as simply beauty (and ugliness) and their species. But it still fails to capture the full range of such properties. This emerges most clearly when we consider his account of aesthetic gratification. Beardsley gives us a choice by employing the "and/or" operator in defining it. Suppose we read the operator as "and". Then his account holds that gratification is aesthetic when it is obtained primarily from attention to formal unity and regional qualities, and when its magnitude is a function of these. But that underplays the sources of aesthetic gratification. One can take aesthetic gratification in the cognitive merits of works, celebrating their profundity or the insights that they deliver. And one can gain aesthetic gratification from exercising cognitive skills in appreciating works, ranging from the humble pleasures of the detective novel to some of the pinnacles of modernism. Consider that extraordinarily fragmented and magnificently bizarre film by Buñuel and Dali, *Un Chien andalou*: in this film it is not at all clear what is going on, the number of characters involved, the relation (if any) between the scenes where the action is set, or indeed very much else. The viewer is set to work on an obdurate cinematic puzzle that lacks apparent solution, and much of the interest of the film depends on this fact. It functions to create an intricate play of hypothesis formation and destruction in its audience, the pursuit of which is part of the aesthetic pleasure that it delivers. So there are cognitive merits that these works possess that Beardsley's formalist account does not countenance.[11] If, conversely, we read the "and/or" operator in terms of "or", the opposite problem arises for Beardsley's account. Now far too many things are included as the objects of aesthetic gratification. For instance, a colonel taking pleasure in the fact that his troops are dressed exactly alike according to regulations would count as taking aesthetic pleasure in them, for he would take gratification in the formal unity of his men on parade.

More promising than Beardsley's formalist account is Alan Goldman's account of aesthetic properties, since Goldman consciously eschews formalism and allows for a wider variety of aesthetic properties.[12] Goldman holds that aesthetic

[11] These points are meant only to sketch out problems with Beardsley's account; a defence of the claim that cognitive merits can be aesthetically relevant is given in Ch. 8; and Ch. 7 argues that artworks can deliver genuine insights.

[12] Alan Goldman, "Aesthetic Qualities and Aesthetic Value". In his book *Aesthetic Value*, pp. 17–21, he offers a different characterisation of aesthetic properties, employing three criteria, the first of which is that they are properties "that ground or instantiate in their relations to us or other properties those values of artworks that make them worth contemplating" (p. 20). This account comes closer to that which I defend in Sect. 2.2; but the proffered criterion encounters the objection (as Goldman seems to acknowledge without addressing it) that there are negative aesthetic properties as well as positive ones and that possessing the former does not generally make a work worth contemplating; and it also requires an account of what contemplation is so as to address the difficulties with that idea that we noted above.

properties are phenomenal properties and certain relations between them that make experiences more valuable. Phenomenal properties include not just perceived properties, but also experienced ones, so as to cover literary works and also to allow experiences such as sadness to count as phenomenal.[13] The aesthetically significant relations are, first, internal ones (relations between tones and coloured patches, such as contrast, variation and repetition); secondly, representational and expressive relations; and, thirdly, relations to earlier works, such as being original or conservative. Since these relations are not always perceivable, they allow Goldman to acknowledge the existence of perceptually indiscriminable counterparts that differ in aesthetic value, and also to acknowledge as aesthetically relevant properties that formalism would not countenance as such, for instance, originality. Goldman also explains the value of formal, representational and expressive relations partly in terms of the values of the exercise of cognitive powers, of imagination and of the emotions.

This account is thus commendably inclusive in its treatment of aesthetic properties. Some of the difficulties it faces, however, stem from its very inclusiveness. Any phenomenal properties standing in the specified relations count as aesthetic; and that means that phenomenal mental contents, such as something looking a certain way to me, or a feeling of nausea that I have, that stand in these relations will also count as aesthetic. Large chunks of ordinary experience are thus counted as aesthetic on this proposal. If I notice that the corner of a room looks slightly darker than the centre of the room, because the wall-lights have failed, and this experience is valuable, since it prompts me to replace the bulbs, then the experience counts as aesthetic. If I notice that the feeling of nausea I am having now is similar to the feeling I had when I last dined at my local café and this experience is valuable since it stops me from eating more, the experience also counts as aesthetic. The proposal thus allows the aesthetic realm to balloon out so as to cover an extensive chunk of our mental life. Conversely, it excludes some properties that Goldman legitimately wants to count as aesthetic. Representational properties are supposed to be aesthetic, but aesthetic properties are relations of the specified kinds between *phenomenal* properties. If a painting represents a tree, which is not a phenomenal object, the account is forced to say that the painting is really representing the phenomenal aspect of a tree—how the tree looks to someone—not the tree itself. Certainly, paintings can represent this: but they can also represent the tree, not just the appearance of the tree. Goldman's account cannot acknowledge the former, while holding the representational relation to be aesthetic. Likewise, literary works cannot on this account represent characters, such as Anne Elliott and Captain Wentworth, but only characters as experienced; yet that is very different from how we normally think and talk of the representational capacities of literature.

[13] Goldman, "Aesthetic Qualities and Aesthetic Values", p. 30. Goldman thus countenances the point noted earlier that even narrowly aesthetic properties are not always perceptible.

2.2. THE AESTHETIC AND THE ARTISTIC

We are in something of a quandary: on the one hand, we need to employ some notion of (broad) aesthetic properties in order properly to pose our question about the intrinsic relation between the aesthetic and the ethical values of artworks; on the other hand, some of the more promising attempts to characterise aesthetic properties, whether as objects of the aesthetic attitude or more directly in terms of some common factor, have failed. How, then, are we to proceed?

Consider again Sibley's examples of aesthetic properties: being beautiful, elegant, graceful and dainty; being tightly knit, unified, integrated and lacking in balance; being serene, sombre, lifeless, dynamic, tragic, sentimental; being deeply moving, exciting, full of tension; and being trite and vivid. One feature that they have in common is that they are all evaluative terms: a work is good *because* it is tightly knit, dynamic deeply moving; it is bad *because* it lacks balance, is sentimental and trite. Not all evaluative terms can figure on this list: being a sound investment and being prestigious, for instance, could not. So what else is required? Strikingly, all these terms are used in art-critical practice, that is, are employed by art critics to evaluate works of art. Indeed, the list reflects the imprint of different critical schools. Besides the basic, narrow aesthetic notions of the beautiful and the ugly, there is the mark of formalism on Sibley's list, in the use of concepts such as that of being tightly knit, unified and lacking in balance. There is also the influence of expressivist critics and philosophers shown in the appeal to the lifeless, the serene and the sombre. This reflection of art-critical practice is not in the least surprising: Colin Lyas tells us how Sibley spent 1948 and 1949 in Oxford libraries, combing through critical writings on literature and painting, extracting terms from them as a kind of database for his future philosophical reflection.[14] The critical schools whose terms appear on Sibley's list reflect the date of this activity, the late 1940s. Were one compiling such a list now, one might add terms that reflect more recent critical trends, such as 'challenging preconceptions', 'resisting closure', 'oppressive' and so on. So the list of aesthetic terms seems to be comprised of those terms that figure in art-critical evaluations. But we need not leave it there, for art-critical evaluations are as such aimed at the evaluation of art qua art: that is, not at art as an investment, as a social symbol and so on, but at establishing the value of art as art.

Putting together these thoughts, we have the hypothesis that (wide) aesthetic terms are terms that are evaluative of art qua art. On this view, the (wide) aesthetic value of an artwork W is simply the value of W qua work of art. This definition of aesthetic value can then be used to define other terms in which 'aesthetic' figures: the aesthetic properties of W are W's evaluative properties

[14] Lyas, "Sibley".

that have aesthetic value (that is, that give *W* its value qua work of art). And to adopt an aesthetic attitude towards *W* is to consider *W* qua work of art. To put it overly simply: the notions of (wide) aesthetic value and artistic value turn out to be one and the same.

However, this hypothesis is a little too simple. For what is one to say of things such as natural objects, and mathematical theorems, that are not works of art, but that possess aesthetic value? The answer is that one needs to refine the account to create a two-part account of the aesthetic. The notion of the aesthetic value of an *artwork* is, as claimed above, its value qua work of art; and its aesthetic properties are those of its evaluative properties that have aesthetic value, as so defined. But now consider the range of these properties. Some of them cannot be possessed by natural objects, for they presuppose that their bearers have at least derivative intentionality. For instance, natural objects cannot literally possess expressive properties: a tree cannot literally be tragic or sentimental. Others of the properties that figure as aesthetic properties of art can also be possessed by natural objects: natural objects can be beautiful or ugly, and, though not the product of actions, their shapes and colour-patterns can exhibit unity and balance. And a large class of aesthetic terms applied to art are heavily metaphorical, as when one talks of a vibrant painting or a stifling sonata. Natural objects can possess these metaphorically ascribed properties too: a brook can be vibrant, a gloomy glen can be stifling.[15] So the class of aesthetic properties of artworks divides into two: those that can be possessed by natural objects, and those that cannot be, because their literal application presupposes that their bearers are the products of agency.

Thus our claim can be refined as follows: first, the aesthetic properties of works of art are as characterised above; and, secondly, the aesthetic properties of natural objects are those of their properties that can figure among the aesthetic properties of works of art. In other words, the notion of the aesthetic has its primary application to works of art, and its application to natural objects is derivative from this primary application. The importance of this claim lies not just in the clarification it provides to the term 'aesthetic', which figures in our question about the relation of the aesthetic to the ethical domain. It also shows that one cannot consistently maintain, as some have supposed, that there is a relation between ethical and artistic value, but not between ethical and aesthetic value.[16]

There are various objections that might be advanced to this account. I shall consider five. The first is that not all aesthetic terms are, as I have claimed, evaluative. For instance, 'sombre', 'tragic', 'happy' and 'sad' (used aesthetically)

[15] See my "Metaphor and the Understanding of Art" for an examination of the significance and extent of the use of metaphor in art-criticism.

[16] For instance, George Dickie in "The Triumph in *Triumph of the Will*" holds that ethical defects can be artistic ones, but not aesthetic ones. Dickie refers to the aesthetic in Sibley's sense as the narrow use of the term, but the argument given above shows that it is in fact equivalent to that of the aesthetic in the wide sense.

have no evaluative force: they merely serve to describe some object aesthetically. For instance, a tragedy might be good because it is sombre, but a comedy might be bad because it is sombre. So 'sombre' cannot be an evaluative term: some aesthetic terms are merely descriptive.

Now even were this objection correct, the account defended here—the artistic theory of the aesthetic—would still have shown something important: for it could be modified to hold that aesthetic *evaluative* properties and artistic evaluative properties are identical for artworks. And that would still establish a central connection between the realms of the aesthetic and the artistic, albeit now restricted to aesthetic evaluative terms, excluding purportedly aesthetic descriptive terms. That would be all that is required in order to formulate and defend the main claim of this book. However, the objection does not succeed. For the most it shows is that some aesthetic terms do not have the same evaluative force in all contexts, not that these terms lack all evaluative force. 'Sombre' is an evaluative term, but whether it picks out a merit or demerit will depend on what particular object it is applied to. When applied to a tragedy it picks out a merit, applied to a comedy it may pick out a demerit. A linguistic test involving "because" brings out the evaluative force. There is no puzzle in being told that "the tragedy is good in part because it is so sombre", but consider the statement "the tragedy is good in part because it involves ten characters and lasts two hours". Without a special explanation for why the number of characters and precise running time should have anything to do with the value of the play, we are left baffled by the latter claim. But there is no surprise, or need for supplemental explanation, in the claim that a tragedy is good in part because it is sombre. And that is because 'sombre' in its aesthetic use is an evaluative term. So, if we acknowledge that not all aesthetic properties have the same evaluative valence in all contexts, we can meet this kind of objection.

A second objection holds that some aesthetic properties of nature cannot be subsumed under the artistic. For instance, there may be aesthetic properties of smells and tastes that are not possessed by artworks: perhaps there are complex aesthetic properties associated with the smell of autumn that are not artistic, but art does not deal with smells.[17]

Though it has sometimes been denied that aesthetic qualities can attach to smells or tastes, one should agree that there are aesthetic properties that are applicable to them: for instance, 'pungent' is legitimately applicable to smells and tastes. However, this does not show that nature has aesthetic properties that art lacks: the pungent is a cross-modal quality, which can also attach to the sound and look of things. Moreover, some art forms do deal with smells and tastes: some gardens are works of art, and in Japanese culture, gardens are an important art form, where smells and sounds are the objects of appreciation as well as visible forms. The Japanese tea ceremony also centrally involves awareness of the taste,

[17] The objection is due to Robert Stecker.

smell and texture of the tea that is served. The twentieth century developed landscape art, and some recent artworks have striking and prominent smells, ranging from the odour of molten chocolate in Helen Chadwick's *Cacao* to the reek of a rotting cow's head in Damien Hirst's *A Thousand Years*.[18] So claims that the aesthetic properties of nature outrun those of art rest on too narrow a view of the range of artworks.

Third, there are artistic or art-critical properties that are not aesthetic ones: being in Baroque style, being linear and being painterly are examples of artistic terms that are not aesthetic. So, even for art, it is not true that the artistic is to be identified with the aesthetic.[19]

However, the existence of art-critical terms that are not aesthetic can be acknowledged by the artistic theory of the aesthetic. Such terms are ones that lack an evaluative dimension. Appeal to artistic properties here is to artistic *evaluative* properties (those that constitute the value of artworks qua artworks): it is these that are aesthetic properties. There are many art-critical terms that are merely descriptive of art, and are therefore not aesthetic terms. So 'painted in Baroque style' does not have any evaluative force, nor does 'linear' or 'painterly', used merely as classificatory terms for kinds of style. Consider too the notion of the tragic. Used simply as a term for a genre of art, it is not an aesthetic term, merely an art-critical one; and so used it has no evaluative force. However, used as an evaluative term, as when one says that an actor produced a powerfully tragic performance, it is employed in an aesthetic sense. So here again it is the evaluative component that must be present for an aesthetic use to occur.

Fourth, one could object that the artistic theory of the aesthetic makes the aesthetic appreciation of nature incorrectly and implausibly dependent on the aesthetic appreciation of art. But that is surely wrong: plausibly, humans first appreciated nature aesthetically before they invented art, and in the life of an individual the aesthetic appreciation of nature often predates the appreciation of art. So it must be possible for a person to appreciate nature aesthetically without even being aware of the existence of art. Yet it seems that, according to the artistic theory of the aesthetic, this cannot happen: given the conceptual priority of the aesthetic properties of art to those of nature, someone could not have an aesthetic appreciation of nature without knowing about art. And that seems plain false. Sibley, for instance, found it "inconceivable, or at least wholly unlikely, that there could be no aesthetic awareness of natural phenomena, of the beauty or ugliness of human faces and bodies, of animals, of sunrise and sunset, of clouds, the sea, meadows and mountains unless some art already existed".[20]

In reply, it is important to see that the artistic theory concerns what *unifies* the items that we categorise as 'aesthetic' in the wide sense. It explains why

[18] I owe these last two examples to David Davies.
[19] This objection is due to Peter Lamarque.
[20] Frank Sibley, "Arts or the Aesthetic—Which Comes First?", p. 136.

the items are thus classified and allows us to project the notion of the aesthetic correctly. But it is consistent with the theory that one could grasp and appreciate many *individual* aesthetic qualities without grasping the general concept of what unifies them, that of the aesthetic. So, for instance, one could appreciate the beauty of human faces and bodies and of nature, just as Sibley says, as well as its metaphorically ascribed properties, and so forth, without having a concept of the aesthetic (and therefore of artistic value) as what unifies these diverse qualities. One appreciates the individual qualities, but does not bring them under the notion of the aesthetic, as that which unites them all. So all that the objection, if successful, would show is that the person who aesthetically appreciated nature without being acquainted with art would not be able to *describe* her appreciation as aesthetic in the wide sense, since she would not understand the unifying principle behind her various evaluations. It would not show that she was not aesthetically appreciating nature in the sense of appreciating each of its individual properties that we classify as 'aesthetic'. In the same way, it is possible for 'primitive' societies to make what we classify as art, without themselves having that concept or therefore being able to describe their activity under it.[21]

Moreover, *contra* the assumption of the objection, even the briefest survey of the historical record suggests that the development of the idea of the aesthetic was dependent on the appreciation of art. Consider the history of two of the key terms of aesthetic appreciation. The term 'aesthetics' seems first to have been employed by Alexander Baumgarten in 1735. Initially using it to describe sensuous knowledge, he later refined it in his *Aesthetica* of 1750 and 1758 to include amongst other things "the art of thinking beautifully", and thereby the appreciation of beauty. Baumgarten's paradigm of beauty was the beauty of poetry. And the beauty of poetry he found in large part to consist in its "extensive clarity", its evocation of a wide variety of rich ideas and images. He thereby explicitly connected beauty to values such as truth and certainty.[22] Thus even at the genesis of the term 'aesthetics' in its wide sense, there is an inclusion of values that nature cannot possess, such as truth and certainty.

The same connection to artistic value is seen in the history of the concept of taste, which was traditionally understood as the faculty that grasps aesthetic qualities. The notion of taste goes back to Renaissance and Mannerist Italian critics of the sixteenth and seventeenth centuries, of whom the most famous is Giorgio

[21] Sibley also argues that the notion of the aesthetic is prior to that of art because one must think of art as the production of things "which are attempts to create, if not beauty, at least things of some aesthetic interest" ("Arts or the Aesthetic—Which Comes First?", p. 136), and so the making of art requires the notion of the aesthetic to be already available to the artist. However, even if one were to agree (as I would not) that having an aesthetic aim is a necessary condition for making art, the reply just given applies here too. One can appreciate beauty (and many other individual aesthetic properties) without having at one's command a notion of the aesthetic in general. So one can still aim to make beautiful things, and therefore satisfy what is a necessary condition of art making according to Sibley, without possessing a notion of the aesthetic in the wide sense.

[22] Paul Guyer, "Baumgarten".

Vasari. These critics were concerned with the development of connoisseurship, which took as its object the appreciation of qualities of art. These qualities included not just beauty but also properties such as the *maniera* of the artist as shown in his work. The *maniera* is the artist's style, seen as a manifestation of his personality, and is closely associated with values such as originality.[23] Artistic style and personality are not properties that can be possessed by merely natural objects. And so, from the start, aesthetic properties (as they would later be known), the objects of taste, included ones that only works of art, rather than natural objects, could possess. So the history of the key concepts of aesthetics bears out, rather than undermines, the claim that aesthetic appreciation of art, under the concept of the 'aesthetic' in the wide sense, is prior to that of nature.

The fifth and final objection holds that claiming that the aesthetic value of art is simply its value qua art has merely replaced one conundrum—the meaning of 'aesthetic'—with another at least as intractable—the meaning of 'art'. I have argued elsewhere that one can give an account, though not a definition, of 'art'. 'Art', I hold, is a cluster concept—that is, a concept that resists definition in the sense of there being a set of individually necessary and jointly sufficient conditions for something to be a work of art. Nevertheless, one can give a set of criteria, satisfaction of which counts towards something being art, but which need not all be satisfied for something to count as art. These criteria, I have argued, include such things as being beautiful (or possessing other narrow aesthetic properties), being expressive of emotion, being intellectually challenging, being formally complex and coherent, having the capacity to convey complex meanings, exhibiting an individual point of view, being an exercise of creative imagination, being the product of a high degree of skill, belonging to an established artistic form and being the product of an art-making intention.[24] This account with its plurality of criteria, many of which are evaluative, fits smoothly with the view that there is a plurality of aesthetic values.

However, though I believe that the cluster account of art is correct, I need not insist on it here to establish my main point about the connection of the aesthetic to the artistic. For consider a supporter of the Institutional Theory of Art who holds that the definition of 'art' is to be given in terms of the acts of the agents of a social institution, the artworld. He would reject the cluster account of the concept of art, but could nevertheless sign up to the aesthetic–artistic link; for he could hold, as for instance does Dickie, that the Institutional definition tells us what art is in the classificatory sense, but the evaluative question of what makes something *good* art is quite distinct and independent of this definitional question.[25] Moreover, even if one holds that the definition of 'art' involves some evaluative criteria, as suggested above, the determination of what makes

[23] Dabney Townsend, "Taste: Early History".

[24] See my "'Art' as a Cluster Concept" and "The Cluster Account of Art Defended".

[25] See George Dickie, "The New Institutional Theory of Art".

something *good* art is not exhausted by the evaluative criteria that partly determine the concept of art. For not all the evaluative criteria for something being good art need be constitutive of the concept of art. Consider an analogy. We can evaluate an individual qua businessman, and what it is to be a businessman can presumably be defined. But what makes someone a good businessman is partly determined by factors that are not part of the definition of the concept. Being disciplined in one's work habits, being a good communicator and being enthusiastic for what one does improve one's business abilities, so are relevant to evaluating someone qua businessman; but none of these factors is plausibly part of the definition of the concept of a businessman. So the questions of the definition of 'art' and of what makes something good qua art are not one and the same. Hence the cluster theorist and the supporter of very different accounts of art could both agree that the aesthetic value of art is the same as its artistic value and even agree on what that artistic value consists in, while disagreeing on the very possibility of defining 'art' or on what such a definition might consist in, were it possible.

We have identified the (wide) aesthetic properties of artworks with their artistic properties, the properties that make something valuable qua art, and so have given an explanation for the otherwise mysterious diversity of aesthetic properties. The account has important consequences for the issue of the relation of aesthetic to ethical and cognitive evaluation. First, it opens up a large space for cognitive and ethical values to enter into aesthetic evaluation. The use of the term 'aesthetic' often suggests a narrow focus on the beautiful or on formal properties of works; but, since these uses cannot capture the whole range of what we intuitively (and correctly on the above account) accept as aesthetic properties, there is less temptation to exclude the ethical and cognitive from the aesthetic domain. Indeed, on the artistic theory of the aesthetic, it may be not simply that ethical and cognitive properties interact with aesthetic properties, but that some ethical and cognitive qualities of art actually are, under certain conditions, aesthetic properties of art; and I will argue that this is indeed the case. Secondly, we saw how the list of aesthetic properties was a reflection of art-critical evaluative practices; so we need to be sensitive to how such practices have developed and the role of ethical criticism within them: some of these practices will be briefly surveyed in Chapter 5. However, we should not countenance just any art-critical practice as legitimate: there are a number of dubiously coherent practices (such as deconstruction), and we should allow for the possibility of otherwise mistaken or insensitive practices. Art-critical evaluative practices are subject to reflective equilibrium and are ultimately responsive to the value of art qua art. To establish some constraints on the legitimacy of such practices, we need to say something about what makes art valuable; or, to put the point directly in terms of aesthetic properties, our account of aesthetic properties as artistically valuable properties requires us to give at least a partial account of what makes art valuable if we are to delimit the range of what properly counts as an aesthetic property. Chapters 7, 8

and 10 develop a partial characterisation of what makes art valuable, a cognitive-affective view, which also shows how ethical features are relevant to the value of art. Thus the account of the aesthetic as the artistic lays out much of the agenda to be pursued in thinking of the relation of the aesthetic to the ethical.

2.3. THE CONCEPT OF THE ETHICAL

The other term that we need to discuss is that of the ethical. It is less a term of art (in more than one sense) than is the notion of the aesthetic and is less philosophically puzzling, so we can deal with it more briefly. But, even so, it stands in need of clarification, for it has figured in more than one sense in the debate about the relation of the aesthetic to the ethical. The terms 'ethical' and 'moral' are often employed as synonyms, but there is also a tendency within moral philosophy, literary theory and sometimes within common speech to mark a difference between the two. Bernard Williams, perhaps most prominently, has argued for a distinction, holding that the moral is a (particularly problematic, in his view) sub-set of the ethical.[26]

Certainly, it is plausible to mark out some such distinction here. Benjamin Franklin was a great compiler of useful precepts and lists of virtues and vices; amongst virtues he numbered wisdom, resolution, courage, patience and diligence, and amongst vices folly, idleness, impatience and cowardice.[27] These are all recognisably virtues and vices, delineating a particular ideal of how one should lead one's life. But one might wonder whether they are all moral qualities. Patience is certainly a virtue: but is it a moral virtue? Should one, for instance, condemn the impatient schoolchild in the same kind of way or with the same degree of force as the schoolchild who had just hit one of his classmates without provocation? Similarly, laziness, impatience, cowardice, lack of fortitude, carelessness and obtuseness are all character failings. But are they moral defects?

The broader set of merits and defects, which we will count as ethical in the broad sense, are qualities of character or intellect that are virtues—that is, forms of excellence. We admire people who have these traits, and may seek to emulate them. They are the kind of qualities the possession of which tends to make a life, or lives of certain kinds, go well. Thus their possession can be thought of as providing an answer to the question, 'How should I live my life?' or 'What is the good life?' This broad sense of 'ethical' is, of course, to be found in ancient Greek ethics, and is salient in Aristotle's version of ethics. For Aristotle, courage, temperance and wit are virtues, just as are justice, friendliness and generosity.[28]

[26] Bernard Williams, *Ethics and the Limits of Philosophy*, ch. 10.

[27] For a representative sample of Franklin's musings on these matters, see his *Autobiography*, pp. 84–6, and "The Way to Wealth".

[28] Aristotle, *Nicomachean Ethics*, bks III–V.

Several prominent proponents of the ethical criticism of art, including Wayne Booth and Martha Nussbaum, have located themselves within this Aristotelian tradition, and have formulated ethical criticism in terms of this broad notion of human merit. Booth, for instance, writes:

The word "ethical" may mistakenly suggest a project concentrating on quite limited moral standards: of honesty, perhaps, or of decency or tolerance. I am interested in a much broader topic, the entire range of effects on the "character" or "person" or "self". "Moral" judgments are only a small part of it. ... For us here the word must cover all qualities in the character, or ethos, of authors and readers, whether these are judged as good or bad.[29]

However, to avoid an easy, though entirely trivial, victory for ethical criticism in showing that at least some ethical qualities are of aesthetic import, one cannot simply take ethical qualities as any good or bad aspect of character. For on this understanding, several aesthetic qualities will uncontentiously figure as ethical ones: having a capacity to write stylishly, beautifully or elegantly and possessing an acute aesthetic sensibility, for instance, are kinds of excellence in people. Booth is happy to draw this implication: "a critic will be doing ethical criticism just as much when praising a story or poem for 'raising our aesthetic sensibilities' or 'increasing our sensitivity' as when attacking decadence, sexism, or racism."[30] But the autonomist would not and should not *ipso facto* concede victory to the supporter of ethical criticism. Indeed, the autonomist Richard Posner has made this very protest against Booth's defence of ethical criticism, holding that Booth defines the "ethical" with "promiscuous breadth", since Booth claims that thinking straighter and writing better are ethical values, and on this construal, Posner notes, "the term no longer defines the disagreement between us".[31]

One might try to winnow down the notion of the ethical by insisting that it is only traits of character, and not of intellect, that are strictly speaking ethical; hence skills, such as the ability to write beautifully, do not count as ethical. But the difficulty with this is that it would exclude traits, such as wisdom and sensitivity, that intuitively should count as ethical, but that involve an ineliminable role for the exercise of judgement. And the ability to write beautifully is not independent of one's character as it manifests itself in one's writing, but is rather in part an expression of that character. So for purposes of the debate about ethical criticism,

[29] Wayne Booth, *The Company We Keep*, p. 8. Martha Nussbaum also connects the ethical with the question of how one should live; see, for instance, *Love's Knowledge*, p. 173.

[30] Booth, *The Company we keep*, p. 11.

[31] Richard Posner, "Against Ethical Criticism: Part Two", p. 405. Marcia Eaton, in her *Merit, Aesthetic and Ethical*, also defines ethical evaluation broadly, holding it to be "the assessment of someone's character or behavior in terms of the effects it has on human well-being or in terms of the behavior's compliance with dictates of conscience or principles governing human beings' treatment of one another" (p. 125). However, since art has good effects on human well-being, being a good artist would also count as an ethical quality on this definition. So Eaton's definition would also ground a Posner-type complaint.

in so far as it is based on the broad notion of the ethical, it seems best to exclude from the broad sense of the ethical those character excellences that are explicitly aesthetic and are agreed to be such by all sides, such as the ability to write beautifully, and likewise for defects. The debate can then focus on the aesthetic relevance of those terms such as 'sincerity' or 'wisdom' that autonomists either think of no aesthetic import, or that they hold have a distinct and non-ethical sense in their aesthetic employment. Posner and Booth will still have plenty to argue about concerning the aesthetic relevance of those character excellences that fall inside this range.

Given this broad sense of the ethical, how do we carve out the narrower sense, that in which we talk of moral merits and demerits of persons? The relation of morality to aesthetic judgements has generally been at the core of the debate between autonomists and moralists, and is that on which we will primarily focus here. So it is important to get some sense of what this narrower domain consists in.

Perhaps what is still the most influential definition of morality has been given by Richard Hare, who holds that moral judgements are overriding, universalisable and prescriptive.[32] As Hare acknowledges, other kinds of judgements besides moral ones are prescriptive and universalisable. In fact, any action-guiding judgement couched as an 'ought' is prescriptive, including aesthetic judgements applying to an artist's actions ('he ought not to have painted the sky so dark') and to how a spectator should react to a work of art ('it's an excellent painting, you ought to see it'), as well as to prudential judgements. Also, other judgements besides moral ones are universalisable. Hare understands moral judgements as universalisable in the sense that "they entail identical judgements about all cases identical in their universal properties".[33] This is equivalent to one kind of supervenience, and, as such, it also holds for aesthetic judgements. And on a widely accepted view all practical reasons satisfy the universalisability requirement: if an agent holds that he has reason to ϕ in circumstances C, then he ought to hold that anyone in circumstances C has reason to ϕ.[34] This is not, of course, to deny that universalisability is an important property of moral judgements—indeed, we shall see in Chapter 7 that it is a very important one—but is simply to hold that it is at best a necessary condition for a judgement to be moral, and is insufficient on its own to distinguish moral from other kinds of action-guiding judgements.

Crucial for Hare's definition, then, is that moral reasons *override* other kinds of reason. This is not a claim about what people will do: evidently, agents not infrequently do not do what they morally ought to do. It is a claim that moral reasons *ought* to override other kinds of reasons. What, then, is the status of

[32] See R. M. Hare, *Freedom and Reason*, especially pp. 168–70.

[33] R. M. Hare, *Moral Thinking*, p. 108.

[34] Though it is widely accepted, there are dissenters to this general claim—particularists about reasons, including moral reasons, would deny it. See Jonathan Dancy, *Moral Reasons*, especially chs 4–6.

this claim? It cannot, *contra* Hare, be that it is part of the meaning of 'moral', since then, if I asked, 'I am under a moral obligation to do something, but ought I all things considered to do it?', the question would be trivially answered in the affirmative. But to ask that question is to pose a non-trivial query, and an agent might seek reasons for and against so acting. It is a substantive issue, which needs to be argued for or against, to determine whether one always has overriding reason to act on what one acknowledges to be moral reasons. Such an argument would have to show that other reasons, such as prudential, egoistic and aesthetic ones, are always rationally subordinate to moral ones. So a claim to overridingness is not part of the definition of morality.

Another popular claim is that morality is to be identified by its function or object. Geoffrey Warnock has argued that the object of morality is to ameliorate the human predicament, which is inherently such that things are liable to go badly, because of limited resources, information, intelligence, rationality and above all limited sympathy.[35] This basic claim has been supported by John Mackie, and has its roots in the work of Hobbes and Hume.[36] Though it contains valuable insights about the shape of much of morality, as a claim about definition it fails. We can make perfect sense of non-human beings who are fully possessed of a morality, and whose morality is not a response to the *human* predicament. Nor could we resolve this problem by broadening out the claim to encompass the predicaments of any rational being; for, it makes sense to suppose that God is a moral being, but, being omnipotent, he never is in a 'predicament'. And even as a claim about human morality, it is too restrictive: one can meaningfully think that one has moral obligations towards animals, but such obligations are not grounded on the human predicament.

More recently, some philosophers have appealed not to overridingness or to function, but to the sanctions that support morality as being definitive of it. Bernard Williams has identified what he calls "the morality system" partly in terms of the response of blame directed at those who violate it; and this thought has been developed in some detail by John Skorupski.[37] Again, the point captures a valuable insight, for there very often is a connection between negative moral judgements and blame, but it cannot provide a definition of morality. For we can blame someone for things that they do that are not morally wrong: I may blame someone, including myself, for my laziness in not mowing the garden, or my carelessness for dropping and smashing my favourite cup. In such cases, blame is appropriate, since my action, or failure to act, should be censured, and I am responsible for what I have done, or failed to do. But it seems odd to claim that my actions here are immoral (what have I done that is morally wrong in breaking

[35] G. J. Warnock, *The Object of Morality*, ch. 2.

[36] John Mackie, *Ethics: Inventing Right and Wrong*, ch. 5. David Hume applies the claim only to the artificial virtues; see *A Treatise of Human Nature*, bk III, pt II.

[37] Williams, *Ethics and the Limits of Philosophy*, ch. 10; and John Skorupski, "The Definition of Morality".

the cup that I loved so much?): grounds of censure and therefore of blame are wider than merely moral ones. Nor can we solve this problem by appealing not to blame but to guilt; for, in this case, the definition of morality would be tightly circular: guilt is by definition a kind of self-blame directed towards what is *morally* wrong. Nor is it even clear that moral assessment tracks only what we are responsible for (and therefore what is the proper object of blame). It makes sense to think that a psychopath is morally evil, yet also to hold that he is not responsible for his actions, since he is insane.

There have been several other attempts to define 'morality';[38] but the above brief remarks should indicate some of the general difficulties that beset them. It is quite possible that one cannot define 'morality', just as (I have suggested) one cannot define 'art', and certainly the class of moral virtues has a vague and indeterminate boundary within the domain of the ethical in the broad sense. But it would be disappointing to be entirely devoid of a criterion, since much of the debate about art and ethics has focused on the narrower sense of the ethical, raising questions about whether such undoubtedly moral vices as sadism, cruelty and callousness manifested by a work are aesthetic defects in it. Indeed, it might be thought that it is precisely in respect of the moral, rather than the broader ethical defects of works that ethical criticism has the harder part of the argument to make. So it would be good to be able to identify this narrower class.

If we try to capture the sense of 'moral' as employed in ordinary usage, there is, I suggest, a fairly simple and central employment of it. Consider our reactions to the following pairs of cases: an anorexic young woman who slowly starves herself to death, as compared to a young woman who slowly starves a child to death who has been left in her care; a man who commits suicide, as compared to a man who commits murder; and a person who is somewhat depressed and cheers herself up by going out and enjoying herself, as compared to a person who sees that her neighbour is somewhat depressed and cheers him up by taking him out to enjoy himself. In each case the same activity that is self-directed in the first case is directed towards another person in the second case. Yet our assessment of the pairs of actions is quite distinct: in the first case of each pair, it is generally agreed that nothing morally wrong has been done in the first two cases and that nothing morally commendable has been done in the third case; but in the second pair of each case, something very morally wrong has been done in the first two cases and something morally commendable has been done in the third case. It seems, then, that the category of the moral is applied only to actions, feelings and motives directed towards others: that is, to *other-regarding* actions, feelings and motives. Where such motives involve active hostility or improper neglect towards the other person, we talk of moral defects; where they involve concern for the other, we talk of moral merits. However, this concern for the

[38] See G. Wallace and A. D. M. Walker (eds), *The Definition of Morality*, for a useful compilation of attempts to define morality.

other person must not be purely instrumental: that is, a concern for the other based entirely on whether or not he will advance one's own interests, as when someone is concerned about an employee's injury only because he is unable to do his job or might sue. Rather, this other-regarding concern must be an *intrinsic* concern—that is, a concern for the other, in part, for his or her sake.

The claim that the moral domain concerns the nature of the motivations we have towards other people tracks well our use of the term. However, it is a comparatively modern usage. Kant, for instance, could take it as a datum for any adequate moral theory that it should account for self-regarding moral duties, such as the duty not to kill oneself through a desire to escape from one's pain and the duty to improve oneself, as well as other-regarding duties, such as the duties not to lie and to help others.[39] As anyone who has taught these doctrines to modern students will know, Kant's view about there being self-regarding duties is not now widely shared. It is usually thought that the would-be suicide is someone who needs counselling, rather than being a fit object for moral censure, and that the lazy person, if his laziness affects only himself, is to be censured, but has not done anything morally wrong. In this spirit, Bernard Williams curtly dismisses the possibility of "one of those fraudulent items, a duty to myself".[40]

However, there are still some tensions within the modern usage: one might morally criticise someone for being too self-sacrificial and not thinking of herself enough, for instance. Here there seems to be a moral failure, though it would be harsh to hold that the woman ought to be morally *blamed* for her self-sacrifice. One might, rather, invoke the moral claim in trying to persuade the woman to do more for herself. The tension here appears to derive from the notion of impartiality. We normally invoke it in order to reduce an individual's bias towards herself and make her think of others more. Yet complete impartiality should not discriminate between oneself and others, so an impartial person would not morally demand more of herself than of others. What we appear to operate with for the most part, then, is a notion of *asymmetric* impartiality, by which people are generally not blamed for treating themselves less well than they treat others, but are blamed for treating themselves better than they treat others.[41] The explanation for this is clear enough, being grounded on Warnock's observation that a role for morality is to correct limited sympathies: people generally care for themselves too much, not too little, and this is the bias to correct. Hence we tend not to condemn people for the opposite inclination. So there is some tension within ordinary moral talk, but, since our task here is merely roughly to map the ordinary usage of 'moral', it is still correct to hold that the predominant usage concerns other-regarding motives.

[39] Kant, *Grounding for the Metaphysics of Morals*, Ak. 421–3.
[40] Williams, *Ethics and the Limits of Philosophy*, p. 182.
[41] The role of self–other asymmetries in morality is explored by Michael Slote, "Morality and Self–Other Asymmetry".

That this is so is further supported by considering virtues and vices that are in some applications moral, in others not. Courage is a virtue; but we tend to praise it morally only when directed towards helping others. The courage displayed in standing up to one's boss in order to win oneself a pay rise is admirable, but not yet morally commendable. It becomes so when the motive for standing up to him is in order to protest about his ill-treatment of a downtrodden colleague. Laziness is a character defect, but not yet a moral one when the consequences of the defect affect only oneself. When one's dependants suffer because of it, then the criticism turns moral.

What is the scope of the moral as thus construed? On what might be termed the *purely practical* conception of morality, the moral assessment of a person's character is determined only by what he does and by the motives that determine his actions. Any feelings or thoughts that play no role in motivating actions are morally irrelevant. Thoughts, fantasies and desires, however gruesome, inappropriate or corrupt we would judge the actions they motivate to be, are not themselves morally bad, unless they issue in actions that express these feelings and thoughts. So a person may be morally good while having these feelings and thoughts, and his goodness may consist partly in his capacity to resist their influence on the will, for these feelings and thoughts may have arisen purely passively in him, and he is not to be held responsible for their occurrence.[42]

This view, however, speedily runs into problems in historical cases where the will cannot be engaged, yet where ethical assessment is still appropriate. If someone admires Hitler and wishes he could have helped him, we can morally criticise him, even though there is nothing he can do to act on his feelings and desires towards Hitler. Indeed, much of our ethical assessment is directed at what people feel, even though these feelings do not motivate their actions. Suppose that a man is praised for some deserved achievement by his friends, but later discovers that they are secretly deeply jealous and resentful of him. Their feelings have not motivated their actions, yet we would properly regard these people as less morally good, were we to discover this about them. They are flawed because of what they feel, not because of what they did or the motives from which they did it. Also, that people feel deep sympathy for us, even though they are completely unable to help us in our distress, is something that we care about and that properly makes us think morally better of them. In fact, much of our vocabulary of moral assessment is directed wholly or in part at the assessment of feelings: we criticise people for being crude, insensitive, callous or uncaring, we praise them for being warm, friendly and sensitive.

[42] This conception is Kantian in spirit, though Kant's own view differs from it in salient ways. His view is in one way narrower: it is only the motive of duty (not motives involving feelings) that can motivate actions if they are to have genuine moral worth. (Or, on an alternative reading of his position, feelings can operate only as primary motives of morally good action, while the secondary motive must be from duty—see Marcia Baron, *Kantian Ethics almost without Apology*, ch. 4). In addition, Kant holds that actions are not directly assessable, but only their maxims.

So, for the moral assessment of character, an *affective–practical* conception of assessment is correct, a conception that holds that not only are actions and motives ethically significant, but also feelings that do not motivate. Virtue of character is "concerned with feelings and actions", as Aristotle correctly observes.[43] The importance of this for our purposes is that an affective–practical conception of moral assessment allows the moral assessment of the feelings that people have, or are called upon by works to have, when they respond to fictions, even though they cannot act towards the fictional events described.

I have argued, then, that the notion of the ethical in the broad sense concerns the entire domain of character excellences and deficiencies (which standardly involve an element of intellectual judgement) and that the notion of the ethical in the narrower sense, that of the moral, though not without tensions, concerns the kinds of motivations and feelings that we have towards other people. I also distinguished the aesthetic in the broad sense from the aesthetic in the narrower sense. With these distinctions between broader and narrower usages of each term in place, an immediate point we can note is that autonomists, such as Beardsley, have tended to focus on the aesthetic in the narrower sense and its relation to morality, and have argued against any connection between the two. In contrast, supporters of ethical criticism, such as Booth, have tended to focus on both the aesthetic and the ethical in the broader senses of the terms, and have argued for a connection between the two. The debate can to some extent be clarified, then, by asking of any particular dispute *which* senses of the terms are in play. And some of the disagreement, particularly in regard to the use of the narrower and broader senses of the aesthetic, can be defused in this manner. But, as to the main part of the disagreement, argument must decide. And, in order to clarify the sense of the term in play, from this point on, when I refer to the 'ethical' without qualification, then it will be the ethical in the narrow sense, that of the moral, that I will mean. If the broader sense of the ethical should be meant, then I will use the phrase 'ethical in the broad sense'.

[43] *Nicomachean Ethics* 2.6 1106b16, trans. Terence Irwin.

3

A Conceptual Map

Having clarified the notions of the aesthetic and the ethical, we can now begin the detailed discussion of the intrinsic issue, which was distinguished from the other issues about art and ethics in the first chapter. The goal of the present chapter is to address the confusions that have darkened philosophical discussion on the intrinsic issue and to offer a more conceptually coherent set of distinctions in their place. The upshot is that the normal way of classifying the debate is partially reconfigured.

3.1. OPTIONS IN THE DEBATE

As we saw in Section 1.3, the main contemporary philosophical positions usually identified on the intrinsic issue are autonomism, moralism and immoralism. All of these come in various varieties; for instance, several philosophers have supposed that, among less strong versions of moralism, one can distinguish ethicism as being stronger than moderate moralism. However, though the notion of autonomism is, as we shall see, relatively clear, there is much confusion surrounding the relation of the other positions to each other.

In a useful survey of work on the topic of art and ethics, Noël Carroll draws distinctions between ethicism, moderate moralism and immoralism in ways that reflect some of the received classifications, and also thereby illustrates some of the problems with them. His own position, moderate moralism, he tells us, "claims only that sometimes a moral defect in an artwork can be an aesthetic flaw and that sometimes a moral virtue can be an aesthetic virtue".[1] The position that I defend, ethicism, he says is materially stronger than this, since it holds that "certain kinds of ethical failings in a work of art are always aesthetic defects".[2] Yet a moment's reflection on these two statements reveals that as thus characterised ethicism is no stronger than moderate moralism: both positions allow that not all kinds of ethical defects of works are aesthetic defects. The reasons why one should not allow just any ethical defect to count as an aesthetic one are straightforward.

[1] Noël Carroll, "Art and Ethical Criticism", p. 377.
[2] Ibid., p. 374. Carroll also holds that ethicism is considerably stronger than his own position in "Moderate Moralism versus Moderate Autonomism", p. 419.

Works may have ethically bad consequences that are clearly irrelevant to their aesthetic merit. Recall the example of a novel, celebrating liberal democracy, which in a politically unstable country might help trigger a military coup, the army fearing that its publication would undermine its tottering power. But, even if one focused only on the intrinsic ethical features of works, rather than their actual ethical consequences, one should still not hold that any intrinsic ethical feature of a work is aesthetically relevant. Consider a novel onto which one appends in its final chapter a list of moral platitudes, such as 'kindness is a virtue', 'it's wrong to lie' and so on. Has the novel been made thereby aesthetically better or worse? It seems not to make any difference at all; or, if it does, it is not because of the moral content of the platitudes, but because of the disunity and superfluity that this extraneous excrescence has brought to the novel.

Ethicism and moderate moralism agree, then, that not all, even intrinsic, ethical defects and merits are aesthetically relevant; and they also agree (*contra* autonomism) that sometimes such defects are aesthetically relevant. They stand foursquare in these respects. The disagreement, if there is one, is rather about *under what conditions* ethical qualities are aesthetically relevant. In the article that Carroll discusses, I proposed that the aesthetic relevance condition is secured when the ethical attitudes are manifested in the responses (these being affective–cognitive states) that works prescribe their audiences to have. Carroll has suggested a variety of criteria, most commonly that ethical qualities are relevant when they facilitate or hinder the absorption of the audience in the work of art.[3] I will return to the question of when ethical qualities are aesthetically relevant in the next chapter. What we need to note here is simply that one purported difference between ethicism and moderate moralism is really a dispute about the conditions of aesthetic relevance, rather than a difference about whether, when aesthetically relevant, ethical defects count as aesthetic defects.

There is a second unclarity in the formulation of the current debate. Consider again Carroll's point that moderate moralism "claims only that sometimes a moral defect in an artwork can be an aesthetic flaw and that sometimes a moral virtue can be an aesthetic virtue". This seems to leave it open that sometimes a moral defect in an artwork can be an aesthetic virtue, and that sometimes a moral virtue in an artwork can be an aesthetic flaw. Yet that is a position that is usually identified as immoralism. One of its defenders characterises it thus: "Immoralism is the claim that a work's value as art can be enhanced in virtue of its immoral character."[4] And in fact Carroll appears at one point to accept that his position as currently developed is compatible with immoralism. In discussing Daniel Jacobson's criticism of his position that it "does not allow that a moral defect in an artwork might sometimes contribute to the positive aesthetic value of an artwork", Carroll replies: "It is not clear that the moderate moralist has explicitly

[3] See e.g. Carroll, "Moderate Moralism", p. 235.
[4] Matthew Kieran, "Forbidden Knowledge", p. 72.

made such a claim, nor that he is committed to it."[5] But, if he is not committed to it, then moderate moralism must indeed be compatible with immoralism. Yet, if the two are compatible, the terminology employed is wildly misleading and the debate deeply misconstrued. If a kind of moralism and a kind of immoralism are mutually compatible, how could they capture much of interest in the debate about the intrinsic issue?[6] Clearly, the debate had better not be about *how often* ethical flaws count as aesthetic flaws and how often as aesthetic merits, since that would be a matter properly to be settled by a tally of all available artworks with ethical qualities—a statistical investigation that is certainly not for philosophy to conduct (even if it were worth conducting). And the protagonists do not in fact suppose that they are debating a point that could be settled by such an empirical investigation. Whatever, then, is the dispute supposed to be about?

I propose that the options concerning the intrinsic issue need recasting and some of the positions need renaming.[7] There are in fact two issues being addressed in the debate, the first concerning aesthetic relevance, the second the value-relation between ethical and aesthetic properties. The question about aesthetic relevance concerns whether the ethical merits or defects of artworks are always, sometimes or never aesthetically relevant. We have already seen that there are good reasons to deny that ethical merits or demerits are always aesthetically relevant. Indeed, no one in the current debate seems to hold this position, though there may be historical figures who have maintained it—given the strength of Tolstoy's moralism, it is possible that he would defend this view. The live debate is between those who maintain that ethical properties are never aesthetically relevant and those who maintain that they sometimes are. The latter include those who describe themselves as ethicists, moderate moralists or immoralists; those who maintain that ethical qualities are never aesthetically relevant are autonomists (or aestheticists, as they are sometimes called).

So we will understand autonomism as the position that ethical assessment of artworks is always irrelevant to their aesthetic assessment (that is, their assessment qua works of art). We can follow Carroll's useful distinction between radical and moderate autonomism. The radical autonomist as construed here holds that artworks cannot possess any intrinsic ethical properties at all: it makes no sense to evaluate artworks as ethically good or bad (though they may have good or bad consequences). They are not the kinds of things that can possess ethical qualities; hence their ethical assessment is irrelevant to their aesthetic assessment, because here ethical assessment cannot get off the ground at all. In contrast, moderate

[5] Carroll, "Art and Ethical Criticism", p. 379.

[6] Kieran, "Forbidden Knowledge", pp. 58–9, also notices the compatibility of immoralism and moderate moralism, and wonders whether the term 'immoralism' is overly strong to describe his position.

[7] Daniel Jacobson has also recently noted the confusions surrounding the debate and has offered some distinctions, which parallel in some respects those offered here. See his "Ethical Criticism and the Vice of Moderation".

autonomism, unlike its radical cousin, holds that ethical assessment of artworks is possible, since artworks can and do possess ethical qualities. However, the moderate autonomist holds that these ethical merits or demerits are irrelevant to the works' aesthetic merit or demerit. The latter position is most commonly associated with formalism, but is also held by some non-formalists. We will examine both varieties of autonomism in the next chapter.

Thus the first question, concerning whether the ethical qualities of artworks are always, sometimes or never aesthetically relevant, gives a way of distinguishing between autonomists, who answer 'never', and the rest of the field, who answer 'sometimes'. These latter positions, therefore, ought to be formulated only about ethical merits or demerits that are aesthetically relevant, so as to rule out aesthetically irrelevant ethical qualities.

The second question, concerning the kind of value-relation between ethical and aesthetic properties, gives us a way to separate out the latter positions, as well as reason to recategorise them. It is an issue more complex than may at first appear. The value-relation between the ethical and the aesthetic can differ along two dimensions. The first concerns whether the relation is monotonic (invariant) or polytonic (complex). An invariant relation would hold where positive ethical qualities are always associated with positive aesthetic qualities; a complex relation would hold where positive ethical qualities are only sometimes associated with positive aesthetic qualities. The second dimension on which the value-relation can vary concerns the polarity of the relation: is the relation symmetrical (positive) or inverted (negative): is it the case that positive ethical qualities are associated with positive aesthetic ones, and negative ethical qualities with negative ones; or is it the case that positive ethical qualities are associated with negative ethical qualities and negative ethical qualities with positive aesthetic ones?

I have categorised the possible value-relations generally by employing the term 'is associated with', in order to allow for a variety of possible ways to formulate the relation. The particular formulation that I favour (for reasons to be considered in the next section) uses the 'in so far as' relation. Employing this latter relation, let us consider how the options other than autonomism are best categorised, starting with monotonic theories.

One position with a positive value-relation holds that a work is always aesthetically flawed in so far as it possesses an ethical demerit that is aesthetically relevant; and a work is always aesthetically meritorious in so far as it possesses an ethical merit that is aesthetically relevant. This is the position that I term *ethicism*. Ethicism is monotonic, since it speaks of what is always the case; and it also countenances a positive value-relation between the two value domains. As so represented, it is what might be called *full-blooded* ethicism: it is formulated in respect of both ethical demerits and ethical merits. But one could choose to defend weaker versions; for instance, one could maintain that it is only aesthetically relevant ethical flaws that are invariably aesthetic flaws, and that the story about ethical merits is more complex. Some have found such a weaker

position more plausible than the full-blooded variety; but the position considered in this book will be the full-blooded one. If it can stand, the weaker versions are either false or at best only partial truths.

The mirror opposite of ethicism, a position that is monotonic but countenances an invariant negative value relation, is what we will call (extreme) immoralism. This holds that a work is always aesthetically flawed in so far as it possesses an ethical merit that is aesthetically relevant; and that it is always aesthetically meritorious in so far as it possesses an ethical demerit that is aesthetically relevant. This kind of extreme immoralism has, as far as I am aware, no defenders,[8] but its possibility is nevertheless thrown up by the two dimensions of the value-relation that we have identified.

What of positions that support a complex (polytonic) value-relation? Consider the following position: a work is sometimes aesthetically flawed in so far as it possesses an ethical flaw that is aesthetically relevant. The position is polytonic, since it refers to what is sometimes the case; but then we need to know what happens in the other cases. Could we hold that in these cases the ethical flaw is aesthetically neutral? Not so: to hold that the flaw is aesthetically neutral in some cases is just to hold that in these cases the ethical qualities of works are aesthetically irrelevant (they make no aesthetic difference). But, of course, the position is formulated in terms of aesthetically relevant ethical qualities, so these cases are already ruled out. Hence there is no other option but to hold that, in the other cases, there is value-inversion. So we need to complete the formulation of the position as follows: a work is sometimes aesthetically flawed in so far as it possesses an ethical flaw that is aesthetically relevant and is sometimes aesthetically meritorious in so far as it possesses an ethical flaw that is aesthetically relevant. The case for ethical merits is then formulated as follows: a work is sometimes aesthetically meritorious in so far as it possesses aesthetically relevant ethical merits, and sometimes aesthetically defective in so far as it possesses aesthetically relevant ethical merits. This is the position that I will term *contextualism*, since it holds that whether an aesthetically relevant ethical flaw or merit is aesthetically meritorious or defective varies, and so is a contextual matter.

This position is full-blooded contextualism, since it encompasses both ethical defects and ethical merits. And one could here also choose to defend weaker versions of it, encompassing only ethical defects, or only ethical merits. Indeed, if one has the intuition that works are always aesthetically defective in so far as they have an aesthetically relevant ethical defect, but that the situation for ethical merits is much more complex, then one would believe in (weak) ethicism for ethical flaws and (weak) contextualism for ethical merits. I will not consider such

[8] Daniel Jacobson, who should count as an immoralist on the same grounds as does Kieran, in "In Praise of Immoral Art", p. 162, explicitly denies that he believes in the extreme version of immoralism.

a mixed theory, but its possibility is worth noting, and it is a merit of the analytic framework here offered that it highlights this possibility.

In terms of the proposed framework, we are left with three plausible contenders for the relation of art to ethics in respect of the intrinsic issue: autonomism, ethicism and contextualism. But what has happened to moderate moralism and immoralism? The answer is that these two latter positions ought to embrace one of the three options just identified. Consider first moderate moralism. As we noted, Carroll formulates it to hold that sometimes a moral defect in an artwork can be an aesthetic flaw and that sometimes a moral virtue can be an aesthetic virtue; and he wishes to leave it as an open question whether Jacobson is right in holding that sometimes a moral defect might contribute to the positive aesthetic value of an artwork. But leaving the question open means that moderate moralism is an incomplete theory. How should it be completed? One option would be to hold that in the remaining cases the ethical qualities are aesthetically neutral; but we have already seen why that should be ruled out, since such cases are ones in which the ethical properties of a work make no aesthetic difference, which is to say that they are aesthetically irrelevant; and that has already been covered by the aesthetic relevance condition built into the favoured definition. Another option, which is viable, would be to acknowledge that the value-relation sometimes inverts in the way that Jacobson claims: this would yield contextualism. The last option, also viable, would be to note that a relation sometimes obtaining is compatible with it always obtaining, so that the incomplete definition is compatible with ethicism. One consistent completion would therefore embrace ethicism. Given these two viable options, moderate moralism, when the request to specify it completely is satisfied, reduces either to ethicism or to contextualism. If it reduces to ethicism, then there can still be disputes, of course, about the way to specify the aesthetic relevance condition that determines when ethical merits or demerits are aesthetically relevant. But that dispute, whether or not it can be resolved, should not cloud the fact that this is a dispute within the ethicist camp, since both sides would agree on the two fundamentals: that ethical qualities of artworks are sometimes aesthetically relevant (against autonomism) and that the value-relation is invariant and positive (against contextualism).[9]

What of 'immoralism'? As already noted, no one embraces extreme immoralism, so immoralists, such as Kieran, hold that the value-relation is sometimes positive, sometimes negative. Hence they too are contextualists. And that leaves

[9] In "The Interaction of Ethical and Aesthetic Value" Robert Stecker develops an account that exhibits the same incompleteness as does Carroll's. Stecker holds that, under certain restricted conditions, ethical defects of works are responsible for aesthetic defects. But he does not consider whether ethical defects are ever responsible for aesthetic merits. Depending on what he would say about the latter issue, his account would be compatible with either contextualism or ethicism. In *Sight and Sensibility* Dominic McIver Lopes also defends an account of the interaction of moral (and cognitive) values with aesthetic value, but, though he calls the account "moralism" at some points, his position seems to be similarly indeterminate between contextualism and ethicism.

both one kind of completed moderate moralism and also immoralism in the same, contextualist, camp. That of course is exactly what we should expect, given that both sides seem intermittently aware of the compatibility of their positions, despite oddly still sometimes believing that they are in dispute. And an advantage of the label 'contextualism' is that it makes clear that the position in itself is neither moralist nor immoralist in flavour.

Once one sees this point, the burden is on the contextualist to say something about when, where and why the value-relation inverts: why should a positive value-relation sometimes become negative? Contextualists have said little about this; Carroll (who on one completion of his theory is a contextualist) remains neutral on this possibility and so does not explore it. Jacobson confines himself to arguing for those cases where the value-relation is negative and announces an 'antitheoretical' approach to the matter.[10] Only Kieran has given a more general argument for when and why the relation might vary by employing a cognitivist theory of aesthetic value (Kieran's argument will be discussed in Chapter 8). Yet it is clearly incumbent on contextualists to offer some kind of adequate explanation for why the value-relation should invert in this fashion; otherwise it remains a mystery. And recall that the autonomist is hovering over the debate, ready to strike: she has a ready explanation for why the value-relation appears to vary. It is because it never holds at all: there is always a merely adventitious correlation between aesthetic and ethical values of artworks, since the latter are never aesthetically relevant. If two properties have no relation to each other at all, it is hardly surprising if they are sometimes to be found together and sometimes not. The autonomist thus has a simple, powerful explanation for the appearance of variation in the value-relation; and that explanation threatens to undermine the tenability of contextualism, if the latter simply notes variation without any further explanation, adopting an 'antitheoretical' approach.

Once we have the contextualist position firmly in view, we can see, then, that it needs more work than it has hitherto received; moreover, we can see that the moderate moralist may and the immoralist will end up in this camp, so it is becoming a rather crowded gathering-ground. A way to create more space is by distinguishing different kinds of contextualism, and, in the light of the point about the need for explanation, the issue of explanatory priority is a promising route to take. So consider what I will call the basic *character* of the value-relation. The value-relation will have a positive character if the fundamental relation is positive: cases of value-relation inversion are to be explained in terms of the fundamental positive direction of the relation.

What I mean by 'character' here can be best explained by considering an instance of character in the sense of personality. Suppose that Otto is an optimist, and is almost invariably ebullient and cheerful. One day he comes into work surprisingly downbeat and depressed. We may say that he is acting 'out of

[10] Jacobson, "Ethical Criticism and the Vice of Moderation".

character', not evincing his normal flamboyance, and we are very surprised. Closer enquiry reveals that he has gambled away his life savings on a tip on a horse that came in last in the race. So there is an explanation for why his reactions and demeanour are inverted from his normal behaviour and mood; we cease to be surprised by his behaviour. And this explanation appeals not just to the special circumstances in which he finds himself (having lost most of his money), but also to his basic, fundamental character. It is *because* Otto is fundamentally an inveterate optimist that he took the dubious tip so seriously, convinced himself that he would make a fortune on his gamble, and committed all his funds to it; and it is this, together with the fact that the gamble went wrong, that explains his present gloomy demeanour. So, even though Otto is acting 'out of character', we can explain why his demeanour is different from normal by appealing to his fundamental character, understood as grounding an explanatory principle that can, together with details of his circumstances, explain his apparently anomalous behaviour. And note that this is not a statistical notion: we are not required to count the times that Otto is cheerful as opposed to depressed in order to know that he has a fundamentally optimistic character. Rather, the issue is one of explanatory priority: which of his psychological features are basic in explanations of his actions, feelings and so on?

In a similar way, contextualism might hold that there is a fundamental character to the value-relation, grounded in some general account of the relation between the two. Deviations from this relation would be explained by specific features of a work or property that, when combined with the general account, would explain the value-inversion (which would be analogous to Otto's demeanour being different from normal). So, for instance, one might hold that the fundamental relation is positive, but argue that, with certain aesthetic features, such as humour, the value-relation inverts: a play might be funny partly because it has such a cruel attitude towards its characters and people in general. And one might explain this in turn by arguing, for instance, that in humour ordinary moral attitudes are held in abeyance, that they are 'on holiday', and that this is why it is possible for works to be aesthetically good in so far as they manifest morally bad attitudes through their humour. The value-relation thus would still be fundamentally positive, since the notion of attitudes being 'on holiday'—that is, not subject to the normal moral constraints on them—only makes sense as a deviation from a background of what is normal.[11] Conversely, one might hold that the fundamental character of the value-relation is negative, and that instances where it reverses and are positive are to be explained in terms of this fundamental character. For instance, it might be held that all good art is transgressive, pushing forward and sweeping aside the normal boundaries of what is acceptable, and that such boundaries include moral ones, so that art is directed against morality. Those cases where works are good in so far as they have ethically positive features

[11] We will discuss a variation of this claim about humour in Sect. 10.3.

are, then, to be explained in terms of peculiar circumstances of the properties or works concerned. In a world in which this view of art was victorious, a work could be transgressive precisely by being morally proper, just as an anarchist could be truly individualistic by dressing in a business suit and buttoned-down shirt when surrounded by his fellow-believers in T-shirts and jeans—or, indeed, as Gilbert and George are in their pinstripe suits.

These possibilities illustrate that one can distinguish between types of contextualism. *Ethicist contextualism*, besides embracing the basic contextualist doctrine as formulated above, would also hold that the basic character of the value-relation is positive. *Immoralist contextualism* would hold instead that the basic character of the value-relation is negative. The third possibility is that the value-relation has no fundamental character: there is no explanatory priority given to either the positive or the negative direction of the value-relation. This would yield *neutralist contextualism*. Such a form of contextualism need not give a 'shapeless' account of the value-relation: it could try to specify under what circumstances the value-relation is positive and under what circumstances it is negative, without holding that either direction is fundamental. This kind of account would still owe us, however, an explanation of why the value-relation is positive in some cases and negative in others; and such an account might well be hard to provide. In the absence of this explanation, the autonomist threat is a serious one.

Making these distinctions should encourage contextualists to be more careful in specifying their position. Should the moderate moralist complete his theory in a contextualist direction, it is likely that he would want to embrace ethicist contextualism, since his main concern lies in defending the positive value-relation. It is not so clear what view 'immoralists' would adopt. It is quite consistent with their basic position to adopt any of the three kinds of contextualism just distinguished; indeed, given Kieran's earlier adherence to ethicism, it may be that his volte-face to immoralism is really a shift from ethicism *simpliciter* to ethicist contextualism.[12] But in any case, making these distinctions, as well as adopting the contextualist terminology, makes clear both that the terrain of the battlefield does not lie as customarily supposed, and that the contextualist has unfinished business in further developing his theory.

3.2. *PRO TANTO* PRINCIPLES

So some of the terminology and definitions figuring in the debate about the intrinsic issue is inappropriate or flawed. We should distinguish autonomism, ethicism and contextualism with their subvarieties as the main contending positions,

[12] Kieran defends ethicism in "Art, Imagination, and the Cultivation of Morals". Jacobson's 'antitheoretical' approach would suggest that he is a neutralist. It is unclear how to classify Lawrence W. Hyman, "Morality and Literature—The Necessary Conflict", within contextualism.

rather than autonomism, moderate moralism, ethicism and immoralism, with their subvarieties. And we should realise that there are in fact two questions, not merely the one, to ask about the theories of the intrinsic issue. First, are ethical qualities of artworks never aesthetically relevant, as the autonomist claims, or sometimes aesthetically relevant, as the ethicist and contextualist claim? Second, if they are sometimes aesthetically relevant, is the value-relation invariant and positive (as the ethicist claims) or is it complex, exhibiting negative and positive relations in different cases (as the contextualist claims)?

I remarked earlier that the most general talk of ethical values being 'associated' with aesthetic values is best construed in terms of holding that artworks are aesthetically meritorious or defective *in so far as* they have certain aesthetically relevant ethical properties; and I formulated the positions accordingly. The goal of the present section is to explain the 'in so far as' terminology and justify it against some other ways of formulating the notion of association. The upshot will be that this formulation allows us to answer an important objection to ethicism.

One way to make precise the idea of the association of ethical and aesthetic values is in terms of whether the work is aesthetically improved or worsened by the presence of ethical values. On this formulation, autonomism would claim that artworks are never aesthetically improved or worsened by the presence of ethical qualities in the works; ethicism would claim that artworks are always made aesthetically better by the presence of ethical virtues and always made aesthetically worse by the presence of ethical flaws (when these virtues and flaws are aesthetically relevant), and contextualism would claim that sometimes artworks are aesthetically improved by the presence of ethical merits and sometimes improved by the presence of ethical flaws (again, when these ethical merits and flaws are aesthetically relevant). These kinds of judgements formulate the positions in terms of what will improve and worsen the aesthetic quality of the artwork *overall*, rather than merely in some respect or other. Sometimes claims have been advanced in terms of these overall principles: for instance, Kieran writes of the Nazi propaganda film *Triumph of the Will* that "The work would have been better, *qua* art, had it vilified just as well that which it seeks to glorify".[13]

One objection to this kind of formulation is that it makes no sense to talk of an artwork being made better or worse by changing its ethical properties, since, if this were accomplished, it would no longer be the same artwork. Jacobson, commenting on Kieran's claim, remarks that it is "either meaningless or false; for whatever such a work would be, it would not be *Triumph of the Will*".[14] But this objection, the *non-identity* objection, as I will call it, falls short of its target. First, we can arguably make sense of a work being the same work, though

[13] Kieran, "Art, Imagination, and the Cultivation of Morals", p. 348. Kieran also advocates *pro tanto* principles in this article, but it is possible to combine these with adherence to overall principles.
[14] Jacobson, "In Praise of Immoral Art", p. 193.

altered in some of its properties (which is to say that not all a work's properties are essential to it). We can say that George Eliot could have rearranged some of the early scenes in *Middlemarch*, or been slightly more charitable to Casaubon. Here we are talking about how *the novel* might have been different in various ways; we are not talking about different novels that Eliot might have written, which shared the same title. And, indeed, this is how creating a work can present itself to the artist, as the locus of a number of artistic options that she might pursue in realising the work: the artist thinks of altering the work in various ways, rather than of which one of many possible works to make. So it is not the case that the work cannot survive a change in *any* of its properties; and hence the non-identity objection is too strong. Nevertheless, it is clear that there is *some* limit, crossing which entails that we are no longer dealing with the same work, however indeterminate this boundary might be. So this reply does not defuse the non-identity objection when directed at all possible targets. Second, and more importantly, an overall principle need not be formulated in a way that rests on claiming the *identity* of the work with its current ethical properties to the work with different ethical properties. For overall principles could be formulated in terms of counterparts of works, rather than in terms that presuppose identity of works. Principles could be formulated so that, of two artworks, identical except that one is ethically good and the other ethically bad (and with whatever other differences are required by the different subvenience bases of these properties), the ethically good work is overall aesthetically better than the ethically bad one. So the non-identity problem is easily circumvented.

However, there is a more serious problem with overall principles. Jacobson remarks of *Triumph of the Will* that "The continuity of the film's political and aesthetic ideas—what might once have been called the unity of its form and content—is thus now obscured not by formalism but by moralism. ... The moral defects of the film are not aesthetic blemishes, because they are inseparable from the work's aesthetic value."[15] Though Jacobson goes on to claim, as we have seen, that the *work* is inseparable from its ethical properties, the passage just quoted contends that, at least in the case of this film, the *aesthetic value* of the film is inseparable from its moral defects. This latter point does not require the truth of the non-identity claim; and, indeed, it is far more plausible, and far more damaging to overall principles. For, to elaborate on Jacobson's point, if we think that unity is (at least on occasion) an aesthetic value, then an artwork might have its various stylistic, rhetorical, expressive and formal properties unified by a consistently vicious attitude. Ameliorating that attitude might make the film more disunified and therefore less overall valuable. Or take a simpler example: suppose that a novel is viciously immoral, but is the first significant work in a tradition to espouse such an attitude. This may be true of de Sade's novels: no one had been quite so cruelly ghastly in the Western literary tradition before

[15] Ibid., pp. 192–3.

him. In this case, for example, *The 120 Days* of Sodom has the aesthetic merit of originality because of its ground-breaking viciousness. Remove that viciousness, and the work would no longer be original, and overall might be made worse. This is what I will term the *inseparability objection* to ethicism: the aesthetic value of some works is inseparable from their moral viciousness.

One response to this kind of point—and Jacobson's own response—is to say 'so much the worse for ethicism'. Given the complexity that changes in ethical properties might make to the overall value of the work, contextualism looks sagely judicious and ethicism appears dementedly misguided. A different response to the point—and unsurprisingly the one that I adopt—is to say 'so much the worse for this formulation'. Construing ethicism in terms of overall principles does not just undermine that doctrine, but it would similarly undermine *any* attempt to find *any* aesthetic principles. For there seem to be no properties, such that adding them to an artwork is guaranteed invariably overall to enhance or invariably overall to diminish the aesthetic value of a work.

Commenting on Monroe Beardsley's account of aesthetic principles, Frank Sibley remarks that "Beardsley supposes it necessary to perform what I called the heroic task of finding certain criteria to fall back on . . . ones that always, in every work, can count only one way", and denies that such principles are to be found.[16] Sibley, as we shall see, is right on this point; but, ironically, not even Beardsley, perhaps the most prominent defender of aesthetic principles in the analytic tradition, supposed that such principles could be found. Beardsley defines his primary criteria (comprising unity, complexity and intensity of regional qualities) thus: "the addition of any one of them or an increase in it, *without a decrease in any of the others*, will always make the work a better one."[17] As the italicised phrase reveals, Beardsley was well aware that even his primary criteria could not be formulated as simple overall principles, since the satisfaction of one of them might undermine the presence of another of them, and thus the work might be overall rendered worse.[18] Beardsley, in short, was well aware of the fact of the *interaction* of aesthetic properties: for example, the addition of a good aesthetic property to a work may undermine the presence of another, perhaps better one, and thus the work could be rendered overall worse.

The interaction of value properties is fundamental to art, but it does not defeat the possibility of principles, nor indeed is value-interaction confined to art. Sibley, for instance, proposes a set of prima facie principles, which are general, but allow for the fact of value-interaction.[19] Prima facie, or as they are also known, *pro tanto* principles can be formulated in slightly different ways. The way I favour is in terms of the 'in so far as' relation. To understand this,

[16] Frank Sibley, "General Criteria and Reasons in Aesthetics", p. 106.

[17] Monroe C. Beardsley, "On the Generality of Critical Reasons", p. 485; emphasis added.

[18] That Sibley does not see that Beardsley's definition allows for the interaction of primary criteria is noted by George Dickie, *Evaluating Art*, p. 89.

[19] Sibley, "General Criteria and Reasons in Aesthetics".

consider the case of moral principles. An action may be morally good in so far as it is the keeping of a promise, but morally bad in so far as it failing to help someone in need—for instance, one rushes past an injured crash-victim whom one could help, in order to keep a promise to meet someone at a certain time. Whether the act is overall (all-things-considered) good or not depends in part on the weight of the promise and the degree of the need of the victim. The goodness and badness of the action rest on its different aspects: it would be good to carry on one's way in so far as to do so is fulfilling a promise, but bad in so far as it would be ignoring a claim of need. This aspect-terminology is fundamental to the nature of *pro tanto* principles. Moreover, even when one correctly decides on one course of action, the subordinated moral demands do not entirely surrender their normative force, though the actions required may be somewhat different. If I correctly decide to stop and help the injured victim, it is right for me to apologise to the person to whom I made the promise, even though I overall did the best thing. The promise still has some normative force over my actions. Further, one can hold and indeed should hold that in the case of moral principles there is no further principle that determines in all cases what is overall best to do when *pro tanto* principles give conflicting evaluations of the action. This is the doctrine of moral pluralism.[20]

The notion of *pro tanto* principles allows for the fact of value-interaction. Consider the road accident again: suppose that the best thing to do is to stop and help the victim. If I instead decided to keep my promise, I would improve my action in respect of its being the keeping of a promise. So it would now be good in that respect, even though it previously had the moral flaw of being the breaking of a promise. But it would overall be a morally worse action, because the fact that I kept a promise would undermine the valuable property of my alternative action of its being the helping of someone in need. So overall the action would now be worse: the instantiation of a morally good property undermines the presence of another morally good property, which is more weighty in this context, and overall the action is made morally worse.

Consider another example: suppose that you have a colleague who is prickly and with whom you have had a difficult history. He corners you and asks you what you *really* think of him. You dislike him. To say so would be truthful but unkind (he is very sensitive). To dissemble would be to lie (silence is not an option, since silence would be eloquent), though it would be kind to do so. What do you do? Telling him that you like him would be good in so far as it would be kind, bad in so far as it would be dishonest; telling him what you really think of him would be good in so far as it is truthful, bad in so far as it is unkind. *Pro tanto* principles here again capture the nature of the conflicting norms laid on you. And it is plausible that there is no further general principle to which you could appeal to adjudicate on what to do: what one should do is dependent on

[20] For a defence of this view, see my "Moral Pluralism".

the particularities of the situation. Suppose that it is, in fact, best to tell him a lie to spare his feelings; then, were you instead to tell him the truth, your action would be better in so far as it is now truthful, but would overall be worse, since your honesty has undermined what was in the circumstances a more important consideration: that you be kind. Here, again, we see how improving an action in respect of a certain aspect can render the action overall worse. And even when one has overall done the best thing (by telling the lie), the subordinated evaluative aspect still has some moral force: it is appropriate to feel guilty about having lied, even though you recognise that this was the best thing to do.

The idea of *pro tanto* principles can also be formulated in terms of intrinsic and extrinsic merits. In the example, both honesty and kindness are *intrinsic* moral merits: acts are always morally good in so far as they are honest and in so far as they are kind. Conversely, telling a lie is an intrinsic moral demerit: acts are always morally bad in so far as they are lies. But it may be that exercising a moral virtue, such as kindness, is achievable only by lying, so that your act of kindness has an extrinsic demerit—its instantiation undermines the presence of some other good ethical quality, in this case your truthfulness towards your colleague. This demerit is extrinsic, since it is not a necessary feature of a kindly action that it be an untruthful one—we are often kindly without having to lie. Rather, it is a feature of the peculiarities of the situation that your act of kindness, which is an intrinsic merit of your action, also has an extrinsic demerit.

The existence of *pro tanto* principles does not require the existence of overall principles, and indeed appeal to the former is most plausible when one supposes that the latter do not exist. And, if there are any aesthetic principles, these are *pro tanto* principles, not overall ones. Consider the claim that beauty is an aesthetically valuable property. This grounds the principle that a work is aesthetically meritorious in so far as it is beautiful. But it does not follow from this that an ugly work could be overall improved by making it more beautiful. Picasso's *Les Demoiselles d'Avignon* is in many ways an obstreperously ugly painting: the faces of the two women on the right seem almost physically torn apart by the proto-Cubist distortion, the brushwork looks raw and unfinished, the colours clash wildly and so on. While one might try to find in this picture a new kind of beauty, it is far more plausible to acknowledge that this is in some ways a deeply ugly painting. But it is also a masterpiece. And, far from the work being overall improved by rendering the faces in more alluring and orthodox fashion and touching up the brushstrokes to shape them to a greater harmony, the work would be materially weakened, if one did so. And that is, of course, because many of the features that make this a great painting would be undermined by this act of aesthetic vandalism: much of the originality, the raw expressive power and the strutting chutzpah of the painting would vanish in the retouched version. So one can acknowledge that a work is aesthetically meritorious in so far as it is beautiful, and aesthetically flawed in so far as it is ugly, while still holding that altering an ugly work to make it beautiful would overall be a very bad thing. And one might even

hold that the ugliness of a particular painting is inseparable from its outstanding aesthetic qualities, in the sense that in this case they can be instantiated only if the painting is ugly. But this claim is quite compatible with the existence of *pro tanto* aesthetic principles. For one holds that, in this particular case, ugliness is necessary for the presence of these other aesthetically good properties, but nevertheless maintains that the picture still has an aesthetic flaw, in so far as it is ugly.

Consider a second example. One can hold that a touch of humour is a good thing in a play; and one can also hold that dramatic intensity is a good thing. Is it the case that making a play more humorous always improves it? It might, under certain circumstances, even in tragedies: in *Macbeth* the gravedigger's jokes and the drunken porter work to enhance the tension of the tragedy, and overall improve it.[21] But in other cases, it would definitely not do so; were Othello to make witty puns while preparing to strangle Desdemona, this would not be a happy change in the play. In such a case the tragic tension would be undermined. But that need not lead one to assume that humour is only sometimes an aesthetically good thing: the *pro tanto* structure of principles allows us to acknowledge that a feature might have aesthetic merit in so far as it is humorous, but nevertheless be overall an aesthetic disaster, since it undermines aesthetic values that are far more weighty in a particular context.[22] Or, to put the point in terms of intrinsic and extrinsic terminology, a touch of humour and dramatic tension are both intrinsic aesthetic merits, but in certain contexts they may be extrinsic demerits, as when the presence of the touch of humour has the extrinsic demerit of reducing or abolishing the dramatic tension.

The nature of *pro tanto* principles allows us to reply to the inseparability objection. For it is perfectly true that making an immoral work morally better may overall be an aesthetically bad thing. But that is quite compatible with

[21] The example is taken from Beardsley, "On the Generality of Critical Reasons", p. 485; Beardsley, however, gives a different treatment of it, using it to illustrate his doctrine of primary and secondary criteria.

[22] Aesthetic particularists would deny the existence of these or any other aesthetic principles. It is not essential to the argument of this book that aesthetic principles in general be defended, since the only principle for which I will be arguing is the ethicist one. So particularists can reject the two examples of *pro tanto* aesthetic principles just given without loss to the argument of the book. However, I believe that there are many aesthetic principles, not just the ethicist one. For an argument for the existence of aesthetic principles, see Sibley, "General Criteria and Reasons in Aesthetics". Note, though, that Sibley's prima facie principles differ in one respect from the *pro tanto* ones advocated here. Considering the example of the tragedy whose tragic intensity is reduced by its inappropriate humour and that is overall made aesthetically worse thereby, Sibley holds that, though a touch of humour is inherently a prima facie merit, it is in the play an actual demerit, since it undermines the play's predominant tragic intensity (Sibley, "General Criteria and Reasons in Aesthetics", p. 107). The claim that the touch of humour is an actual demerit in the context is, however, false: it still makes sense to say of the tragedy flawed by inappropriate humour that at least it (or parts of it) are funny, and so it has some merit; so humour still has some aesthetic merit in the context. It is just that the presence of humour diminishes the overall aesthetic worth of the play, as we have seen, because of its undermining of other aesthetically valuable features, such as the tragic intensity.

holding that the work is aesthetically flawed in so far as it has an ethical flaw that is aesthetically relevant. *Pro tanto* principles allow for the fact of value-interaction. It may even be true in some cases that the aesthetic merits of a work are inseparable from its ethical defects, as Jacobson claims of *Triumph of the Will*. But that too is compatible with the existence of *pro tanto* principles, just as being kind to your colleague is inseparable in this instance from lying to him (since that is the only way one can be kind), but that does not mean that your action is not bad in so far as it is a lie. The expressive power and originality of *Les Demoiselles d'Avignon* may be inseparable from the ugliness of the picture, but that need not lead one to deny that ugliness is an aesthetic demerit.

The same distinction allows us to answer a counter-example to ethicism offered by Kieran. He argues that Henry Miller's *Tropic of Cancer* is a good novel in part because of its immoral, indeed obscene, attitude of embracing and accepting the horrors and corruption of humanity. Discussing the objection that the novel could have dealt with the lower depths of humanity, while expressing shame about the human condition rather than its actual immoral attitude, he writes that "in so doing the intensity, integrity, and coherence of the work would have suffered, and the novel would have turned out a lesser rather than a better work for it".[23] This may be true; but that is clearly a judgement about the work's overall aesthetic merit, and claims that improving the morality of the work would undermine other aesthetic values of the work. One can agree with this, while maintaining the *pro tanto* principle that a work is aesthetically flawed in so far as it has an aesthetically relevant ethical flaw. For, if one agrees that Miller's novel manifests an obscene attitude to humanity, one can apply the ethicist *pro tanto* principle, but still agree that improving the work's morality might undermine its overall aesthetic value for the reasons that Kieran gives. Here the intrinsic aesthetic merit of an improved morality might have the extrinsic aesthetic demerit of undermining other aesthetically valuable features, so that overall the work is rendered aesthetically worse.

Once we get clear about the distinction between overall and *pro tanto* formulations of ethicism, then, a powerful set of intuitions is shown not to undermine ethicism. One can agree that one should be a contextualist about overall aesthetic judgements (of any sort, not just ethically based ones; for plausibly there are no overall aesthetic principles), but also maintain the truth of ethicism formulated in terms of *pro tanto* principles. Further, ethicism turns out not to be as strong a position as some have supposed, once one grasps the significance of its formulation in terms of *pro tanto*, not overall, principles.

There are other ways in which the formulation in terms of *pro tanto* principles has important implications for the defence of ethicism. One should hold that there is a plurality of aesthetic values, of which aesthetically relevant ethical qualities are only one kind. Only in this way can the ethicist make sense of good

[23] Kieran, "Art and Morality", p. 463.

or even great works of art that have salient ethical flaws. Riefenstahl's *Triumph of the Will* is one such work.[24] The Ring Cycle is another, at least if one agrees that the portrayal of the *Nibelungen* reflects Wagner's anti-Semitic views. Ezra Pound's anti-Semitism in the *Cantos* is very clear, but the poem-cycle nevertheless has considerable aesthetic worth. These works, though aesthetically flawed in respect of their ethical faults, nevertheless have other, indeed considerable, aesthetic merits that outweigh their flaws. As the examples illustrate, one should also deny that ethical acceptability is a *necessary* condition for a work to have aesthetic merit or even to be a great work (unless we require a great work to be flawless—but that would be a dauntingly high standard). Works can be ethically flawed, yet still be artistic successes. Some writers have denied this: Tolstoy, for instance, holds that all good art must evoke a feeling "of joy and of spiritual union with another". Yet, since he infamously concludes on the basis of this criterion that all his own works, including *War and Peace* and *Anna Karenina*, are, with the exception of two short stories, to be consigned to the aesthetic dustbin, the implausibility of the necessity claim is sufficiently illustrated.[25]

Neither should one hold that the obtaining of aesthetically relevant ethical merits is *sufficient* for a work to be aesthetically good. First, there may be aesthetic flaws of other than ethical kinds that outweigh the aesthetic merit accorded by the ethical qualities. Cack-handed and plodding prose, wooden characterisation, creakingly implausible plotting, weepy and woolly sentimentality, an empty-headed and superficial view of human psychology will aesthetically damage even the most morally upstanding artwork: such qualities can swamp in their oleaginous excess the merit accorded to a work through its ethical qualities. *Uncle Tom's Cabin* is arguably such a work.

There is a second reason why the sufficiency condition should be rejected. I have talked of aesthetic merit and of aesthetic goodness indifferently to this point. But, if we are careful, the *pro tanto* principles should be formulated in terms of 'has some aesthetic merit', rather than of 'being aesthetically good', and likewise in terms of 'has some aesthetic demerit', rather than of 'being aesthetically bad'. The reason is that in ordinary usage talk of an artwork's being good is a fairly strong term of praise, and we can distinguish it from the artwork's merely having some aesthetic merit. I may agree that the amateur watercolour hanging on my wall has some aesthetic merit, since the perspective is reasonably handled, the colours are not jarring and there is a modicum of skill. But I may deny that it is good—it just does not have enough aesthetic merit to make the grade. Conversely, a less well-done watercolour may have aesthetic weaknesses in respect of its perspective, colour mismatches and handling, but I may still note that, despite these aesthetic demerits, it is not quite bad—it is just pretty weak. So aesthetic badness and

[24] For an interesting analysis of this film based on a broadly ethicist position, see Mary Devereaux, "Beauty and Evil".

[25] Tolstoy, *What is Art?*, pp. 227, 246.

goodness require more than a minimal degree of aesthetic demerit and merit respectively. And the same thing could happen with aesthetically relevant ethical qualities: a work may throw some ethical light on its subject, but, being so low on all other aesthetic dimensions, not have enough aesthetic merit to count as good, even though it does indeed possess some aesthetic merit by virtue of its ethical qualities. So, strictly speaking, the *pro tanto* principles should be formulated in terms of having some aesthetic merit (being meritorious) and having some demerit (being aesthetically flawed), rather than in terms of aesthetic goodness and badness. Though I will not highlight this point from now on, it is worth bearing in mind when one reflects on weaker works.

Ethicism, then, is formulated using *pro tanto* principles; it holds that there is a plurality of aesthetic values and it denies that ethical merits are either necessary or sufficient for works' being aesthetically good. Ethicism is one kind of moralism. Moralism we will understand as any thesis that holds that ethical values of works are sometimes aesthetically relevant, and that, when they are so, there is an invariant and positive association (to employ the most general term for the relation, introduced in the previous section) between ethical flaws and aesthetic demerits, and between ethical merits and aesthetic merits. The notion of association could be formulated employing overall principles, or could be formulated to hold that ethical values are the only kind of aesthetic values, or be formulated in terms of either necessity or sufficiency conditions. We have seen reasons in this section why all these kinds of moralism should be rejected, as falling to fairly straightforward counter-examples. The ethicist formulation of the notion of association in terms of *pro tanto* principles is by far the most promising; and it is this version of moralism that is defended in this book.

4

Autonomism

In the previous chapter we distinguished three viable approaches to the intrinsic issue: autonomism, ethicism and contextualism. The overall strategy of the book is to argue for ethicism, but the arguments given here and later will also support ethicist contextualism, since the latter shares with the former a claim about the fundamental nature of the value-relation. It differs, of course, in holding that sometimes the value-relation inverts; so we will also consider, by examining criticisms both of ethicism and of the arguments for it, whether there are cases where such value inversion plausibly occurs. The present chapter considers autonomism, and in arguing against it provides support for ethicism, by showing that one of its leading rivals is untenable. I begin with a discussion of radical autonomism, and show how the idea of artistic acts performed in a work undermines this view. Then various arguments for moderate autonomism are considered and rejected. Finally, a criterion for the aesthetic relevance of ethical qualities is advanced.

4.1. RADICAL AUTONOMISM AND ARTISTIC ACTS

The radical autonomist holds that it makes no sense to evaluate works ethically, since works of art cannot possess ethical qualities, either ethical merits or flaws. Thus stated, the thesis is an entirely general one about all artworks, and, if true, entails that ethical criticism has no application to them.

Radical autonomists may point to certain kinds of artworks, such as abstract painting and absolute music (that is, music without words or programme), to support their case. Such works seem obdurately resistant to ethical assessment in terms of their intrinsic qualities—one might morally criticise them as a waste of resources, or as having bad effects on people, but these are appeals to the economic preconditions or psychological, empirical consequences of works, not to their intrinsic moral qualities. It is the latter with which we are concerned here.

If the autonomist is correct about abstract art and absolute music, it would not, of course, establish the broader claim that no artworks are susceptible to ethical analysis. Rembrandt's and Drost's treatments of Bathsheba, for instance, are properly subject to ethical scrutiny. So supporters of ethical criticism could still maintain that representational art forms are legitimately subject to ethical

criticism, and in fact most ethical criticism has been directed at the narrower class of narrative art forms. To take this line is to narrow the scope of ethical criticism, but in no way undermines its tenability.

One can be more robust in defending the scope of ethical criticism. For the autonomist objection assumes that, unless there is a determinate moral content to a work of art, ethical criticism can gain no purchase. According to the formalist musical theorist Eduard Hanslick, for instance, the beauty of music is purely autonomous, and, other than in metaphorical applications, its content is tonally moving forms.[1] On such a construal, ethical assessment seems to get no grip on absolute music, and the same would apply to abstract painting. However, the autonomist assumption here is mistaken: even for representational artworks, the object of ethical assessment is not as such a work's *content*, in one widely recognised sense of the term. It is quite possible for works to portray evil characters in a way that condemns them, as witness works ranging from Milton's treatment of Satan in *Paradise Lost* to any number of classic Westerns' treatment of the villains. What matters for the ethical assessment of even a representational work is the *attitude* that the work manifests towards the characters and situations, which it represents, and the notion of an attitude here should be construed in the broad sense of including both cognitive and affective states, as noted in Section 1.3.

The expression of attitudes is not confined to explicitly representational works, as the very name 'abstract expressionism' bears testimony. The colour-field painter Mark Rothko wrote that "I do not believe that there was ever a question of being abstract or representational. It is really a matter of ending this silence and solitude, of breathing and stretching one's arms again."[2] This attitude, life affirming and sociable, is one that can be ethically assessed, yet it does not presuppose a determinate content for the artwork. And one can see the manifesting of that attitude in Rothko's glowing early abstract works, watch it darken, become more complex and seek mystical solace in the mid-period works, such as the Seagram murals (now in Tate Modern), until it hardens to despair in the literally black works painted shortly before his suicide in 1970. Likewise, one can hear the musical manifestation of attitudes, even in music that lacks an explicit programme, as in the defiant optimism that many have heard ringing out in the final movement of Beethoven's Fifth Symphony. It is certainly true that an attitude requires some content or other (an attitude is necessarily an attitude *towards something*), but the content need not be anything as determinate as particularised characters or situations. It may be an attitude towards life in general, the rather indeterminate object being supplied by the viewer or listener's imagination under the work's guidance. And that is the kind of object at which abstract paintings and absolute music may well be able to hint. So, though it

[1] Eduard Hanslick, *On the Musically Beautiful*, especially pp. 28–44.
[2] Mark Rothko, "The Romantics Were Prompted", p. 548.

would be wrong to insist that all such works are susceptible to ethical assessment, it would equally be wrong to insist that ethical assessment cannot extend to abstract works.[3]

The radical autonomist's more weighty and general charge is that, despite appearances to the contrary, no artworks are truly amenable to ethical assessment. As one of Oscar Wilde's epigrams has it, "There is no such thing as a moral or an immoral book. Books are well written, or badly written. That is all."[4] On the face of it, this is hopelessly untenable, running counter to much of what we say about artworks ranging from George Eliot's *Middlemarch* to Rembrandt's *Bathsheba*. Yet there is a way for the radical autonomist to press her case with some plausibility. Ethical assessment is directed at people's character, motives and actions; yet works are not persons: they have no will, exercise no choices, have no feelings and do not act. So how could an artwork intelligibly be the object of ethical assessment? In assessing it, one is not assessing its actual consequences, nor the morality of its actual author: it is the *work* that one is assessing.[5]

This is an interesting and powerful challenge. As we have seen, the intrinsic issue is separate from the question of a work's empirical effects. And the assessment of the moral qualities of a work cannot simply be equated with those of the artist who produced it. Artists as they reveal themselves in their lives and in their works can show radically divergent qualities. The Rembrandt who shows himself to be so compassionate and insightful in his painterly treatment of Bathsheba sits oddly with the man who seems to have broken a promise to marry Geertje Dircx, his son's nurse, and who then pursued a vicious fight with her through the courts, which culminated in her committal, probably instigated by him, to a workhouse for five years.[6] The Tolstoy who so sensitively describes the plight of Anna Karenina stands in no simple relationship to the aristocratic landowner who fathered a son on one of his serfs, and who never helped or even acknowledged that son in any way; the son as a dutiful serf always addressed Tolstoy as 'master'.[7] The morality of works and the morality of their authors in real life can be very different.

The radical autonomist challenge is grounded on the observation that moral assessment presupposes that the object assessed has mental qualities and capacities, yet works of art do not possess minds; so they cannot be subject to ethical assessment. And the general presupposition of mental qualities in the subject of

[3] Many seemingly non-representational works are also in fact representational. There are elements of representation in many musical works and their context of production can also provide a specific content. Shostakovich's later symphonies and string quartets are often thought to be a protest against the Stalinist regime in which they were produced; if so, their implicit content is provided by their circumstances of production.

[4] Oscar Wilde, *The Portrait of Dorian Gray*, preface, p. 3.

[5] Mary Devereaux, "Moral Judgments and Works of Art", nicely brings out the importance of the fact that it is the work itself that is the object of moral judgement.

[6] See Simon Schama, *Rembrandt's Eyes*, pp. 542–9, for some of the unpleasant details.

[7] C. P. Snow, *The Realists*, p. 147.

ethical assessment is borne out by the observation, made in Section 2.3, that ethical assessment centres on the attitudes of people towards others. The first point to make in reply to the challenge is that we do in fact very frequently ascribe mental qualities and activities to works of art. Indeed, the extent to which we personify works is quite extraordinary. We can describe works of art as intelligent, insightful, wise, shallow, sentimental, compassionate, sombre, serene, detached, calm, sad, joyful, angry, aggressive and so on. And we ascribe not just mental qualities, but also actions to them; we talk of works as inviting us to view their subjects in various ways, as challenging our preconceptions, as demanding our assent and so forth. If we employ the notion of the expressive broadly, to cover not just the expression of feeling, but also more generally states of mind and capacities, we can maintain, against the radical autonomist, that works are properly ascribed a very wide range of expressive qualities and activities.

The autonomist will reply that such attributions are and must be merely metaphorical. No work is literally sad, insightful or compassionate, nor does a work literally invite us to do anything, precisely because works lack any kind of mental life. So the ethical assessment of works is not *bona fide*, but is at best a kind of metaphorically ascribed activity, quite different from what it appears to be. If one says of a meeting that it was stormy, one is not issuing a meteorological report about it; in the same way, if one remarks that a poem is compassionate, one is not making an ethical claim about it.

That some of these ascriptions in some usages are merely metaphorical is clear enough; indeed, the role of metaphor in art-criticism is powerful and pervasive.[8] But that does not mean that all such usages are metaphorical. The use of metaphor is particularly clear in the case of natural objects: the weeping willow is only metaphorically sad. But, while we can properly apply this metaphor, it would be wrong to say that the willow *expresses* sadness. Yet we can say of a work of art not only that it is sad, but also that it expresses sadness, so metaphorical possession is at best insufficient for expression. Furthermore, we can say that something is a sad work, in the sense that it is an unsuccessful work, and here the term 'sad' is employed metaphorically. But it does not follow from this that the work is expressive of sadness (it might be an unsuccessful, but jovial work). So a metaphor-based account of expression must be able to mark this kind of distinction. And the best metaphor-based account, that of Nelson Goodman, can indeed do so, for it holds that expression is a property of symbol systems, and so must involve an essential core of reference, as well as metaphorical possession.[9] For Goodman, expression is a matter of metaphorical exemplification; a work is expressive of sadness if it is not merely metaphorically sad, but also exemplifies sadness—that is, refers to sadness, just as a tailor's swatch not only literally has

[8] For a discussion of the significance of this for the interpretation of artworks, see my "Metaphor and the Understanding of Art".

[9] Nelson Goodman, *Languages of Art*, ch. 2.

a certain colour and texture, but also refers to that colour and texture, since it is used as a sample of them.

However, the metaphorical account cannot capture the full generality of expressive qualities. This is particularly evident when we move away from considering simple expressive qualities, such as sadness. We can talk of a poem of Kipling's as being an expression of pride in being an Englishman, but it would be very odd to hold that the poem is metaphorically proud of being an Englishman; or a poem may express loyalty to the Queen, but is it metaphorically loyal to the Queen?[10] Similarly, Rembrandt's *Bathsheba* invites the viewer to view Bathsheba with compassion and understanding, but is the painting metaphorically issuing complex invitations of this kind? The powers of expression outrun those of metaphor in these complex cases. And neither does the idea of metaphorical exemplification capture the correct account of expression in simple, non-artistic cases. If I say to you 'You had better leave the room now!', my words may be expressive of anger. But it is not the case that my words are metaphorically angry. Rather, it is I who use the words to express anger; the expressive features of the words are derivative from the expressive acts of the speaker.

This last point suggests a very different account of expression in the broad sense. Though we may say that Rembrandt's *Bathsheba* is compassionate, we could equally well say that Rembrandt portrays Bathsheba compassionately in the picture, or that he expresses compassion towards his subject in the picture. In such locutions, we talk about what the artist does in the artwork; these kinds of acts have been called *artistic acts* by Guy Sircello, who holds that they ground a wide range of expressive properties.[11] In fact, it is not only expressive properties in a narrow sense of which this is true. Rather than talking of a painting representing a subject, we can talk of the artist representing that subject in the painting. And, in both cases, the locution in terms of what the artist did in the artwork is more basic, for the intentionality of artworks derives from the intentional acts of the artist in representing and expressing certain things. Derivative intentionality is a common feature of all symbols; words have meaning ultimately because speakers employ words meaningfully.[12]

This suggests that, in ascribing certain mental qualities and actions to artworks, we should be best thought of as holding that the artistic acts performed in these works have certain properties. Drost's *Bathsheba* presents its subject as sexually enticing but is shallow by virtue of Drost treating his subject in the picture in a sexually enticing but shallow way. And this answers the radical autonomist's challenge about how works can intelligibly be ethically criticised and ascribed mental predicates. For the ascription is to the artistic acts performed in the

[10] See Bruce Vermazen, "Expression as Expression", p. 206. Vermazen makes several other telling criticisms of Goodman's view.

[11] Guy Sircello, "Expressive Properties of Art".

[12] I am here employing 'intentional' in the sense of a state that can be about something, not in the narrower sense of intentions (which are a particular kind of intentional state).

works, and ethical criticism is of these artistic acts. Drost's picture is alluring but insensitive by virtue of the alluring but insensitive way that Drost portrays his subject. There is no basic category mistake evinced in the ethical criticism of artworks.

It is important to understand the notion of an artistic act correctly in formulating these claims. An artistic act is simply one performed by the artist in and by means of the work. As Sircello stresses, it is internally related to the properties of the work: "one may, without change of meaning, say either that Eliot's 'Prufrock' is a compassionate poem or that Eliot portrays Prufrock compassionately in his poem; that Poussin paints his violent scene in an aloof detached way or that the Sabine picture is an aloof, detached painting."[13] So the artistic act is not to be thought of as something that exists prior to and as the cause of features of the work; rather, the description of an artistic act is a redescription of features of the work in order to bring out how they are internally related to acts of the artist. In this, as Sircello also notes, artistic acts are closely akin to facial, vocal and gestural expressions. Someone has an angry scowl on his face by virtue of his scowling angrily; this does not mean that scowling angrily caused the angry scowl, but is, rather, a redescription of the scowl so as to bring out its internal relation to what the person is doing.

So ethical assessment is directed towards the artistic acts performed in the work. We can smoothly substitute, for talk of a work manifesting or expressing certain attitudes or views, talk of the artist manifesting or expressing certain attitudes or views in the work. The latter locutions bring out better, even though they are equivalent to the former, how it is that ethical assessment can be made of works and how mental qualities or activity can be ascribed to them. Moreover, to take a step beyond Sircello's claims, instead of criticising what the artist did in the work, one can equivalently talk of criticising the artist as he manifests himself in the work. Rather than saying that Rembrandt treats Bathsheba compassionately in the painting, one can talk of Rembrandt as compassionate in his treatment of Bathsheba in the work. The manifested artist is ascribed the qualities that are possessed by the artistic acts performed in the work. The manifested artist is, then, the artist as manifested in the artistic acts performed in the work.

This response to the radical autonomist seems to lay itself open to a number of objections. First, if one holds that *Bathsheba* is compassionate by virtue of Rembrandt treating his subject compassionately, then, to make the latter claim, one seems to need to know something about what Rembrandt was feeling at the time he was painting the work. But this opens up a worrisome epistemic gap, for in most cases one cannot know what artistic acts were performed, since one generally has no idea of what the artist was feeling at the time. The reply to this is that artistic acts do not require the artist to have had any particular feeling

[13] Sircello, "Expressive Properties of Art", p. 409. Sircello remarks in a footnote, p. 420, that this applies to those anthropomorphic predicates that are applied to works only by virtue of artistic acts.

when he performed them. This is true of expressive acts in general. I may treat someone compassionately without feeling compassion; and I may express grief in a speech without feeling grief. To express a feeling, it is not necessary that I actually have that feeling (that may at most be required for *self*-expression). Sircello's comparison with facial expression helps to show this: someone has an angry scowl on his face if he scowls angrily, but this does not require that he feel angry. He might be pretending to be angry, or be imitating someone, or practising the look, or simply acting.[14]

Second, the position may seem to require an untenable intentionalism about artistic acts: to identify an artistic act, we must know what the artist intended in performing it. Now it is true that any act, by definition, is intentional under some description, for otherwise it would merely be a piece of behaviour (like a reflex), not an action. But it does not follow from this that every significant feature of the action must be intended. For that is not true of actions in general: my act of turning on the light switch must be intentional under some description (for instance, that of turning on the light), but it does not follow that all its features are intended (it may also be an act of warning off the burglars, who, unknown to me, are watching the house). And this is also true of expressive actions: I may express my anger or grief without intending to do so, for I may be overcome by the force of my feelings, despite my intention to keep them bottled up. So, in general, the action-paradigm for the understanding of art (understanding the artwork partly in terms of artistic actions) does not require the truth of intentionalism.[15]

Finally, the reply to the radical autonomist seems to founder on the rock of the discrepancy, earlier noticed, between the kind of person we would judge artists to be on the basis of their work, and what we know of their real-life personalities. Yet the account says that it is Tolstoy and Rembrandt, the actual artists, who treat their heroines compassionately, which sits at odds with what we know of some of their real-life actions and attitudes. Moreover, if it is one and the same person who writes compassionately and yet treats real people less than compassionately, are we not obliged to bring in irrelevant factors such as how artists really were in order ethically to assess their work?

It should be no surprise that people can evince one set of attitudes in one context, and quite a different set in another. A man may be a loving father and kindly husband at home, yet be a martinet to his subordinates in the office. One would not therefore say that there are two people here, one perhaps a merely fictional or postulated being, the other the real man. Such discrepancies are unsurprising when a person can craft the image that he wishes to project in a certain context: the man, in the office, may, for instance, wish to appear as more decisive and stronger than he really is. But that does not show that it is not the actual man who is crafting a *persona* in this way. Still less does it show

[14] Ibid., pp. 411–12. [15] On this general point, see my "Interpreting the Arts".

that the *persona* thus crafted is a fiction; indeed, if the man's decisive and strong image were a fiction, it would not perform its intended task. For a fiction by definition involves an invitation to the audience to imagine something, rather than to believe it, yet the man wants to be believed to be strong and decisive. So it is quite possible for the same Rembrandt to portray Bathsheba compassionately in his work, and also to be ruthless with Geertje Dircx. It may be because he had different but equally real attitudes in different contexts; or because he was concerned to fashion a non-fictional compassionate *persona* (one in which we are invited to believe) in his work that differed from his real-life personality; or because he was concerned to craft a fictional compassionate *persona*. None of these points undermines the claim that it is one and the same person who performs artistic acts as performs acts outside the making of art.

Moreover, ethical criticism based on this view need not be forced to entertain irrelevancies about how the artist treated people outside his work in order ethically to assess the work. This follows from the points already noted: people vary in their attitudes in different contexts and also can fashion delusive or fictional *personae* in their work. However, the view also allows that the artist's personality as manifested outside his work *may* be relevant, since it is the same person who acts in both contexts. The test must be whether, in the light of one's knowledge of the artist's attitudes outside his work, one can detect in the work traces of these attitudes. And that is a matter of fine interpretative inspection, not a matter to be settled by general theoretical edict. In Rembrandt's treatment of Bathsheba, there appears to be no trace of the kind of attitudes he seems to have exhibited towards Geertje. But there may well be traces of his feelings towards Hendrickje, particularly if she is the model for the painting. And, in the case of Picasso, to take a particularly clear instance, knowledge of his attitude to the women in his life illuminates the kinds of attitudes towards women revealed in much of his work. Someone who was previously ignorant of the biographical facts could come, after learning them, to see attitudes in the paintings with greater focus and clarity than she previously had done.

I have claimed that talk of a work having certain expressive properties is equivalent to talk of what the artist expresses in the work, and that ethical criticism of a work is equivalent to criticism of what an artist does in the work, the artistic acts performed. How does this relate to the view that ethical criticism of a work is equivalent to ethical criticism of its *implied* author? This view has been endorsed by Wayne Booth.[16] Booth's notion of the implied author is in many ways unclear, but its core idea is that the object of critical assessment is the artist as the work implies him to be. Judging on the basis of *Anna Karenina*, then, one would take Tolstoy to be a compassionate person: that is implied by

[16] Booth, *The Company We Keep*, especially chs 6 and 7. Devereaux, in "Moral Judgments and Works of Art", adopts a similar view of the object of ethical criticism, but employs the notion of the posited author, which is more related to Nehamas's idea of a postulated author than to Booth's notion of an implied author.

how he describes and treats Anna. Booth is particularly concerned to stress that one should not impute features of an artist's personality as revealed outside his work to the artist as implied by his work. The author creates a 'second self' in writing a text, and this second self may vary greatly from one novel to another. Booth appears to hold that this second self is epistemically detached from the actual author, in the sense that evidence about the actual author is irrelevant to establishing the character of the implied author. Ford Maddox Ford condemned Fielding for being insincere, since Fielding wrote his novels as if he had a virtuous character, which he did not in fact possess. Booth thinks that this condemnation is misconceived, since "we have only the work as evidence for the only kind of sincerity that concerns us: Is the implied author in harmony with himself—that is, are his other choices in harmony with his explicit narrative character?"[17]

If we mean by the implied author simply the author as he manifests himself in the artistic acts in the work, then the claim that ethical criticism has the implied author as its object is equivalent to the view defended here. There is no harm in talking of the implied author, if that is all that is meant. The problem is that the notion of the implied author is often used in a manner that strays far from this straightforward sense and ends up entangled in a conceptual thicket. Even in Booth's initial formulation, the claim that sincerity is a purely intratextual matter goes beyond the claim that the artist's personality as revealed outside his work *may* be irrelevant to the ethical judgement of his work. Instead, it claims that this *must* be so, and that is hard to square with those cases where such matters are relevant, because they illuminate the attitudes exhibited in the work. And there are many other conceptual encrustations on the notion of the implied author or uses of it. It is sometimes held that the implied author is a fictional entity. But that is not required by the concept itself: the author's character as implied by his work may be exactly the same as that revealed in his life; and one can produce a *persona*, as we have seen, that is intended to be the object of belief and not to be fictional. Moreover, the view that the implied author is a fictional entity sits ill with the fact that non-fictional works, such as histories and biographies, have implied authors too. Finally, the notion of the implied author is often employed as part of the doctrine of implied author intentionalism—the claim that what a work means is what its implied author intended it to mean. Here the implied author is often thought of as a critical construct, and the doctrine aims to rescue intentionalism from the problems that beset it if we ascribe the meaning-determining intentions to the actual author.[18] Implied author intentionalism is, I would argue, false;

[17] Wayne Booth, *The Rhetoric of Fiction*, p. 75; for his views on the implied author, see especially pp. 67–77 and 151–3.

[18] For defences of various varieties of implied author intentionalism, see Jerrold Levinson, "Intention and Interpretation in Literature"; Alexander Nehamas, "The Postulated Author"; Gregory Currie, *Image and Mind*, ch. 8. For criticisms of the doctrine, see my "Interpreting the Arts"; Robert Stecker, *Artworks*, ch. 10; Paisley Livingston, "Pentimento".

but, in any case, it is a *use* of the notion of the implied author, rather than part of its concept, and should be distinguished from the deployment of the concept to analyse attitudes manifested by works. Given the multiple ways that the notion of the implied author has been understood and the sometimes dubious uses to which it has been put, it is probably better to avoid use of the term in defending ethicism.[19] So I shall talk of the 'manifested author' if reference is needed to the author as he manifests himself in his work. And it should also be noted that, though there is often just one manifested author in a work, in collaborative works there are several. Authorship is not always singular, and when I talk of the author in general, I should be understood throughout to mean the author or authors.

4.2. MODERATE AUTONOMISM

So far we have seen that ethically to assess a work is ethically to assess what the artist does in the work. And talk of a work inviting its audience to take up certain attitudes or challenging certain preconceptions is equivalent to the artist inviting the audience to adopt those attitudes in the work or to the artist challenging preconceptions in the work. And that undermines the radical autonomist claim that no artworks are properly the objects of ethical assessment. But there is a more modest version of autonomism that does not query the possibility of ethically assessing artworks, and merely holds that ethical assessment is always irrelevant to the aesthetic assessment of such works. The present section considers some of the arguments that have been advanced in support of this kind of autonomism.

Moderate autonomists hold that the ethical qualities of artworks are always irrelevant to their aesthetic merit. As part of this general claim, they also maintain that any ethical insights that artworks offer are similarly irrelevant. The latter view is distinct from the former. Not all ethical qualities of artworks promise ethical insights: an author may treat her characters compassionately without vouchsafing the reader any insights into ethics, in the same way as a person may do the morally right thing without thereby advancing moral understanding (and this of course is the normal case). Moreover, the claim that any ethical insights offered are irrelevant to the aesthetic value of art is an instance of the more general doctrine of aesthetic anti-cognitivism. I will not consider autonomist arguments grounded on anti-cognitivism here: these will be dealt with in Chapter 8. I consider below only those autonomist arguments that do not rest, at least explicitly, on anti-cognitivism.[20]

[19] See also Sect. 6.1 for further discussion of unclarities in Booth's notion of the implied author.

[20] Aesthetic anti-cognitivism is the denial of aesthetic cognitivism; the latter is the view that art can non-trivially teach us, and that this partly determines its aesthetic value. The first part of the claim is an *epistemic* one: art can provide us with genuine knowledge. A defence of this claim is given in Ch. 7. The second part of the claim is an *aesthetic* one: this epistemic capacity of art contributes to its value as art; this claim is defended in Ch. 8.

The moderate autonomist position need not be an unsubtle one. In particular, it need not hold that one could be unaware of the moral features of a work and still evaluate it correctly. For these moral features, though their correctness does not in itself matter aesthetically, may instantiate *other* properties that do matter aesthetically. For instance, Beardsley holds that the anti-Semitic and anti-usury opinions espoused in some of Ezra Pound's *Cantos* are irrelevant to their aesthetic merit, but that the complexity, coherence and intensity of regional qualities of these doctrines are aesthetically relevant.[21] In similar fashion, Arnold Isenberg holds that the truth of moral views expressed in artworks does not matter aesthetically, for moral ideas are in a kind of free play when present in works.[22] So crucial to moderate autonomism is the claim that the moral attitudes or views expressed in works do not matter aesthetically; but it can also concede that these attitudes or views may possess other qualities, such as complexity or coherence, which contribute to the aesthetic worth of works.

A plethora of arguments have been advanced in favour of moderate autonomism, and it is impossible to survey them all within a reasonable compass. So I will concentrate on six arguments, which do not rest, at least explicitly, on anti-cognitivism, and that are influential, interesting or have some normative weight. In broad terms, I will proceed from less theoretically based to more theoretically based arguments.

First, the philosopher and short-story writer William Gass, in his ebulliently written defence of the autonomist credo that "Goodness knows nothing of Beauty. They are quite disconnected", notes that considerable artistic achievements can be the products of less than morally admirable people: "Wagner's works are not wicked simply because he was . . . Frost's poetry seems written by a better man than we've been told he was. In fact, we are frequently surprised when an author of genius (like Chekhov) appears to be a person of some decency of spirit."[23] The general point is undeniable, but we have already seen how to respond to it. It is the quality of the artistic acts performed in the work, and thereby the artist as he manifests himself in the work, that is the proper object of ethical evaluation; and the artist as he manifests himself in the work may be quite different, for a variety of reasons, from how he shows himself to be outside his work. Rembrandt was no saint; neither, it appears, was Frost. But it is whether their reprehensible attitudes infect their work, as they arguably did in the case of Wagner, that is relevant to ethical assessment, not their attitudes as displayed outside their work.

Second, Gass also holds that "Moralists are not especially sensitive to form. It is the message that turns their noses blue. It is the message they will murder you for."[24] And, in criticising Martha Nussbaum's ethical reading of James's

[21] Beardsley, *Aesthetics*, pp. 427–9.
[22] Arnold Isenberg, "Ethical and Aesthetic Criticism", p. 274.
[23] William Gass, "Goodness Knows Nothing of Beauty", pp. 43, 42. [24] Ibid., p. 41.

The Golden Bowl, Richard Posner claims that "Ethical readings of works of literature tend to be reductive—and digressive".[25] This charge of insensitivity to literary nuance and form is widespread, but it is difficult to sustain. Much popular moralist criticism of works of art, such as warnings against the violence of popular films, is indeed crudely reductive. But there are also splendidly subtle and insightful critical works informed by moralism. David Parker, for instance, has provided a rich and indeed revelatory ethical analysis of George Eliot's *Middlemarch*, which argues that Eliot became so exasperated by the character of her creation, Casaubon, that she failed to live up to the standards of sympathetic understanding that she set herself in the novel, and that this is displayed in a too easy evasion of the moral complexities of the marital situation in which Dorothea finds herself and of the nature of Casaubon's character, evasions that are aesthetic flaws in the novel.[26] And Wayne Booth has offered subtle ethical readings of Rabelais, Austen, Lawrence and Twain.[27] The discussion of the Bathsheba paintings in Chapter 1 was also designed to show that ethical criticism need not be unsubtle or insensitive to painterly form. It is indeed hard to see why ethical criticism *must* be insensitive to issues of artistic form (nor, characteristically, do autonomist critics explain why it should be so). In fact, locating the ethical point of view of a work often requires sustained critical work: Booth, for instance, argues on the basis of close attention to the text that the standard charge that *The Adventures of Huckleberry Finn* is infected with racism is mistaken. Moreover, it is the *aesthetically relevant* ethical qualities that matter for aesthetic judgement, and that requires that the critic pay close attention to how the moral 'message' (or, better, point of view) is realised within the artistic structure of the artwork. The thought that there is necessarily something unsubtle about ethical criticism may be persistent, but it is ungrounded.

Third, autonomists have appealed to the pervasiveness of ethically reprehensible views in literature. Posner writes that the classics are full of moral atrocities of which their authors apparently approved: "Rape, pillage, murder, human and animal sacrifice, concubinage, and slavery in the *Iliad*; misogyny in the *Oresteia* and countless other works; bloodcurdling vengeance; anti-Semitism in more works of literature than one can count, including works by Shakespeare and Dickens; racism and sexism likewise; homophobia . . .".[28] The list rolls luxuriously on for several more lines, as Posner piles up the count of moral infamy with considerable relish.

In discussing the *pro tanto* formulation of ethicism, we have already provided the resources to help answer these concerns; for nothing Posner says commits the ethicist to a blanket aesthetic condemnation of the works. We noted that it is not

[25] Richard Posner, "Against Ethical Criticism", p. 12.
[26] David Parker, *Ethics, Theory and the Novel*, ch. 6.
[27] Booth, *The Company We Keep*, chs 12, 13.
[28] Posner, "Against Ethical Criticism", p. 5.

a necessary condition for works' being aesthetically good that they have ethically good qualities. Also, the ethicist thesis is pluralistic about values: one should hold that works are aesthetically flawed in so far as they have an aesthetically relevant ethical flaw, but they may have other, compensating aesthetic merits, which outweigh these defects. One should also not exaggerate the moral differences between works of the past and our current views. Many, probably most, of the features of the moral universes of Shakespeare and Dickens are shared with us. We may deplore their putative anti-Semitism, but we recognisably share such values as charity, sympathy for the underdog, the value of individuality and so forth with them. We are not dealing with authors who exhibit the systematic moral corruption of *The 120 Days of Sodom* or *Triumph of the Will*. So there are limits to how far Posner's litany of shame extends.

Posner's list also prompts an interesting question about the extent to which we should adjust our assessment of the morality of works to take into account the morality of the society in which they were produced. A contemporary author who celebrated the values that Posner ascribes to the *Iliad* would be a moral monster; if these are the values of the epic, ought we to judge their author in the same way? We do in general make adjustments in morally assessing figures from the past: John Locke displayed a degree of misogyny in his political writings, but he also argued for marriage as a kind of contract, which women could terminate if its terms were breached, rather than an indissoluble bond; hence he took an enlightened view for his time. While we can make the absolute judgement that his political position was morally flawed, we can also make the relative judgement that his position was morally enlightened for his time. These relative moral judgements are made in non-aesthetic contexts, and there is no reason not to make them in aesthetic ones too. On one (disputable) reading of *The Merchant of Venice*, it is a savage anti-Semitic comedy, based on the Jew-ogre Shylock trying to stymie the amorous fortunes of the young lovers.[29] If this is right, one need not react to the play's morality in exactly the way one would were it written yesterday. Shakespeare lived in an anti-Semitic age and culture, and could not have foreseen the full horror in which anti-Semitism was to culminate in the twentieth century. So, while condemning the putative anti-Semitism of the play, we also need to place it in its historical context and make the relative judgement that it was not morally outrageous for its time. In fact, we can go further, for Shylock emerges as a surprisingly sympathetic figure in the play, and it is the power of Shakespeare's empathic understanding that explains this. If the play is ethically flawed, it is nevertheless ethically enlightened for its time. Moral assessment of historical works, then, should take account of both absolute and relative moral qualities of these works. Works are precisely *works*, things that someone created at a particular time and place in a certain culture. Fully to understand them requires one to understand their generative context,

[29] This is the reading advocated by Posner, "Against Ethical Criticism: Part Two", pp. 407–9.

including the *mores* of the culture in which they emerged. Ethical assessment of artworks needs to be sensitive to these features. And this is quite consistent with our stress on the manifested author. For instance, Rembrandt manifested a compassionate attitude towards Bathsheba in his painting, and did this in 1654 in Amsterdam; artistic acts occur at a particular time and place, in a particular culture. So in aesthetic assessment, as in moral assessment, our judgement may have to be complex, in order to account for the fact that the work is historically situated.

Fourth, consider Gass's claim that aesthetic qualities are insensitive to moral considerations. Imagining himself seated next to Hermann Goering at a dinner party, feasting on the quail that Goering shot, he writes: "It would be a serious misjudgment, however, if I imagined that the quail was badly cooked on account of who shot it, or to believe that the field marshal's presence had soured the wine, although it may have ruined the taste in my mouth."[30] The aesthetic qualities of the food and wine are unaffected both by how they were produced and by who is present when one eats and drinks. And this is undoubtedly so. But the ethicist claim concerns the intrinsic ethical qualities of works, not their empirical consequences or accompaniments. Quail and wine possess no such intrinsic ethical qualities; they cannot, for instance, express ethical views in the way that works of art standardly can. It is the intentionality of works' properties—the fact that they possess referential capacities, as evinced in their expressive and representational properties—that allows them to be subject to this kind of ethical assessment. So a simple model of taste based on the phenomenal qualities of sensations provides a poor model for aesthetic taste in general.

Fifth, James Anderson and Jeffrey Dean argue that only moderate autonomism can correctly allow for the pervasive presence and nature of the conflicts or tensions between ethical and aesthetic values in artworks. They present a taxonomy of four kinds of cases: those in which moral flaws override aesthetic virtues, as in *Triumph of the Will*; those in which aesthetic virtues override moral flaws, as in *The Merchant of Venice*; those in which neither kind of value overrides the other, but the values exist in tension, as in *Lolita* and in some of John Woo's films; and those in which there is a dispute about whether the aesthetic values override moral ones or vice versa, as with *Huckleberry Finn*. Anderson and Dean remark of the latter kind of cases that "these are cases in which one's moral sensibilities and one's aesthetic sensibilities are in conflict. These are not cases in which there is a conflict internal to one's aesthetic dimension."[31] The latter, of course, is the position of the ethicist.

This is a heuristic argument, designed to show that the best understanding of these kinds of cases is provided by autonomism. The ethicist does not, of course, deny that in such cases moral values are in conflict with aesthetic values; but she

[30] Gass, "Goodness Knows Nothing of Beauty", p. 41.
[31] James C. Anderson and Jeffrey T. Dean, "Moderate Autonomism", pp. 164–6.

also claims that by virtue of this fact there is also a conflict between aesthetic values—works are aesthetically flawed in so far as they have an aesthetically relevant moral flaw, and hence the moral tension is also present in the aesthetic dimension. So it is the latter point that is the nub of the dispute between the two doctrines. But, if moderate autonomists deny that the tension is also internal to the aesthetic dimension, what, then, is their account of a conflict in which one moral value may or may not override an aesthetic value? What *kind* of judgement is the judgement that we are making in determining which of the conflicting sorts of values overrides the other? Is it, for instance, a judgement about whether something is worth seeing or reading? But to that judgement all sorts of values are relevant, not just moral and aesthetic ones; one may read a novel because it is an important historical source of information, for instance. Is it a judgement about whether or not one should praise and celebrate a work? But that is also a judgement to which many other kinds of values are relevant, besides moral and aesthetic ones. A producer might celebrate a film as being the year's highest earner at the American box office. In fact, the nature of the judgement on which possibly conflicting moral and aesthetic values bear is clearly an *aesthetic* judgement. Anderson and Dean in effect concede this when they say about the controversy over *Huckleberry Finn* that the dispute is about whether the work "should be read and cherished as a classic American novel".[32] If that is not an aesthetic dispute, what is it? So, when we argue about whether moral or aesthetic values override, we are arguing about which of these values override in making an aesthetic judgement. Hence the best heuristic account of the tension between moral and aesthetic judgements holds that the tension is also one *within* the aesthetic sphere. Moral values are not irrelevant to aesthetic judgement, which is just what the ethicist claims and the autonomist denies.

Finally, autonomists often appeal to the aesthetic attitude, characterised in terms of contemplation, to argue that ethical assessment has nothing to do with aesthetic value. The root of this strategy is to be found in Kant's notion of disinterest, which holds that aesthetic judgement is never concerned with the existence of the object it judges, but adopts a merely contemplative attitude towards it. The moral good, in contrast, "carries with it the highest interest. For the good is the object of the will".[33] A straightforward way of understanding his position here is that morality concerns the practical, governing how we ought to act, while aesthetic judgement is merely contemplative; so, when we make a judgement of taste, our will is disengaged and moral judgement can play no role.[34] This construal of Kant's position has been enormously influential on the subsequent aesthetic attitude tradition, and its imprint is to be found, for

[32] Anderson and Dean, "Moderate Autonomism", p. 166.

[33] Kant, *Critique of Judgment*, Ak. 209.

[34] Kant's actual position appears to be more complex, however: though in this passage he sharply distinguishes between the aesthetic and the moral, his final account allows for a more complex interrelation between the two domains. See Paul Guyer, *Kant and the Experience of Freedom*, ch. 1.

instance, on Stolnitz's discussion of the aesthetic attitude as contemplative and in his claim that, if we reject a novel because it conflicts with our moral beliefs, then "We have *not* read the book aesthetically, for we have interposed moral or other responses of our own which are alien to it. This disrupts the aesthetic attitude."[35]

I have already argued in Chapter 2 that, even if we acknowledge the existence of an aesthetic attitude, adopting it is consistent with having a practical attitude towards its object. The artist in making her work has a practical attitude to it, but it would be very odd to hold that this is somehow inconsistent with her acute aesthetic attention to the object. But, even if this claim were denied, the argument for autonomism based on the supposed contemplative nature of the aesthetic attitude would fail. For one also has and must have a contemplative attitude towards historical events: one cannot intervene in the past, so there is no possibility of one's acting towards them, and hence one's attitude to them cannot be practical. But one can and does morally judge people and events in the past. So the disengagement of the will does not entail the inapplicability of moral judgements. Moreover, as we earlier argued, the correct account of ethical evaluation is that it governs, not only actions, but also feelings. And one can certainly feel things towards events about which one can do nothing. The fact that death is inevitable does not mean that one cannot fear it.

4.3. AESTHETIC RELEVANCE

So the arguments just considered fail to establish the moderate autonomist position. There are other arguments, grounded on anti-cognitivism, which autonomists have developed, and I will consider some of them in Section 8.2, since they are best criticised in the context of a broader discussion of aesthetic cognitivism. The reader will not be surprised to learn, however, that I will argue that these anti-cognitivist autonomist arguments also fail. Failure of the philosophical arguments in favour of autonomism does not, of course, entail that the doctrine is false, since it might be the best account of our critical practices and judgements, and so be supported heuristically, independently of philosophical arguments. However, as we shall see in Chapter 5, moderate autonomism is inconsistent with the dominant practices of artistic criticism, and even theoretical autonomists have frequently in their critical practice had to appeal to moralist considerations in order to do justice to the works they discuss. Since autonomism matches critical practice so badly and is unsupported by philosophical arguments, we should conclude that it is false, and so therefore is the claim that ethical qualities are never aesthetically relevant. However, this is

[35] Stolnitz, "The Aesthetic Attitude", p. 337.

not the only argument against autonomism advanced here: the truth of ethicism entails the falsity of autonomism, so the philosophical arguments for ethicism that I advance in the rest of the book also undermine autonomism.

The crucial moderate autonomist claim is that ethical qualities are never aesthetically relevant, so it is appropriate now to consider the question of what the ethicist should say about the conditions under which aesthetic relevance obtains. To answer this question we need first to get clearer about what we mean by talking of aesthetic relevance.

One sense of 'aesthetic relevance' is that in which any quality is aesthetically relevant just in case adding it to, or subtracting it from, a work would give one reason to change one's judgement about the aesthetic quality of a work. For instance, strengthening the wooden supports of a picture would on this criterion count as aesthetically irrelevant. However, this should not be the sense in which the dispute between the moderate autonomist and the ethicist is formulated. For the former concedes that altering the ethical qualities of works may affect their aesthetic value. As we noted, moderate autonomists such as Isenberg and Beardsley think that ethical properties can possess qualities such as unity, complexity and intensity; so, even on their view, altering ethical qualities may well alter the aesthetic qualities of works. Rather, the autonomist holds that altering ethical qualities qua ethical qualities, and not in respect of other properties they may possess, does not alter the aesthetic quality of the work. We should formulate the aesthetic relevance notion so as to rule out these possibilities. To do so, I will understand the aesthetic relevance of ethical qualities in a strong sense: under certain conditions, ethical qualities of works of art *are* aesthetic values. Recall that aesthetic values are those that a work of art has qua work of art, and include more than narrow aesthetic (beauty and its subspecies) and formal properties. So, on the artistic account of the aesthetic, the possibility of ethical qualities of artworks being aesthetic values is allowed for.

We can focus the discussion of what makes an ethical property aesthetically relevant if we consider the arguments to be deployed here for ethicism. Three arguments will be advanced, and each needs to establish that the ethical properties that it identifies are aesthetically relevant. The first argument concerns moral beauty, and holds that ethical values are themselves a kind of beauty. Works that manifest ethically good qualities thus possess a kind of beauty. Since no one denies that beauty is an aesthetic value, it follows that, in so far as works manifest ethical goodness, they are aesthetically valuable, and conversely for the case of ethical badness, which is a kind of ugliness. The second, cognitive argument holds that works are aesthetically good in so far as they convey ethical insights. So ethical insight is an aesthetic value according to this argument. The third argument, in terms of merited responses, holds that ethically merited prescribed responses are aesthetic values, and ethically unmerited prescribed responses are aesthetic demerits. So the claims to be defended are, at a first pass, that moral beauty, ethical insight and ethically merited prescribed responses are aesthetic

values in works, and, conversely, that moral ugliness, ethically distorted views and ethically unmerited prescribed response are aesthetic defects in works. It is these claims that underwrite the *pro tanto* form of ethicism: it is by virtue of these properties being aesthetic merits or demerits that, for instance, a work is aesthetically valuable in so far as it is morally beautiful and aesthetically defective in so far as it is morally ugly.

However, this can only be a first approximation of the relevance claim. For, in each case, one can think of exceptions where the ethical properties as thus specified are plausibly aesthetically irrelevant. This is clear in the case of ethical insights. For it is not true, laying aside consideration of morality for a moment, that the fact that a work of art conveys an insight is always aesthetically relevant. *Moby Dick*, for instance, is replete with detailed claims about nineteenth-century whaling practices, but that seems irrelevant to its value as a novel—would one fault it, for instance, if it turned out that Melville had made up some of these practices? Old photographs and films convey a great deal of information about the look of the times in which they were taken, but that also seems irrelevant to their value, if any, as art. And we can learn a vast amount about the beliefs and practices of ancient civilisations from their artworks, but the fact that they convey valuable information about the past seems irrelevant to their value as art. Likewise, ethical insights in a work of art are not necessarily aesthetically relevant. A novel might have appended to it a list of true ethical claims, but the list might be aesthetically irrelevant to the value of the novel.

Similar points about relevance also apply to the other two arguments. Consider a painting of a woman, the manner of painting of which does not convey any particular feelings towards her, and suppose that it had appended to it by the artist a label that said 'please feel sympathy for this woman'. The viewer would be prescribed to feel sympathy, but should we say that this prescribed response is aesthetically relevant to the work? It seems too extraneous to the painting itself to count as such. Likewise, the sympathy putatively shown in such a case would not count as a moral beauty of the work.

So what more is required to make these ethical values aesthetically relevant? A suggestive observation has been made by Beardsmore, who holds that "when we learn from a work of literature, then what we learn, the content of the work, is essentially bound up with the way in which the writer expresses himself, bound up, that is, with the author's style".[36] This cannot be true in general, since one can, as noted, learn a great deal about whaling practices from *Moby Dick*, but that is not essentially bound up with Melville's style. But what Beardsmore may have in mind is that the inseparability of what we learn from how we learn it is a condition for what we learn being of aesthetic relevance. And that looks like a promising suggestion: it is the *way* that a work conveys its ethical or other insights that makes them of aesthetic relevance.

[36] R. W. Beardsmore, "Learning from a Novel", p. 45.

Beardsmore appeals, as I am interpreting him, to a writer's style as the crucial determinant of aesthetic relevance. But that cannot be the only factor, unless we understand the notion of style in an overly broad fashion. For it is in such matters as the construction of particular characters and events that aesthetically relevant ethical insight may display itself, rather than in the particular choice of words or tone. So it is by endowing Emma and Harriet with particular sets of psychological characteristics, and then constructing a detailed narrative in which they interact, that Austen conveys her views about how being socially privileged, young, beautiful and confident can lead to systematic self-delusion and harm to others. Austen could have conveyed the same thought employing a somewhat different style, choosing different words, provided that she kept the events and characters much the same, and evinced the same attitude towards them. So, unless style is broadened to include what is represented as well as how it is represented, it cannot be only style that matters for the aesthetic relevance of cognitive claims.

I propose, instead, that insight achieves aesthetic relevance when it is deployed by the use of artistic means, not just by style or by how the artist treats her subject. These artistic means include general artistic strategies, as well as the deployment of specific features of media, genres or forms. Examples of general artistic strategies are conveying general insights by means of the treatment of particular examples; getting us to *feel* the force of a particular claim or truth, to bring it home to us; and building up in the work a manifested personality, a *persona*, in which these attitudes prominently figure. Examples of more specific strategies to do with individual media are the deployment of painterly effects, such as those we saw used by Rembrandt, to do with the employment of light, the handling of brushstrokes and pictorial construction, in order to convey a certain attitude towards his subject. In literature, it includes the deployment of narrative techniques, symbolism, the construction of particular fictional scenarios, and so on, to convey a certain attitude. Let us consider some examples.

Some of the simplest possible works of art are Aesop's Fables. Here is a famous example:

A man and his Wife had the good fortune to possess a Goose which laid a Golden Egg every day. Lucky though they were, they soon began to think they were not getting rich fast enough, and, imagining that the bird must be made of gold inside, they decided to kill it in order to secure the whole store of precious metal at once. But when they cut it open they found it was just like any other goose. Thus, they neither got rich all at once, as they had hoped, nor enjoyed any longer the daily addition to their wealth.

Moral: Much wants more and loses all.[37]

If we consider the general moral (which in fact varies somewhat in different versions) in abstraction from the story, there would be little or nothing of aesthetic

[37] "The Goose that Laid the Golden Egg", in a version quoted by Wayne Booth, *The Company We Keep*, p. 138.

value in it. What makes it of aesthetic relevance is the way it structures the particular story told; indeed, there being an explicit moral is strictly dispensable, aesthetically speaking (and indeed not all versions provide an explicit moral). What matters is that something like this moral is implicit in the particular story that we are told. It is because Aesop *dramatises* the moral in the story that it has aesthetic relevance. He deploys a fantastic situation and a neatly compressed narrative structure to secure our interest, symbolises an abstract vice (greed) by an interestingly bizarre situation, gets us to feel the ludicrousness and greed of the couple's attitude, and brings home the lesson of their moral stupidity in the denouement. Thus, even in this extremely simple example, it is by deploying some of the central means of narrative art—plotting, characterisation, inviting the reader to take up a cognitive and affective perspective on the story, symbolism and seeing the universal in the particular instance—that Aesop renders his general lesson aesthetically relevant. Similar remarks apply to Nathan's parable, a much more borderline work of art, in which it is by symbolism, narrative structure, inviting the auditor to take up an affective perspective (David feels anger towards the rich man), and seeing a universal vice in a particular situation, that Nathan secures, not just the success of his moral lesson, but also its aesthetic relevance.

The same general points apply to more complex works of art. Rembrandt's compassionate attitude towards Bathsheba is of aesthetic relevance because he manifests it in the way he deploys painterly means to treat his subject. As we saw, his treatment of the gentle and golden light falling on her, the painstaking development of brushwork delineating her face and body, the way he poses her, the choice of a sad and resigned expression with a hint of erotic anticipation, the role of the servant in anchoring her in a social but non-erotic context and so forth are deployed to eschew any sense of voyeurism and to invite us to feel sympathy for her in her plight. And, in so doing, he implicitly invites us to take up a similar attitude towards other women who are under the thrall of sexual power. Indeed, this point about seeing the universal in the particular applies more widely to Rembrandt's painterly method. Simon Schama remarks that "All through his career, though, Rembrandt had been executing portraits in ways that transcended the specifications of the commission without doing violence to them. ... Rembrandt tried to distil something universal out of the particular and immediate presence of his subjects, to catch an ethos as much as a person."[38]

Consider also the following passage from *Middlemarch*:

An eminent philosopher among my friends, who can dignify even your ugly furniture by lifting it into the serene light of science, has shown me this pregnant little fact. Your pier-glass or extensive surface of polished steel made to be rubbed by a housemaid, will be minutely and multitudinously scratched in all directions; but place now against it a lighted candle as a centre of illumination, and lo! the scratches will seem to arrange themselves in a fine series of concentric circles round that little sun. It is demonstrable

[38] Schama, *Rembrandt's Eyes*, p. 602.

that the scratches are going everywhere impartially, and it is only your candle which produces the flattering illusion of a concentric arrangement, its light falling with an exclusive optical selection. These things are a parable. The scratches are events, and the candle is the egoism of any person now absent.[39]

Even considered on its own, this striking passage could count as a little work of art. It works because it manages to take a general observation about egoism, and find an apposite and interesting symbol for the general phenomenon, a kind of visual metaphor for an abstract thought, locating a universal in a particular that is strange and far removed from our normal thinking about egoism. And this symbol works not only in its own terms, but also structures and helps us make sense of the rest of the novel (indeed this link to events happens immediately, for the passage continues "—of Miss Vincy, for example"). It is a central image in the novel, and its rays illuminate the behaviour of the main characters—even Dorothea's apparent selfless devotion to Casaubon's scholarly project is gradually revealed to be another form of selfish dedication to her own ideal of intellectual achievement.

I have suggested, then, that ethical attitudes and insights tend to be of aesthetic relevance when they are expressed by artistic means, which includes general insights, whether or not explicitly stated, being integrated into the particulars dealt with by the work. But this claim is likely to meet an objection from the autonomist, who will hold that the ethical *per se* is doing no work in securing aesthetic relevance. What matters is simply that artistic means are deployed, and this is what is relevant to aesthetic value; the ethical is an aesthetic irrelevance.

This objection is mistaken. Consider again Drost's painting: seen purely in terms of artistic technique, it lacks little if anything compared to Rembrandt's version of Bathsheba. Drost's picture is skilfully painted, the perspective is accurate, the colours are finely handled and richly harmonious, an erotic mood and tone are very successfully achieved. One may argue that it lacks the variety of Rembrandt's pictorial technique, which in the *Bathsheba* runs the full range from the finest modelling to coarse, expressive brushwork. In contrast, Drost's painterly style is consistently smooth and delicately handled. But, while this is true, the difference seems insufficient to account for the great disparity in worth that separates the two paintings. What does make a significant contribution to account for this difference is, as we saw, the nature of the attitude, in particular the ethical attitude, that Rembrandt takes towards his subject. So the ethical component is not aesthetically irrelevant, even if one holds that, in order to be aesthetically relevant, the attitude should be expressed by painterly means.

One can also support this point by considering the converse case of a painting that displays indifferent pictorial skills but that has some aesthetic value by virtue of the nature of the attitude expressed through pictorial means. One of

[39] George Eliot, *Middlemarch*, p. 297.

Rembrandt's pupils, whose obscurity has kept him out of the history books, was Willem Dross. Dross was a painter with few pictorial skills; his handling of perspective, chiaroscuro, modelling and colour harmonies was pedestrian and uncertain, unlike the dazzling painterly skills of Drost, his contemporary and near namesake in Rembrandt's studio. But Dross was a kindly young man who was particularly friendly with and sympathetic to the lot of women, and who had commiserated greatly with Geertje Dircx during Rembrandt's vendetta against her. Given the routine studio task of painting a Bathsheba in 1654, he brought something of his own nature and attitudes to bear on the painting. Though the result was, typically for him, somewhat clumsy, with the space handled not quite right, the colours coming forward and receding in an odd and slightly jarring manner, and the modelling of Bathsheba's left hand in particular going badly wrong, yet there was something that was unusual and intriguing in his treatment of the subject. For, rather than taking the standard view of Bathsheba as an object of concupiscence, Dross had expressed a sense of sympathy for her in her plight and conveyed, despite his poor handling of pictorial construction, a sense of Bathsheba as having her own interior life independent of the sexual interests of the viewer. Rembrandt, despite his awareness of the manifold shortcomings of the painting, saw something that was right and touching here. Indeed, it was Dross's painting that first gave him the idea for his own great *Bathsheba*, Rembrandt perfecting and finessing with his masterly skills the effects of interior presence and of sympathetic attitude that Dross had only clumsily outlined. Dross's painting (sadly now lost) had some real aesthetic merit, despite the poverty of pictorial skills that it displayed.

Drawing on Beardsmore's suggestion, what I have proposed, then, is that the criterion of aesthetic relevance, in the sense of when ethical qualities of works of art tend to be aesthetic values of works, is when artistic means (an artistic mode of expression) are employed to convey these ethical qualities. Sticking a label reading 'Please sympathise with this woman' on a neutrally painted picture of her does not count as an aesthetic value of the work; painting her in such a way as to express this attitude towards her does. An artistic mode of expression is constituted at the most general level by widespread artistic strategies, such as viewing the universal in the particular and getting viewers to respond affectively to represented characters and events, and by strategies more specific to individual media, genres and art forms, such as the employment of painterly techniques or the use of narrative and literary techniques in the case of literature. This criterion does not deliver the ethicist into the hands of the autonomist, since, as we have seen from considering the Rembrandt/Drost/Dross example, it is consistent with its use to hold that the aesthetic value of an artistic expression of an ethical quality is in part determined by the nature of the ethical quality.[40]

[40] In Ch. 8 we will also develop a defence of the aesthetic relevance of ethical insights in some detail, since attacking the relevance of such insights has been a major autonomist concern.

I end with two caveats. First, use of this criterion must of its nature allow for a degree of indeterminacy as to what is to count as an artistic mode of expression, and this will inevitably change as art itself alters. This is to be expected, since I doubt if there is any completely determinate criterion: I have spoken only in terms of what *tends* to make ethical attitudes and insights of aesthetic relevance. Second, one can believe in ethicism without adopting this criterion, or indeed any other, for aesthetic relevance. Ethicism holds that works are aesthetically good or bad in so far as they have aesthetically relevant ethical merits or defects, and the ethicist needs to show that ethical merits and defects are *sometimes* aesthetically relevant. But she could simply abjure the attempt to find a general criterion that states when these conditions of aesthetic relevance obtain, and could even hold that such a criterion is impossible to find, given the complexity of art. She could simply recognise aesthetic relevance on a case-by-case basis. So, though I have proposed the artistic mode of expression criterion as the correct one and will use it at various points, its correctness, or indeed that of any other general criterion, is not essential to the ethicist project.

5

Artistic and Critical Practices

In the previous chapter, I argued that autonomist arguments fail, so that we have no reason to believe that autonomism is true. But a nagging worry for many is that autonomism is ineliminably rooted in the production and reception of art, so that it must in the end be the correct account of artistic value. That worry probably derives in large part from the influence of formalist-inspired New Criticism during the second half of the twentieth century, and in particular from its near hegemonic grip on literary educational practice below university level. Alternatively, some will feel that ethical criticism cannot be right because it fits so badly with more recent growths in the luxuriant and tangled jungle of critical theory, such as post-structuralism, which apparently favour contextualism. It is important to calm some of these persistent worries, since, if ethical criticism really is inconsistent with critical practice, that is a serious argument against its tenability. In fact, I will argue that ethical criticism is consistent with a great swathe of critical practice and that it has played a powerful role in the work even of those critics who think of themselves as adherents of rival traditions, both of aestheticism and of the art-as-transgression view. So the practices of art give support to ethicism. Evidently, fully to support this point and to do justice to the full richness of artistic and critical practices would require a multi-volume work, which the reader may be relieved to hear I do not propose to produce. But even within the necessarily short compass of a single chapter, we can at least give reason to question the easy assumption that ethical criticism is inconsistent with the lived experience of art, and to display some of the resources it has available to answer the objection that it ill comports with critical practice.

It is important, however, to understand what this appeal to the practices of production and reception of art does and does not establish. If the practice of aesthetically praising works of art for their ethically good properties and aesthetically denouncing them for their ethically bad properties is widespread, then that supports ethicism, and thereby gives reason to reject autonomism. But the support is only prima facie. Given the influence on some critical practices of doctrines such as deconstruction, which fail, I would argue, on basic grounds of philosophical coherence, mere appeal to a critical practice is insufficient to establish anything. As a minimum requirement, critical practices

must be coherent. Moreover, given the sheer diversity of such practices, there are limits to what can be established by appeal even to coherent practices. Here there is an asymmetry between the relations of ethicism to autonomism and to contextualism. Autonomism makes a strong claim on the relevance dimension—ethical properties are never aesthetically relevant—whereas ethicism makes a weak claim on this dimension—ethical properties are sometimes aesthetically relevant. If, as we will see, there is a widespread practice of taking ethical properties to be aesthetically relevant, and even autonomist critics have succumbed to this practice, this is a serious problem for autonomism. For it would turn out that the theory does not square with coherent critical and literary practices, and in some cases even autonomists' own practices. And if, as Chapter 4 argued, autonomists have not produced successful arguments for their own view, then we have strong reason to reject autonomism. Autonomism has to hold that vast expanses of critical practices that appeal to ethical criteria are mistaken. Given how widespread these practices are, this becomes a dauntingly difficult claim to defend. Mere coherence of a practice does not, of course, prove its correctness, which is the ultimate point in dispute. But, where those practices are extremely widespread, the price that the autonomist pays for her position is rejection of such a large, well-entrenched set of critical practices that it becomes highly implausible to hold that they are all mistaken. And, where the autonomist gives no good reason for holding these practices to be mistaken, we have more reason to reject her position than to reject those practices.

The situation is, however, different in the dispute between ethicism and contextualism. For, though both doctrines make weak claims on the relevance dimension, holding that sometimes ethical properties are aesthetically relevant, they differ greatly in strength on the valence dimension. Whereas ethicism makes a strong claim on this dimension by holding that aesthetically relevant ethical merits are always positively aesthetically valenced, contextualism makes a weak claim by holding that they are sometimes positively and sometimes negatively valenced. So the contextualist enjoys the same kind of tactical advantage on the valence dimension against the ethicist that the ethicist (and the contextualist) enjoy against the autonomist on the relevance dimension. And that means that ethicism cannot be decisively established merely by appeal to the widespread practice of ethical criticism; any coherent critical practice inconsistent with ethicism poses a potential problem. So, in appealing to critical practices, the ethicist has mainly to concentrate on a fire-fighting role in respect to contextualism, dampening down the threat from those practices that appear to be inconsistent with her doctrine. In the present chapter I will answer some of the more pressing contextualist worries about practices. To establish ethicism decisively requires not merely appeal to practices, but the a priori heft of philosophical arguments. However, given the pervasiveness of ethical practices considered here, a person would be well advised to be an ethicist contextualist, if she is to be a contextualist at all.

5.1. ARTISTS' AMBITIONS

The ambition to educate one's audience, and in particular to educate it in virtue, has been one of the most strikingly pervasive features of Western art. The position of Homer in classical Greece seems to have been as something of a cross between Shakespeare and the Bible, a source of moral and religious instruction, as well as a literary masterpiece. Indeed, the nature of Plato's attack on poetry, and on Homer in particular, would make little sense in Plato's own terms unless the ambitions of poetry were understood to be partly cognitive and moral. Plato, as we noted, attacks poetry on the grounds that it fails to teach one about reality and that it corrupts its audience. Yet, if the art of his time had not been assumed to have the goal of instruction, Plato's attack on it would have been akin to an attack on priests for being no good as potters. One would not be assessing a thing in terms of its own *ergon*. The "long-standing quarrel between poetry and philosophy" to which Plato adverts in the *Republic* seems to have been a squabble between literature and philosophy about which is the proper source of instruction.[1]

The instructional aspiration was also at the core of religious art, the goal of Christian art being to bring home the truth, power and majesty of the holy doctrine to the masses. A myriad of wall paintings in simple churches sought to instruct their congregations in the central tenets of the Christian doctrine, acting as a kind of illustrated book of the faith. Michael Baxandall has argued that *quattrocento* paintings were often designed as frameworks to guide the devotee's religious imaginings, the better to bring home the force of the doctrine to them.[2] The goal of religious instruction was forcefully restated by the Counter-Reformation Council of Trent, and its influence on Baroque religious art was immense, both on the gritty realism of Caravaggio, which aimed to make religious events more palpable by presenting them as part of everyday life (as in the famously dirty feet of the male pilgrim in *The Madonna of Loreto* and in the worn look of Judas's face in *The Taking of Christ*), as well as in the soaring theatrics of Rubens, designed to move the audience to religious conviction. That other great source of patronage, the secular political powers, employed art as a way to inculcate into their subjects the legitimacy of their rule and the virtues of its exercise. Innumerable royal portraits present their subjects as the living embodiments of the political virtues. Even Michelangelo's *David* was commissioned by the Florentines as an encapsulation of the civic virtues of the plucky young republic against the lumbering Goliath-like states threatening them. The visual arts have for most of their history in the Western tradition

[1] Plato, *Republic*, book 10, 607b3.
[2] Michael Baxandall, *Painting and Experience in Fifteenth-Century Italy*, pp. 45–56.

been in the service of instructing their audiences in moral, religious and political values, and their success has been judged in large measure by how well they discharge these functions.

This has also been true of the literary arts. We earlier quoted Horace's formulation of the poet's goal as being to "please and give lessons of life", and saw that sentiment echoed in Sir Philip Sidney's writings, the latter praising a play "as full of notable morality, which it doth most delightfully teach, and so obtain the very end of poesy".[3] The ambition to instruct morally is also to be found in the founders of the modern novel. Richardson in *Clarissa* writes that "I thought the story, if written in an easy and natural manner . . . might tend to promote the cause of religion and virtue"; Fielding in *Tom Jones* opines that, "when we find such vices attended with their evil consequence to our favourite characters, we are not only taught to shun them for our own sake, but to hate them for the mischiefs they have already brought on those we love"; and Defoe hopes that "Every wicked reader will here be encouraged to a change, and it will appear that the best and only good end of a wicked mispent life is repentance".[4] Later writers were less prone to regale their novels with statements of ethical intent, but their motivation remained the same. It is implicit in the novels of Jane Austen and explicit in those of George Eliot. Dickens waged a sustained campaign against the iniquities of Victorian society in his novels; *Nicholas Nickleby* was intended to destroy the system of Yorkshire schools, the conditions of which were so appalling that many of the children went blind through malnutrition and neglect.[5] Trollope writes in his autobiography that "I have ever regarded my art from so different a point of view that I have ever thought of myself as a preacher of sermons, and my pulpit as one which I could make both salutary and agreeable to my audience".[6] And Henry James wrote that "To deny the relevancy of subject-matter and the importance of the moral quality of a work of art strikes us as, in two words, ineffably puerile."[7] This moral intent finds echoes amongst novelists of the present day; John Updike holds that "Surely one of the novel's habitual aims is to articulate morality, to sharpen the reader's sense of vice and virtue."[8] And, in summarising the relation of ethics to the novel, A. Z. Newton can report as a generally agreed path of development that

ethics closely informed the novel's early development as a discourse both accessory (Samuel Johnson) and internal (Richardson, Fielding) to narrative texts. Novels trained ethical sensibility. On the one hand, in texts like *Tom Jones*, and later and with greater sophistication, *Pride and Prejudice* and *Middlemarch*, narrators schooled their readership

[3] Horace, "Art of Poetry", p. 73, and Sidney, "An Apology for Poetry", p. 173.

[4] Samuel Richardson, *Clarissa*, preface; Henry Fielding, *Tom Jones*, book X, ch. i; Daniel Defoe, *The History and Remarkable Life of the Truly Honourable Colonel Jacque*, preface. All quotations are from Miriam Allott (ed.), *Novelists on the Novel*, pp. 85, 91, 89–90.

[5] Peter Ackroyd, *Dickens*, pp. 136–43. [6] Anthony Trollope, *An Autobiography*, p. 146.

[7] Henry James, "Charles Baudelaire", in James, *Literary Criticism*, p. 157.

[8] John Updike, quoted by Booth, *The Company We Keep*, p. 24.

in the correct evaluation of and response to character and moral situation. This tradition culminated, with Henry James's novels and critical prefaces, in an inquiry into moral language and the way words shape and deform social relations.

More overtly sentimental fiction, like *Pamela*, *Uncle Tom's Cabin*, or *Dombey and Son*, on the other hand, instructed response by inducing identificatory states of compassion and pity . . . [9]

Even some of the literary figures who have warned against embracing an explicitly moral aim have done so because they feared in part that this would undermine the moral effects of their work. Shelley criticises several poets for affecting a moral aim, since "the effect of their poetry is diminished in exact proportion to the degree in which they compel us to advert to this purpose". But this is because poetry of its nature leads to moral improvement, so it does not require this aim to be forced upon it:

A man to be greatly good, must imagine intensely and comprehensively; he must put himself in the place of another and of many others; the pains and pleasures of his species must become his own. The great instrument of moral good is the imagination; and poetry administers to the effect by acting upon the cause. ... Poetry strengthens the faculty which is the organ of the moral nature of man, in the same manner as exercise strengthens a limb. [10]

Schiller similarly attacked art's having a moral aim: "No less self-contradictory is the notion of a fine art which teaches (didactic) or improves (moral); for nothing is more at variance with the concept of beauty than the notion of giving the psyche any definite bias." [11] But here again a relation to morality is maintained, for Schiller sees both the creation and the contemplation of beauty in art as the realm of freedom, and under Kant's influence associates the realm of freedom with that of morality; so the experience of art returns us to the moral realm, reconciling the realm of moral freedom with that of the sensuous. [12]

Even Oscar Wilde, that oft-cited and little-understood proponent (in some moods) of autonomism, appears on closer inspection to have had grave doubts about the tenability of that doctrine. The source of his most pungent autonomist aphorisms is the preface to *The Picture of Dorian Gray*, including the lines that "There is no such thing as a moral or an immoral book. Books are well written, or badly written. That is all." [13] Yet the aphoristic, paradox-loving style and the ideas of the preface are also the style and ideas of Lord Henry Wotton, who seduces Dorian away from his earlier moral sympathies onto the path of terminal moral ruin. And pivotal in that seduction is a decadent book that Henry presents to Dorian. Near the end Dorian realises what has happened, telling Henry that

[9] Adam Zachary Newton, *Narrative Ethics*, p. 9. Newton is employing the term 'ethics' in the customary sense here, though his own usage in the rest of the book is, he says, different.

[10] Percy Bysshe Shelley, "A Defense of Poetry", p. 503.

[11] Friedrich Schiller, *On the Aesthetic Education of Man*, Letter 22, p. 157.

[12] Ibid., Letter 25, p. 189. [13] Wilde, *The Picture of Dorian Gray*, preface, p. 3.

"you poisoned me with a book once. I should not forgive that".[14] Art according to the novel really does have the power to corrupt; and the sentiments of the preface that art is morally inert are thereby called into question.

I am not, of course, maintaining that all (even successful) artists have had a moral purpose in their work. That would be plainly false, and there are dissenters enough to be found. Ford Madox Ford, for instance, writes that "I have always had the greatest contempt for novels written with a purpose. Fiction should render, not draw morals."[15] And some artistic forms, such as absolute music, are relatively resistant to being turned to specifically moral use. Nor do I deny that artists can have self-consciously immoral aims and can seek to make readers complicit in them. In *The 120 Days of Sodom* Sade writes "now, friend-reader, you must prepare your heart and mind for the most impure tale that has ever been told since the world began" and says that, if any modes of pleasure-taking sanctioned by good manners should occur in that work, "they will always be accompanied by some crime or colored by some infamy".[16] I will, of course, be arguing that realised immoral aims count as aesthetic flaws in their work. What I am maintaining here is that the aim of instruction in the virtues has been so important in artistic practices that the autonomist claim that cognitive and ethical features are aesthetically irrelevant can be sustained only by disregarding core and recurrent goals of artistic practice. Given the prominence of these aims, one has good prima facie reason not to regard them as aesthetically irrelevant; and, in the absence of any convincing theoretical arguments in favour of their aesthetic irrelevance, one should reject autonomism.

5.2. CRITICISM

So far we have considered the aims, implicit or explicit, that artists have set themselves. But the realm of ethical criticism is wider than this, since one can ethically assess works whether or not their makers had ethical purposes. In the same way, moral assessment in a non-artistic context applies even when agents have no moral aims: one can criticise someone for simply not thinking about the moral aspects of her actions, for instance. In this wider domain of critical assessment, the dominance of ethical criticism is pronounced. This is conceded even by its opponents: Isenberg writes that "The greater part of all the art

[14] Ibid., p. 172. For a convincing account of why the novel should be understood as a critique of the kind of aestheticism that would exclude moral properties from the assessments of artworks, see McGinn, *Ethics, Evil, and Fiction*, ch. 6.

[15] Ford Madox Ford, *It Was the Nightingale*, pt II, ch. ii; quoted in Allott (ed.), *Novelists on the Novel*, p. 103. Ford goes on to say, though, that he had breached his principle by writing a whole series of novels aimed at obviating future wars. Ethical aims are hard to avoid, it seems.

[16] Marquis de Sade, *The 120 Days of Sodom and Other Writings*, pp. 253–4.

criticism that has ever been written has been moralistic in tone or content".[17] And, as Booth notes, until the late nineteenth century, almost everyone assumed that a major task of the critic was to assess works ethically.[18] Given the ethical aims of the artists we discussed, artists who were often numbered amongst the most prominent critics of their era, the ubiquity of ethical criticism up to the late nineteenth century causes no surprise. And that tradition of ethical criticism has continued strongly into more recent times. Evidence of this is to be found even in the language of aesthetic assessment, where works can be aesthetically praised as sincere, mature, wise, morally profound and treated analogously to friends, or aesthetically denounced as sordid, base, corrupt and corrupting. And ethical criticism is to be found widely in the work of critics who continue the humanist tradition. F. R. Leavis praises Wordsworth's poetry for its "intense moral seriousness" and for "the significance of this poetry for actual living. ... this achieved naturalness, spontaneous, and yet the expression of an order and the product of an emotional and moral training".[19] And Lionel Trilling argues that the novel in general is "an especially useful agent of the moral imagination".[20]

More recently, ethical criticism has undergone a renaissance. Feminist writers have criticised both individual works and conventional aesthetic criteria on ethical grounds. Lillian Robinson argues that we should reconfigure our aesthetic criteria and thereby reshape the canon so that they are more sensitive to the values that she finds in women's writings; so that, for instance, "clichés or sentimentality need not be signals of meretricious prose and that ultimately it is honest writing for which criticism should be looking".[21] In urging a similar reconsideration of aesthetic evaluations, Annette Kolodny holds that

readings of *Paradise Lost* which analyze its complex hierarchal structures but fail to note the implications of gender within that hierarchy; or which insist upon the inherent (or even inspired) perfection of Milton's figurative language but fail to note the consequences, for Eve, of her specifically gender-marked weakness, which, like the flowers she attends, requires "propping up"; or which concentrate on the poem's thematic reworking of classical notions of martial and epic prowess into Christian (moral) heroism but fail to note that Eve is stylistically edited out of that process—all such readings, however useful, will no longer be deemed wholly adequate.[22]

And Gilbert and Gubar interpret and valorise *Wuthering Heights* as a proto-feminist text, noting at one point that "anxious self-denial, Brontë suggests, is the ultimate product of a female education. What Catherine, or any girl, must learn is that she does not know her own name."[23] Political criticism, which has

[17] Isenberg, "Ethical and Aesthetic Criticism", p. 266.
[18] Booth, *The Company We Keep*, p. 25. [19] F. R. Leavis, *Revaluation*, pp. 138, 143.
[20] Lionel Trilling, "What is Criticism?", p. 67. Cited by Mary Devereaux, "Moral Judgments and Works of Art", p. 7.
[21] Lillian S. Robinson, "Treason Our Text", p. 117.
[22] Annette Kolodny, "Dancing through the Minefield", p. 158.
[23] Sandra M. Gilbert and Susan Gubar, *The Madwoman in the Attic*, ch. 8.

also been a major component of post-structuralist theories, is similarly replete with ethical criticism, though it does not often identify itself as such. But in the sense of 'ethics' used in this book, ethical values include political ones; for, as we saw in Section 2.3, ethical values centre on the nature of our concern for others, which includes the exercise of the prime political virtue of justice.[24] Marxist literary criticism is avowedly ethical in this sense.[25] Its claims can be sweeping; for instance, after examining all the major strands of contemporary literary theory, Terry Eagleton writes that the "conclusion is that the literary theory we have examined is political".[26]

Other strands within recent critical practice are more resistant to ethical criticism, notably New Criticism, most of whose proponents identify themselves as autonomists, and those aspects of post-structuralist theories that are inspired by the notion of art as transgression. But even in these cases ethical criticism plays a surprisingly strong, if unacknowledged role. This point has been pressed in particular by two leading literary proponents of ethical criticism, Wayne Booth and Tobin Siebers. Unfortunately, there are problems with some of the considerations that they bring to bear in arguing their case. As we saw in Section 2.3, Booth's claim rests on so wide an understanding of what counts as 'ethical', that even thinking straighter and writing better count as ethical merits. Siebers, in arguing for the implicit ethical commitments of the New Critics, maintains that they had hidden ethical motivations: in stressing the autonomy of the poem from the poet, he suggests that they hoped in part to shield the poet from aggressive personal attacks and gossip.[27] But having an ethical motivation does not in itself make one an ethical critic, since it is whether the values that one is applying to works are explicitly or implicitly ethical that make one an ethical critic. A critic might have as her motivation the general happiness of mankind, thinking that the appreciation of literature is an important source of happiness; her motivation would be ethical, yet she might be employing purely non-ethical, formal criteria in her work.

Though their arguments misfire, Booth and Siebers are correct that extensive ethical criticism is to be found even in traditions that are ostensibly against it. New Criticism is generally held to be autonomist; John Willingham, for instance, writes that New Critics "try to resist tainting the aesthetic dimension by moralism, didacticism, or intellectualism; their central concern is only *form*, the unifying principle within the work".[28] And their greatest philosophical

[24] Parker, *Ethics, Theory and the Novel*, pp. 4–6, supposes that the dominance of political criticism in the 1970s and 1980s shows that ethical criticism was in abeyance during this period; however, in the sense of 'ethics' employed here, its dominance supports the contrary assertion.

[25] See, for instance, Theodor Adorno, "Trying to Understand *Endgame*", for a subtle Marxist ethical reading of Beckett's play.

[26] Terry Eagleton, *Literary Theory*, p. 195.

[27] Tobin Siebers, *The Ethics of Criticism*, pp. 47–60

[28] John R. Willingham, "The New Criticism", p. 24.

proponent, Monroe Beardsley, is explicit in rejecting ethical criteria in aesthetic assessment. Yet in practice a great deal of New Criticism was imbued with ethical values.[29] Its central value of organic unity seems to have been taken over from the political domain, the critical doctrine having evolved from the Southern Agrarian movement, which sought to defend the supposed organic unity of the American South from the atomising influences of capitalism.[30] On this view, the work of art is like a little society, with its tensions successfully resolved through the governing organic order. But it is not through its employment of a quasi-political value that New Criticism chiefly shows its ethical nature. Its ethical viewpoint is sometimes much more explicit than that. In his famous essay, "Irony as a Principle of Structure", Cleanth Brooks, pedagogically the most influential of the New Critics, provides a close reading of "Eighth Air Force", a poem by Randall Jarrell. Brooks writes:

At his best, Jarrell manages to bring us, by an act of imagination, to the most penetrating insight. Participating in that insight, we doubtless become better citizens. (One of the "uses" of poetry, I should agree, is to make us better citizens.) But poetry is not the eloquent rendition of the citizen's creed. It is not even the accurate rendition of his creed. Poetry must carry us beyond the abstract creed into the very matrix out of which, and from which, our creeds are abstracted. That is what *The Eighth Air Force* does. That is what, I am convinced, all good poetry does.[31]

Praising a poem because it provides us with insights that make us better citizens is about as far removed from autonomist doctrine as one can imagine. The passage well illustrates that the actual practice of New Criticism could be very different from what its official and simplified stance maintained. For what Brooks is chiefly concerned to show in this passage is that in poetry moral insight should not be delivered as an abstract doctrine, but should be integrated into and emerge from living experience. (This latter point is closely connected with the main claim of the essay, that meaning can only be accurately appraised from the context within which it is located, which is what Brooks means, oddly, by "irony".) Brooks is correct, I think, about the conditions for aesthetic relevance of moral insight—indeed, he is making the same point about the importance of locating universals in particulars that we made in Section 4.3. His objection is to abstraction, not to ethical criticism; for what he has produced is both an ethical reading of Jarrell's poem, and a statement of adherence to ethical criticism.

In that same essay, Brooks also discusses Matthew Arnold's poem "Dover Beach", and in particular the line that the world "which seems to lie before us

[29] Vincent B. Leitch, *American Literary Criticism from the Thirties to the Eighties*, p. 32, refers to the "long-standing conventional and misleading image of New Critical 'close reading' as the purely aesthetic and rhetorical interpretation of texts", noting that its actual practice was far more diverse and could include moral, religious and philosophical emphases in interpretation.

[30] See ibid., pp. 27–8.

[31] Cleanth Brooks, "Irony as a Principle of Structure", p. 1048.

like a land of dreams . . . hath really neither joy nor love nor light". Brooks remarks that such a line could not be validated by asking scientists or metaphysicians what is true, but by applying

T. S. Eliot's test: does the statement seem to be that which the mind of the reader can accept as coherent, mature, and founded on the facts of experience? But when we raise such a question, we are driven to consider the poem as drama. We raise such further questions as these: Does the speaker seem carried away with his own emotions? Does he seem to oversimplify the situation? Or does he, on the other hand, seem to have won to a kind of detachment and objectivity? In other words, we are forced to raise the question as to whether the statement grows properly out of a context; whether it acknowledges the pressures of the context; whether it is "ironical"—or merely callow, glib, and sentimental.[32]

What is striking about this test is that, in considering the justification of the line, we are directed to the ethical qualities of the speaker, the virtues of his character. These encompass the broad sense of the ethical, but also qualities that are ethical in the narrower sense (to be callow is to be immature, and to be glib is to be fluent in a generally insincere and deceptive fashion), or the exercise of which is conducive to moral judgement, especially objectivity and detachment. So Brooks's (and Eliot's) test of justification makes reference to ethical qualities. The quarrel with biographical criticism is clearly with using the actual author's ethical qualities; what matters according to Brooks is the speaker's ethical qualities, the speaker being a figure internal to the literary text (this could be the narrator or the implied author, the distinction not being clearly marked in the pre-Boothian world). The literary work may be autonomous from its context according to this view, but that properly leads to a relocation of the object of ethical assessment to a figure internal to the work; it does not lead to a renunciation of ethical criticism.

What I have suggested, then, is that, behind the sloganeering and simplifications of the New Critics about ethical criticism, there lurks a practice that was not adverse to its employment. These critics' advocacy of 'irony' (an attention to meaning-in-a-context) produced a welcome sensitivity to the correct understanding of the ethical viewpoint conveyed by texts, and their focus on the 'speaker' evinced a plausible concern with the viewpoint of the text, as opposed to that of the actual author. Both of these moves were advances in ethical criticism; neither undermined its practice. Indeed, it should come as no surprise that the New Critics could be drawn to ethical criticism. Poems such as "Dover Beach", with its meditation on the effects of loss of religious faith, and "Eighth Air Force", with its reflection on how it is possible for ordinary men to be murderers in time of war, positively demand an ethical response, for they are meditations on ethical themes. The New Critics numbered among their ranks some of the best critics of

[32] Ibid., p. 1043.

the twentieth century and were sensitive to the nuances of the texts they read, so one can easily explain why they were drawn to ethical criticism when confronting these works.

Ethical criticism is even to be detected at one point in the work of Monroe Beardsley, the movement's most committed exponent of theoretical rigour. Beardsley thinks that the correctness of ethical views does not matter to the success of artworks; so the anti-usury views of some of Pound's *Cantos* and the anti-Semitic views of others of them, do not per se affect their literary worth. Rather, it is only how they are presented that matters, whether the views are unified, complex or intense. The presentation of the anti-usury view is a success, since "it serves as a thread, so to speak, on which a series of rough but strong images is strung; the tone is serious and the attitude appears deep, fixed, pervasive, and weighty"; in contrast, the "anti-Semitism appears suddenly in its context, not closely connected with the rest of the Canto; it is essentially a cheap and vulgar passage, reflecting the grossest stereotypes about middle-European Jews; its tone is insensitive and imperceptive".[33] With the exception of the formal value of closeness of connection, the values adverted to in the commentary on the anti-Semitic passage are not formal; indeed, they are clearly ethical failings when employed in this context—talk of cheapness, vulgarity, gross stereotyping, insensitivity and imperceptivity are the kinds of moral accusations that one might make against an anti-Semite in real life. Even Beardsley cannot avoid ethical criticism when the correct appreciation of a work demands it.

So even criticism that is in theory autonomist turns out in practice to embrace ethical criticism, and for good reasons, given the nature of the poems discussed. If even New Criticism employs ethical criticism at times, it is hard to see how there is good support from critical practice for autonomist doctrines. What of criticism, though, that seems to support contextualism? Here those strands of post-structuralist and reader-response criticism that are influenced by the idea of art as transgression are a promising source of contextualist support.

The writings of Michel Foucault have been of immense influence on recent post-structuralist criticism. In his early *Madness and Civilization*, Foucault defends the inmates of asylums against what he sees as the "gigantic moral imprisonment" of a medical system intent on crushing them into conformity to oppressive social norms. And he writes of the works of de Sade and Goya that "the Western world received the possibility of transcending its reason in violence".[34] Such judgements seem to celebrate these works for their immorality and to be grounded on a general view of art as transgressive of morality.

One way to counter these judgements is to dispute their correctness. Goya's later works, such as the *Disparates*, *Caprichos* and *Desastres de la guerra*, are not instances of madness or immorality, nor do they celebrate these traits. Rather,

[33] Beardsley, *Aesthetics*, p. 428.
[34] Michel Foucault, *Madness and Civilization*, pp. 278, 285.

they are satires and warnings, and in the case of the *Desastres* (which Foucault does not discuss) are denunciations of the madness and evil that Goya saw around him in the Peninsular War. They are a full-throated scream of moral outrage. As the art critic Robert Hughes remarks, Goya "was the first painter in history to set forth the sober truth about human conflict: that it kills, and kills again, and that its killing obeys urges embedded at least as deeply in the human psyche as any impulse towards pity, fraternity, or mercy. Most of all, he drives home the undeniable message that there is nothing noble about war . . .".[35] And, while the works of de Sade are indeed endorsements of sexual torture, amongst other things, they emerge as banal and tedious on any extended encounter.

However, my main point about Foucault is not the accuracy of his critical or historical judgements; it is simply that Foucault is recognisably himself an ethical critic, albeit one with an unorthodox moral system. For what he celebrates in *Madness and Civilization* is the idea of art as a mode of liberation, as an escape route from the oppression and conformity of the bureaucracy of the everyday. As such, he is at this point in his career a late descendant of the Romantic tradition of seeing art as a force for freeing the individual spirit. What Foucault attacks as 'morality' is a particular kind of conventional moral system stressing conformity and control that he thinks is (to use our terms) deeply immoral. In this he is like all those artists who in attacking bourgeois morality were not in fact endorsing immorality, but were attacking the *conventional* morality of their time, which they believed to be in fact immoral, whether they used the term or not. This point does not trivialise the issue by allowing any set of views to count as moral: we can still allow that critics and artists can celebrate what they themselves think of as, and what is, immorality; advocacy of immorality is a coherent doctrine and could be practised as a mode of aesthetic assessment. Recall the test advanced in Section 2.3, concerning whether attitudes evince a concern for others for their own sakes. Foucault's celebration of the cause of the imprisoned, both in jails and in mental asylums, and his conviction that he is opening a liberatory path for all, passes the test for what counts as a moral view (which is not, of course, to say that it is a *correct* moral view). Grasp this point, and contextualist celebration of works for their immorality turns out to be far less common and influential than dutiful genuflection to the tradition of art as transgression might suggest. And the ethicist will argue that the remaining contextualist judgements are incorrect.

Another highly influential defence of de Sade in the art-as-transgression tradition is due to Simone de Beauvoir and bears out the same point.[36] De Beauvoir concedes de Sade's artistic failings, his repetitions, his flat characters and his lack of the detachment of the true artist. Nevertheless, she celebrates him as a great literary figure; and strikingly she chooses to do so in ethical and cognitive terms. De Sade, she tells us, was a "great moralist", who through his striving to obtain freedom attempted to regain "authenticity by an individual

[35] Robert Hughes, *Goya*, p. 289. [36] Simone de Beauvoir, "Must We Burn Sade?"

decision".[37] She also hails him as a pioneer in sexual studies, anticipating the work of Krafft-Ebing in sexual pathology. Her talk of de Sade as a moralist is not (merely) a wilful toying with paradox: she seems to mean it. De Sade is recast as a proto-Existentialist hero, a celebrant of freedom, as well as a pioneer scientist. So, strikingly, here again we find an apparent celebration of art as transgression resting on an ethical viewpoint. One can hardly help adding that de Sade is about as implausible a candidate for ethical celebration as one can imagine (and de Beauvoir's defence of him as such sits very oddly with her feminist convictions). And, while de Sade may have made some contribution to the study of sexual pathology, one need not be a celebrant of sexual violence and torture to do so, and it is the latter attitude that is the proper object of ethical condemnation.

A second strand in recent criticism and practice also seems to support contextualism. Contemporary artists often talk of their work as 'raising questions', 'questioning assumptions', 'challenging beliefs', and many of these questions, assumptions and beliefs concern moral, especially political, matters. Artists have been joined in this talk by critics: Foucault claims that the work of art "opens a void, a moment of silence, a question without answer, provokes a breach without reconciliation where the world is forced to question itself".[38] Writing more sedately in the tradition of reception hermeneutics, Hans Robert Jauss argues that the work of art can be "a summons to moral reflection", and that it does this by querying our basic moral assumptions through stylistic means. *Madame Bovary*, for example, employs a *style indirect libre* by which the inward thoughts of characters are reported without the signals of direct discourse; hence the reader has to decide whether she should take an observation as the character's or as the narrator's. For instance, the sentence referring to Emma contemplating adultery, "at last she was going to possess those joys of love, that fever of happiness of which she had despaired", is not marked explicitly as her thought or as the narrator's. The new device "broke through an old novelistic convention—the moral judgment of the represented characters that is always unequivocal and confirmed in the description". By employing the device and withholding explicit moral judgement, Flaubert was thus "able to jolt the reader of *Madame Bovary* out of the self-evident character of his moral judgment, and turned a predecided question of public morals back into an open problem".[39]

Jauss undoubtedly points up an important device for ethical reflection in the novel, but it is not one that should give any comfort to the contextualist, who holds that sometimes works of art are good in so far as they have aesthetically relevant ethical defects. For one must distinguish between *raising questions* about some domain and *rejecting* the views questioned. Philosophers should be

[37] Simone de Beauvoir, pp. 40, 58. [38] Foucault, *Madness and Civilization*, p. 288.

[39] Hans Robert Jauss, "Literary History as a Challenge to Literary Theory", pp. 180–2. Compare Chekhov's remark in a letter to A. S. Souvorin, 27 October 1888, that "you confuse two conceptions: *the solution of a question and the correct setting of a question*. The latter alone is obligatory for the artist" (quotation from Allott (ed.), *Novelists on the Novel*, p. 99).

particularly sensitive to the distinction, since it is a basic philosophical strategy to question some viewpoint, the better to understand it and its rationale; the strategy in some cases leads to rejection of the viewpoint, but in other cases it leads to its defence. A philosopher can raise sceptical doubts about the existence of the external world, but need not go on to claim that it does not exist, and will instead probably attempt to answer the sceptic. She may raise questions about the justification of abortion or of the wrongness of lying, without going on to claim that abortion is unjustified or that it is permissible to lie. A fully adequate moral point of view is not one that is uncritically accepted, but is the product of critical reflection. So moral improvement may consist not just in correctly rejecting one's previous views as inadequate, but also in enhancing critical reflection on one's views. Not just any questions, of course, will aid in this improvement, since questions can be irrelevant, badly posed, confused or otherwise misleading. But, if the questions are pertinently posed, works of art may play an important role in critical improvement of one's views, partly through the mechanism to which Jauss draws attention. By actively drawing the reader into considering the moral merits of what is being represented, rather than simply informing her what to think, the author can enhance the quality and nature of the reader's ethical thought as well as creating an aesthetic merit in the work.[40]

Here again *pro tanto* principles play an important role in stating and defending ethicism. One can hold that a work is good in so far as it raises pertinent questions about some moral practice, questions that invite critical reflection on it. But the work might also be bad in so far as it endorses a moral viewpoint that ought to be rejected—or the work could be good in so far as it endorses the correct moral viewpoint. *Madame Bovary*, for instance, does indeed invite the reader to reflect critically on the rights and wrongs of adultery; but (despite the misreading of the book that led Ernest Pinard, the prosecutor at the 1857 trial, to claim that the book glorified adultery) it is certainly not a paean to the joys of marital infidelity. No sensitive reader, contemplating Emma's wretched end, could take it that way. A work can question a view and thereby invite reflection on its merits without also endorsing its rejection. Were a *Bovary*-counterpart novel to question the wrongness of adultery, but in addition endorse the enthusiastic practice of adultery by deceit and manipulation, the ethicist could consistently hold the former feature to be an aesthetic merit, yet hold the latter, when aesthetically relevant, to be an aesthetic demerit.

Finally, besides appeal to some recent critical schools, contextualists might also look to some common critical judgements for support. One is the use of 'moralistic' and 'didactic' as terms of aesthetic derogation by art critics. Vermeer's

[40] Eagleton, *Literary Theory*, pp. 78–80, discusses Wolfgang Iser's views on the importance of critical questioning by works, views that are very similar to Jauss's, and claims that this sort of view is "based on a liberal humanist ideology" (p. 79). However, it is hard to see why there is anything specifically liberal about critical reflection; it is simply a general rational requirement on possessing a fully adequate point of view.

Young Woman Reading a Letter at an Open Window originally included a painting of Cupid on the wall behind the woman, but Vermeer painted it out. Writing about this over-painted Cupid picture, the art historian Irene Netta remarks:

> It refers to a particular emblem in Otto van Veen's *Amorum Emblematum* and reminds the viewer to have only one lover. The fact that Vermeer removed the Cupid to achieve the final composition testifies again to his intention deliberately to avoid any kind of symbolic reference or emblematic allusion that could open the depicted moment to other associations, such as a moralistic didactic meaning. Such an allusion would inevitably interfere with the quiet atmosphere and secluded privacy of the young woman.[41]

If moralistic and didactic art is aesthetically bad, then that seems to be a problem for ethicism; and the discussion of the Vermeer pentimento sharpens this point by apparently providing a concrete example of how aesthetically relevant moral merits can be aesthetic demerits.

 However, 'moralistic' and 'didactic' are terms of blame, even outside aesthetic contexts. Someone deemed moralistic in her judgements and attitudes is held to be narrow-minded, unresponsive to others, and too prone to condemn where sympathetic understanding is called for. She is, in short, judged to have moral defects, albeit ones that are combined with some morally good points (being moralistic is more properly opposed to being morally sensitive than it is to being immoral). Likewise, someone who is didactic in her judgements and attitudes stands accused of narrow-mindedness, of lecturing (in the pejorative sense) others rather than listening to them and learning from them, thus betraying an attitude of superiority and condescension. Again, we are dealing with a set of moral faults, and also in this case educational faults—the didactic person is not a good teacher in the way that someone willing to listen to and consider opposing points of view is. Moralism and didacticism are moral defects, and the latter is also a cognitive defect; so aesthetically condemning a work of art for possessing them does not undermine ethicism. As these points also show, morally assessing an attitude is not just a matter of working out what precepts might be extracted from it, but also of assessing how that attitude is conveyed. The moralistic and didactic person may possess much the same beliefs as does the morally sensitive and responsive person, but the latter also manifests in her attitude a sensitivity to others that is distinct from the moral precepts that she holds. Assessment of the kind of attitude that someone has towards others is often at the core of the moral assessment of a person, rather than merely determining what moral principles she would endorse.

 Turning more specifically to the Vermeer painting, the over-painted Cupid would, if Netta's interpretation of it is correct, have functioned a bit like Vermeer tapping the woman sharply on the shoulder to remind her that fidelity is a virtue

[41] Irene Netta, "The Phenomenon of Time in the Art of Vermeer", p. 260, quoted in Livingston, "Pentimento", p. 99. Livingston employs the example to argue for the truth of actual intentionalism in the theory of interpretation.

and that she had better watch her conduct. A moralistic and didactic attitude might then have been manifested by the picture through painterly means, and, if so, would have counted as an aesthetic defect in it in so far as these traits manifest morally bad features. The actual picture is not only free of this aesthetic defect; it also evinces a very different moral attitude. A sense is conveyed of the woman as having a self-consciousness of her own, as having thoughts and feelings largely unknown to us, since we do not know what the letter is about. Indeed, the "secluded privacy" to which Netta draws attention is in large part a privacy of the mind. And, as Livingston notes, the occlusion of the Cupid allows the viewer "to linger on the delicate depiction of the young woman's reflection in the windowpane, with its gentle suggestion of the reflexive quality of her thoughts and feelings as she reads a letter".[42] So the attitude manifested by the painting towards the young woman is quite different from that which the over-painted version might have conveyed. It is an attitude of sensitivity towards another person as a conscious being, with an awareness of her separateness as a person, an awareness that here there is an interior world of emotion and thoughts to which others are at best only indirectly privy, a world glimpsed in a reflection. This attitude is, of course, recognisably a moral one; indeed, it is a core moral attitude of respect for another person, and is ethically superior to the admonitory attitude of the over-painted version. So the final version of the picture is an ethical improvement on the earlier version, and, given the painterly way in which Vermeer has conveyed that attitude (the reflection in the pane, the quiet subdued light, the inscrutability of the girl's countenance and so forth), it is also an aesthetic improvement in that respect. Indeed, there is a close parallel here with Rembrandt's *Bathsheba*, which as we saw similarly accomplished, also via an over-painting, a moral shift from a conventional attitude, in that case one of concupiscence and condemnation, towards an attitude of empathy and sympathy, an awareness of Bathsheba as a separate individual with an inner life of her own. Though we know roughly the contents of Bathsheba's letter and know not at all those of Vermeer's young woman, the painters' sensitivity to a woman's inner life and respect towards it are the same in both cases and account for part of the aesthetic success of these extraordinary pictures.[43]

I have argued in this chapter, then, that appeal to artistic practices and to critical judgements, both those made by specific schools and those made by critics more widely, supports neither autonomism nor contextualism. Our dominant critical practices are flatly inconsistent with autonomism; and even autonomist-influenced critics have sinned mightily against the faith. Given the criticisms of autonomist arguments advanced in the previous chapter, we have good reason

[42] Livingston, "Pentimento", p. 107.

[43] Vermeer on more than one occasion painted out items that had explicit emblematic meanings, so as to concentrate on more subtle effects; see, for instance, the discussion by Anthony Bailey, *A View of Delft*, pp. 83–6, of Vermeer's *Girl Asleep at a Table*.

to reject that doctrine in the light of its failure to fit coherent and considered practice. Further, we have seen how several elements in critical practice that seem to support contextualism do no such thing: the line of 'immoralist' criticism in the Foucauldian tradition is partly flawed in its judgements and is in any case the substitution of what is supposed to be a more liberatory morality for a conventional one; the notion of works 'questioning' assumptions, even moral ones, does not undermine ethical criticism; and the aesthetic condemnation of moralistic and didactic works is itself an exercise in ethical criticism. Moreover, I will argue in Chapter 10 that dark humour in artistic genres, such as satire and black comedy, which is often thought to support contextualism, in fact does no such thing, but is consistent with ethicism.

One could clearly say a great deal more about critical practices, but it is not space alone that forbids further exploration here. For, as noted at the start of this chapter, given the strength of its valence claim, ethicism cannot be decisively established against contextualism by its handling of examples. To do that, it must employ philosophical arguments. What this chapter has tried to show, more modestly, is that many apparently pressing contextualist counter-examples to ethicism fail, and, in doing so, we have displayed some of the resources available to the ethicist in handling apparently recalcitrant critical judgements: either such judgements turn out to be themselves crypto-ethicist judgements, or they are consistent with ethicism, or they can be shown to be false. We have also seen how ethicism fits snugly with critical practice, when subject to reasoned scrutiny. But, since reflection on critical practice cannot decisively establish ethicism, it is time to turn to the a priori arguments in favour of that doctrine.

6

Questions of Character

This chapter is grounded on the idea that a core object of ethical assessment of artworks is the character of the manifested artist. That claim, made in terms of the implied artist, lies at the centre of a striking argument by Wayne Booth for a version of moralism. Booth's argument is that aesthetically evaluating a work of art is akin to befriending its implied author, and that we assess friends by their ethical character. The first section of this chapter discusses Booth's argument, and, though it finds much of merit in it, argues that there are salient differences between assessing artworks and choosing friends. The next two sections take the idea that assessment of the character of the manifested artist is a central object of ethical concern, but uses it to support a different argument for ethicism. This argument rests not on the notion of friendship, but on the view that moral character constitutes a kind of beauty, and that moral qualities of the manifested author are under certain conditions aesthetic merits in the work. This argument constitutes the first of the three a priori arguments for ethicism defended in this book.

To see the importance of the character of the manifested artist and to show how the notion is being used here, it is useful briefly to retrace some steps that we have taken. In Chapter 3 we formulated ethicism as a claim that a work is aesthetically defective in so far as it has an aesthetically relevant ethical defect, and conversely that a work has an aesthetic merit in so far as it has an aesthetically relevant ethical merit. In the context of discussing radical autonomism in Section 4.1, we also saw that works possess ethical merits or defects not by virtue of simply representing good or bad characters or situations. Rather, the crucial issue is of *how* works represent characters and situations; in particular, what matters is the *attitude* that the work manifests towards these characters and situations. This attitude can be complex and multi-layered, and not infrequently some interpretative subtlety is required correctly to identify the attitude actually manifested by a work, as opposed to that which it appears to manifest. We also saw that a work's manifesting some attitude is equivalent to the artist manifesting that attitude in the work.

As we noted, the latter claim needs to be understood carefully so as to avoid pitfalls and misunderstandings. That *Anna Karenina* manifests an attitude of sympathy towards its heroine is equivalent to the fact that its author manifests

sympathy towards Anna in the work. This is true by virtue of what Tolstoy did in writing the work, the artistic acts that he performed, such as representing Anna in certain ways. That he showed sympathy towards Anna in the work does not entail that he manifested sympathy towards real women whom he encountered in his life.[1] Hence we cannot simply equate these two attitudes. Nor does the fact that he is sympathetic to Anna in the novel entail that he intended to be sympathetic or was even aware of being sympathetic; for artists are not always successful in fulfilling their intentions, even when they are not self-deceived about them. Tolstoy might, for instance, have intended to give a harsher treatment of her than he did (something that does indeed seem to have been the case). Conversely, artists may intend to give insightful and sympathetic treatments of their characters, but only produce narrow-minded and censorious treatments of them. And an artist's attitude towards a character may vary with context: in the novel he may be sympathetic, but, reflecting on his achievement in his diary, he might be more censorious. So there is no entailment from claims about the author's attitude in one context to claims about his attitude in another.

This lack of entailments means that we cannot simply infer, say, from the intentions expressed in Tolstoy's diary or from the attitudes he had to real women in his life to claims about his attitudes to Anna in the novel. However, this is consistent with holding that there may be evidential links between intentions and attitudes, and between attitudes in various contexts. People often succeed in acting on their intentions; and people's attitudes are often the same across different domains; so we may take his intentions and attitudes in other contexts as defeasible evidence for what Tolstoy's attitudes towards his heroine were. But, as we noted, the test is whether knowledge of his intentions and of his attitudes in other contexts sheds light on the attitudes manifested in the novel: do they allow us to see some aspect of his attitude in the novel that is genuinely there, but that we might have overlooked without knowledge of these other matters?

So it is the artist's attitudes manifested in the work that are a central object of ethical assessment. And we can recast this statement in terms of assessing the character of the manifested artist. The manifested artist is simply the set of characteristics we would ascribe to the artist on the basis of the attitudes that he manifests in the work. If, for instance, he manifests sympathy and shows insight, then we can talk of a sympathetic and insightful manifested artist. And this way of putting the matter shows that a core object of ethical assessment of artworks is the character of the manifested artist. With this point in place, we can now examine Wayne Booth's employment of a similar point in his argument for a version of moralism.

[1] However, if the artist manifests an attitude towards characters in an artwork, then he implicitly in the artwork also manifests that attitude to real-life counterparts of the characters. This is a distinct issue, of course, from what his attitudes manifested outside the artwork are towards real-life people.

6.1. ARTWORKS AND FRIENDS

The thought that there is a close connection between literary works and friends is an old one.[2] It is found in Hume, who remarks that "We choose our favourite author as we do our friend, from a conformity of humour and disposition".[3] Talk of books as friends was widespread in the nineteenth and early twentieth centuries, as witnessed by titles such as *The Friendship of Books* and *Friends on the Shelf*.[4] Wayne Booth has developed an argument for ethical criticism that is grounded on this metaphor. The core of his claim is that to evaluate a literary work aesthetically is to evaluate its implied author as a would-be friend. If we evaluate the implied author as a good friend, the work is aesthetically good; if we evaluate the author as a bad friend or someone we would reject as a friend, the work is aesthetically bad. If we add that a good friend is good partly by virtue of her moral qualities, we can conclude that, in so far as a work has a morally good implied author, the work is aesthetically good, and *mutatis mutandis* for a work with a morally bad author. And that comprises the friendship argument for ethicism.[5]

This argument has many virtues. The friendship metaphor has some power and plausibility. And it is a salient virtue in a friend that she has some good moral qualities, whether of sympathy, kindness, a sense of justice or so on. Indeed, the friendship relation is partly defined in moral terms. For it is constitutive of a friend that she cares for her friend for the friend's own sake. An acquaintance who was interested in someone merely as a way to increase her own pleasure, or otherwise only as a means to advance her own interests, would not count as a true friend. As we saw in Section 2.3, the core moral attitude consists in caring for another person for her own sake, and, since someone is a real friend only if she cares for her friend for the friend's own sake, friendship is intrinsically a moral relation.[6] Yet we do not pick our friends merely for their moral qualities: someone may want her friends to be lively, interesting, even-tempered, amusing, with an ability to open her eyes to new interests and so on. Moral qualities are only some

[2] Most of the talk of friendship has focused on literature; but if appeal to friendship is to ground ethicism as a general view, friendship must also have its place in our relations to artworks in other media. So, though I will mainly concentrate on literature and authors in developing the view, the claims advanced should be understood as applying to artworks and artists in general.

[3] David Hume, "Of the Standard of Taste", p. 321.

[4] Booth, *The Company We Keep*, p. 171.

[5] This is a rational reconstruction of the argument. Booth does not formulate the argument precisely, and I have used the notion of the moral, rather than the broader notion of the ethical that Booth employs, in order to avoid the danger of the vacuity that threatens his account, as we noted in Sect. 2.3.

[6] Booth, however, follows Aristotle, as Booth interprets him, in holding that friends made merely for pleasure or for profit are still friends, albeit not friends in the fullest sense, which is roughly that sense identified in the text above; see Booth, *The Company We Keep*, pp. 173–4.

of a range of admirable character traits (ethical ones in the broad sense) for which we may value friends. And the same is true of our valuing of authors. Thus the friendship argument naturally grounds the pluralism of aesthetic values that we saw was an important aspect of the ethicist position.[7] Finally, talk of friendship captures the strong sense that we can have in many works of a personality present to us through them, and of the aesthetic importance of our relationship to that personality.

Talk of books as friends is a metaphor; but, if the friendship argument is to succeed as a grounding for ethicism, we need to find a literal version of the claim. Perhaps Booth thinks it a literal truth that the implied author of a work is assessed as a would-be friend. But I am inclined to think that he holds that this too is a metaphor;[8] and, if so, he is certainly right to do so. To see why, we need to mark a distinction that applies to the notion of the implied author. In one sense, an implied author would be the actual author with those characteristics imputed to him that one would regard as his based on reading his work (imputation might be a matter of *believing* that he has these characteristics or of *imagining* that he has them, based on one's reading of the text). In this sense, the implied author of *Anna Karenina* is Tolstoy, the real man, with those qualities of sympathy and insight ascribed to him that one would regard as his based on reading the novel, characteristics that he might not have displayed in his real-life actions. This sense is equivalent to that of the manifested author, as I am using the term. A distinct sense is that in which the implied author is a merely postulated or imagined person, one who unlike the actual author never existed, with those characteristics imputed to him that one would regard as his based on a reading of his work. In this sense, the postulated author is himself a character, albeit one not explicitly described in the text, but one postulated by its interpreter. Call this sense the *postulated* implied author.[9] It is unclear as to which of these two possibilities Booth has in mind; in one place he talks of the implied author as a "character", suggesting the latter reading; but, in elaborating on this, he cites Saul Bellow's remark that revising *Herzog* consisted in "just going through drafts and removing those parts of my character I don't like", which naturally suggests the former interpretation.[10] On either reading, however, the implied author cannot literally be a friend. It is a necessary condition for someone's being

[7] Booth in effect makes the same point in ibid., p. 179; he writes that moral distinctions are pertinent to our appraisals of friendship, but that the broader category of the ethical is central, since otherwise one could not explain how some good friends in life and literature are beneficial, even though they are immoral.

[8] Ibid., p. 174.

[9] Nehamas's postulated author is explicitly the latter kind of implied author; see his "The Postulated Author: Critical Monism as a Regulative Ideal".

[10] See Wayne Booth, "Why Banning Ethical Criticism is a Serious Mistake", p. 378. As noted in Sect. 4.1, there is also a difference in respect of epistemic detachment between Booth's conception of the implied author and that of the manifested author, as I am using the term, but that difference is not germane to the present issue.

a friend that she be someone with whom one has had some kind of relationship involving mutual awareness, normally by meeting her. But the manifested author is a person whom one is likely never to have met. If someone said 'Flaubert is a good friend of mine' and one took him literally, one would have to suppose that he was suffering from a gross delusion. And claiming that a living author, such as Nick Hornby, is a friend, if one has never met him or had any other kind of interaction with him, would be a simple lie. Suppose, on the other hand, that the postulated implied author is meant, then one is claiming that a character is a friend; this is like someone saying that Emma Bovary is a good friend of his. If the speaker meant this seriously and literally, one would have to question his sanity.[11]

So talk of an implied author as a friend is a metaphor; but, if it is a good metaphor, it must draw attention to some important, literal truth; yet what is that truth? One possibility is that talk of an implied author as a friend should be construed fictionally. It is fictional that the implied author addresses me, the reader, and that she is aware of me; it is fictional that she cares for me for my own sake, and it is fictional that I care for her too. Thus, within the bounds of this game of make-believe, the implied author and I are friends, mutually aware of each other and mutually caring for each other. A close analogy would be with children who have 'imaginary friends': within their game of make-believe they have friends, even though these friends do not really exist. And one could also talk of being friends with a fictional character in the same fictional sense.

However, we encounter serious difficulties if we take the literal truth expressed by the metaphor to be that the implied author is a fictional friend. First, not all literary works are fictional; if I think that Edward Gibbon's *Decline and Fall of the Roman Empire* is a literary masterpiece, then on the account under consideration it is fictional that I am addressed by the implied Gibbon, that he cares for me and that I care for him, and so forth. But why ever should one suppose that all these things are fictional, since the work itself is not a work of fiction, and does not ground fictional truths? Even if one supposed that one must postulate an author to explain features of the text, it does not follow that this postulated author is fictional: a postulate is something that is hypothesised to explain a phenomenon, but it is not required that the postulate be fictional. Quarks are postulates, but not fictions. Second, even in the case of fictions, it is an ungrounded stipulation, lacking independent support, to hold that it must be implicitly fictional in each work that the author offers his friendship to me. And, if we hold instead that the fiction is not implicit in the work, but implicit in the game of make-believe that

[11] Nussbaum also notes that the problem with Booth's metaphor is that when one is reading one is alone, so that "there can be, except in fantasy, no interchange of the sort we associate with love and friendship" (*Love's Knowledge*, p. 239). She nevertheless endorses Booth's metaphor, though it is unclear how she believes that the literal truth that it captures should be formulated; given her talk of fantasy, perhaps she has in mind something like the fictional account suggested in the next paragraph.

I play with the work, then a different difficulty arises. I may choose to play any game of make-believe with a text: I may choose, for instance, to treat Gibbon's work as an accountancy text within a game of make-believe. So any evaluations I make in such a game, which is unauthorised by the work, do not ground a correct evaluation of the work. Likewise, if I choose to play a game of make-believe with a work in terms of befriending its author, where this is not grounded in implicit fictions of the work, then any evaluations made in my game do not ground a correct evaluation of the work.

The best way to understand the literal truth aimed at by the friendship metaphor is, I suggest, in terms of a conditionality thesis. Consider an analogy. Suppose that I come across some old diaries and letters of a long-dead ancestor of mine. Reading them, I form a strong impression of his character. Of course, I do not know what he was like other than through these writings; but, on their basis, I warm to him. 'I wish I had known him,' I think; 'he would have been a good friend.' The utterance is grounded on a perfectly intelligible thought: that if someone with the characteristics manifested in these writings existed now, that person would probably be a good friend of mine. This thought could apply to the manifested author, and also to fictional characters and postulated implied authors. And this, I suggest, is the best construal of the literal truth expressed by the friendship metaphor. It even finds an echo in Booth's tongue-in-cheek question of whether you would like your daughter to marry the implied Thomas Hardy.[12]

Construing the friendship relation in this conditional way, and employing our preferred concept of the manifested author, we can consider whether the friendship argument provides a solid grounding for ethicism. It certainly has attractions for the reasons adumbrated earlier, and it does indeed capture important aspects of our appraisal of some artworks. But it fails as a general argument for ethicism. For our relationship towards the manifested author of an artwork that we esteem is not always happily characterised as one of friendship.[13] Consider the case of Michelangelo's *The Last Judgement* in the Sistine Chapel. I judge it to be a great work, but I am not thereby judging the manifested Michelangelo to be a great friend. First, the fresco is, in the literal sense of that overused term, awesome: the appropriate attitude before it and the achievement that it represents is awe. Vasari's repeated use of "divine" to characterise Michelangelo seems peculiarly apt when one looks at this work.[14] Friendship is a relation that characteristically holds when two people feel that they are roughly on a par, and that is certainly not something that one feels on viewing Michelangelo's stupendous achievement. Awe is a feeling that has no

[12] Booth, *The Company We keep*, p. 206.

[13] I am grateful here to Antony Duff, whose observation that, though he believes Dostoevsky to be a great artist, he would not characterise his relationship to him as one of friendship first prompted these reflections.

[14] Giorgio Vasari, "Life of Michelangelo Buanorroti", in *Lives of the Artists*, pp. 325–442.

central place in friendship, more naturally characterising the feelings of a disciple or acolyte; and, if any terms were to capture's one's relationship to Michelangelo, these cohere better with the stunned admiration one feels. This feeling of having done something quite extraordinary, of the artist having lifted him or herself out from the normal sphere of human achievement, characterises by definition the greatest artistic achievements. In such cases talk of friendship seems peculiarly inappropriate, if not downright presumptuous. Second, in *The Last Judgement* as a whole Michelangelo evinces a troubled, despairing personality. This is partly because of the greater power and force of his depiction of the damned than of the saved—think in particular of the cowering male figure, his hand cupping and clenching over his left eye, hunching forward in agony, being dragged down to hell by three demons. This sense of troubled personality is there too in the depiction of the martyr St Bartholomew, who holds his flayed, sagging skin in his left hand; the ripped-off skin bears the agonised visage of Michelangelo himself. And the extraordinary scale of the Sistine Chapel frescos suggests an obsessional, monomaniacal character. All these characteristics fit well with those manifested in other works by Michelangelo, including his lyric poetry, and receive evidential support in the descriptions of the real man by Vasari and others. These traits may be of interest and importance when found manifested in the work of an artist; but being difficult, obsessional, troubled and despairing are not characteristics that one naturally looks for in one's friends. Given the choice of whom to have as a friend, an artist who makes technically competent and pleasing watercolours of quiet village scenes and who evinces a strong interest in country pubs might well, with his promise of enjoyable walks and a good pint afterwards, prove a more inviting prospect as a friend than the difficult, sometimes tormented Michelangelo. The qualities that may make a good friend can be very different from those that a great artist manifests in his work.

After this confession of my hobbit-like tendencies, you, dear reader, may well lodge a protest. Perhaps you are made of sterner stuff than I, and would welcome the difficult Michelangelo as a friend. But, even if this were so, that would not solve the difficulty. For, as long as there are settled and rationally supportable preferences that allow someone to judge that a great work of art manifests an artist whom he or she would not judge to be a great friend, there is a problem for the friendship argument.

Talk of variability in the choice of friends introduces a second problem. Hume, after stating that we choose our favourite author as we do our friend, from a conformity of humour and disposition, continues: "Mirth or passion, sentiment or reflection; whichever of these most predominates in our temper, it gives us a peculiar sympathy with the writer who resembles us."[15] But things are more variable than even this acknowledges, for it is not only in romantic relationships that opposites sometimes attract. And friendship can also rest on

[15] Hume, "Of the Standard of Taste", p. 321.

peculiar idiosyncrasies of shared history or interest, perhaps a common school, a shared childhood hobby long since discarded, or a common enthusiasm for observing the avian activities of the grey-breasted woodwren or the laughing kookaburra. And one person's best friend may regularly drive another person to distraction. The degree of variability in the characteristics that bind friends, the role of idiosyncrasy in the formation of their friendship, and the fact that a friend to one person may be an intolerable excrescence on the life of another, mean that friendship does not form an adequate basis for capturing any objectivity in aesthetic assessment. Were we to model artistic appreciation on this relationship, we would have to permit huge variation and disagreement in what is to count as a great artistic achievement; so this relationship might better model what it is personally to prefer one artist and artwork to another than the distinct relation of what it is to judge one artist and artwork better than another (a distinction of which all reflective aficionados of junk literature are well aware). Given the moral nature of the friendship relation, the only securely objective property would be that of the moral nature of the friend. But, if that were so, then we would have an argument for a kind of moralism that permits *only* moral properties of artworks to count as aesthetic ones. And that, as we have seen, sits ill with our reflective endorsement of a plurality of aesthetic values.

So, though on the conditional reading of friendship, talk of friendship with a manifested artist does make sense, and one may also befriend a favourite artist, the friendship relation cannot in general capture the nature of artistic valuing, both because a good manifested artist might not be a good friend, and because of the insufficient objectivity of the friendship relation. When one assesses a work aesthetically, one does indeed assess what the artist did in the work and thereby what sort of person he shows himself to be in the work; but it does not follow from the fact that one assesses a person in some way that one assesses him as a friend. Some manifested artists of good works may be judged to be good friends for a person, other manifested artists of good works may not be so judged. We must look elsewhere for an argument for ethicism derived from the character of the manifested artist.

6.2. MORAL BEAUTY

In recounting the lamentable history of Rembrandt's treatment of Geertje Dircx, Simon Schama remarks: "The man who had created so much beauty showed himself, in this one matter, capable of great moral ugliness".[16] Schama's remark is a striking one: he locates a tension between the beauty of Rembrandt's work and the wickedness of his actions. Yet why should there be such a tension?

[16] Schama, *Rembrandt's Eyes*, p. 547.

Rembrandt, after all, showed himself in his litigious pursuit of Geertje to be capable of many other things, including of pursuing a sustained course of action over time; yet here is no tension between this quality and the beauty of the work. The answer lies, of course, in that telling phrase "moral ugliness": morality can be ugly or beautiful; moral virtues are beautiful, moral vices are ugly. Indeed, we have already come across the same thought in discussing Rembrandt's *Bathsheba*: we saw that, though Bathsheba is not especially beautiful by current standards, Rembrandt conveys through his portrayal of her body and countenance qualities of nobility that lend her a kind of inward beauty.

Suppose for a moment that talk of moral ugliness and beauty expresses a literal truth. Then we have the promise of a relatively straightforward a priori argument for ethicism. For, if a work of art manifests ethically good attitudes, then it possesses in that respect a kind of beauty; and, since beauty is undoubtedly an aesthetic value, it follows that a work has aesthetic value in so far as it manifests ethically good attitudes. Conversely, if a work manifests ethically bad attitudes, then it possesses in that respect a kind of ugliness; and it follows that the work has an aesthetic flaw in so far as it manifests such attitudes. And, surprising as its premiss may seem, that, with some refinements, is the argument for ethicism that I will now defend.

The connection of this argument with the question of the character of the manifested artist, which is the common theme of this chapter, is straightforward. As we noted, there is an equivalence between a work's manifesting an attitude and an artist's manifesting that attitude in the work; taken together, these manifested attitudes constitute the manifested artist's character. So talk of a work's manifesting an attitude can be recast in terms of the manifested artist's character in that work. Applying the moral beauty claim, we get the result that a manifested artist with a morally good character has to that extent a beautiful character, and, since his or her character is by definition manifest in the work, the work has to that extent a beautiful feature, and hence an aesthetic value. Hence, given the equivalence, the argument can be recast in terms of the character of the manifested artist.[17]

Why, though, should one believe that moral virtues are beautiful and moral vices are ugly? For it may seem obvious that such talk is merely metaphorical, in the same way that saying that someone is 'cool' is clearly metaphorical. We have a well-stocked battery of moral metaphors at our call, accolades with which to crown the good and excoriations with which to lambaste the wicked. We may call a bad person a 'swine', but that does not ground a porcine theory of vice; we may say of the evil person that his conduct 'stinks', but that does not establish an olfactory theory of wickedness. The outstandingly good person may be deemed

[17] It is worth noting that, if anyone should reject the equivalence, this does not necessitate rejection of the argument; for the argument can still proceed in terms of the attitudes manifested in the work, as formulated in the previous paragraph.

an 'angel', but there is no support here for a supernatural theory of goodness. If a use is clearly metaphorical, no sensible theory is to be grounded on a literal application of the term. Why should talk of aesthetic qualities applied to moral character be any different?

One way to approach that question is to reflect on the topic of moral beauty as debated in history of philosophy, a matter on which we touched briefly in Section 1.2. Talk of moral beauty and moral ugliness has been widespread in a heterogeneous variety of philosophical traditions, and that talk has not been meant metaphorically. Though it seems to have been present in the Pythagorean tradition, its first sustained development is in Plato's *Symposium*. There Socrates retells with approval Diotima's doctrine that the true lover ascends a ladder of ever more authentic beauty, starting with the love of particular beautiful bodies, then to beautiful bodies generally, then to the beauties of the soul, including ethical virtues, and on ultimately to grasp the beauty of the Forms themselves. Diotima holds that the "the beauties of the body are as nothing to the beauties of the soul", so that ethical qualities, and even more so philosophical wisdom, are to be loved and regarded as more precious than bodily qualities.[18] The Stoics went on to develop the theory, holding that ethical virtues were beauties of the soul, and that therefore one could create in oneself true beauty, no matter what the contingencies of chance had dealt one in respect of bodily beauty. Plotinus too, following Plato, holds that "all the virtues are a beauty of the Soul, a beauty authentic beyond any of these others [the beauties of the senses]", and he identifies beauty and the good, "Beauty, this Beauty which is also The Good". He compares the person who is striving morally to improve himself with a sculptor, carving away stone from a coarse block of matter in order to reveal the beautiful form within it. As this comparison suggests, whereas Plato is hostile to the claims of art to awaken us to true beauty, Plotinus exalts the powers of art in this respect, asserting that artworks "are holders of beauty and add where nature is lacking".[19] The linkage of moral virtue to beauty entered the Christian tradition through the influence of Plotinus on St Augustine and the pseudo-Dionysius, and so continued to be of considerable influence in the West.

In the modern empiricist tradition, the link of virtue to beauty was forged again in the work of Shaftesbury, who was much influenced by Neoplatonism. Hutcheson endorses the view: he writes that the "Author of Nature" has "made Virtue a lovely Form, to excite our pursuit of it", and he asks rhetorically: "may not we find too in Mankind a Relish for a Beauty in Characters, in Manners?"[20] The moral beauty view was also endorsed by Hume, who claims that taste ascertains moral matters as well as aesthetic ones, taste giving "the sentiment of beauty and deformity, vice and virtue".[21] He talks repeatedly of "moral

[18] *Symposium*, 210b. [19] Plotinus, *The Enneads*, I, 6.1 and 6.6; V, 8.1.
[20] Francis Hutcheson, *An Inquiry into the Original of our Ideas of Beauty and Virtue*, p. 9.
[21] Hume, *An Enquiry Concerning the Principles of Morals*, app. I, p. 88.

beauty" and says that "in many particulars, it bears so near a resemblance" to natural beauty.[22] Here he seems close to thinking of moral assessment simply as assessment of the beauty of someone's character, so that the moral domain is but a subset of the broader aesthetic domain. Indeed, talk of moral beauty became pervasive in the eighteenth century, in both the philosophical and the literary traditions, culminating in the writings of Schiller.[23] And that view has continued to resound within philosophy down to the present day; it is one that Colin McGinn has recently endorsed and argued for at some length.[24]

So the moral beauty view has had considerable resonance within the philosophical tradition. But it may be thought that, in endorsing the view, I am still skating on thin ice, even if the rink on which I am perilously gliding is a well-patronised one. And it is, of course, true that this litany of philosophical endorsement does not prove the correctness of the claim. But it does show that the idea has had considerable intuitive attraction to many philosophers, who otherwise hold extremely diverse philosophical views. And the philosophical attraction finds an echo within common modes of speech. We may call someone who exhibits many moral virtues a beautiful person; we may say of a kind and generous action that it was a beautiful action; we may say of someone who has done something wicked that it was an ugly action; and so on. The phenomenology of virtue supports these attributions: the type of pleasure one has in contemplating a markedly good act seems very like the type of pleasure one takes in beauty; and, in seeing the kindness in someone's face, one seems to see a kind of beauty. So within common speech and experience and also within the philosophical tradition there is much support for the idea of moral beauty. As such, it deserves serious attention and scrutiny. However, since the sceptic thinks that the usages are merely metaphorical and the tradition simply confused, we need to find an argument for the view.

One apparently attractive option is a Hume-type argument, though it may not be Hume's own. Virtue, writes Hume, is to be defined as "*whatever mental action or quality gives to a spectator the pleasing sentiment of approbation*; and vice the contrary".[25] So virtues on this account are those character traits that a spectator contemplates with pleasure. But, one might suppose, if one takes pleasure in the contemplation of some quality, then that quality is *ipso facto* beautiful. So virtues are beautiful character traits, vices are ugly character traits.

[22] Ibid., p. 86.

[23] For a useful survey of this, and of the ancient origins of the tradition, see Robert E. Norton, *The Beautiful Soul.*

[24] McGinn, *Ethics, Evil, and Fiction*, ch. 5. Though McGinn embraces the moral beauty view (which he terms the "aesthetic theory of virtue"), and also appears to adopt some version of moralism concerning aesthetic assessment of artworks, he seems not to argue for moralism by appealing to moral beauty. Rather appeal to aesthetic cognitivism appears to be his preferred argument for moralism (ibid., ch. 8). As we have noted, though, only a short step is needed to ground ethicism on the moral beauty view.

[25] Hume, *An Enquiry Concerning the Principles of Morals*, app. I, p. 85.

On this view, then, there is outer beauty, the beauty of physical objects; and inner beauty, the beauty of character traits; and the latter are the virtues. Moral qualities are simply one kind of aesthetic property, differentiated by their being mental traits, rather than physical ones. One would then have a straightforward argument for moral virtues being literally beautiful, and moral vices being literally ugly.

This argument would need refining. Though he mentions only a spectator, Hume would need to specify the kind of spectator to give an adequate definition. The spectator would have to be suitably informed, so as not to be mistaken about the nature of the mental qualities, which she is contemplating; she would have to be rational enough and sufficiently free of prejudice to take pleasure rather than feel jealousy or scorn for these qualities, and so on. That refinement would present no insuperable difficulties, since something like the account of the "true judge" in Hume's "Of the Standard of Taste" could provide these kinds of restriction.

There would still be, however, a serious problem with the argument. For it simply is not true that any feeling of pleasure in the contemplation of some quality is the kind of pleasure one takes in what is beautiful. In finding a joke funny, I am contemplating it with pleasure; but I am not thereby judging that it has a kind of beauty (the joke might be disgusting, for instance). So the pleasure we take in the amusing is a pleasure of contemplation, but the amusing is different from the beautiful; hence not all contemplative pleasure is directed towards beauty. And this is true, even if one holds that the pleasure of beauty is a disinterested kind of pleasure. We argued in Section 2.1 that disinterest is not the mark of the aesthetic attitude, but, even if one held that it were the mark of the contemplation of the specific aesthetic property of the beautiful, it would not help in the current context. For one can similarly take a disinterested pleasure in the contemplation of what is amusing. In Kant's sense of 'disinterest', appreciation of the humorous is disinterested, for one need not establish whether the joke describes an actual situation before one knows whether to find it funny. Nor is one concerned only to advance one's practical interests in finding something funny, so appreciation of humour is disinterested in this sense too. Hence the Hume-type argument does not prove that moral virtues are beautiful. For this, it would need to show that the type of pleasure that we take in moral virtues is the type of pleasure that we take in the beautiful. But to assert that this is so would simply be to beg the question against the sceptic about moral beauty. Nor, notoriously, do we have a robust criterion for what makes something beautiful, so we cannot appeal to some common quality or set of qualities, such as uniformity in variety, in various objects that moral qualities and beautiful physical objects have in common. The beautiful is plausibly a response-dependent property, and such properties do not require, and typically lack, a response-independent property that all their instantiations have in common. The result is that, though the Hume-type

argument is alluringly attractive, it remains frustratingly out of reach of our theoretical grasp.

There is another way, however, to argue for the moral beauty view. If one wants to show that two apparently distinct things are identical, or if one wishes to show that an object necessarily possesses some property, one can do so by considering our dispositions to classify counterfactual scenarios—that is, one can engage in thought-experiments. These are common in conceptual analysis: we know that all bachelors are unmarried men, since when we consider a bachelor who is married, we realise that this is not possible. Thought-experiments also yield substantive truths concerning what we morally ought to do, as we shall see in Section 7.4. And they also feature with respect to a posteriori identities: having discovered that water is H_2O, one can then argue that this is necessarily so by contemplating worlds in which something other than that chemical compound is in the seas and rivers, and conclude that one would not call that substance 'water'. Likewise, one can argue that cats are necessarily animals by considering what one would say about robots that looked and acted like cats, and conclude that one would not call them 'cats'.[26]

To argue for the moral beauty claim by using thought-experiments, we need to establish how precisely to formulate it. In his discussion of the view, McGinn formulates it as a supervenience claim: "if two persons are exactly alike with respect to the moral virtues and vices, then they are exactly alike in their morally aesthetic properties." Morally aesthetic properties are beauty and ugliness of soul, and grades of these. He also says that this does not constitute an identity claim about moral properties and beauty of soul, but it does tie them conceptually together; an analogue is the way that the beauty of pictures supervenes on their colour and shape. He goes on usefully to distinguish between a strong version of the view that holds that *every* aesthetic property of the soul has moral significance, and a weaker version that holds that *some* aesthetic properties of the soul have moral significance. He endorses the stronger version.[27]

McGinn's formulation has several merits, but it also has shortcomings. As formulated, it is consistent with immoral aestheticism: the supervenience claim is satisfied if moral virtue is always accompanied by ugliness of soul. However, his definition is easily modified to rule this out. His talk of beauty of soul might also seem to bring in a quasi-religious view of humanity, which might skew the argument in favour of the aesthetic theory of virtue. But he also equates soul, character and personality, and I will use the term 'character' to avoid smuggling any religious overtones in to help the view. There is also an important unclarity in his account. He does not tell us whether the supervenience formulation is in

[26] For the classic arguments of this kind, see Hilary Putnam, "The Meaning of 'Meaning'"; and Saul Kripke, *Naming and Necessity*.

[27] McGinn, *Ethics, Evil, and Fiction* pp. 97–8. He also says that inner beauty and ugliness should be understood to include a wide variety of morally aesthetic properties, such as being, in the former case, pure and stainless, and, in the latter, rotten, vile and foul (pp. 92–9).

terms of weak or strong supervenience, yet which way we read the relation results in significantly different versions of the aesthetic theory of virtue.[28]

Given these problems, I shall reformulate the moral beauty claim as follows, in terms of biconditionals and conditionals. A strong version of the claim holds that a quality is a moral virtue if and only if it is beautiful character trait; conversely, a quality is a moral vice if and only if it is an ugly character trait. A weaker version gives a sufficiency condition: if a quality is a moral virtue, then it is a beautiful character trait; and, conversely, if a quality is a moral vice, then it is an ugly character trait. The sufficiency condition is weaker, since it allows that there might be other beautiful character traits besides moral virtues, and other ugly character traits besides moral vices.[29]

There are good reasons to hold the weaker formulation to be the correct one. There are many character traits that are beautiful, though they are not specifically moral. Plotinus held that the greatest beauty of soul consists in wisdom; and this was meant to include more than moral wisdom and to involve a more general grasp of the eternal verities. Indeed, we still talk of someone who is exceptionally intellectually gifted as having in that respect "a beautiful mind" (this was the title of the biography of and subsequent film about the gifted Princeton mathematician and game theorist John Nash). And we count several other traits as beautiful: for instance, having a vivacious capacity to experience life to its full and being open and positive towards opportunities is an attractive character trait, but it is not a specifically moral one. Conversely, a tendency always to be pessimistic, to be neurotically fearful of every change, with a killjoy view of any proffered possibility of happiness, is an ugly aspect of someone's character, though it is not in itself a moral defect, and is quite consistent with being morally upstanding. So, despite McGinn's espousal of the stronger version of the moral beauty claim, there are good reasons for embracing the weaker version: not all kinds of beauty of character are moral virtues, and not all ugliness of character is a moral vice.

Is the weaker version of the moral beauty view tenable? Consider a person who is morally worthy but deeply dull: is she not an example of a morally good person with an ugly character? Here we should distinguish between her morally good character traits, which are beautiful, and her deep dullness, which may be an aesthetic blemish on her character. So she does not have an ugly character in

[28] According to both sorts of supervenience, if a person A in a possible world W has a set of moral virtues and has a beautiful soul, then another person B with the same set of virtues in W has a beautiful soul too. But weak supervenience allows for the existence of another possible world W* in which A and B have the same moral virtues as they do in W, but in which both lack beauty of soul. Strong supervenience in contrast rules out the possibility of W*, given the existence of W. Strong supervenience holds that in *all* possible worlds in which A and B have the same set of moral virtues that they have in W, A and B have beautiful souls in those worlds, given that they have them in W.

[29] Note that, in these formulations, we should employ the notions of beauty and ugliness so as to admit of degrees, hence permitting degrees of virtue and vice.

so far as she is morally good: again, sensitivity to the *pro tanto* structure of these judgements is essential to grasping the correct structure of evaluative assessment. The morally good but dull person has her beauties, but it may take a sensitive, patient eye to discern them, as compared to the more obvious beauties of others. The ability to discern this person's beauty of character is akin to Constable's ability to see and to show us the quiet beauties of his native Suffolk landscape; and it may take a practised eye to see the more reticent beauties of some moral landscapes.

What of the stern moralist, unbending in his adherence to moral principles? Is such a person an example of a morally good person with an ugly character trait? The answer depends on how the example is filled out. One possibility, to recall the discussion of the notions of the moralistic and didactic in the previous chapter, is that this person is in a certain way morally flawed: he is incapable of the sensitivity to context and to others' points of view that any adequate moral grasp requires. In such a case, we should hold that, in respect of his moral character, he has a touch of ugliness, though with some compensating beauties. The other possibility, depending on how one fills out the details of his character further, is that this person is not defective in respect of his moral sensitivity or in other ways, but simply has a full-hearted passion for doing what is morally right: he cannot be swayed by petty-fogging self-interest, and does not tack and weave in his pursuit of the morally right. Here there is no moral defect, though the character of his moral beauty is different from that of the dull person: the stern person's inner moral landscape is not one of quiet beauty, but is more akin to the perhaps somewhat intimidating beauty of a mountain landscape, lofty peaks towering dauntingly above one.

What of someone who is kindly, but performs his kindly acts with the ungainliness that he brings to all his actions? There is no counter-example to the moral beauty claim here: we must distinguish between the beauty of the character trait of kindness that finds expression in his action, and the physical ungainliness of his gestures. The aesthetic defectiveness of the latter does not impugn the aesthetic merit of the former. Conversely, someone may have a vicious and therefore ugly character trait that is expressed in a particular act of physical violence. In so far as the act is an expression of viciousness, it is ugly; but it may still be elegant in respect of some of its other features, perhaps in the curving arc of the fist flying through the air. In actions, the expressions of a character trait in physical form, we must distinguish between the nature of the mental act expressed, and the other, particularly physical properties of the expression of that act. The aesthetic features of the moral qualities of the former may differ from the aesthetic qualities of the latter. Moral beauty is inner beauty, and its outward accompaniments are not necessarily beautiful.

Finally, what of someone who performs an act that we might describe as being 'cruel to be kind', such as a life-saving operation without an anaesthetic, because none is available, or who puts down an animal to end its misery? These

are, surely, good actions that are not beautiful.[30] In reply, we need again to distinguish between the moral motivation of the actions and the (in this case) grisly outer accompaniments of the actions. Only the motivation is beautiful. And note too the naturalness but also oddness of the description 'cruel to be kind'. For these are not really cruel actions: they are motivated by a concern for the welfare of another being, and may even require a heroic overcoming of one's reluctance to perform them. Yet they have an appearance of cruelty, in the sense that someone who did not understand the situation would naturally take them to be cruel. The appearance of cruelty grounds an appearance of ugliness; but delve deeper into the motivation, and one realises that they are good actions and can recognise the beauty of their motivation. This distinction between the appearance of immorality and the actions' genuine goodness explains (together with their possibly grisly aspects) why we are disposed to think of them as ugly actions (because cruel), but, through reflection on their motivation, we can see the genuine beauty in them that is given by their motivation. So there is no counter-example to the moral beauty claim here.

Hence the weaker moral beauty claim is robust enough to withstand counter-examples. But it might still be rejected on other grounds. It might, for instance, be held that it cannot account for the categoricity of morality, nor for the nature of moral motivation. The moral beauty view might seem to provide a plausible motivation for morality, since concern with doing the right thing is concern with one's own beauty. Indeed, Shaftesbury has been interpreted as trying to ground moral motivation on this kind of concern, thus seeking an alternative, non-theological foundation for morality.[31] Yet such a goal looks like precisely the wrong kind of motivation to count as moral: it is a concern for one's own good, which lacks that sensitivity to others' interests, which we saw is the hallmark of the moral attitude. Likewise, we can demand of people that they do what is morally required, even if they do not want to do so, but it is strange to suppose that it could be the beauty of their act that is the ground for this categorical demand, since we do not demand that people in general are beautiful or produce beautiful things.[32]

A related objection was advanced by Edmund Burke to the moral beauty view: "This loose and inaccurate manner of speaking, has therefore misled us both in the theory of taste and of morals; and induced us to remove the science of our duties from their proper basis, (our reason, our relations, and our necessities,) to rest it upon foundations altogether visionary and unsubstantial."[33] Reason,

[30] The objection is due to Stephen Davies. [31] Norton, *The Beautiful Soul*, ch. 1.

[32] McGinn, *Ethics, Evil, and Fiction*, p. 119, claims that moral motivation is overdetermined, but is in part a matter of seeking to increase the beauty of the world and of one's own character in particular. However, one should note that, if someone acted *only* on these motivations, this would be good grounds for claiming that she was not acting morally.

[33] Edmund Burke, *A Philosophical Enquiry into the Origin of our Ideas of the Sublime and the Beautiful*, quoted in Norton, *The Beautiful Soul*, p. 96.

according to Burke, should be the foundation of morality, not considerations about the beauty of one's actions.

The reply to this kind of objection is to distinguish between an identity version of the moral beauty view and a predicative version. The former holds that the moral goodness of some character trait simply *consists in* its beauty: there is no more to the trait's being morally good than its being beautiful. On this version, moral motivation would indeed have to consist in the motivation to produce a certain kind of beauty, and a demand to perform a morally right action would simply be a demand to perform a beautiful action. This version of the moral beauty view would fall to the objections just considered. But the predicative version holds simply that morally good character traits are beautiful, without maintaining that their moral essence is exhausted by their beauty. Hence a morally good character trait might have other essential features besides its beauty, and it would be these that would ground the categoricity of the moral demand and be the source of moral motivation. We have already argued against the strong version of the moral beauty claim, and this version is logically equivalent to the identity view, if we understand identity in terms of necessary coextensionality. So the response to the categoricity and motivation objection gives us further reason to adopt the weaker version of the moral beauty claim.

A second objection appeals to the notion of aesthetic disinterest. As we saw in Section 2.1, the idea of aesthetic disinterest in Kant's sense is that, when we make an aesthetic judgement, we are concerned not with the existence of the object of that judgement, but only with its appearance; and, relatedly, we have no practical interest in the object, that is, no interest in acting in any way towards it, as opposed merely to contemplating it. The moral judgement, in contrast, does ground an interest: in judging that an action is morally right or wrong, I necessarily have a motivation to act in that way, if I am able. Kant appeals to these factors in distinguishing between the moral good and the beautiful.[34] And, although Kant's views on the relation of morality to beauty are complex and not in fact inconsistent with the moral beauty view, his advocacy of the conceptual distinction seems to have been historically one of the sources of the demise of that view.

There are two replies to this objection. First, as we argued in Section 2.1, the aesthetic disinterest view should be rejected. An aesthetic judgement very often grounds a practical interest in its object: an artist makes constant aesthetic judgements in creating her work, and these judgements certainly ground an interest in changing it so as to improve it. And the same is true when one looks at oneself in a mirror and adjusts one's clothing or brushes one's hair, so as to look nice (or at least nicer). Second, and more importantly, even if the aesthetic judgement were disinterested, the predicative version of the moral beauty claim would not be undermined. For, if moral judgements entailed a motivation to act,

[34] Kant, *Critique of Judgment*, Sects 1–5.

when one could, then this could be so not by virtue of the beauty of the moral virtue that was being exercised in making the judgement. Rather, it could be so by virtue of some other of its essential features. So, again, the predicative version of the view proves superior to the identity version.

What, however, of the main objection, earlier mooted, that talk of moral beauty is merely metaphorical (or, in Burke's words, is a "loose and inaccurate manner of speaking")? The use of a metaphor here might be merely a way of expressing moral approval, and have nothing to do with beauty. If so, one could explain the robustness of the counterfactual links between morality and beauty; for appeal to beauty would merely be a way of expressing our moral approbation. In reply, one should first note that the application of a term in a context is prima facie evidence of literal usage. Metaphorical employment is established typically by the evident falsehood of the phrase. The reason that we take talk of someone being a swine or an angel to be metaphorical is that the person is evidently human, and neither a pig nor divine. This is the main test, though there are others—in some cases one takes a usage to be metaphorical, since the claim is evidently true when taken literally, though puzzlingly off the point: if one says 'no man is an island' to someone who is feeling lost and lonely, he might be rather surprised in his hour of distress to be reminded that he is not a piece of land surrounded entirely by sea. So metaphorical usage is ascribed when something blocks the understanding of the utterance as literal: so interpreted, it would typically make the speaker believe in evident falsities, or be puzzlingly irrelevant.

Talk of moral beauty is not puzzlingly irrelevant, but it might be held to be evidently false, and hence metaphorical. One could support this on the grounds that beauty is an essentially sensory property, or more weakly requires the presence of sensory properties.[35] Sights and sounds are beautiful; hence we can talk of beautiful paintings, poetry and music. But entities that cannot be perceived, such as a moral character, cannot be beautiful. However, this flies squarely in the face of much of our common acknowledgement of what is beautiful: theories, arguments, proofs and ideas are commonly called beautiful, yet none can be perceived. (Indeed, an entire section of Hutcheson's *Inquiry* is entitled "Of the Beauty of Theorems".) And, even for artworks, many of their salient aesthetic properties are not directly perceivable: literary works can have beautiful, elegant plots and graceful characterisation, and these do not require any particular kind of perceptible expression, but may be dependent on semantic and structural features of the work. So the sensory view of beauty should be rejected.

However, Nick Zangwill has defended a sophisticated version of the sensory view, and replies to these kinds of objections. He argues for aesthetic/sensory dependence: aesthetic qualities are always in part dependent on sensory properties,

[35] Jerrold Levinson, in "Artworks and the Future", pp. 182–3, for instance, characterises aesthetic properties (including gracefulness, unity and expressive properties) as higher-order perceivable properties.

sensory properties being necessary for aesthetic properties. By 'aesthetic', Zangwill means beauty and its subspecies—properties that we have termed aesthetic in the narrow sense—and the truth of this weak dependence thesis would directly rule out literal talk of beauty of character.[36] It still follows from this weaker view that many aspects of literature are not counted as aesthetic, since the same literary content could be expressed in different sensory ways, employing words with different sensory properties. Zangwill explicitly embraces this conclusion:

if a literary work has aesthetic properties, they derive from the particular choice of words, because of the way they sound, either in themselves or as the sonically apt expression of a particular meaning; and if a literary work has values which are not linked in one of these ways to the sonic properties of words, then they are not aesthetic values.[37]

Talk of a plot being beautiful is thus ruled to be metaphorical, since a plot is not thus linked to sensory properties. It further follows that talk of proofs, theories, arguments and football goals as beautiful is also metaphorical, a conclusion that Zangwill also adopts. He holds that in these cases we admire how well, say, a proof accomplishes its end, but that this admiration is intellectual, not aesthetic, since aesthetic admiration requires us to be able to distinguish cases where something *expresses* an end (which may be the object of aesthetic admiration), and cases where something *accomplishes* an end (which is the object of a kind of technical admiration). A library, for instance, may express through its design its purpose of housing books, and we can assess it aesthetically in terms of its function, but it may still be no good as a means for housing books. Such things as proofs admit of no equivalent distinction: we admire them only as means to ends.[38]

The weak dependence view should, however, be rejected. First, the account of literary values has some pressing defects. There is no reason to believe, apart from one's adherence to the theory, that talk of a narrative poem's rhymes and rhythms as being beautiful is literal, but that talk of its plot development, characterisation and imagery as being beautiful is merely metaphorical. John Donne's famous comparison of a pair of parted lovers to a dividing compass, the one leg moving as the other moves, is a beautiful image, but, on the weak dependence view, it is not literally beautiful, since its quality does not depend on the sound of the words. On this view, the aesthetic experience (in the narrow sense of the experience of beauty and its subspecies) of reading a novel must be entirely distinct from that of hearing a novel, since sounds and sights are very different sensory objects. It also follows that a blind person who reads a novel in Braille can have no aesthetic experiences, since she cannot see or hear the words—or, if we allow touch-properties to count as sensory for the weak dependence view, then her aesthetic experience of the novel is totally dissimilar

[36] Nick Zangwill, *The Metaphysics of Beauty*, ch. 8.
[37] Ibid., p. 137. In a footnote on the same page, Zangwill confesses to occasional doubts about the truth of the weak dependence thesis when applied to literature.
[38] Ibid., pp. 140–3.

from that of someone who reads or hears it. Novels translated from one language to a dissimilar one lose whatever aesthetic qualities they may have had, since the sound of the translation is likely to be very different from that of the original; so, for instance, no non-Russian speaker has ever experienced the aesthetic properties of *Anna Karenina*. A view that has these consequences should be rejected.

Second, the reasons offered for rejecting the literal talk of proofs, theories, arguments and goals as being beautiful are unconvincing. Some mathematicians and physicists hold that the most beautiful things are abstract theories and proofs—a view that is defended in the Pythagorean and Platonic tradition, and the mode of apprehension of the beautiful in this tradition is understood as being contemplation, rather than perception, precisely to allow for the beauty of abstract entities. And it is part of ordinary, uncontentious talk that goals in football can be beautiful. None of these things is evidently false when taken literally, in contrast to the way that saying that a man is a swine is evidently false when so taken. And Zangwill's argument for a metaphorical use in such cases is odd. Suppose that we agreed that the application of aesthetic predicates to some activity requires a distinction between the expression of a purpose in the activity, to which an aesthetic predicate properly applies, and the fulfilment of a purpose. Non-sensory items (items that require no particular sensory realisation), such as theories and goals, could still have aesthetic qualities, since the foregoing distinction applies to them as well. Kicking a ball can express the purpose of scoring, even if it were not successful in achieving its purpose. A theory may express the purpose of yielding a truth, and yet not be true. And, in any case, aesthetic qualities can also apply to the qualities that conduce to something fulfilling a purpose: a beautiful picture of a horse may be aesthetically appreciated in part because of how well it fulfils its purpose of representing a horse. So the sensory view of beauty and the weaker dependence theory of beauty should both be rejected, and hence they provide no grounds for holding that talk of moral character as beautiful is metaphorical on the grounds that character is not dependent on sensory properties.

If one accepts that non-sensory entities can be beautiful, then one might still reject the notion of moral beauty because moral characteristics do not have the appropriate structure to be beautiful. It might be held, for instance, that beautiful theories and proofs exhibit a kind of unity in complexity that is required for beauty, but that merely being kind does not. Beautiful goals are suited to their purposes, but the same cannot be said for moral virtues. However, this objection presupposes that one can identify some subvening basis for beauty, and then demonstrate that entities such as proofs possess it and that moral characteristics do not. But attempts to specify a subvening basis for beauty are notorious failures, and provide no purchase for such arguments. Unity in complexity, for instance, fails to account for the beauty of simple colours, or the beauty that can be found in some disunified works, such as *The Waste Land*. And, in any case, the possession of the virtues can exhibit a kind of complexity, the virtuous

person being one in whom the virtues integrate properly and fit in with how she lives her life. (Indeed, it was Hutcheson, the believer in moral beauty, who also proposed that the basis for beauty is uniformity amidst variety.)[39] Beauty is a response-dependent notion, and its mark is that competent judges find something beautiful; we have seen no reason to deny that competent judges find the moral virtues beautiful.

In conclusion, having cast doubt on a Hume-type argument for the moral beauty view, I have instead employed an argument of the sort that Aristotle termed *dialectical*: that something appears to be so gives it some plausibility, and, if these appearances can withstand objections and counter-examples, if the *aporiai* (puzzles) to which they give rise can be solved, then we have reason to believe that things are as they seem to be. Thus I have argued that the idea of moral beauty has a good deal of intuitive plausibility, as witnessed by much linguistic usage, by common experience and by the idea's recurrent appeal in the history of philosophy. Thought-experiments, such as the kind but dull person, showed that this intuitive plausibility withstands apparent counter-examples, which can be shown to fail. And more systematic objections can also be answered: the view does not yield an implausible account of moral motivation, it is not undermined by the idea of aesthetic disinterest (even if that view were true), nor is the usage merely metaphorical, for we have seen that beauty is not necessarily a sensory property or essentially dependent on sensory properties. So we should conclude that the intuitive plausibility of the view is not undermined, and so we should accept it: the morally virtuous person does indeed have a kind of beauty of character, and the vicious person exhibits an ugly character.

6.3. MORAL BEAUTY AND WORKS OF ART

If a manifested author has a morally good character, it follows from the moral beauty view that he or she has, in this respect, a beautiful character. Since the manifested author is the author as he or she manifests herself in the work, it follows that the work has a beautiful aspect, in so far as the author has a beautiful character. The beautiful is undeniably an aesthetic value. So, in so far as the manifested author has a morally good character, the work has aesthetic merit in this respect; and *mutatis mutandis* for a morally bad manifested author, whose presence contributes an aesthetic flaw in this respect. And that shows that ethicism is true.

This argument can be challenged on both autonomist and contextualist grounds, even if one accepts the moral beauty view. One autonomist line of objection is that, though the manifested author has a beautiful character trait,

[39] Hutcheson, *An Inquiry into the Original of our Ideas of Beauty and Virtue*, p. 29.

this does not show that the work possesses a beauty. Consider a parallel with originality. A formalist could maintain that, whereas originality is a value, it is a value of the artist, not of the work: we admire an artist if he was the first to produce some significant aesthetic feature in his works, but his being the first to do this has nothing to do with the aesthetic merit of the work, since the latter concerns the work's intrinsic properties, not its relational features to other works.[40] Similarly, the autonomist may hold that beauty here is a feature of the artist, not of his work. We can reply that one cannot divorce the manifested artist from the work in this way: the manifested artist is the artist in so far as he manifests himself in his work. So his properties are *ipso facto* properties of the work. Moreover, unlike the case of originality, the properties here are not relational to other works, but are the characteristics manifested in that work; so, even on the relationality ground (which we should in any case dispute), one cannot rule out the manifested artist's qualities as irrelevant to the work.

A second autonomist objection relies on counter-examples, actual or imagined Imagine a work that is deadly dull, wooden in its characterisation, style and tone, yet in which the manifested author displays an extremely good moral character. On some views of the novel, *Uncle Tom's Cabin* is an example of such a work. Surely, this sort of work has no aesthetic merit whatsoever, and certainly does not possess any kind of beauty. So possession of a beautiful, because moral, character by an author does not entail that her work possesses any sort of aesthetic merit at all. Hence, despite my reply to the first objection, there is a gap between the aesthetic qualities of the author and those of the work.

In reply, since the ethicist claim is a *pro tanto* one, it follows on the moral beauty argument only that there is a beauty in the work; there may be other, far stronger aesthetic flaws in it that mean that the work is not overall an aesthetic success. Secondly, the case of the dull novel recalls the case of the dull but morally good person discussed in the previous section; and the response should be similar to the two cases. There is indeed a beauty to be discerned here, albeit one that may require careful scrutiny and attention to identify; and, as just noted, it may be, though present, outweighed by larger aesthetic defects that mean that the overall judgement is still of aesthetic failure.

A third autonomist objection holds that the notion of manifesting a character is insufficient to show that the work has some aesthetic feature; for manifesting is a matter of providing evidence of one's character through the work, yet there are ways of providing evidence that do not transmit the aesthetic quality of the artist to the work. For instance, an author might pen a list of morally improving aphorisms to the end of the novel, which stand in no natural relation to the rest of the novel; or a painter might place a label inviting sympathy towards its subject on a painting that in itself did not express any particular attitude towards the subject. In such cases, suitably filled out, we might be justified in ascribing

[40] This kind of line about originality is taken by Beardsley, *Aesthetics*, p. 460.

moral beauty to the artist, but not to the work, since the list and the label stand in too tangential a relation to the work to be aesthetically relevant to it.

What this objection shows is that we need to refine the moral beauty argument for ethicism. For we have already conceded in Section 4.3 that moral qualities in the kinds of cases just rehearsed may be aesthetically irrelevant to the work. Since the quality of beauty cannot be aesthetically irrelevant, it must be that more than mere manifesting of a characteristic is required for one to ascribe an aesthetic quality of the *artist* to the *work*. One option would be to adjust the notion of manifesting to meet this problem. It is better, though, to remind ourselves that ethicism holds that it is the *aesthetically relevant* ethical qualities of a work that are aesthetic merits or demerits in it. Thus the aesthetic relevance condition should also feature in the moral beauty argument for ethicism. And, in the light of the discussion of Section 4.3, I will hold that it is when the ethical qualities of the artist are manifested through the artistic means of expression that they are aesthetically relevant. This, as we saw, rules out cases like the list and label ones just considered. Once we have a case of aesthetic relevance (that is, when the manifested artist's qualities are aesthetically relevant to the work), the moral beauty argument shows that the artist's moral goodness is an aesthetic merit of the work. The moral beauty argument thus proceeds with the extra step that the artist must manifest his morally good attitudes in the work by deploying artistic means of expression.[41]

Contextualists will also object to the moral beauty argument. Sometimes a work of art can be beautiful, they may hold, *because of* its viciousness; it may be its cool, uncaring cruelty, or its ecstatic torrent of hate, that makes a work particularly beautiful. Consider Sam Peckinpah's classic Western *The Wild Bunch* (1969). The film was enormously important in establishing what is now one of the canonical styles for the representation of violence in film. Its culminating scene is the bloody massacre at Aqua Verde, where hundreds die, including most of the film's protagonists. By intercutting slow-motion shots with shots running at normal speed, by employing multiple cameras, by using elaborate intercutting to produce a complex, satisfying montage structure, by wiring up the actors with squibs to produce showers of blood that gracefully explode from them in slow motion, the film produces an astonishingly effective and at times searingly beautiful representation of what is in fact mindless, bloody carnage. And many of the film's initial audience, and not a few since, have understood this scene and the film more generally as a celebration of the cult of violence, as a rapturous

[41] Recall, though, that it is not essential to ethicism that the artistic means of expression criterion be adopted as the condition of aesthetic relevance. One could reject this criterion, and replace it with some other general criterion of relevance, which would be substituted in the argument above. Alternatively and more modestly, one could simply recognise aesthetic relevance on a case-by-case basis. Whilst the list and label cases are ones where ethical qualities are aesthetically irrelevant to the work, cases such as Rembrandt's *Bathsheba* are ones where they are relevant. As long as some of these latter cases exist, the moral beauty argument will apply to them.

ode to the machismo of the male killer. The film seems an apt and influential illustration of how beauty can subsist in cruelty and violence.

Let us suppose for a moment that those who have seen the film as a celebration of slaughter are correct. It would still not follow that the film is beautiful in so far as it evinces a cruel attitude. That would require us to hold that attitudes can be beautiful in so far as they are evil, and thus to reject the moral beauty claim that we defended in the previous section. Rather, what the film would show is that there can be beautiful *presentations* of evil, not that evil itself can be beautiful. But that one can present evil attitudes in a beautiful way should come as no surprise: it is simply the converse of the case of the kindly but ungainly actions discussed earlier. So we should distinguish between the ugliness of the cruelty expressed in the actions (in this case of film-making) and the beauty of other, particularly visual, features of the action, such as the intercutting of slow and normal motion, the beauty of the showers of blood cascading out (considered as colour and motion, and abstracting away from what it is that we are seeing). None of this shows that the scenes are beautiful because of the evil attitude expressed.[42]

However, as so often in aesthetics, the reality of the particular case is more complex than its use as a quick philosophical example would suggest. Peckinpah's expressed intention with respect to the film was in fact to show that violence can be both repulsive and yet fascinating, and thereby to warn his audience against it and its powers.[43] The motivation was particularly strong, given his opposition to the Vietnam War being waged at the time. He was disturbed to discover that much of his audience took him to be celebrating violence, rather than condemning it, and his later films, such as *Pat Garrett and Billy the Kid* (1973), eschewed the use of similarly elaborate film techniques lest his audience again misconstrue his view of violence. But one can see why many (though not all) of the audience understood the film to celebrate violence; for, by making such a beautiful representation of it, transforming reality by elaborately artistic means, the film was easily supposed to be manifesting an attitude of approval towards the carnage depicted. Since the viewer was being invited to take aesthetic pleasure in the representation of violence, an implied attitude of approval towards violence was not hard to assume. What this misunderstanding demonstrates is not the

[42] Richard Hare reports a story told of the Roman Emperor Heliogabalus that he had people slaughtered because he thought that red blood on green grass looked beautiful (Hare, *Freedom and Reason*, p. 161). Considered merely as a colour scheme (if one could abstract away from what it was one were seeing), someone might conceivably agree with the Emperor's aesthetic judgement. But, even if this were so, the scene would be beautiful because of the colours involved, not because of the evil that was manifest in the act. If one brought that into account, and relatedly the judgement that it was a scene of carnage that one was observing, even the judgement of beauty in respect of the colour scheme would be hard to sustain.

[43] See Stephen Prince, "Introduction: Sam Peckinpah, Savage Poet of American Cinema", especially pp. 25–32. Peckinpah's film is thus a not entirely successful example of the seduction strategy, which will be discussed in Ch. 8.

falsity of ethicism, but the power of art, and the truth of Plato's warning against its dangers; in different hands than Peckinpah's, his cinematic techniques could easily be employed to celebrate the mayhem that the director in fact sought to condemn.

A distinct contextualist objection would admit that a morally good attitude manifested in a work is beautiful, but hold that this does not support ethicism. For, while the work would gain aesthetically by virtue of its moral attitude, it could well suffer aesthetically by virtue of the other qualities that the morally good attitudes brought in its train. The life of a moral saint, according to Susan Wolf, does not constitute an unambiguously attractive personal ideal, for, given the overriding commitments to helping others that are involved in extreme goodness, the saint must inevitably abjure other perhaps interesting projects (such as becoming a gourmet cook), would be unable to appreciate certain kinds of cynical or sarcastic humour and (one might add) would generally be pretty dull.[44] Applying this view to the debate about art and ethics, one could hold that a moral saint would make a pretty terrible, uninteresting novelist. Given the general lack of development of his other interests, his book would be thin gruel and pretty humourless at best; yet the moral beauty of his attitudes would presumably be present in the work. Good morals can make bad works.

This point is an instance of the contextualist objection that we examined in Section 3.2, now applied to the moral beauty argument. And it suffers the same defect as does the general point: it confuses overall principles with *pro tanto* ones. Suppose that it were true that moral saints are dull and narrow in their interests; it would still be the case that their works had some aesthetic merit by virtue of the moral beauty of their characters, if they were manifested via artistic means of expression. It would on the Wolf hypothesis also be the case that the authors' extreme goodness undermined other aesthetically valuable properties in their works, such as a sense that the authors had wide and engaging interests. The case would be parallel to that of a work that, were it made more beautiful, would thereby lose other aesthetically valuable properties, such as raw expressive power (something that might happen, I suggested, if one tried to render *Les Demoiselles d'Avignon* or a counterpart work more beautiful). This possibility is allowed for by the structure of *pro tanto* principles, and it does not undermine the claim of beauty to be an aesthetic merit and to ground an aesthetic principle; nor does the moral saints case undermine the claim that moral beauty in works is an aesthetic merit. Even if moral beauty *always* undermined some other aesthetic merits, there would be no ground for claiming that the moral beauty is not intrinsically an aesthetic merit. For such a scenario would merely show that there is, as it were, a tragic conflict between aesthetic merits. The contextualist needs a case, not where moral ugliness can promote the possession of some other quality

[44] Susan Wolf, "Moral Saints". Nick Hornby develops a similar view in his engaging novel *How to be Good*.

that is an aesthetic merit, but where moral ugliness under certain conditions itself constitutes an aesthetic merit. The most plausible case for this stronger, constitutive claim is that of the amusing, where many have held that works can be funny by virtue of being vicious and cruel (hence by virtue of being morally ugly). Here moral ugliness displayed in humour is held to be an aesthetic merit, rather than merely to promote some distinct quality that is an aesthetic merit. I will argue against this constitutive claim about humour in Section 10.3. *Modulo* the outcome of that discussion, the contextualist objection fails.

Given the moral beauty view, and the failure of the autonomist and contextualist objections just considered, we should accept the moral beauty argument for ethicism. This yields an interesting result. McGinn, in his discussion of the moral beauty claim, points out that aestheticism, in the sense of the belief in the primacy of the pursuit of beauty in life, is self-contradictory if it pursues beauty at the expense of morality. For "The true aesthete must be a moralist, since he cares about the beauty of his soul."[45] A parallel point, we can add, can be made when we apply the moral beauty claim to art. Even if we consider only aesthetic values in the narrow sense, ignoring aesthetic values in the broader sense, it turns out that aesthetic values have a necessary connection to ethical values. Moral beauty is a kind of beauty. So even aestheticists, in the sense of those who hold that only beauty and its subspecies are artistic values, ought to be ethicists. And it is contradictory to hold that beauty matters in art, but that morality does not. Formalist philosophers who have sought to exclude moral values from artistic ones have failed to see that not all beauty is outward; there is inner beauty too.

[45] McGinn, *Ethics, Evil, and Fiction*, p. 139

7

The Cognitive Argument: The Epistemic Claim

Caravaggio's great painting *The Taking of Christ* (also known as *The Betrayal of Christ*, 1602, National Gallery of Ireland, Dublin; Figure 7.1) depicts the climactic moment in the Garden of Gethsemane when Judas embraces and betrays Christ. The embrace and the kiss, gestures of love, are transformed in Judas's actions into ones of betrayal. The scene was often depicted in Christian tradition before Caravaggio's time; but in his treatment there are a number of striking departures from conventional presentations.

The traditional depiction of the scene is well exemplified by Barna da Siena's much earlier *Betrayal* (1350s, Collegiate Church, San Gimignano), a fresco replete with narrative detail, including St Peter's cutting-off of the soldier's ear, a phalanx of brute-like soldiers advancing to engulf Christ, and a clutch of panicked disciples fleeing the scene. Judas is the embodiment of evil, his sharp visage and scimitar-like nose thrust against Christ's face, his eyebrows drawn down to emphasise his scowling hatred. Christ coolly returns his look, aloof but sternly judgemental in his divine security, his inviolability marked by a golden halo.

The Caravaggio painting is very different. Only seven figures are shown, none of them in full length, and the background details of the garden are hidden in the enveloping gloom, focusing our attention on the figures. They are pressed up against the picture-plane, which seems both to draw them into the viewer's space and to compress them one against the other. The saturated reds and oranges of the garments and the sheen of the soldiers' armour glow with a throbbing, almost hallucinatory intensity against the dark background. Christ and Judas are locked closely together, their faces almost touching, and they are united by the moonlight illuminating them from the upper left; this sense of unity is further enhanced by their faces being enclosed by a fleeing disciple's cloak billowing above them, and by Judas's arm gripping Christ. The expression on Christ's face is that of intense, deeply felt suffering; his fingers are nervously interleaved, as if in a gesture of prayer that has become compressed and flattened by the force of his grief. A fleeing disciple screams out in the background, his hair merging with that of Christ's: the contained terror that Christ feels seems to be expressed in the upwardly thrust hands and open mouth of the disciple, the two forming a Janus-head of grief and fear. Judas grips Christ to him, as much holding onto

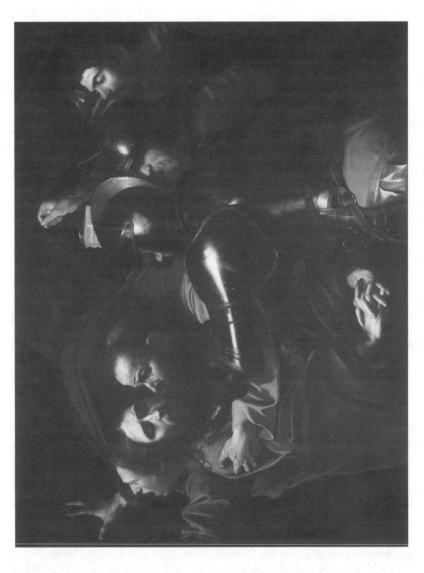

Figure 3. Caravaggio, *The Taking of Christ*. 1602, National Gallery of Ireland, Dublin. Oil on canvas.

him for support as securing him for identification; the betrayer's face is worried and worn, deep lines etched over pursed brow, and with a look that, far from being a gaze of hatred, is one that almost beseeches Christ for help.

Caravaggio in this painting eschews all interest in the traditional narrative clutter of the scene, focusing instead on the psychology of the protagonists; both Christ and Judas are represented as fully human and as particular individuals, the divine majesty of the one and the pure devilry of the other nowhere in evidence. And in their humanity they are caught in a relationship that was once clearly one of love, and that still bears those traces in Christ's anguish and Judas's conflicted gaze. This is a painting that dwells on the significance of betrayal. Betrayal requires a previous history, one that has involved obligations, and, in the case of personal betrayal, obligations of friendship or love. We are invited to see this history in the interrelation of the two central figures, to feel the force of the grief that their rupture produces. We are shown how even the betrayer bears some of the grief, for he too loved, and perhaps still loves, the person whom he betrays. There is here, then, an insight into the significance of the morally charged nature of betrayal and into the complexity of the psychology involved, an insight lacking in earlier works such as Barna's; and that insight, as conveyed by Caravaggio's dazzling pictorial mastery, is a central reason why this is such a great and moving painting.

There is one thing more. In the background, crowded out towards the upper right of the picture-plane, a man looks on, his eyes shadowed but intently observant, his mouth slightly opened in concentration. In his right hand he bears a lantern that is, besides the moon, the only source of illumination. The hand that holds the lantern's chain, its form modelled by the lantern's light, is delicately poised, the thumb touching the forefinger in a way that could as well serve to hold a pen, or a paintbrush. The face of the man is Caravaggio's own. Why, one wonders, has he placed himself in this way into the scene? Partly in homage to a long tradition of artists' self-depiction in biblical scenes; partly no doubt from bravura, a visual signing of himself into his own creation; partly too as a knowing gesture to the cognoscenti who would recognise him. But he has also done this, one suspects, as a kind of painterly manifesto, a statement that through those quietly observing eyes he can see the significance of what passes before him, through that carefully raised lamp he can illuminate the scene for the viewer, and through that hand poised as if gripping a paintbrush he can convey to the viewer what it is that he sees. So understood, this self-insertion into the depicted world is a claim that the painter can illuminate for us what we otherwise would not have seen so clearly and can capture his insight through his pictorial skill. Not only does the painting reveal the significance of the scene, but the artist self-consciously lays claim to the role of showing us something more clearly than we could have seen it on our own.

Caravaggio's painting exemplifies the way in which insight, psychological and moral, can be an artistic merit, when conveyed through pictorial means; and,

if the suggestion about the point of the pictorial self-insertion is correct, then the painting also claims that providing this kind of illumination is part of the painter's task. The picture thus both exemplifies and illustrates the doctrine of aesthetic cognitivism, a theory that grounds our second argument for ethicism.

7.1. FORMULATING AESTHETIC COGNITIVISM

There are different ways of formulating the claims of aesthetic cognitivism. The core claim is that the cognitive (or, equivalently, epistemic) merits of works of art are, under certain conditions, aesthetic merits in those works or condition their aesthetic merits. This claim can be refined in at least three different ways: these cash out the idea of a cognitive merit of a work in terms of the work's exhibiting an appropriate kind of understanding, or of its teaching the audience something, or of the audience's learning something from it. As we shall see, these are importantly different formulations; but let us cover all of them for the time being by the notion of a work's conveying or giving knowledge. Then a common argument-schema for arguing for moralism from cognitivism runs as follows. A work of art can convey knowledge; when a work does so, this is, under certain conditions, an aesthetic merit in the work; one kind of knowledge a work of art can convey is moral knowledge; so, when a work of art conveys moral knowledge, this is, under certain conditions, an aesthetic merit in the work. Arguments for moralism on these kinds of lines have been advanced by several aesthetic cognitivists, or at least their explicit claims imply that they would endorse arguments of roughly this sort.[1]

Evidently there are several variations possible on this basic argument-schema. One such concerns the kinds of knowledge that are relevant: are we dealing with propositional knowledge, practical knowledge (know-how), phenomenal knowledge or something else? Also there are variations on how general the premises should be: a stripped-down version of the argument would simply target the claim that art can convey moral knowledge, and then argue for the aesthetic relevance of this kind of knowledge when given by art. However, most writers who support something like the argument-schema favour the view that we can gain more kinds of knowledge from art than simply moral knowledge: these may include knowledge about other kinds of values, such as prudential ones, and knowledge about human psychology. Though my main focus will be

[1] For variations on the theme that art can convey moral knowledge and that this is an aesthetic merit in it, see R. W. Beardsmore, *Art and Morality*, especially ch. 5; Noël Carroll, "Art, Narrative, and Moral Understanding"; Gregory Currie, "The Moral Psychology of Fiction"; Kieran, "Art, Imagination, and the Cultivation of Morals"; David Novitz, *Knowledge, Fiction and Imagination*, esp. pp. 139–42; Nussbaum, *Love's Knowledge*; Sharpe, "Moral Tales". Various conceptions of what kind of knowledge is involved (including knowledge-how, phenomenal knowledge, knowledge about the application of principles, etc.) are in play in these discussions.

on the moral case, I will also defend this more general claim. This is partly because of its interest in its own right, but also because many of these kinds of knowledge-claims are intertwined: psychological explanations often appeal to moral facts or are couched in moral terms, as when we explain that someone is so spiteful because he was neglected as a child.

One should distinguish two parts to the cognitivist claim. The first holds that art can convey non-trivial knowledge; call this the *epistemic* claim. It is certainly controversial, and needs to be defended against several objections that have been advanced against it. But it, together with the claim that one kind of knowledge that art can convey is moral knowledge, would not on its own suffice to establish any kind of moralism. For it is possible to hold that the epistemic merits of art in general (that is, the capacity of artworks to convey knowledge), including moral epistemic merits, are aesthetically irrelevant. One source of support for this tenet comes from formalism; but, as we saw in Section 4.3, one need not be an adherent of this view to see that there is a gap to be filled here. For everyone should admit that epistemic properties are not always aesthetically relevant. The art of ancient civilisations is a major source of our knowledge about them. If ancient Egyptian, ancient Greek and Inca art had never survived, we would know far less about these civilisations than we do. This is not simply because their artworks record what happened in the past—indeed, very often the events they recount are mythical. It is largely because the works reveal much about the presuppositions and attitudes of those who produced or commissioned them. Yet it would be fallacious to claim that something is an excellent work of art because it is very important as historical evidence. And one can easily imagine execrable works of art that are richly informative about the presuppositions and lives of their makers. So works can have epistemic properties that are aesthetically irrelevant. And, once the point is seen, one can easily find other examples from more recent eras. For instance, seventeenth-century paintings of sailing ships by Dutch artists such as Simon Vlieger are so richly detailed that one can reconstruct the rigging of the ships, and so the paintings are invaluable sources of information for the naval historian; but they are not good works of art simply by virtue of their historical value. Likewise, photographs of nineteenth-century life are historically valuable for what they record, but they do not thereby possess aesthetic merit.

So aesthetic cognitivism, if it is to be employed to establish some version of moralism, must claim that the capacity of art to give knowledge is at least in some cases aesthetically relevant—and in particular is an aesthetic merit. Call this second claim the *aesthetic claim*. Aesthetic cognitivists seem invariably to endorse this second claim; and this is unsurprising, since the thesis is put forward as one in aesthetics, rather than simply as a claim in epistemology. Yet often the aesthetic claim is only implicit in what cognitivists say, rather than being something that they have clearly identified as a separate point that must be established. And that means that it has been surprisingly little argued for in explicit terms, which is unfortunate, since establishing it is not a trivial matter.

The need to establish the second, aesthetic, claim of cognitivism also highlights that one has to establish, in any cognitivist argument for ethicism, not just that moral knowledge is one kind of knowledge that art can convey, but also that the moral knowledge so conveyed is at least sometimes aesthetically relevant.

We also need to refine the argument-schema in respect of the placeholder notion of conveying or giving knowledge, which we have employed up to this point. The epistemic claim can be captured, as we noted, in terms of the understanding manifested in works, or in terms of works teaching us things, or in terms of our learning things from works. These are importantly different claims, though most discussions of cognitivism run them together.

The first, minimal, version of cognitivism is cast in terms of the understanding manifested in a work. Given the argument of Section 4.1, we may speak equivalently of the understanding manifested by the artist in the work, and, since 'attitude' should be understood here to include both cognitive and broadly affective states, the understanding shown is an aspect of the attitude manifested by the artist in the work. 'Understanding' covers the wide variety of kinds of knowledge that we distinguished earlier, and includes knowledge about morality, values in general, psychological claims and so forth. Ethicism is the doctrine that a work of art is aesthetically meritorious in so far as it has an aesthetically relevant ethical merit (and conversely for aesthetic flaws and ethical demerit). In respect of moral understanding, the view would hold that an artwork is aesthetically good in so far as it manifests aesthetically relevant moral understanding (and conversely for aesthetic badness and moral misunderstanding or failures to understand). A defence of cognitivism would then show that works can exhibit this kind of understanding, and that under certain conditions it is aesthetically relevant. Moral understanding consists not just in knowing propositions, but in possessing certain skills, such as empathy, and in knowing how to feel; it thus exhibits the wide variety of kinds of knowledge to which we have called attention; and the cognitivist defence of ethicism would show that these kinds of knowledge can be exhibited by works.

The second, stronger, version of cognitivism holds that works of art can teach us certain things (or equivalently that manifested artists can teach us certain things through their works). One can teach someone something only if one understands that thing, so this version entails the first, minimal version. Additionally, to teach someone something one must communicate that knowledge, so there is a communicative dimension to the claim; and also there must be a cognitive gain in the audience—that is, the audience must learn something. Without such a gain, someone merely tells one what one already knows, rather than teaching one that thing ('you can't teach me anything' is true if everything you know, I know already). So on this version of aesthetic cognitivism applied to ethicism, ethicism would hold that an artwork is aesthetically good in so far as it morally teaches in an aesthetically relevant way. Aesthetic cognitivism is often defended in this stronger version, and I will also defend it here (and thereby also the

minimal claim), in respect of both moral and other kinds of knowledge. The terminology of 'teaching' should not, however, be taken to suggest that there is a classroom quality to one's relations with art: the claim is sometimes put in terms of works 'showing' us certain things, and this perhaps better captures the looser feel of one's encounters with art. Also, in our discussion in Section 5.2 of Jauss's remarks about *Madame Bovary*, we noted that successful teaching is often in part a matter of active stimulation to critical reflection, of getting someone to explore the answers to pertinently posed questions, thinking through issues in her own terms. This is especially important in the case of moral teaching, since a fully adequate moral point of view is the product of critical reflection, not of simply accepting moral norms as given. And this notion of reflective teaching is quite consistent with the teacher having her preferred view of the matter, which she is aiming to get her audience to embrace through exploration of the issues that she raises. Finally, in talking of teaching us—that is, the audience—aesthetic cognitivism should be understood as referring to a normatively specified audience, rather than referring to whatever audience happens to come across a work. The audience is normatively specified in the sense that it is an audience that can interpret the work *correctly*—that is, grasp the communicative aims of the work. An audience that interprets a work incorrectly is in no position to be taught anything by it.

This second version of cognitivism is one to which appeal is often made: when we talk of learning something from art, this takes us beyond the minimal version, holding that we are not already familiar with the moral or psychological understanding exhibited in a work. And talk of profundity or insight in works also suggests that the work exhibits an understanding of matters deeper than that which we are likely to command. Discussion of this stronger version also has the heuristic merit that it focuses attention on the issue of how we are in a position to establish whether a work exhibits an understanding, as opposed to a misunderstanding or failure of understanding, of some issue. To do so, one must be able to decide whether the work is manifesting genuine knowledge, or merely the appearance of such; and to accomplish this, one must be in a position to confirm whether the work's claims are true or not. Thus this formulation focuses attention on the issue of how we can confirm the work's claims. (The first formulation does not make this issue so pressing, since one may already be in possession of the knowledge that the work exhibits, whereas, if one is taught something by the work, one does not already possess the relevant knowledge.)

The third common formulation of cognitivism is simply in terms of whether or not we learn something from art. This is importantly different from the first two formulations. The fact that one can learn from something does not entail that it has taught one that thing, or even that it understands that thing. A geologist may learn a great deal about the geological history of an area from a stone found in it, but it would be absurd to say that the stone taught him about

the area, or that the stone understood the history of the area. The fact that one learns from something is an instrumental notion, and does not therefore entail anything about the understanding, or communicative intentions, of that from which one learns. This is true even when one learns from a person who could in principle know about that thing. Consider an incompetent do-it-yourself enthusiast, whom I watch trying to fix his plumbing; after prolonged efforts, disaster ensues, and the house is flooded. It might well be true that I learned a lot from watching him—primarily not to try to fix my plumbing if I do not know what I am doing, and even specifically about not to use the particular techniques and tools that he employed. But, while I learned much from him, it would be false to say that he taught me anything, for he did not understand at all what he was doing, and so was in no position to communicate this knowledge to me. Indeed, this is a case where I learn something from someone *precisely because* he does not understand what he is doing and therefore cannot teach me about it. So the learning formulation of cognitivism does not entail either of the first two claims. Moreover, the purely learning formulation is not one that aesthetic cognitivism should adopt, since, as we have just seen, there is not necessarily a cognitive or epistemic merit in the object or person from which one is learning. This point is easily obscured, since normally, when cognitivists invoke the claim that one can learn from a work, they hold that the work manifests that understanding as well, so that the claim, when it is specified more carefully, is properly cast in terms of the second, teaching, formulation. But, if the work does not manifest this understanding, then whatever one may learn from a work is a purely instrumental value, like the value of looking at the stone or watching the incompetent do-it-yourself enthusiast, and not something that evinces any cognitive merit in the work. Yet it is the claim that the cognitive merits of a work can be aesthetically relevant that is the core of the aesthetic cognitivist view. So, when we defend cognitivism here by employing the notion of learning from art, the implicit restriction will always be that it is the kind of learning that is correlative with the understanding manifest in the artwork and with its capacity to teach its audience. (The significance of this point will become apparent in Section 8.2 when we consider some criticisms of ethicist cognitivism.)

The present chapter defends the epistemic claim of cognitivism, formulated in terms of artworks' capacity to teach us, and therefore to exhibit a kind of understanding about certain matters, including psychology and values. The argument proceeds by first investigating the sources of knowledge, and showing how art can teach us through experience, testimony and especially through the exercise of the imagination. The next section shows how one can learn from imagination, and the final section argues that ethical knowledge too can be gained through imagination, as illustrated by examples drawn from ordinary discourse, philosophical reflection and by William Styron's novel *Sophie's Choice*. The aesthetic claim of cognitivism is argued for in the next chapter.

7.2. SOURCES OF KNOWLEDGE

The cognitivist holds that art can teach us various things; that is, it can communicate knowledge (understanding) about these matters. Knowledge, as we have noted, comes in various varieties, including propositional, phenomenal and practical knowledge. Propositional knowledge at least requires beliefs, that these beliefs be true, and some third condition, traditionally that of justification, or, in the light of Gettier's challenge, some other condition. We will refer to this third condition, however formulated, as the 'confirmation condition'. Some, though not all, aesthetic non-cognitivists deny the possibility of art's satisfying the epistemic requirement of cognitivism. They may do this by pressing the point that art does not convey beliefs about the world.[2] But this line of attack is not promising, for there are many artworks that are not fictional, and even fictional artworks are replete with (usually implicit) claims about the real world, such as *Emma*'s implied claim that rich, spoilt and pretty young ladies are often not the best judges of their own and others' motivations. More promising for the non-cognitivist is the denial of the possibility of satisfying the confirmation condition, a point pressed by Jerome Stolnitz. He notes that, even if Dickens's *Bleak House* is correct on the subject of the slowness of estate litigation in nineteenth-century England, one would not be justified in believing this about the period simply on the basis of reading the fictional account.[3]

In reply, note that there is here a conflation, surprisingly common in non-cognitivism, between artworks and works of fiction. The two categories are distinct, not just because there are fictions that are not artworks, but more saliently because plenty of artworks are not fictions. There are documentary films; much poetry recalls personal experience rather than being fictional; many paintings are portraits or landscapes, which purport to represent features of the real world; and even many works of literature are non-fictional, such as the essays of Addison or Plato's dialogues. Any confirmation that can be provided by non-fictional works in general will also be provided by non-fictional artworks. So the confirmation problem is confined to fictions, rather than arising for artworks in general, and it is on fictions that I will now chiefly concentrate.

Recall the distinction between the minimal, understanding, version of cognitivism, and the richer, teaching, conception of cognitivism. The former does not require one to learn from the artwork; if the work exhibits merely an understanding that one already possesses, the confirmation of what it conveys is something that we already possess, based on our prior knowledge. Suppose that Caravaggio had painted *The Taking of Christ* (or, to put the point more carefully,

[2] T. J. Diffey, "What Can We Learn from Art?", p. 30, for instance, holds that art is not by its nature fact-stating, reference to the real world being suspended.

[3] Jerome Stolnitz, "On the Cognitive Triviality of Art", p. 196.

a counterpart work), such that at the climactic moment of his betrayal Christ wore an expression of mild annoyance, as if suffering from a slight attack of dyspepsia, and Judas an expression of considerable boredom. We would justifiably feel (if the work were not meant as a spoof) that the artist had got the psychology of betrayal badly wrong, that he did not understand the first thing about what was going on. Our justification for this would not be anything we still had to find out about the world, but simply our knowledge of what betrayal involves. So the confirmation problem need not arise at all for the minimal version of cognitivism.

What, though, of the stronger version, cast in terms of teaching? Here it is useful to think of the confirmation question in terms of the sources of knowledge. Robert Audi distinguishes at least five such sources in general: perception, memory, consciousness (introspection), reason and testimony.[4] The first three may be grouped together as kinds of experience, thus leaving three basic groups. Of these, reasoning plays little explicit role in most artworks—exceptions being those works of literature that are also works of philosophy, such as Plato's dialogues, or in those works of literature, such as Thomas Mann's *The Magic Mountain*, that have philosophical aspirations. In the case of most works, audiences 'draw their own conclusions', as we say, and the reasoning going on lies in the audience's response to the work, in the "afterlife" of the work, as Peter Kivy has nicely termed it, rather than being explicitly represented in the work.[5] But even here this reasoning, if it is not merely using the work as an occasion for thought but is genuinely a reflection *on* the work, is guided by the work through its presentation and choice of narrative events. So, though there are rarely explicit representations of reasoning in artworks, there is often an implied train of thought that the audience is invited to adopt. This implied reasoning can be important, as we shall see, in moral matters, through its deployment and guidance of readers' imaginations.

In respect of experience, no representational work, whether it be an artwork or not, provides one with direct experience of what it represents, simply because a representation is a representation, and not an experience. Even straightforwardly factual works, such as encyclopaedias and road maps, do not teach by experience. But prior experience of the roads being as the map shows them may confirm the map's accuracy, as can later experience, when one successfully navigates by using the map. In the same way, no artwork teaches by experience of what it represents—though in addition, if the artwork is fictional, one cannot experience the fictional world in the sense of perceive it, since it does not exist. But one can confirm the implicit psychological or moral tenets advanced even by fictional artworks in the light of one's earlier experience, and also by one's later experience, successfully applying them to the world. So these claims, like the

[4] Robert Audi, *Epistemology*, especially pt one.
[5] Peter Kivy, "The Laboratory of Fictional Truth", p. 131.

claims of non-fiction, can be tested out in light of one's experience. If literature is a map of the human heart, one must navigate by that map to see if it is accurate.

There is a way, however, in which all representations can teach by experience, for one must evidently experience the representation in order to interact with it, and this experience can itself convey concepts, skills and habits of discrimination. Consider maps again: by highlighting certain features of the landscape through conventionalised representations and the omission of other features, maps enable one to navigate through it better, and see interrelations between its features that one might otherwise have missed. Likewise, a painting highlights certain features of the world and omits others, and so can teach one how to look, to notice certain features of scenes and their interrelations that one might otherwise have missed. As Nelson Goodman has noted, "What a Manet or Monet or Cézanne does to our subsequent seeing of the world is as pertinent to their appraisal as is any direct confrontation [with the work]."[6] In similar fashion, in creating characters, a novelist also groups together a set of qualities, and, if a character has depth and plausibility, as do Emma Woodhouse and Emma Bovary, then one can learn to see real people in terms of the characters, and so discover more about the former. In this respect, one can regard the creation of a rich and interesting character as the making of a new concept that can fruitfully be applied to the world. Here it is one's experience of the representation that matters, since it groups together the characteristics that constitute the character. Finally, one's experience of an artwork also generally has an affective dimension; perhaps one is moved by the beauty or power of its working, so one may come to experience feelings one otherwise might not have felt. (This point is distinct from one's affective reactions towards imagined states of affairs, which we will examine later.) So fictions do not suffer a disadvantage in respect of teaching by experience that non-fictional works somehow avoid.

One would expect testimony to be a major source of knowledge from representational works in general, including artworks. Philosophers have increasingly recognised that knowledge through testimony cannot be reduced to another category, such as knowledge from experience. Any attempt to ground a general principle concerning the reliability of testimony entirely on other sources of knowledge, such as experience, fails, since, given the pervasiveness of testimony, testimonial evidence would appear among the grounds adduced in support of the general principle. This is particularly evident in the case of our knowledge of history, which rests overwhelmingly on testimonial evidence.[7] So there is good reason to believe that there is a presumptive, though defeasible, warrant for an item of testimony to count as a source of knowledge. Are there any conditions that defeat this presumption in the case of fiction? Defeating conditions in general include the testifier's not being sincere, perhaps wanting to deceive his

[6] Goodman, *Languages of Art*, p. 260.
[7] See C. A. J. Coady, *Testimony*, for the classic treatment of the issue.

or her audience; and the testifier's being in no position to know about the claims she is making. Neither of these conditions necessarily applies in the case of fiction. In writing about what is fictionally so, the writer is not attempting to deceive her audience, but rather getting it to imagine that something is the case. In advancing claims that are meant to be true also of the real world, the fiction-writer can be perfectly sincere. And she may well be in a position to know about such matters—writers are in at least as good a position as the rest of us to reflect on character and value, for instance, and they can and do convey those reflections through the medium of fiction. Indeed, that they have these insights can be confirmed from their works. Given one's own understanding of psychology and morality, say, one may believe that a writer is accurate in the way she presents these matters; in the light of this, one has some reason to believe that observations about these matters that one finds surprising in the writer's work may be true. One comes to think the writer trustworthy in these respects, gives credence to her views, and so treats views new to one as potential insights. There is thus a reciprocal relation between one's prior knowledge of the world and knowledge gained through the artwork in such cases.[8]

One source of disanalogy in respect of testimony involves what we can call an *institutional guarantee*. Non-fiction works are very often refereed, their claims being checked by the author's peers, or by professional fact-checkers. The same is not true of fictional works. So, if one consults a refereed non-fiction work, one knows that it is a reliable source of testimony; but that is never true of fiction. Now there is undoubtedly a difference here, and it explains why readers of fiction are more often thrown back onto their own epistemic resources in judging a text's implicit claims. But it is a difference of degree in the robustness of the testimony, rather than a qualitative difference. For one cannot tell simply by looking at the non-fiction work whether the vetting has really occurred (even if it is stated in the text that it has been), nor that it has been done properly. There are outright frauds and also honest mistakes in non-fiction works. To establish whether the vetting has been done properly, one must research the work's generative conditions, and that involves appealing to other evidence, including experience and the testimony of those who claim to have done the vetting. So the institutional guarantee is not an absolute one, and is subject to further testing for defeating conditions.

So far we have seen that, even for works of fiction, though there are some differences between the epistemic grounds provided by fiction and non-fiction

[8] Fictional works can also provide more specific kinds of testimony. These include works in realist genres, such as Zola's naturalistic works, which have a commitment to reporting how things are; and works may make general declarations or cite specific non-fictional evidence in their prefaces or even in their text. John Le Carré's novel *The Constant Gardener*, which has the form of a thriller, is in part an attack on the operations of international pharmaceutical companies. It includes extracts from non-fictional articles, cites various statistics in the main body of the novel; and in the Author's Note at the end Le Carré avers that "I can tell you this. As my journey through the pharmaceutical jungle progressed, I came to realise that, by comparison with the reality, my story was as tame as a holiday postcard" (p. 568).

works, none of them suffices to undermine the epistemic claim of aesthetic cognitivism. My main point in support of the epistemic condition, however, is that the traditional list of the sources of knowledge saliently misses out an important one: the imagination.

Imagination has a particular importance in the way that art can teach us, for art guides our imaginings. One can learn about certain features of the world by deploying one's imagination. Consider some examples: I can correctly determine that I ought to become a philosopher, not a medical doctor, by imagining both careers, and seeing how I imaginatively fare in them; I can learn something about how courageous I am by imagining myself being tortured and contemplating how I react; I can learn what it is like to be a bereaved woman whose husband has died after sixty years of marriage by imagining myself in her position; I can meditate on whether there ought to be free universal healthcare by imagining myself to be poor and ill in a society without such a system, and seeing whether I can endorse what would happen to me. Knowledge about what one should choose, self-knowledge, knowledge about others and knowledge about what is morally right are all, it seems, achievable by imagination.[9]

If this is so, then it is no surprise that literature can aid in our imaginative pursuit of knowledge: novels can describe the lives of philosophers and doctors, scenes of torture, the loneliness of the bereaved and the plight of the poor and ill. Some people are better at imagining than are others: they can imagine more vividly, comprehensively and accurately than others can. Perhaps I just cannot make sense of the extremity of the widow's grieving behaviour: you are able to imagine what she is going through, and to get me to see why she is reacting as she is. I wonder what would happen if a local politician were found out to be corrupt; you are able to lay out the resulting scenario in richly plausible detail. My imaginings tend to be self-serving and focused on my own glory; your imaginings more accurately reflect how things would really turn out. Given the natural variability in human imaginative capacities, we can benefit from being guided in our imaginings by those with greater imaginative talents than we possess. Some of these people become artists, and artworks, particularly representational artworks, give them a platform from which to guide others' imaginings. Indeed, just as economies are grounded on the division of labour and so become more productive, so we can think of art in general and literature in particular as grounded on the division of imaginative labour, which fosters better imaginings. Fictions also have a collaborative aspect that further enhances their value as aids to imagination. Readers can go beyond what is explicitly stated by the work and use it as a ladder from which to reach greater imaginative heights. Shakespeare could not possibly have explicitly envisaged all the interpretations of his plays,

[9] Imagination is, of course, fallible and so its warrant is defeasible. But it can be disciplined in various ways, and knowledge does not in any case require indefeasibility. These points will be discussed in Sect. 7.3.

given the multiplicity of these interpretations and the fact that some draw on psychological theories unknown to him. Yet some of these interpretations are legitimately grounded on the texts; in these cases there is a genuine collaboration between author and reader, who, guided by the author's imaginings, extends them beyond what the author had explicitly considered.

So we can learn about aspects of the world by imagination, and literature aids these imaginings; literature, amongst other things, is a guide to learning from imagination.[10] This learning process is one from which not just readers but also novelists may benefit. Novelists sometimes remark that their characters have taken on lives of their own; when they do so, they can be surprised by what they find themselves imagining, and can learn from it. Tolstoy reportedly started *Anna Karenina* quite hostile to Anna, intending the novel as a meditation on the folly of 'loose love': but evidently it turned into a more complex and sympathetic account of its heroine than these initial narrowly moralistic impulses would have led one to expect. Tolstoy could come to learn something about the values of love and sympathy from his own novel.

It is in part in learning about human psychology, our own and others, that we can learn from imagining; it is no coincidence then that so many have thought that literature can teach us much about human nature. The fact that it is within the psychological domain that one can learn from imagination is supported when one considers those many cases where one cannot learn about the world by imagination. What is the date of the Battle of Trafalgar? Could I learn this by imagining the naval battle as happening in different years—say, 1770, 1805 or 1832—and then noting which date seems right to me? That would be absurd. But it would not be absurd to try to figure out why Nelson took some of the reckless risks he did in his later life by imagining being in his situation, with its great public expectations and crushing political pressures, and then seeing how one would imaginatively act and react in that situation.

This view fits smoothly with one influential conception of literature, as the exploration of kinds of possibilities. Aristotle, the first aesthetic cognitivist known to us, talks in the *Poetics* of possibility when he describes the goal of the poet: "the poet's function is to describe, not the thing that has happened, but a kind of thing that might happen, i.e. what is possible as being probable or necessary."[11] And reporting his own literary practice, Milan Kundera makes a similar point more eloquently:

characters are not born like people, of woman; they are born of a situation, a sentence, a metaphor containing in a nutshell a basic human possibility that the author thinks no one else has discovered or said something essential about. ... The characters in my novels are

[10] See Gregory Currie, "The Moral Psychology of Fiction" and "Realism of Character and the Value of Fiction", for a similar view; Currie's arguments are grounded, unlike mine, on appeal to simulation theory.

[11] Aristotle, *Poetics*, 1451[a]37–9.

my own unrealized possibilities. That is why I am equally fond of them all and equally horrified by them. Each one has crossed a border that I myself have circumvented. It is that crossed border (the border beyond which my own "I" ends) which attracts me most. For beyond that border begins the secret the novel asks about. The novel is not the author's confession; it is an investigation of human life in the trap the world has become.[12]

Kundera's explicitly cognitivist conception of his literary task is striking, and, with its stress on the exploration of possibilities, it fits neatly with the idea that the imagination, which is peculiarly suited to explore possibilities, is a cognitive faculty centrally employed in the literary endeavour.

7.3. HOW TO LEARN FROM IMAGINATION

So far I have argued that fictional artworks can function as sources of knowledge, since they can make (usually implicit) true claims, and these claims can be confirmed through reasoning, experience, testimony and, especially, the use of the imagination. But the role of the imagination in learning is a controversial one, so I will now develop an account of how this is possible and defend the claim against objections.

The most direct objection is that one cannot learn about the world from imagination, for imagination can teach one only about what is possible, not about the world. One way philosophers traditionally employ imagination is to establish possibility: as David Lewis notes, one might try to establish whether there could be such a thing as a dignified tramp by trying to imagine one.[13] How imagination can fulfil this role is controversial: but it is hard to deny that it does. Philosophers also deploy imagination in order to establish the correct analysis of concepts. The literature about personal identity is full of invitations to imagine what would happen if, say, one person had all the memories, desires and character traits of a deceased individual: would they be the same person? But, the objection insists, the investigation of possibility is one thing, learning about the world quite another. The objects of investigation in the two cases are quite distinct.

This objection presupposes an over-simple distinction between the world and mere possibilities (counterfactual states of affairs). Statements about features of the world, such as psychological states and what is valuable, often entail or otherwise ground statements about counterfactuals. Consider dispositional psychological states: for instance, if I were truly courageous, it follows that I would withstand certain sorts of hardship (such as torture), and this claim concerns counterfactuals; and I may never have been subject to such hardships.

[12] Milan Kundera, *The Unbearable Lightness of Being*, p. 221.
[13] David Lewis, "Truth in Fiction".

For this reason, it is relevant to determining whether I am courageous to establish what I would do under these merely possible circumstances. Likewise, choices concern whether to actualise counterfactual states of affairs: saying that it would be best for me to be a doctor makes a claim about a counterfactual situation, and how I respond to this imagined situation is relevant in determining its value for me. Consider now moral judgements. Owing to their universalisability, any such judgement commits me to a claim about what ought to be done in all those counterfactual situations that possess the same universal properties referred to in the judgement. So, if I hold that sickness is not a sufficient ground for a right to free healthcare, I must also hold that, were I sick, I would have no right to free healthcare, even were I too poor to afford it.[14] (We will explore this point in more detail later.) And, finally, in considering how others, such as a bereaved woman, react to adversity, it follows, given a suitably fine-grained description of psychological character, that anyone with that character would react similarly. So it is relevant to imagine how I, had I that character, would react. Statements about the world involve or imply claims about counterfactual conditions, whose features can be explored through imagination. Hence one can learn about aspects of the world through imagination.

There is a second objection to the cognitive role of the imagination. This holds that imagination can never deliver knowledge, because imagination is not subject to any constraints (other than at most concerning what is logically or conceptually possible).[15] But, if I can imagine anything, I cannot learn from imagination; for learning requires some independent testing of one's hypotheses, paradigmatically achieved by experience of the world or testimony. And this absence of constraints also applies to cases where one's imaginings are guided by something outside oneself, rather than being spontaneously generated. Literature can be a matter of pure fantasy, of imagining things for the sake of pure pleasure, however wildly implausible those imaginings might be. Ian Fleming's James Bond novels are not noted, after all, for their robust realism. Since literature, like imagination, can engage in this freewheeling mode, serving no more than fantasy, how can either be a source of knowledge?

7.3.1. Simulation Theory

In seeking an answer to this objection, a promising place to begin is with simulation theory, the most influential account of how one can learn from

[14] See Carroll, "The Wheel of Virtue", for a similar point about literature's capacity to teach us about morality; however, such knowledge is not merely, as Carroll seems to hold, conceptual: if I learn something from the healthcare thought-experiment, it is not about the concept of a right, but something substantive about what rights we have.

[15] One can even challenge the claim that imagination is subject to the constraint of what is logically possible. For instance, one can imagine events that are arguably not logically possible, such as time travel (involving cases where one kills one's ancestors or earlier self), and in fairy tales and myths, plants or non-living beings exhibiting human personalities.

imagination.[16] The theory started in the philosophy of mind as an account of how we understand others' mental states, but it has also been applied to our capacity to engage in planning. The core idea is that we know what other people are thinking and feeling by imagining ourselves in their situation (for instance, being faced by a wild lion), and then discovering what we would think and feel in that situation; we then attribute these states, with suitable adjustments, to them. The theory holds that imagination as simulatiòn operates by running mental states 'off-line'—that is, disconnected from their usual perceptual inputs and behavioural outputs. According to one way of understanding the notion of 'off-line', in simulating another person's state of mind, I substitute for her beliefs my own make-beliefs with the same content, and for her desires, my own pretend desires. I then run these make-beliefs and pretend desires, allowing them to produce further make-beliefs, pretend desires and affective states, which tell me about the mental states of the person whom I am simulating. The use of imagination as simulation contrasts with the 'theory theory' account of understanding others, which holds that knowledge of others' minds is a matter of theoretical knowledge. On this view one has (usually implicit) mastery of folk-theoretic generalisations that are applied to the situation of the person one is attempting to understand, and then one infers that she has those mental states that best explain the behavioural evidence.

Simulation theory holds, then, that it is the off-line running of my mental states, which I achieve by imagining myself in another person's situation, that yields knowledge of the other person's mental states. I disconnect via simulation my mental states from their normal input and output conditions and by so doing I can run off-line the very same types of state that my target is running on-line. The account thus relies on a basic similarity between human psychologies: we are sufficiently alike that I can reliably simulate your mental states knowing what situation you are in. My mental states can model yours. The theory also provides an account of how we can learn about values: someone can simulate the position of the poor and unhealthy patient under a policy of removing state-funded healthcare, and so be in a position to decide whether he really can support this policy; and I can simulate my future possible state of being a doctor or a philosopher, and so on.

Though simulation theory gives an important part of the answer as to how one can learn from imagination—one exploits basic psychological similarities between oneself and others (or one's future self)—the account, at least in its basic version, oversimplifies how the process of imagining works.

[16] Martin Davies and Tony Stone (eds), *Folk Psychology*, collects some of the most important early papers on the theory. Simulation theory has since widened to embrace a variety of approaches; the version discussed in the text, with use of notions such as make-belief and pretend desires, draws on that of Gregory Currie, the leading defender of the account within aesthetics, as stated in his "The Moral Psychology of Fiction" and "Realism of Character and the Value of Fiction". For a more recent and nuanced development of his views, which acknowledges the relations of simulation to theory, see Gregory Currie and Ian Ravenscroft, *Recreative Minds*, ch. 3.

First, the contrast it draws between simulation and theoretical knowledge is too stark. Besides having basic psychological similarities, people also evidently differ in their psychology. So merely simulating, say, the situation of Isobel, a grieving elderly woman who has recently lost her husband, will not help me to understand how she is reacting unless I can adjust for differences between her psychology and mine. Perhaps I am much more optimistic and resourceful than she is, and, finding myself in her situation, I would react quite differently. Simulation theory, of course, acknowledges these psychological differences: hence I must also try to simulate those beliefs and desires that she has that differ from those that I have, so that I can more accurately model her reactions. But this raises the question of how I do this. I cannot simply determine what I would feel if I were in her situation, since *ex hypothesi* there are significant differences between how she is reacting and how I would react. So I need to know what are the relevant differences between her psychology and mine. But then I need access to at least some of her psychological states, independently of my ability to simulate her situation. And that shows that simulation cannot be the only means by which we understand others. At a minimum, I must draw on observational evidence, observing what mental states someone is in: sometimes I can just *see* that someone is in despair from the way in which she looks and acts. And, in building up my sense of what Isobel is undergoing, I can also draw on generalisations, some of which are folk-psychological: for instance, that older people tend to be more risk-averse and less confident about the future than are younger people; that women of Isobel's generation tend to have their sense of their own identity and worth more bound up with that of their husbands than younger women do, and so on. So simulation needs to be supplemented by wider sources of evidence if it is to establish how someone is reacting; and that means that simulation theory is over-simple in opposing itself to theory theory—and indeed to observational accounts of how we know about others. Imagination needs to draw on observational evidence of mental states and generalisations about such states in order to be a good guide to understanding others. This, however, is not to say that imagination cannot go reliably beyond these observations and generalisations, for it can exploit the underlying similarities between different people, which are there, despite their manifold differences.

A second way in which simulation theory is over-simple concerns the idea of running states 'off-line'. This metaphor suggests that the process is straightforward: our mental processes can be disconnected from their normal inputs and outputs, and they will then proceed in the same way as they would have done were they connected up to them. Thus we know that they will reliably model those of a subject whose mental processes are connected up to those inputs and outputs. But even the metaphor suggests a problem with the account. One can run a motor 'off-line'—rather than drive the wheels, a car motor can be disconnected from the gearbox and one can accelerate it up, observing its behaviour, as a mechanic might do in trying to spot a problem with the engine.

But its behaviour 'off-line' does not accurately corresponds to its behaviour when under load: accelerate it enough, and it will burn itself out, destroying itself in the process, but, at equivalent power rates under load, it would operate quite satisfactorily.

The same kind of problem arises with imagination. Our imaginations can operate in ways different from the ways the corresponding beliefs and desires would work. It is easy to fantasise that I would be nobler, more heroic, kinder or more perceptive in a given situation than I would be in reality. Maybe I hate my boss, and enjoy fantasising about how, when he is particularly obnoxious to me again, I will confront him with the facts about how insensitive and boorish he is, crushing him verbally, so that he abjectly begs for my forgiveness. In reality, the next time he slights me, I will yet again hold my tongue, and acquiesce in my habitual humiliation. States running 'off-line' can operate very differently from how they operate 'on-line'. The metaphor works to conceal this point: yet it is a traditional warning of the moralists of the imagination, such as Roger Scruton, that fantasy involves a rejection of reality, rather than a coming to grips with it, and can further distance the fantasist from any hope of seeing his situation as it is.[17] And a similar admonition about the dangers of fantasy has been a recurrent theme in literature, from *Emma* to *Billy Liar*.

7.3.2. The Disciplines of Imagination

Simulation theory points to an important fact about how we can learn from imagination, in stressing the similarities between the psychology of different people at a deep level; and it has much intuitive support: the idea of coming to understand someone by 'putting yourself in their shoes' is a common and powerful one; and it is closely related to the idea of understanding as involving *verstehen*, understanding from the inside, to be found in the writings of Max Weber, and, in a less developed version, in the works of Giambattista Vico. But, as noted, it hides the complexity of the process of imaginative understanding and occludes the dangers of misfiring in one's imaginings. How would a better theory of the cognitive role of imagination handle these difficulties?

Imagination, in a *minimal* sense, is I propose the power of entertaining a thought-content—a proposition or a concept—without commitment to the proposition's truth (or falsity), or to the existence (or non-existence) of an object that instantiates the concept. What we will call *experiential* imagination, imagining what something is like, is a matter of entertaining a sensory or phenomenal thought without commitment to the thought-content's truth or instantiation. Imagination is thus free of a constitutive commitment to representing how things actually are. (A constitutive commitment is one that makes an intentional state the state that it is.) This is not to say that one cannot imagine what is in fact the

[17] See, for instance, Roger Scruton, "Fantasy, Imagination and the Screen".

case—I can imagine, say, that there is a sea outside my office, while also believing that this is so. But it is to say that it is not irrational to imagine that things are a certain way, while holding that they are not so. In contrast, in the case of belief, which constitutively aims at truth, it is irrational to believe that such and such is the case, while holding that it is not so. Also, it is not irrational to imagine something because I enjoy imagining it, but it is irrational to believe something because I enjoy believing it, for the same reason that belief constitutively aims at truth, and is therefore answerable to it.[18]

Imagination thus can be used for many things, without being subject to the charges of irrationality to which similar uses of beliefs would succumb. Indeed, imagination has many uses, each fixed by one's aims in imagining. I can aim, for instance, to imagine whatever is required to make me feel good about myself and to give me pleasure. That is the central aim of personal fantasy. However, even in this case my imagination does not operate in a normatively unconstrained fashion: for what I should imagine is determined by my goal of maximising personal pleasure. If I find myself imagining scenes of personal misery and humiliation, I have failed in my project of fantasising. The constraints on what and how one should imagine are fixed then by one's goal in imagining. Some literary works feed and foster personal fantasy in just this way. Ian Fleming's James Bond novels describe a hero who in many respects is the epitome of a male adolescent's fantasy life; the reader is encouraged to identify with this hero, to imagine himself participating in that kind of life, and to be that kind of hero. Bond novels, at least for their target audience, successfully obey the norms of fantasising.

A different aim of imagining is to learn something about the world. The examples of imagining being tortured, of confronting my boss and of imagining being a bereaved woman are of this kind. This kind of imaginative project too has normative constraints, likewise laid down by one's goal in imagining. The imaginer should try, for instance, to be as faithful to the facts as she can, to avoid the snares of heroic self-delusion in the case of torture, and shallowness and sentimentality in the case of bereavement. She has to ask herself, honestly, about how she would respond were she in these situations, and, in the case of imagining being others, the scope for getting it wrong is especially large, since she is trying to imagine herself in a situation radically different from her actual one. In these uses of imagination, we aim at truth, though, as we noted, truth is not the constitutive end of imagining.

Clearly literature can share these goals in prescribing imaginings, and it too can be subject to the norms of imagining comprehensively, vividly, unsentimentally, and with fidelity to how things might be. Douglas Dunn's *Elegies* asks us to imagine the situation of a poet (Dunn himself) who has suffered a bereavement,

[18] See my "Creativity and Imagination" for an elaboration and defence of this account of imagination, and a discussion of imagination's constitutive differences to belief and intention.

and the poems do so in a way that evinces a commitment to honesty and an avoidance of sentimentality that tells us much about the nature of loss of a loved one.[19] Likewise, *Emma* shares the goal of a truthful exploration of human psychology and social relationships, and, unlike the Fleming novels, eschews the pursuit of fantasy—is indeed about the destruction of Emma's fantasy about her having insight into her own and others' romantic needs. Literature, like imagination, can have the goal of learning about the world and in such cases shares the normative disciplines on imagination that promote successful pursuit of that goal.[20] This point does not apply only (or always) to works in a realist genre. Consider Ursula LeGuin's novel *The Left Hand of Darkness*. This is a science fiction or fantasy work, generically speaking, but it shares the goals of disciplined imagining aimed at discovering about the world (and recall, as we noted earlier, that the notion of the world includes or implies relevant counterfactual states of affairs). The novel asks a huge 'what if. . .?' question, considering what would happen if humans were to oscillate between female and male genders across their lives, and explores both the kinds of social relations that might evolve and also the complex reactions of a normal human narrator, Genly Ai, who is placed in this society. LeGuin's account of what kind of world this would be is plausible and compelling, and through its exploration of the counterfactual case, shows us much about how even apparently gender-neutral relations are subtly conditioned by the awareness of each party's sexuality.[21] So the contrast I have just drawn between imagining aimed at personal fantasy and imagining aimed at learning about the world is not to be identified with that between fantasy and realist genres. Rather, it is to be understood in the terms of the aims of the respective imaginative projects.

What resources are available to the disciplined imaginer, both in ordinary life and in literature, to learn about the world? Two have already been noted in our discussion of simulation theory. The existence of a basic commonality between different people's psychologies allows one person to imagine another's situation with at least a defeasible presupposition of reliability. Her imaginative projection of herself into someone else's position and her discovery of how she would respond gives some reason to think that she is responding accurately because of the basic similarities between different human beings' psychologies (imaginatively projecting oneself into the position of, say, extraterrestrials would be a considerably less reliable process). And also the way I imagine my reactions to certain events (such as my being tortured) can reveal something of my character in real life, and this too provides some grounds for learning from imagination.[22]

[19] Douglas Dunn, *Elegies*.

[20] The importance of discipline in opposing fantasy is noted by Murdoch in *The Sovereignty of Good*, ch. 2.

[21] Ursula LeGuin, *The Left Hand of Darkness*.

[22] See Kendall Walton, "Spelunking, Simulation, and Slime", especially p. 49, n. 15, for a nice illustration of how one's real tendency to claustrophobia can emerge in one's imaginings.

But, as we have seen, both of these can go wrong, and need to be subject to various disciplines, established by the aim of learning about the world.

The first of these is the discipline of fit with relevant evidence, whether concerning specifics or generalisations. Suppose that I imagine myself reacting heroically to being tortured. Then I may reflect on my traumatised worrying about a forthcoming trip to the dentist: how does that fit with my imagined heroism? In the case of imagining others' situations, such as that of Isobel, we also draw on observational evidence about how emotions show themselves in behaviour, and on general knowledge such as the increased tendency to risk-aversion as one ages. Thus we restrict all the possible things that we could imagine that Isobel is feeling to a smaller set, imagine ourselves having these mental states, and then see how we react in imagination; thus we come to understand her better.

It is important to see that the discipline here is in terms of the *relevant* evidence, not the complete set of properties about the imagined state of affairs. If I want to determine whether or not to eat a particular meal, then part of what would happen if I ate the food would be that my intestines would turn the meal into a brownish slush; vividly imagining this, I might feel so disgusted that I decide not to eat the food, even though it might be delicious.[23] So one needs to know what are the relevant factors in imagining some state of affairs, and this can only be a matter of employing imaginative skills, rather than possessing some mechanical procedure for determining what is relevant and what is not. Indeed, one way in which we can learn from literature is through its showing us the application of imaginative skills by people who are far more accomplished in insightful imagining than we are.

Second, as we noted, one's imaginings can be infected by fantasy of one kind or another. In the case of imagining confronting my boss, it is easy to imagine what I take pleasure in imagining, rather than imagining what sober reflection would convince me would happen, and likewise, in the case of imagining torture, opportunities for self-delusion abound. Especially in the case of imagining others' situations, it is also easy to sentimentalise them, to allow stereotypes and wishful thinking to condition one's responses. If one understands sentimental emotions as those that are conditioned by false or idealising beliefs about their objects, the avoidance of sentimentality is directly linked to the pursuit of truth.[24] So the second resource is the discipline of avoiding fantasy.

A third resource concerns affective imagination. I will argue in Chapter 9 that one can experience genuine emotions, directed towards merely imagined states of affairs. That being so, one can in a certain way learn from experience in imagining some state of affairs. For experience includes more than sense-experience, and covers the entire range of phenomenally characterised mental states. In imagining the instruments of torture with suitable vividness, for instance, I may come to feel

[23] The example is from Mark Johnston, "Dispositional Theories of Value III".
[24] For this understanding of sentimentality, see Savile, *The Test of Time*, pp. 237–45.

actual apprehension, disquiet and even fear, and so may come to learn through affective experience something about myself. This affective dimension plays a large role in one's responses to the events represented in literary works.

Finally, experiential imagination is an important resource in learning from imagination. This, recall, is a matter of imagining what something is like, and goes beyond minimal imagining, involving the sensory or phenomenal presentation of an entertained thought-content. It is the difference between, say, merely imagining being soaking wet and cold, and imagining what it is like to feel and look soaking wet and cold. (The point is sometimes put in terms of imaginative acquaintance with something, as opposed to merely imagining that a description is true.) Experiential imagining can teach things that minimal imagining might have led one to misconstrue: merely imagining that I am tortured may allow me to maintain my fantasy of robustly withstanding the ministrations of my tormentors. But experientially imagining the look of the instruments, the heat of the fires on my skin, the smell of my burning flesh may undermine the imaginative fantasy of courage.

Often one is urged to imagine situations vividly in order to understand them. Vividness here is a feature not of what is imagined, but of how it is imagined (vivid colours such as yellow can be imagined non-vividly, and non-vivid colours such as a dull brown can be imagined vividly). To imagine a situation vividly is to imagine it in such a way that experiential imagining is engaged to a high degree: the more vividly I imagine being tortured, the more intensely do I experientially imagine the situation in all the relevant respects. Indeed, experiential imagining can be sufficiently vivid that it can be very like experience of the world, and explains the sense that one can have that works of art produce a kind of "virtual experience", to employ Dorothy Walsh's useful terminology.[25]

So imagining subject to the discipline of learning about the world has many resources on which to drawn. These include the commonalty of human psychology, both between others and ourselves and between ourselves now and in a possible future, as identified by simulation theory. But it also includes other resources, such as checking the fit of the imagined scenario with relevant evidence (both observations and generalisations); avoidance of affective states that distort cognition, such as fantasy and sentimentality; employing affective imagination; and the use of experiential imagination, particularly when vividly deployed. The disciplined use of these resources shows how imagination can be employed in a way that is not freewheeling, devoid of all constraints, but instead be subject to the disciplined pursuit of truth.

[25] Dorothy Walsh, *Literature and Knowledge*, p. 91. It should be noted that affective imagination and experiential imagination are distinct concepts. The former refers to actual affective states directed towards merely imagined states of affairs; the latter refers to a mode of imagining, employing a sensory or phenomenal dimension. It is possible affectively to imagine a merely minimally presented state of affairs, and also experientially to imagine some state of affairs without having any actual affective reaction to it.

It may be objected that the imaginative resources identified are insufficient to ground a claim to knowledge by imagination, even in those cases of values and psychology on which I have focused. For imaginings can misfire: one can imagine something, and it can turn out to be wrong. Despite imagining vividly, with full awareness of the relevant facts, and with powerful feelings directed at the imagined state of affairs, I may still be mistaken as to what would happen: perhaps I really am more courageous than I believe from my imagined encounter with the torturer's ministrations, and that, tortured in real-life, I would behave heroically. Only experience in the end can reliably inform me of how I will react in such a case.

Part of the answer here is that, in the case of values, a priori knowledge plays an important role (a point to be developed in the next section). But, even for the psychological case, the objection fails; for, unless one incorrectly insists that knowledge requires indefeasibility, the fact that further evidence could undermine one's knowledge claims does not show that knowledge is not to be had. For in cases where I clearly can know, my knowledge claims could be undermined by more evidence: I can know that something is red, but my claim that it is so could always be undermined by further evidence that, for instance, I am examining it in coloured light, so that it does not appear in its true colour. The possibility of defeat by further evidence does not show that one cannot know in such cases; and likewise it does not show that one cannot know in the case of imagination.

So there is good reason to believe that disciplined imagination will impart a degree of reliability to the judgements formed by means of it; but we should nevertheless acknowledge that there are limits to that reliability. Generally speaking, experience will be more reliable than even disciplined imagination (though, as we have noted, affective imagination is also a kind of experience, since experience encompasses more than sensory experience). The great advantage of imagination over experience is that it is relatively costless: I could discover that I am brave through undergoing some terrible misfortune, which I rise above, but it would be better not to have to suffer. "Imagination trades reliability for risk . . . ", as Currie notes.[26] Yet the lesser epistemic authority of imagination compared to experience should not be exaggerated. In choosing between a medical and a philosophy career, for instance, I cannot experience both in full, for I cannot live the rest of my life twice over, once entirely as a doctor, once entirely as a philosopher. However, I can imagine the rest of my life spent entirely as a doctor and can also imagine the rest of my life spent entirely as a philosopher. So there are some epistemic respects in which imagination is superior to experience. And a motivation actually to put myself in danger merely to find out whether I really am courageous calls into question whether I really am courageous, as opposed to reckless, even when I do not flinch from danger.

[26] Currie, "The Moral Psychology of Fiction", p. 53

7.4. IMAGINATION AND ETHICAL LEARNING

We can now examine how learning from imagination operates in the ethical domain, which will both illustrate some of the points made above and allow us to examine the important role of universalisation in imagination. Three kinds of related cases are considered: one from ordinary moral discourse, one from philosophy and one from literature.

How does one come to learn morally, and in what does this knowledge consist? Since morality concerns motivations and feelings, moral learning not only involves knowing that such-and-such is the case (that, for instance, lying is wrong), but is also concerned with knowing how to act and how to feel (being disposed not to lie, and to feel guilty if one does, for instance). One's beliefs about these matters are tested and justified most broadly by using reflective equilibrium—that is, by attempting to render consistent one's particular judgements about individual cases with one's general beliefs, including those about moral principles. This use of reflective equilibrium is not just narrow (that is, confined within the domain of moral beliefs and moral principles), but is also wide (bringing in one's beliefs about non-moral matters, such as human psychology). The use of reflective equilibrium is now relatively well understood and explored in relation to morality.[27] Within its framework, there are two particular methods of moral learning and justification on which we will focus.

The first concerns the use of universalisation, which, as we noted in Section 2.3, is an important feature of moral thought. Because of the universalisability of moral judgements, it is always appropriate to ask the proposer of a policy to consider whether he would still endorse the policy if it were enforced on himself, were he in the situation on which the policy bears. Only if he would still endorse the policy does it pass the universalisation test, and so is at least in this respect morally acceptable (this is not to say, of course, that this is sufficient to make it morally acceptable). If someone proposed abolition of free, state-sponsored healthcare, to return to the example adduced earlier, then we can legitimately ask whether he would still support the policy if he urgently needed medical assistance and could not afford it. The test employs imagination and requires no direct empirical confirmation. It is a test about what the proposer would judge were he in a certain counterfactual situation.

It is important to understand the test correctly. Distinguish between the *judge*, who is considering the proposed policy, and what we will call the *target* of the judgement: the person whose behaviour and options are to be governed by the

[27] For the classic discussion of reflective equilibrium, see John Rawls, "Outline for a Decision Procedure for Ethics"; for wide reflective equilibrium, see Norman Daniels, *Justice and Justification*, especially ch. 2. For a deployment of reflective equilibrium to argue for a version of moral pluralism, see my "Moral Pluralism".

policy (for instance, the person who will not receive free healthcare). John Mackie understands the test to require that the target be able to endorse the proposed policy; in considering what he regards as the third stage of universalisation, he holds that "what one is trying to do is to look at things both from one's own and from the other person's point of view at once, and to discover action-guiding principles . . . which one can accept from both points of view".[28] Mackie is rightly sceptical about whether any principles could pass such a test—given the diversity of even actual viewpoints, it would be unsurprising if no substantive policy could be universally agreed. But this cannot be the correct way to understand the universalisation requirement. For universalisability requires that the judge accept that, were he in the target's position, then he should be treated as he proposes that the target be treated. It is not a requirement that the target be able to endorse the policy. The latter would go beyond what universalisability requires: for universalisation is a test that requires that situations alike in their properties be treated alike by the judge, not that all judges (including those in the target's position) agree with the judgement. The supposed requirement of universal agreement is much too strong: the target may in one way or another be biased, unlikely to endorse the policy because he gains no benefits under it (even though it is fair that he be so treated) and so on. For instance, a legal judge might rightly sentence a defendant for a heinous crime; the universalisation test requires that the judge agree that, had he committed that crime, he be similarly sentenced. But, if the defendant were asked whether *he* would endorse his sentence, then he might well not endorse it, even though he rightly deserved it; given the criminal mindset, this would be hardly surprising.

So understood, a number of important features of the test can be seen more clearly. First, the test is genuinely a priori (for instance, it does not require research into whether everyone would endorse the proposed policy), and is grounded on an experiment conducted in imagination. It is a test based on the universality of reasons, requiring that similar situations be treated similarly. Second, in the case of morality, it is a test that removes or mitigates bias: by placing oneself imaginatively in the target's position, one is invited to consider whether one's adoption of a policy is due to its congruence with one's own interests, rather than it being something that one might endorse from an unbiased perspective. The healthy and wealthy citizen, whose wealth is threatened by the higher taxes needed to fund healthcare, is invited to reflect on whether he would still agree to the abolition of free healthcare, even were it no longer in his interests to do so, because he is, in the imagined scenario, poor and sick. The judge in such imagined scenarios is a kind of observer of the moral scene, and so has the observer's distance from it; but what he is observing is himself in the imagined scenario. The device thus counteracts the biases that tend to occur when one is immediately judging one's own interests. Third, universalisation cannot be a complete test of what is morally

[28] Mackie, *Ethics: Inventing Right and Wrong*, p. 93.

right, for it is (in accordance with the general framework of reflective equilibrium) essentially a consistency test, between one's current moral judgements and what one is disposed to judge about counterfactual cases; and a conflict of judgement, should it occur, can be resolved in more than one direction. Acceptance of a moral requirement of free healthcare is not a necessary consequence of the imagined scenario, for instance. The wealthy, healthy man may judge that, even were he poor and sick, then he should indeed not have the benefit of free healthcare; he might judge that such dependence is demeaning. Nothing within the universalisation test shows him to be wrong about this; for, even if he were to imagine that as poor and sick he did not have his robustly individualist ideals, he could, *contra* Mackie, consistently with the universalisation requirement judge that he should still be deprived of free health benefits.

Up to this point I have talked of the judge 'judging' what ought to be done to him were he in the target's position. This way of putting the matter should not be taken, however, to rule out the role of feelings and emotions in making the judgement. The judge may feel pity towards himself in the target's position, or feel anger at the way he as target has been treated.[29] The emotions here defeasibly reveal something about the judge's attitudes, and he may on reflection realise that the anger that he feels does indicate a settled disposition to judge that the proposed policy is wrong. Since people's judgements and emotions are not always aligned with each other, the affective dimension of responses to the imagined scenario may be very important in revealing what should be done. So affective imagination is importantly involved in a fully developed universalisation test.

There is a second test for moral acceptability, the test of imaginative acquaintance (involving the use of experiential imagination), which we sketched in the last section. One thing that may go wrong in the universalisation test is that one fails to understand the target's situation properly. One might, for instance, suppose that being poor and very sick is really not so bad after all, that life could go on much as normal. This failure of understanding can occur not only about the target's external situation, but also—and perhaps more commonly and crucially in practice—about the target's psychology. One might not realise just how desperately awful it feels to be seriously sick, to be suffering from a curable disease, and yet not to be able to afford treatment. It is then a second source of criticism about a moral policy that one has failed to appreciate the impact of the policy on the target. Both this second kind of criticism, the failure of imaginative acquaintance, as well as the first, universalisation, test, are to be found in the common plea, 'how would you feel if someone did that to you?' The challenge asks one to imagine from the target's perspective what it would be like to be subject to the proposed policy. In the light of the argument above, it

[29] Note that this way of putting the matter requires the possibility of real emotions directed towards situations that are only imagined. The possibility of such emotions, which also play an important role in audience's responses to fictions, is defended in Ch. 9.

should not be construed as a plea that the target be able to endorse the policy; but it is in part a plea that one imagine from the target's perspective what it is like to undergo that policy.

The test of imaginative acquaintance is an important one: not only does it require that one gets the facts, both external and psychological, right about the target's position, but also, by asking the judge imaginatively to adopt the target's position (asking her to imagine what it is like to be the target), it enhances the power and precision of her feelings towards the target. Charities are well aware of the power of the technique: displaying photographs of individuals suffering or details of their life stories is a much more powerful way to stimulate and focus potential donors' sympathy than is the provision of general statistics and facts about deprivation and suffering. Since, as we noted, moral judgement is sensitive to and in part dependent on the feelings aroused towards the target's situation, this focuses the power of moral judgement. Imaginative acquaintance with the situation of particular people can 'bring home' their suffering in a way that rumination on broad generalities may well not do.

Moral judgement in ordinary life also draws on the other imaginative resources identified earlier. In placing oneself in the target's position, one is employing the commonality of human psychology, which one must correct in the light of observation and theory, and one must avoid various kinds of affective delusions, such as fantasy and sentimentality. The full panoply of imaginative resources, disciplined by the pursuit of moral truth, can be engaged in ordinary moral judgement and decision.

Besides its use in ordinary moral life, imagination as a tool for ethical learning is also employed by philosophers, in developing thought-experiments, which are a reflective enhancement of our ordinary moral thought. Consider a famous example deployed by Bernard Williams in the debate about consequentialism in moral philosophy:

Jim finds himself in the central square of a small South American town. Tied up against the wall are a row of twenty Indians, most terrified, a few defiant, in front of them several armed men in uniform. A heavy man in a sweat-stained khaki shirt turns out to be the captain in charge and, after a good deal of questioning of Jim which establishes that he got there by accident while on a botanical expedition, explains that the Indians are a random group of the inhabitants who, after recent acts of protest against the government, are just about to be killed to remind other possible protesters of the advantages of not protesting. However, since Jim is an honoured visitor from another land, the captain is happy to offer him a guest's privilege of killing one of the Indians himself. If Jim accepts, then as a special mark of the occasion, the other Indians will be let off. Of course, if Jim refuses, then there is no special occasion, and Pedro here will do what he was about to do when Jim arrived, and kill them all. ... The men against the wall, and the other villagers, understand the situation, and are obviously begging him to accept. What should he do?[30]

[30] Bernard Williams, "A Critique of Utilitarianism", pp. 98–9.

Part of Williams's point here is that utilitarianism holds that it is obviously the right answer that Jim should kill the Indian, but that, whether it is right or not, it is not *obviously* the right answer. Most people agree with Williams, but, if one had not come across this example or similar ones, one might have assented without demurral to a simple version of the act-utilitarian principle that what one ought to do is what maximises the general happiness or general welfare.

Through dwelling on Williams's example, we have learned something important about moral values. Yet the example is a simple fiction: no actual experience is recorded by it; so we have learned something important about values through imagination. (Given the ubiquity of thought-experiments in philosophy, it is richly ironical that so many philosophers are resistant to the thought that one can learn about the world through imagination.) We are in a position to explain why this is so: the universalisation requirement on moral reasons means that moral claims apply to all situations alike in their universal properties, including counterfactual ones, such as that described by Williams. And our affective reactions to the imagined scenario show us that our actual moral reactions are out of kilter with the theoretical structure of at least simple act-utilitarianism.

Williams's example illustrates something more than the role of imagination in philosophical ethics. Examples of this kind are sometimes called 'intuition pumps', and by 'intuitions' here is meant our reactions to the *particularities* of individual cases, as opposed to our general reflective beliefs (for instance, in the truth of utilitarianism). Someone who had considered the utilitarian principle in the abstract and endorsed it might well hesitate in her commitment now that she discovers some of its applications. And she hesitates because she discovers that her intuitions do not accord with it, neither in respect of her dispositions to judge nor to feel. She has dispositions to judge morally about what is right and wrong that are mobilised by the particularities of the Jim/Pedro case; and she has dispositions to feel disapproval, fear or latent guilt about some imagined courses of action, which are also generated by the case. Williams could have laid out the case in very schematic fashion—for instance, simply asking the reader to imagine being in a situation where he could kill one person in order to prevent twenty people being killed, without any of the elaborating details. But, while that would have posed the problem for the utilitarian, it would have been less effective in getting the reader to understand what she ought to do. For it is the particularities that help to get her to imagine how she would feel, were she in Jim's situation, and help trigger her particular dispositions to feel and judge. Williams tries to make the case as plausible and realistic as he can to do this. The scene is set in South America: in 1973, when Williams was writing, the area was notorious for death squads and dictators. We are told about the expressions on the villagers' faces, and even the captain's "sweat-stained khaki shirt" adds a touch of seedy reality. These and other devices foster our imaginative involvement with Jim's situation, render the scene more realistic, and both enhance the strength of our judgements and responses and make them more directly applicable to the actual world. Through

getting us to imagine vividly and strongly, then, the example shows us what some of our deepest commitments are, and how they are apparently inconsistent with a general principle that we might otherwise have found attractive. And we are more committed to the particular judgements and feelings than to the principle.[31]

So the effectiveness of Williams's thought-experiment rests in part on its literary details: on its attention to the particularities of the case, on the way it describes the characters and scenario, on the fact that it is a small open-ended narrative fiction. These details matter in generating the strength of our responses and our sense that they are reliable guides to moral reality. It is partly by developing the example beyond the merely schematic, by enriching it in its literary qualities, that Williams brings home to us the nature of our commitments. And there is something more. In a passage that I omitted in the ellipsis, Williams says something that suggests a different way of developing the narrative:

Jim, with some desperate recollection of schoolboy fiction, wonders whether if he got hold of a gun, he could hold the captain, Pedro and the rest of the soldiers to threat, but it is quite clear from the set-up that nothing of that kind is going to work: any attempt at that sort of thing will mean that all the Indians will be killed and himself.

It would have been possible to tell the story so that Jim attempted such heroic action, and that as in "schoolboy fiction" he gets away with it. Of course, the story would lose its philosophical point: rather than confronting and exploring a dilemma, it would become an evasion of moral reality, a refusal to think through a problem. And, if we worked up William's little fiction into a fully fledged short story, as we could easily do, the schoolboy heroism version would, other things being equal, undoubtedly be a less accomplished and interesting literary work than would a version in which Jim must confront the dilemma, make his decision and live with its consequences. So, not only can we learn through imagination and can artistic devices help by enhancing imaginative projection, but also the artistic worth of a piece can depend on its exploration of and confrontation with moral complexity. Williams's example then powerfully illustrates not just the epistemic role of imagination in relation to values, but also the conclusion of the next chapter, that the cognitive value of a work can be important to its artistic value.

The third kind of case that I will consider is a literary example. Williams's thought-experiment already deploys literary devices; and it thus shares in embryonic form something with a work of literature that also explores a dilemma, William Styron's novel *Sophie's Choice*. Indeed, in teaching undergraduate classes on moral dilemmas, it is striking how often students spontaneously bring up Sophie's fateful choice as an instance of a moral dilemma. The work has captured their imaginations.

[31] I do not of course mean to suggest by this that the utilitarian has no answer to this kind of objection by counter-examples. (See, for instance, Hare, *Moral Thinking*, esp. p. 49, and ch. 8.) The point is that Williams has discovered through the use of imagination a reason for thinking that utilitarianism is a flawed account of morality; the burden of argument is then on the utilitarian.

The novel's narrator, Stingo, is a 22-year-old, rather callow, aspirant novelist; in Brooklyn in 1947 he meets Nathan, a Jewish intellectual, and his lover, Sophie, with whom he gradually falls in love. As his often bafflingly frustrated relationship with her deepens, he gradually learns, with many hesitant blocks and evasions by her, of her time in Auschwitz and that both of her children were killed in the concentration camp. The details of Second World War Poland come slowly into focus, as Sophie's trust in Stingo, and his love for her, increase; and it seems as if the main horror that she has to relate is her losing fight to preserve the life of her son, Jan, through her liaison with the camp's commandant, Rudolf Höss. But Sophie has always evaded describing how her young daughter, Eva, came to meet her death immediately on arriving at the camp. Only towards the end of the work, on page 594 of the 632-page novel, do we learn that Sophie was given a choice by a drunken medical doctor on her arrival: she had to choose which one of her children was to be sent immediately to the gas chamber, or they would both be sent there. It is this choice that haunts and finally destroys Sophie; at the end of the novel she and Nathan kill themselves.

Sophie's Choice is about many things—about the Nazi death camps, about the nature of absolute evil, about what it is to lose faith in God, and even about what it is like to be a young, self-congratulatory, man in love with an older, much more experienced woman. But what is most pertinent for our purposes is its posing of one of the most horrible of dilemmas. And what it shows, amongst other things, is that such dilemmas can indeed exist; and that the guilt someone feels from making a choice in these circumstances can haunt and even destroy her. Now these things are not at all obvious—the reality of moral dilemmas has been denied by many philosophers; and these philosophers have tried to explain away the feelings of guilt as irrational or misconceived. Terrance McConnell, for instance, denies that dilemmas exist, and holds that one should properly feel in such situations regret (a non-moral emotion, a wish that something had not happened), but not guilt (a specifically moral emotion, requiring one to believe that one has done wrong).[32] Yet the novel poses a powerful challenge to such views; any pat resolution denying the dilemma seems simply ludicrous in the light of its extraordinarily moving account of Sophie's situation. This is not a case where Sophie has equally balanced alternatives, so that it does not matter which child she chooses to sacrifice; nor is it one where she can properly allow a personal preference to sway her as to which child to choose (indeed, it is her preference for her son over her daughter that seems to condition her choice, and that does not assuage her guilt); it is not one where she can simply decide not to choose, for that is to allow both to die; nor, in the light of the work, is the thought that she should not feel guilt, but only regret, anything more than a philosopher's fantasy. In short, the novel shows us that moral life can present acute, irresolvable dilemmas, and so teaches us something very significant about morality—and

[32] Terrance McConnell, "Moral Residue and Dilemmas".

something denied by philosophers as great as Kant. The existence of dilemmas is a non-trivial point: if the accusation of banality can properly be raised here, it should be directed at some philosophical works, not at Styron's novel.

We will have more to say in the next chapter about how literary works can so powerfully convey morally important attitudes and truths. But we can already see that it is through getting us to imagine a situation in such a powerful way, particularly through engaging our emotions, that the work largely succeeds in making its moral point. In doing this it deploys in fully developed form the devices that lie in embryonic form in Williams's little narrative (and the dilemmas explored are, of course, in certain ways similar). It is Stingo's slow spiralling in towards the truth of Sophie's past, his curiosity in part sexual, that forms the lens through which we view her character; so we come to feel his curiosity about and empathy for her situation. Layers of misery unpeel to reveal deeper layers of despair beneath, so the final revelation of her choice appears as the emotionally devastating climax of a sequence of horrors, all set off by the constant counterpoint of urbane life in post-war New York. The accumulation of telling details augments the crescendo of the emotional force of the choice: Eva is constantly associated with her flute and her *miś*, her one-eyed teddy bear, and it is these that she is still clutching as her mother consents to her death. The details of the choice are rendered particular and powerful, symbolically presented through the abrading floor and the metaphor of engrafting: Sophie, presented with the choice, "could not believe any of this. She could not believe that she was now kneeling on the hurtful, abrading concrete, drawing her children toward her so smotheringly tight that she felt that their flesh might be engrafted to hers even through layers of clothes. Her disbelief was total, deranged."[33] Such techniques mark the difference between the merely intellectual exercise of the general run of philosophical thought-experiments and the fully realised literary scenes that can make certain philosophical theories look simply untenable.

We have discussed three kinds of cases of ethical learning: an instance of the kind of argument that could arise in ordinary life; an example employed by a philosopher; and an instance in a literary work. What they possess in common is that they show that we can learn ethically through the exercise of the imagination through the full range of imaginative resources discussed in the previous section, together with the use of universalisation. They also, in a way, present a continuum, where we gradually move towards literary-style devices, to help make those imaginings more vivid, precise and powerful, and at the same time (not coincidentally) more cognitively instructive. By deploying the full force of affective and experiential imagination, we can be made to feel the wrongness, rightness or sheer imponderability of certain moral choices, and so we can learn through imagination. And that is just what the epistemic claim of the cognitive argument maintains.

[33] William Styron, *Sophie's Choice*, p. 594.

8

The Cognitive Argument:
The Aesthetic Claim

In the previous chapter I argued that works of art, and literary works in particular, can non-trivially teach us, and that they can do so not only about psychological matters, but also about morality. This epistemic claim was defended against the confirmation objection—that artworks can never confirm their claims, and so cannot impart *bona fide* knowledge. Reasoning, experience, testimony and imagination can, as we saw, confirm such truths. Confirmation by imagination is particularly important in the case of morality, since the imagination plays an important (and philosophically surprisingly neglected) role in moral deliberation; it is also important in delivering psychological insights into oneself and others. The present chapter is mainly concerned to establish the second, aesthetic, claim of aesthetic cognitivism—the claim that the capacity of a work to teach us is under certain conditions an aesthetic merit of the work. Two arguments in favour of this claim are advanced and defended; autonomist and contextualist objections are considered and answered; and then several techniques and strategies deployed by artworks are examined to show how works can morally teach us and do so in a way that counts as an aesthetic merit in them. In the last section a reading of *Lolita* is developed to illustrate these techniques and strategies in action.

In addition to establishing the aesthetic claim, the present chapter also advances what is roughly, though not quite, the converse claim to its main one: that aesthetic merits in works of art can render the moral power of works considerably more effective, and so can make artworks teach us more powerfully about morality than can many non-artworks.[1] This should not be confused with the view that artworks are *uniquely* well placed to deliver some moral truths; but it does show that they can deliver their moral truths very powerfully by aesthetic means.

8.1. ARGUING FOR THE AESTHETIC CLAIM

Recall that in the previous chapter we distinguished two legitimate senses of 'aesthetic cognitivism': the minimal one, in which it is a work's manifesting

[1] In this subordinate claim I mean, of course, by 'aesthetic merits' non-moral aesthetic merits, since otherwise the claim threatens to become trivial, given the truth of ethicism.

understanding (moral or otherwise) in an aesthetically relevant way that is an aesthetic merit in the work; and the stronger one, in which it is a work's teaching (moral or otherwise) in an aesthetically relevant way that is an aesthetic merit in it. Let us start by considering the minimal version.

Suppose that the anti-cognitivist denied that a work's manifesting understanding ever had anything to do with its aesthetic value. Then consider Caravaggio's *The Taking of Christ*. We saw that part of the painting's greatness rests on Caravaggio's showing a profound understanding of the psychology of betrayal and of its moral significance. If the anti-cognitivist is right, that cannot be true; but, if so, then Caravaggio could have painted an equally successful picture with, say, Christ showing an expression of mild annoyance, as if he had just had a disappointing lunch, and Judas a look of some embarrassment, being seen to kiss a man in public with all those soldiers looking on. This version would clearly be a vastly less successful painting than the original, and probably a downright aesthetic disaster. The painter would have radically misunderstood the moral and psychological significance of betrayal, making it equivalent to something like a tacky public display of bad taste. And this judgement reflects the fact that we count amongst a painter's skills not just technical and expressive facility, but also having some understanding of his or her subject, presented through pictorial means.

This is even clearer in the case of literature. A writer who, though able to write with considerable elegance and narrative drive, yet presented characters in such a way that she evinced considerable misunderstanding of types of personality would lack a core literary skill. Indeed, there is a stock of pejorative critical terms to cover such cases—characters can be condemned as wooden, lacking in depth, as being mere plot devices without an interior life (Agatha Christie's characters are frequently condemned in those terms). Or suppose that William Styron had presented Sophie's climactic choice as something that was a matter of comparative indifference, like choosing between which particular item on the menu one wanted for dessert. To treat it thus would represent a profound failure to understand the nature of moral choice, and would thereby wreck the novel, depriving it of its power to display and explore a devastating moral dilemma.

So reflection on even some basic aesthetic evaluations of artworks shows that evincing such an understanding is a matter of considerable aesthetic importance. And that supports the minimal version of aesthetic cognitivism. The stronger version, as we saw, adds to manifesting understanding the communication of this understanding by the artist and also the audience's cognitive gain (that is, the audience's learning something). It is very implausible to deny the aesthetic relevance of these extra components, if they are linked to aesthetically relevant understanding. If the audience learns something from a work, it follows that the understanding manifested in the work is greater than the audience's prior understanding of the matter. So, given the audience's level of knowledge, a work must show greater understanding if the audience has learned something from it

than if the audience has not. But, if the understanding manifested is aesthetically relevant, then a greater degree of that understanding must be aesthetically relevant too. And the communicative aim is also aesthetically relevant, if the understanding communicated is aesthetically relevant. We often talk of an artist 'showing' us something that we had not previously grasped, and aesthetically praise the work for this. The notion of showing here is clearly a communicative one: it is not just that we observe that the artist understands some matter, but we also have a sense that he or she is communicating this understanding to us, that we are addressed by the work and enlightened by it. So it would be highly implausible to deny that the two extra components of the teaching formulation are aesthetically relevant when aesthetically relevant understanding is conveyed in what is taught.

This is the first, componential, argument for aesthetic cognitivism: break down the stronger, teaching version of the claim into its three components, of manifesting understanding, communication and cognitive gain; then reflection on aesthetic evaluation should concede the relevance of manifesting understanding; and then it is hard to see how one could plausibly deny the aesthetic relevance of the two other components when they convey this understanding.[2]

There is a second argument in favour of the aesthetic claim.[3] It is most clearly displayed in the case of literature, but it applies to the other art forms as well. Much of the vocabulary of literary appraisal and its application seems to show that the practice of literary evaluation is cognitivist: we praise works for their profundity, for being psychologically penetrating, for giving an insightful perspective on the world. We decry them for being shallow, distorted, inane or full of worn clichés. We assess whether characters' actions and motivations are plausible, or a plot structure is realistic. And the cognitive component of literary evaluations extends in less obvious ways. When we talk of a work as being sentimental, we are also making a cognitive claim, for sentimental emotions are ones that involve false or idealising thoughts about their objects.[4] In fact, emotion-terms in general have a cognitive component: we talk about the emotions that works prescribe us to feel as being appropriate, just or true: that is, the evaluative thoughts that partly constitute the emotions are correctly applied to the objects of the emotions.[5] For example, the anger a work asks us to feel about the murder of a character is appropriate because anger involves the thought of something wrong having been done, and this is indeed (fictionally) so. In contrast, emotions prescribed that are not merited by their objects are regarded as manipulative, coarse, off-the-mark and so on. So critical vocabulary

[2] Terry Diffey, however, claims that learning from an artwork requires a refusal of the aesthetic stance, and so he would challenge this claim. His argument is criticised in Sect. 8.2.

[3] See also Richard W. Miller, "Truth in Beauty", for an appeal to critical vocabulary by a cognitivist, though Miller develops his argument in a somewhat different way from that used here.

[4] Cf. Savile, *The Test of Time*, pp. 237–45.

[5] The cognitive–evaluative theory of the emotions is discussed in the next chapter.

involving describing emotions as apt, true, nuanced or manipulative and coarse has a cognitive dimension to it. Hence appeal to some of the vocabulary of critical appraisal shows that our aesthetic evaluative practices are cognitivist; so cognitive values are, when employed in these kinds of evaluations, aesthetically relevant.

The most direct anti-cognitivist reply to this, the critical vocabulary, argument would be to develop an 'error theory' of the employment of aesthetic cognitive vocabulary, in a manner akin to John Mackie's famous error theory of moral judgements.[6] This aesthetic error theory would hold that, though the employment of ordinary critical language is indeed cognitivist, this employment is mistaken, because artworks cannot convey knowledge, since they fail to satisfy some constitutive condition for being vehicles of knowledge—perhaps because they cannot justify their claims. However, this line of attack is closed, if the epistemic claim is correct, as I have argued in the previous chapter. So the anti-cognitivist must try a different tack, and show that the apparently aesthetic cognitivist language is not what it seems to be.

There are three anti-cognitivist lines of reply open in this mode. First, the anti-cognitivist may object that the vocabulary of literary appraisal considered above is not genuinely cognitivist. Appearances can deceive: consider the use of 'profundity' as a term of evaluation of music. To claim that a work is profound appears to require that it convey some non-obvious but true proposition about matters of central importance to human beings. But how can absolute music convey any propositions at all? So, the non-cognitivist may claim, 'profundity' is not being employed in its normal sense here; why assume then that it is being employed in this normal sense when used of literature either? However, we already have the resources to reply to this objection: representational (and even some abstract) works can implicitly convey propositions, some of which may be true; and these epistemic claims can be vindicated by the cognitive role of imagination.

The objection may instead rest on more specific doubts about the particular terms concerned, rather than general worries about implication and confirmation. For instance, Peter Lamarque has claimed that there is no necessary link between, for instance, profundity and truth: "Milton's treatment of the Fall is profound just as is Descartes's appeal to God to refute skepticism but neither need be accepted as true."[7] Since truth is only one cognitive value, this objection would not in itself undermine all versions of aesthetic cognitivism. But, in any case, it fails as an attack on the relevance of truth to aesthetic evaluation. There are indeed some uses of 'profound' where saying that something is profound does not entail that it is true, since it is not the sort of thing that can be true. Without much linguistic strain, one can talk of profound distinctions and profound

6 Mackie, *Ethics*, especially ch. 1.
7 Peter Lamarque, "Cognitive Values in the Arts", p. 130. Isenberg, in "The Problem of Belief", also argues that apparently cognitivist critical vocabulary is not in fact cognitivist.

problems, but distinctions and problems are not, strictly speaking, the kinds of things that can be true or false. However, even in such employment, the notion of profundity is truth-connected: how could a distinction be profound if it did not figure in any profound statements, or a problem be profound if it did not require a profound answer? And when we talk of profound *statements*, there is some kind of necessary relation to truth. If there were no such connection, then it would be coherent to say 'all profound statements are false', yet that sounds like a Wildean paradox without the wit. And also 'this is a profound falsehood' would be coherent; yet that too is absurd (unless we simply mean by this that something is *hopelessly* false, but that is a distinct usage of 'profound', as in 'he's profoundly stupid'). So there is good reason to hold that there is some kind of necessary connection between profound statements and truth; and works of art are capable of making implicit and explicit assertions, some of which are profound. Profundity as a critical term cannot be entirely divorced from truth. The critical term 'insightful' also robustly resists any attempts to sever it from truth: how could there be *false* insights into something?

Lamarque has similarly urged that there is no link between sentimentality and truth. "Much that is true, or that actually happened, can be deemed sentimental so sentimentality cannot literally (i.e. in a nonexotic sense) contrast with truth."[8] However, sentimentality is a property of attitudes broadly construed (including such states as emotions and beliefs). Objects and events considered independently of attitudes are not sentimental; it is the attitudes that one may have towards them that are sentimental or not. So sentimentality is still opposed to truth, for the issue is whether one has a non-truthful or idealising attitudes towards the things that happen.

The second anti-cognitivist objection concedes the cognitivist nature of the vocabulary noted earlier, but holds that such evaluations are never aesthetically relevant. One way to press the relevance problem is to note that we seem not to care in our literary judgements whether an author has got his facts right: we don't mind, for instance, that Shakespeare was wrong about Julius Caesar's battle dates.[9] The point does indeed show that truth is not always artistically relevant. But of course it does not show that truth is *never* artistically relevant. We are interested in Shakespeare's play in part because of its exploration of the themes of heroism, war, love and betrayal, and, if it advanced shallow and false views about these (that war is uncomplicatedly ennobling, for instance), then we would justifiably think worse of it as literature.

However, we have just admitted that not all truths are artistically relevant. So the cognitivist must hold that sometimes cognitive values are aesthetically

[8] Lamarque, "Cognitive Values in the Arts", p. 130.
[9] For the example, see Peter Lamarque and Stein Haugom Olsen, *Truth, Fiction, and Literature*, p. 297; they use it to attack a particular version of cognitivism, the theory of novelistic truth, rather than cognitivism in general.

relevant, and sometimes not. But if we simply leave it like that, as an unsupported claim, the sceptic about relevance will hold that here we have a merely adventitious coincidence of values: in some cases cognitive values are possessed by works that also have artistic value, but it isn't ever the case that these works have artistic value *because of* their cognitive value. Consider an analogy: suppose someone holds that the squareness of paintings contributes to their artistic value; she admits that not all great paintings are square (there are after all many artistic values besides squareness), and there are square but bad paintings (these have artistic defects that outweigh their artistic merit); but nevertheless squareness is a good-making characteristic of paintings. The claim is, of course, absurd; but the relevance sceptic can point out that so far the cognitivist is in an embarrassingly similar position; for she makes similar claims appealing to similar evidence, *mutatis mutandis*, about the cognitive values of art. What the cognitivist needs to do to counter such scepticism is to show that we are not dealing with a merely adventitious coincidence of values, but that cognitive values can contribute to artistic ones.

One way to reply to this is to develop a general criterion for when cognitive values are aesthetically relevant; and that is something that we have already done in Section 4.3, holding that moral and cognitive claims tend to be aesthetically relevant when expressed by artistic means; it is the way, or mode, in which ethical and other insights are conveyed that makes them of relevance.[10] As I suggested, it is factors such as the development of a *persona*, the way that insights are integrated into the particulars dealt with by works, and the way that we are affectively moved to feel the force of these insights, that are germane to securing the aesthetic relevance of the insights. This last criterion, that of 'bringing home' insights by presenting them with affective force, has a peculiarly pervasive role in securing aesthetic relevance. While at least the *possibility* of aesthetic relevance being secured without this factor should be allowed, because of the presence of the other factors in the artistic mode of expression, there are in fact few and perhaps no plausible examples of works that manage to secure the aesthetic relevance of completely 'cool' (lacking in affect) cognitive judgements.[11] Given the importance of the affective criterion, and given the

[10] The importance of the mode of presentation explains why, even if profound truths were inserted into a text, they would not necessarily transform the text into profound literature. Suppose that Newton had been an aspiring, though awful, poet and had written *Principia Mathematica* in doggerel verse: maybe the result would count as a (bad) poem; it would certainly report profound truths; yet we would not say that it was a profound poem. It would be a bad poem that stated profound truths. A piece of writing may be profound and also literature without being profound literature, in the same way that a creature may be small and an ant without being a small ant—'profundity' as a term of aesthetic appraisal has an attributive rather than a predicative use.

[11] The most plausible examples of such works might be found in the self-consciously anti-emotional French *nouveau roman* movement, of which Alain Robbe-Grillet's *La Jalousie* (*Jealousy*) is emblematic. With its deliberately forensic descriptive tone, in which the peeling of paint, the arrangement of banana trees around his house and evidence of his wife's infidelity are all presented

argument of the present and previous chapters, we should think of the value of art as partly deriving from its providing a kind of cognitive–affective perspective onto the world: its ability to bring home an understanding of the world through affective means. And the prominence of this affective dimension fits neatly with the importance of affective imagination in learning, for which we argued in the last chapter.

There is a second and simpler way to show that the connection holds. For our usage of cognitivist evaluative terms shows not just that we hold works to have these epistemic virtues; we also hold that these cognitive merits are relevant to their artistic merit. Consider someone who said 'this novel is a profound and insightful exploration of death without a trace of sentimentality, but this of course has nothing to do with its artistic merit'. That is as bizarre as someone who said 'this novel is well written, elegant and witty, but this of course has nothing to do with its artistic merit'. Clearly, our usage shows that cognitive merits of works are, in the evaluations mentioned, artistic merits too. It is partly *because* a work is profound that it is a good work of literature. So the cognitive–evaluative connection holds in such cases.

A third way of resisting the critical vocabulary argument concedes that the evaluative terms are genuinely cognitive and sometimes make aesthetic evaluations, but holds that cognitive merits are sometimes aesthetic *demerits* in works. Consider the critical term 'didactic', a cognitive term that refers to an aesthetic demerit in a work. However, as we saw in Chapter 5, this objection can easily be answered: what is bad about the didactic work is *how* it teaches us, perhaps the crude, simplistic, narrow-minded or bombastic way in which it delivers its claims. In the absence of these features, objecting to a work that it has taught one something seems a brazen act of aesthetic ingratitude. Alternatively, the objector may note that adding truth-claims willy-nilly to works might wreak aesthetic havoc. Imagine randomly inserting into *Emma* extracts from the telephone directory. Or consider a real-life case: Tolstoy's lengthy musings on the philosophy of history (even if they were true) are generally regarded as defects in the fabric of *War and Peace*. Increasing truth-content may be a kind of aesthetic vandalism. But here what is going wrong is not that the *truth* of the claims is damaging the works, but the fact that the truths are wholly or largely *irrelevant* to what is going on in the novels, that (certainly in the first case) they are not insightful or profound, and that, in placing them in the works, aesthetically valuable features, such as narrative coherence and thematic unity, are badly undermined. No sensible cognitivist should claim that just any truths will count as merits in the works: they must be ones that cohere with or illuminate

by the narrator in an equally neutral manner, the novel seems a plausible example of aesthetic relevance without affective force. Yet, even here, the absence of affect might reasonably be denied. The narrator is no camera, incapable of feeling, but a human being, and his detached tone can be understood as expressive of an obsessive mentality and an alienated set of feelings. His attempt at objectivity can be seen as symptomatic of a kind of breakdown, driven by jealousy.

the main themes of the works, as well as being delivered in the artistic mode indicated earlier.

8.2. AUTONOMIST AND CONTEXTUALIST OBJECTIONS

The previous section developed two arguments in favour of the aesthetic claim of cognitivism and replied to some objections to those arguments. There are also several anti-cognitivist objections, not directly to the arguments for the aesthetic claim just advanced, but to the position itself.

The first such objection is Stolnitz's claim that there are no *distinctive* artistic truths, since anything that one may learn from art could always be learned from some other source. Art is thus unlike genuinely cognitive domains, such as science or psychology, which do possess distinctive truths.[12] One way to understand this argument is as an attack on the aesthetic claim of cognitivism: the value of art must be distinctive (that is, unique) to it; cognitive values are not distinctive to art (being shared with other domains); so the value of art is not cognitive. Anyone who believes that there must be a single, unique value to art will find this argument compelling. However, pluralists believe that there is a plurality of artistic values; so they can hold that the only sense in which there is a distinctive value to art (if art does have a distinctive value) is that there is a unique *combination* of different values in art. If so, one kind of the values in the combination can be cognitive ones (as well as beauty, expressive power and so forth). So Stolnitz's argument fails against pluralist cognitivism.

A second objection is that cognitive values cannot possibly contribute to aesthetic ones, since any truths that art may convey are banal, such as 'Stubborn pride and ignorant prejudice keep attractive people apart'.[13] If that were all that we could get from Austen's novel, it could go no way to accounting for its worth. The most direct response to this is that art not infrequently conveys non-banal general propositions. Novels frequently implicitly or explicitly incorporate general and interesting views about psychology and history: consider the ruminations on the significance of the fact that we live our lives only once in Milan Kundera's *The Unbearable Lightness of Being* and of how that thought structures the entire narrative and tone of the work. And any literary work with a moral point of view is likely implicitly to advance propositions that are not banal (whether or not they are true); we have already seen how works such as *Sophie's Choice* can

[12] Stolnitz, "On the Cognitive Triviality of Art", pp. 197–9. The point may instead be intended as an objection to the epistemic claim; but, if so, it fails, for a discipline might provide truths, even though every truth it gives is shared with some other discipline.

[13] Ibid., p. 193. This point can also be construed as an attack on the epistemic claim, which holds that art can convey *non-trivial* knowledge.

explore moral dilemmas, and the existence of dilemmas is certainly not banal. Or consider *Macbeth*: Shakespeare manages to show there that a certain kind of courage can subsist with evil, yet that is an idea that is still widely resisted, as witness the widespread ritual denunciations of terrorists as cowardly. Evil they may be; cowardly they are not.

However, the more important point is that learning in general, including moral learning, is not invariably a matter of the acquisition of general principles. Moral learning may indeed involve the acquisition of principles, but also involves the acquisition of many other skills and dispositions, such as the ability to imagine what it is like to be in someone else's position, or the ability to view a situation free of the distorting effects of one's own interests, as we saw in the previous chapter.[14] One way to learn morally is by seeing a person's situation as relevantly like another's to whom we know how to respond, and this can make the moral learning involved in our response to art both non-banal and aesthetically relevant. For instance, Tolstoy gives us a portrait of Anna Karenina that has psychological reality and depth, and Anna is presented in such a way that we are encouraged to view her sympathetically, rather than as a heartless woman who abandons a loyal husband. If one comes to learn morally from this artistic achievement, then one acquires the ability to see a real woman caught in a similar situation as an Anna Karenina. One thereby gains the ability to apply to a real woman the feelings and insights won through the fictional portrayal. The nature of one's moral insight, then, is not fully specifiable apart from the specifics of the characterisation and of the novel in which it features, and therefore is sensitive to aesthetically relevant qualities. Yet it is a genuine moral insight that has been achieved.

Here the mechanism of 'seeing-as' is crucial: characters and situations represented in artworks can be employed so that one sees real people and situations in terms of them, and one thereby gets to understand real persons better. In this way, represented characters can function as new concepts, by deploying which one can grasp subtle features of the moral world that otherwise might have escaped one's attention: one sees a real woman as an Anna or as a Bathsheba-as-viewed-by-Rembrandt, and thereby comes to think about her and react to her differently. Likewise, one can see real situations in terms of fictional ones—one may think of a situation as an *Antigone*-type situation, or a *Sophie's Choice*-type situation. It is not a good objection to this that fictional characters and situations are too specific, or indeed unique, for such a mechanism to be cognitively fruitful.[15] For seeing one thing as or in terms of something else allows one to focus on differences

[14] Note too that, even if one believes that there is a complete set of moral principles, which exhaustively specifies what one ought to do, there is still the question of how these principles are correctly applied. According to the moral pluralist, though, not all moral knowledge can be captured by principles: see my "Moral Pluralism".

[15] Lamarque and Olsen, *Truth, Fiction, and Literature*, pp. 394–5, object to the notion of literature as moral philosophy that literary works are unique and the situations they describe are unrepeatable.

as well as similarities, and an awareness of relevant differences can be the source of insight as well as can an awareness of similarities. In implicitly equating moral insights merely with the grasp of moral principles, then, autonomists fail to see that certain moral achievements are not fully separable from certain aesthetic achievements.[16] And, through their presentation of particulars, works can also implicitly argue for extensions of moral concepts or feelings: the First World War poets, such as Siegfried Sassoon and Wilfred Owen, through their presentation of the horrors of the trench warfare, argued for a conception of war as horrific, not ennobling, and for a notion of courage that encompassed conscientious objection as well as military valour.

The same point about the importance of 'seeing-as' answers a (third) objection due to Peter Lamarque. He claims that any moral insights that a tragedy may provide are irrelevant to its aesthetic value: "either the moral lesson is too close to the work, tied too specifically to the characters and incidents in the work, in which case it cannot function as an independent, generalisable moral principle, or the moral lesson is too detached, too loosely connected to the specifics of the work to be perceived as part of the literary content or meaning that the work expresses."[17] We can understand this as posing a dilemma for the cognitivist: either a moral view advanced by a work has no application to the world, since it is tied to the specifics of a work, and so it has no cognitive value; or it does have such application and therefore cognitive value, but then it is not part of its literary meaning, and therefore is irrelevant to its literary value. This dilemma is a false one, however. By learning, as we have just noted, through seeing features of the world in terms of features of fictional situations and characters, what one has come to know brings together the two putatively irreconcilable wings of the dilemma: one has a non-banal moral insight that is not fully specifiable apart from the specifics of the characterisation in the work.

Fourth, it has been noted that great works differ greatly in their cognitive claims and may even contradict each other. This being so, it cannot matter to their aesthetic value whether the works' claims are correct or not. William Gass writes that "Balzac sees the world quite differently than Butor does; Goethe and Milton cannot both be right; so if being right mattered, we should be in a mess indeed, and most of our classics headed for the midden."[18] Gass also applies the point specifically to ethical qualities: "The moral points of view in works of art differ as enormously as Dante's do from Sophocles', or Shakespeare's from Milton's. Simply consider what we should have to say if the merit of these writers depended at all upon their being correct, even about anything."[19] We can add that great works disagree not just amongst themselves, but also with many of our

[16] The cognitive importance of the ability to see real people as fictional characters or to see aspects of fictional characters in real people has also been urged by Gordon Graham, "Learning from Art", and related considerations are also found in Beardsmore, *Art and Morality*, ch. 5.

[17] Peter Lamarque, "Tragedy and Moral Value", p. 140.

[18] Gass, "Goodness Knows Nothing of Beauty", p. 43. [19] Ibid., p. 42.

current views of the world—many lovers of Milton's verse would not sign up to his fully fledged theodicy.

In discussing the moral conflicts between masterpieces, it is easy to exaggerate how great they are, as we noted in Section 4.2. Dante believed in the Christian virtues, and, though distinct in many ways, they are not entirely alien to the virtues that Sophocles embraced. The value of truthfulness and the horror of incest that *Oedipus Rex* embraces were attitudes that Dante shared, and the tensions between loyalty towards one's political leader and loyalty towards one's family playing out in the conflicts in *Antigone* were also ones that Dante, an inhabitant of strife-torn Italy, was all too familiar with. Though the religious views of the works clearly vary, we are not with these masterpieces dealing with the kind of fundamentally distinct and abhorrent moral views that *The 120 Days of Sodom* celebrates.

However, differences remain, particularly in respect to non-moral claims (the metaphysics and religious views of Milton and Lucretius are radically different, for instance). So the question arises as to what one should say in such cases. First, we should of course embrace pluralism, holding that there are several values besides cognitive ones; so a work might have a cognitive defect, but still overall be judged a great work because of its other aesthetic merits, such as its beauty, expressive power, scintillating style and so on. Second, a work can have many cognitive merits, while being wrong about many things. A work may introduce interesting new concepts and exhibit important imaginative skills, while being wrong in its claims—for advancing true propositions is only one aspect of cognition. (Indeed, this is why, on purely cognitive grounds, one can think that both Hume's and Kant's philosophical works are great achievements, even though they cannot both be right, since they contradict each other in their central claims.) And it is quite possible for a work to be wrong about what its author would have thought of as its most important claims, but for others of its claims to be insightful, and to seem to us, who do not share the author's basic views, to be more important. Even if we reject Milton's theology, we can still celebrate *Paradise Lost* for its acuity about the psychological dynamics of pride, its insights into how a kind of heroic courage can subsist with evil, and its clarity into the confused corruptibility of innocence. The theology may be wrong, but the psychology is marvellous. Third, if an author presents a view as true of the actual world, he or she must logically hold that the view is true of a possible world (since the actual world is a possible world). So an author is implicitly making a claim in advancing a view as true, maintaining that there is a possible world in which it holds. This allows for the author to be correct about features of this possible world, while being wrong about the actual world. So an author can be right in believing what would happen, if such and such were the case, but nevertheless be wrong in believing that such-and-such is in fact the case (he can, of course, also be wrong about the conditional claim). Given Milton's theological premises, his views about what would happen in such a world, and

the way that people ought to behave in it, have some considerable conviction. So one can hold that the poet is right in what he says of this possible world, and so his work has this cognitive merit, but that he is wrong in holding that this is true of the actual world, so his work has in that respect a cognitive defect. This leads to the surprising, but I think correct, conclusion that Milton's work would have been artistically even better than it is in one respect, had his religious views been correct. And it also follows that religious believers and atheists may legitimately differ in their assessment of the artistic value of religious works; for the believer may hold that there are in such works deep spiritual insights, subtly and skilfully conveyed, whereas the atheist may see them merely as the expression (however subtly and skilfully done) of a tired, discredited and irrelevant view. It is simply a formalist dogma to insist that, despite their differing views of the world, two people must in principle always be able to agree on the exact artistic value of a work that expresses the views on which they differ.

 We can lend support to this latter point if we consider cases where works differ in their ethical views, and where we are asked to endorse these views, rather than merely to imagine what it would be like to hold them. In these cases it is clear that the authors are making moral claims meant to apply to us as we are, rather than to merely hypothetical beings. In objecting to cognitivism on similar grounds as Gass, Arnold Isenberg considers two poems, one by George Herbert, warning against the dangers of lust, and one by William Blake, attacking religion's opposition to carnality, and holds that, while they both have positive aesthetic value, they cannot both have positive ethical value, for they stand on opposing sides in the ethical debate.[20] Here are two stanzas from the poems that Isenberg quotes, the first from Herbert's "The Church-Porch", the second from Blake's "The Garden of Love":

> Beware of lust: it doth pollute and foul
> Whom God in Baptisme washt with His own blood.
> It blots the lesson written in thy soul;
> The holy lines cannot be understood.
> How dare those eyes upon a Bible look
> Much lesse towards God, whose lust is all their book?
>
> I went to the Garden of Love,
> And saw what I never had seen:
> A Chapel was built in the midst,
> Where I used to play on the green.

Few would now dispute that Blake's poem is the greater of the two. Herbert's imagery is staid and conventional, with its talk of the book of the soul and of God's blood washing away sins; its rhythms are heavy and plodding; its tone that of a hectoring preacher addressing a weary congregation on a drab

[20] Isenberg, "Ethical and Aesthetic Criticism", pp. 272–3.

and rainy Sunday morning. Blake's imagery, in contrast, draws on Christian sources but plays with them, shifting their focus and import, the Garden of Eden becoming a garden of more than merely spiritual love and is linked to childhood innocence; the poem's rhythms are light and tripping, mirroring its celebration of the pleasures of love, drawing the reader into acknowledging the power of Blake's ethic. One reason that Blake's poem has much greater charm and power is because it celebrates a view of love that we are likely to find attractive, in contrast to Herbert's advocacy of an ethic that, even for many contemporary religious believers, seems cold and shallow. The ethical differences are displayed in the characters of the manifested artists: Herbert as he manifests himself in the poem is a forbidding figure, dogmatic, intolerant, keen to beat down and bind what we see as legitimate pleasures; Blake, in contrast, shows himself as a nimble and attractive celebrant of a view about love that we are likely to share. So in these poems, where moral views genuinely clash, the correctness of Blake's view, as embodied in his poetic presence in the poem, through its imagery, rhythms and tone, does indeed contribute to the aesthetic power of his achievement, and Herbert's dour advocacy of an unattractive view flaws his poem. Someone might, of course, object to the ethical judgements about religion and love just made. For such a person, Herbert's dourness might be seen, rather, as stern nobility, justly adhering to the truth; and Blake's nimbleness might appear instead as a shifty and shallow evasion of responsibility. The related aesthetic evaluations of the poet's manifested personalities would thereby partly change as well. Change the moral characterisation, and some of the aesthetic evaluations shift too. As the ethicist maintains and the autonomist denies, ethical qualities matter.

A fifth objection to the aesthetic claim centres on the notion of the aesthetic attitude, and holds that this is incompatible with learning from a work. Terry Diffey, in defending a "qualified formalist" view, holds that:

An aesthetic response to art involves the suspension of reference by taking the work to be holding up states of affairs for inspection, scrutiny, or, to use the traditional term, contemplation. So, to learn from a work of art, that is, to move from what is shown in the world of the work to an assertion of what obtains in the world, requires a refusal of the aesthetic stance, the stance distortedly expressed in Bell's remark that we need bring to art nothing from life.[21]

If this is so, then any moral learning from art is similarly alien to the aesthetic stance, and hence any moral insights provided by art are irrelevant to its aesthetic value.

Diffey's argument here recalls the invocation of the aesthetic attitude to argue for moderate autonomism that we discussed in Section 4.2; the difference is that he holds that the contemplative nature of the attitude blocks cognitive assessment in general, rather than specifically moral assessment. But

[21] Diffey, "What Can We Learn from Art?", p. 30.

similar points in rebuttal apply: having an aesthetic attitude is consistent with taking a practical stance towards the work, as the case of the artist making her work shows; and, even if contemplation were an essential aspect of the stance, this is consistent with learning from a work, since one can learn from things that one can only contemplate, rather than do anything about, such as historical events.

There are further problems with the argument. Works of art include non-fictional works. Some film documentaries, portrait paintings, poems that record personal experiences, many works of literature, including some biographical works, memoirs (such as Mary Karr's *The Liars' Club*), some historical works (such as Gibbon's *Decline and Fall of the Roman Empire*) and so forth are works of art, yet are non-fictional (which is not, of course, to say that they are always accurate). In all these cases, reference is straightforwardly to the real world, and it is a legitimate aesthetic criticism if one says that they are unfaithful to the facts, or distort the truth in various ways. Moreover, even fictional works may advance explicit or implicit claims that refer to the real world. George Eliot writes in *Middlemarch*: "There is no general doctrine which is not capable of eating out our morality if unchecked by the deep-seated habit of direct fellow-feeling with individual fellow-men."[22] That is an unrestricted claim about the real world, and one relevant to the aesthetic assessment of the novel, since it structures so much of Eliot's presentation of character and narrative, including, in the immediate context of its issuance, her treatment of Bulstrode. And implicit assertions of some generality and application to the real world are rampant in novels. Jane Austen's treatment of Emma advances the implicit claim that rich, attractive and spoilt young ladies are not likely to be the best judges of their own character and motivations, or to be good mentors to others. Again, the reference of the implicit assertion is unrestricted, and again is aesthetically relevant, since so much of Austen's novel is structured around that thought, as Emma is educated in the hard school of moral knocks.

Peter Lamarque and Stein Haugom Olsen have advanced a (sixth) objection to the aesthetic claim that is rooted in the idea of a literary practice. Unlike Diffey, they do not deny the aesthetic relevance of explicit or implicit general assertions that encompass the real world, and so they would allow that such reference occurs. Their claim is that the *truth* of these assertions matters not at all aesthetically. The literary stance is characterised as one in which the reader seeks literary aesthetic value, and this value is a matter of humanly interesting content organised in complex and coherent form. Humanly interesting content is a matter of the subject (the events recounted and situations described) and especially of the themes presented. These themes have greatest value when they are not merely topical but are of perennial interest. Works of literature elaborate and develop such themes, such as that of the futility of opposing the forces

[22] George Eliot, *Middlemarch*, p. 668.

of history by individual effort, a theme found in *Julius Caesar*. What matters, from the point of view of literary value, though, is that the content of a work carried by its themes is of interest, not that this content be true.[23] Lamarque and Olsen's main argument for the latter point is that literary value, and indeed literature itself, is constituted by a set of institutional practices of production and reception, and that such practices have no place for the assessment of the truth of a work's content. So there are, for instance, branches of literary studies concerned with narrative techniques and the identification of motifs in works, but there is no branch of literary studies concerned with assessing the truth of the general thematic statements in works.[24] Contrast this with philosophy, where debate about the truth of the views advanced is at the heart of the reception of philosophical works. So Lamarque and Olsen advocate a "no-truth" theory of literary value; and it follows from this that the truth of any moral claims, implicitly or explicitly advanced by works, is also irrelevant to assessing the works' literary worth.

In a later article, which develops some of these points, Lamarque explicitly acknowledges that literature (as well as fiction) can offer distinctive opportunities to learn, and so it is clear that he would not challenge the epistemic claim. It is the aesthetic claim that he rejects. For he holds that these learning opportunities are not *essential* to the practices of literature (or fiction), for it is not true that the constitutive end of these practices is truth (a constitutive end of a practice is an end that at least partly defines the practice). Again he contrasts literature with a genuinely cognitive practice, such as philosophy, where the constitutive aim of philosophical writing is truth and works are evaluated in terms of the achievement of this aim. Literary values, in contrast, concern the exploration and development of themes as they are manifest in the details of a work.[25] So, though we may learn from fiction and literature, we should not confuse "the contingent by-products" of these practices with "the very nature of the practices themselves".[26]

The first point to note is that this no-truth theory of literary value, even if it were true, would not undermine all forms of the aesthetic claim. For, as already noted, learning encompasses knowledge of how to do things, as well as knowledge that something is the case. Know-how is a matter of skills, not of propositional truths, and we have seen that artworks achieve much of their cognitive aim by guiding us to increase our conceptual and affective discriminations, employing 'seeing as' in a central manner. So the no-truth theorist should allow that versions of the aesthetic claim cast in terms of knowledge-how have not been undercut by his view.

[23] Lamarque and Olsen, *Truth, Fiction, and Literature*, chs 10 and 11. Themes, they appear to hold, are expressed by nominal phrases (e.g. 'the futility of war'), so cannot strictly speaking be true or false; but thematic statements or theses (e.g. 'war is futile') can be.

[24] Ibid., ch. 13, especially pp. 331–8.

[25] Peter Lamarque, "Learning from Literature", pp. 16–17. [26] Ibid., p. 21.

Second, Lamarque's later discussion of the notion of a constitutive end allows us to see that it is only an extremely strong form of cognitivism that the argument, if sound, would be justified in rejecting. Let us agree that it is not a constitutive end of the practice of literature that it aims at truth; this supports the claim that it is not *essential* to literature that truth is a literary value. So the practices argument would undermine what we might call *cognitivist essentialism*—that it is essential to any literary practice that it takes truth as a value. But this doctrine is stronger than the cognitivism defended here (or by the general run of cognitivists), which does not make an essentialist claim. For values can be *genuine* literary values without being *essential* literary values. (A property is an essential literary value just in case it is a necessary condition for any practice of writing to count as literary that it acknowledge that property as a value.) Complexity and expressive properties are uncontentiously literary values when possessed by literary works, but one can imagine literary practices that did not acknowledge them as values—such practices might aim for the purest simplicity or abjure all expressive properties, aspiring to be the literary equivalent of some kinds of conceptual art. One can even imagine practices of literature in which the exploration and development of themes-as-manifested-in-details would not be counted as a literary value. Such practices might consist entirely in the writing of pithy epigrams (themes without their development through details) or in the subtle and evocative description of experiences (details without the themes). So, given his implicit move from what is an essential literary value to what is a genuine one, Lamarque would have to reject his own candidate for literary value on the same grounds that he rejects truth as a literary value. Values can be genuinely literary or artistic without being essential to the practices concerned; and this is just as well, since one should have serious doubts as to whether there is an essence, in the ordinary sense of the term, or constitutive end of art in general.[27]

So, for both these reasons, the practices argument would, even if sound, do comparatively little damage to the aesthetic claim.[28] But the argument is not sound. As we saw in Chapter 5, it has been a recurrent ambition of literary writers to advance truths, including moral truths, through their works, to teach virtue through pleasure. This being so, if one appeals to an institutional practice of

[27] See my " 'Art' as a Cluster Concept".

[28] Ironically, Lamarque and Olsen's own criterion of literary value—humanly interesting content in complex and coherent form—seems to support cognitivism. What would it be to think that an implicit assertion made by a work were interesting, but not to be interested in whether or not it were true? Suppose that a work advanced the view that all humans, even the apparent altruists, are completely selfish, and that one finds this an interesting claim. On the no-truth view, one need not be at all interested in whether or not the claim is true. But that would be an extremely odd state of mind in which to be. Assertions aim at the truth, so to be interested in them requires one to be interested in their truth-value, if one is rational. (For a somewhat different ground for querying whether the notion of the interesting can be separated from that of the true, see Gregory Currie, "Review of *Truth, Fiction, and Literature*".)

literary production and reception, then one should acknowledge that moral and other truths are germane to literary value. Lamarque and Olsen are, of course, well aware of this recurrent ambition, and cite George Eliot, amongst others, in this context. Their reply is that, since they are talking of an institutional practice, what matters are the conventions that constitute the practice, not the intentions of particular individuals.[29] Yet, given the long-standing nature of the desire to teach virtue through pleasure, it is arbitrary to exclude this ambition as a legitimate part of the practice of the production of literature and its reception. Moreover, even if one found some good reason to do so, given the fact that very many novelists have had moral aims—moral views the truth of which they advocate through their writings—there would be good reason to reform the practice to be sensitive to such aims. If the institutional practice of literary reception were deaf to the moral ambitions of the works it is studying, then it should start to listen to them.

Moreover, it is not true that readers are indifferent to the truth of the views, especially moral ones, advanced by works when they engage in literary appreciation. Lamarque and Olsen's evidence that they are indifferent is that there is no branch of literary study devoted to debating and assessing the truth of claims contained in works. But note that there is a distinction between being indifferent to truth and debating whether something is true. One may simply accept some statement as true, or as false, without debating it. And in most cognitive domains most assertions are simply taken as true, or false, without debate: most historical factual claims are taken simply as established, and historians tend to confine their debates to matters of interpretation or discussing a small number of disputed events. The lesson is that literary critics may also simply be taking most claims advanced by works to be either uncontentiously true, or uncontentiously false. Indeed, the prevalence of denunciations by political critics of false stereotypes in literature of women, blacks, working-class characters and so on shows that these critics are certainly concerned with the truth of the characterisation of kinds of people in literature.[30]

However, it is not even true that readers do not debate the truth of literary claims. Peter Kivy has pointed out that such debates occur in the "afterlife" of the literary experience, when readers mull over the views advanced by works, particularly the religious, moral or metaphysical hypotheses advanced by works. Indeed, readers must do this, if they are to establish whether these hypotheses are 'live' or 'dead' ones for them. Kivy also notes that works' having this power to produce extended reflection after the reading experience is finished is a mark of their possessing literary merit, a feature absent in the reading of minor science

[29] Lamarque and Olsen, *Truth, Fiction, and Literature*, pp. 331–2.

[30] See M. W. Rowe, "Lamarque and Olsen on Literature and Truth". Carroll, "The Wheel of Virtue", p. 25, also draws attention to the importance of political criticism in this respect, and notes that political critics also sometimes use arguments against the supposed reactionary positions they find in works.

fiction or crime novels.[31] In fact, in respect of moral claims, reflective assessment is even more direct and immediate. Readers can and do assess the moral views implicitly or explicitly presented in works, and they discuss whether particular characters acted correctly or whether the author has been fair in her treatment of them. Is Anna Karenina to be blamed for her actions in leaving Karenin, or is she legitimately following the dictates of her heart? Is George Eliot unfair in her treatment of Casaubon? In holding that a character did the right thing, or that the author treated a character fairly, we are advancing moral judgements as true. And, given the universalisability of moral judgements, such claims implicitly apply to all similar cases. Moral debates are a recognisable part of literary discussion, and their resolution bears on the aesthetic quality of works.

It also follows from the no-truth theory that only the content of a theme matters to the literary success of a work, and not the truth of its thematic statements. Yet this is highly implausible. To take Lamarque's example, the critic J. Hillis Miller praises Dickens's novel *Our Mutual Friend* because "The novel is a brilliant revelation of the results of this false worship of money". Lamarque objects that this is not a reason to value the novel artistically, for such a theme is "thin and banal", endlessly treated in literature. So, he holds, the truth of the proposition expressing this theme does not contribute to the literary value of the novel; what matters is how the theme organises and makes sense of the particularities of the novel.[32]

However, this is not a genuine dichotomy. The cognitivist should admit that the theme as stated is thin and banal; but, as we noted, the object of our aesthetic interest lies in a cognitive claim as expressed in the particularities of the work—through the details of characterisation and narrative, and implied in the feelings prescribed by the work. That is very similar to Lamarque's view that the object of our literary interest is the theme as manifested in the details. So the value of detail and its relation to theme is not under dispute between the cognitivist and the non-cognitivist. What is in contention is whether the *truth* (amongst other cognitive features) of the propositions expressing the theme matters aesthetically or not. If the non-cognitivist is right, the theme's truth matters aesthetically not at all. But, if that were so, one could imagine an equally successful novel as *Our Mutual Friend*, which had as its theme the contrary of that novel's theme. This novel—call it *Our Common Enemy*—has as its theme that the worship of money is the greatest of human goods, and other values such as love, companionship and human achievement are mere glittering illusions, baubles to be cast aside for the enduring value of wealth. The hero of this novel is a miser, and the novel shows us how, by giving up all of the chimerical opportunities for friendship, love, achievement and understanding in his life, he discovers that the only deep, true value is amassing huge wealth. In

[31] Kivy, "The Laboratory of Fictional Truth", especially p. 134.
[32] Lamarque, "Learning from Literature", pp. 17–18.

its closing scene, *Our Common Enemy* celebrates the miser lovingly fingering his gold, having achieved true satisfaction, while all the other characters in the novel, who pursued other values, are revealed as shallow, trivial creatures, blind to what really matters in life. Clearly, this novel is not going to be an artistic success, for, as we try to develop the theme through the details of characterisation, narrative and how the reader is invited to respond to events, we end up with patent absurdities. How could one write that last scene so as not to make it simply ludicrous? (Of course one could write a novel like this as a spoof or parody, but that is a case where the theme is handled tongue-in-cheek, not seriously meant.) It is precisely *in* developing a theme through the details of a work, then, that its truth becomes of artistic relevance, in part because it allows a depth and correctness of characterisation that the false theme resists.[33]

Lamarque has protested against this type of objection that it is "spurious", noting, amongst other things, that "no literary judgment is possible without a work to judge".[34] Now it is mercifully true that *Our Common Enemy* is not a real literary work and exists only as the sketchily described content of my thought-experiment. But to ban thought-experiments in this context would be to undermine a central method of philosophical knowledge. (Of course, the sketchiness of the description might inspire the no-truth theorist to try to fill it out so that the novel does not have the absurdity that I claim; but that is to apply the method in more detail, not to show that it is illegitimate.) Moreover, if thought-experiments were declared illegitimate in this context, then the no-truth theorist's claim of aesthetic irrelevance loses content. For to say that the truth of any thematic statements is aesthetically irrelevant entails that changing their truth-value would make no aesthetic difference; but, if this is so, then one must allow the legitimacy of thought-experiments in which the truth-value of the claim is reversed, or else the theory is eviscerated of content.

Though his non-cognitivism should be rejected, Lamarque's discussion does bring out an important point. Truth and cognitive values in general are of more central importance to practices such as philosophy (or indeed to science, history, psychology and so on) than they are to art; for the ultimate aim of these disciplines is explanatory truth. But to acknowledge that the same is not true of art is quite consistent with holding that truth, and cognitive values more generally, feature among the many aesthetic values that are possessed by artworks. In this respect, Lamarque has produced quite a tasty pudding; it just got over-egged.

The six objections to the aesthetic claim considered so far have all been launched on behalf of moderate autonomism (in a broad sense that holds that the ethical and cognitive values of artworks are irrelevant to works' aesthetic

[33] See Rowe, "Lamarque and Olsen on Literature and Truth", for a similar objection directed at Lamarque and Olsen's treatment of a theme in *Middlemarch*; and see also Currie, "Review of *Truth, Fiction, and Literature*".

[34] Lamarque, "Cognitive Values in the Arts", pp. 138–9.

value). The final objection I will consider to the cognitivist argument for ethicism is rather different. The objection, due to Matthew Kieran, accepts aesthetic cognitivism, but denies that any version of moralism follows from it: rather, aesthetic cognitivism entails contextualism, and so is incompatible with ethicism.[35] The core of the argument can be represented in broad outline as follows.

First, a primary way in which one can fully appreciate and understand experiences is to have these experiences; this includes having experiences of morally bad responses and attitudes.[36] The notion of such morally bad experiences includes both being subject to experiences that are morally bad or problematic in some way, and also experiencing things in a morally bad way. Second, one can also learn from experience indirectly, by having imaginative experiences, such as those afforded by artworks. The conclusion is that artworks, by affording us imaginative experience of morally bad or problematic responses and attitudes in a morally bad way, can deepen our understanding of these responses and attitudes, and so we can learn about morality through works that are morally bad; hence cognitivism supports contextualism (or "immoralism", as Kieran calls it).

For instance, to understand why people are attracted to bullying, it will help if I am bullied, but it will help even more if I bully someone else, and feel the attractions of exercising power. (That is, it will help if I am subject to morally bad experiences, as being the victim of bullying, and also if I experience things in a morally bad way, such as enjoying bullying someone.) However, we fortunately do not need actually to bully or be bullied to gain this knowledge; reading Graham Greene's short story "The Destructors", for example, gives us the imaginative experience of the joys of bullying, for we are invited by the story to have the imaginative experience of feeling delight in the wanton destruction by a gang of boys of the house of a man who has been kind to them. So the story shows us how destruction of things precious to someone can be deeply joyful, and hence gets us to learn something by virtue of its immoral attitudes.

What exactly is it to have an imaginative experience, particularly as concerns moral attitudes? Kieran remarks that we can "allow ourselves to take up moral judgements and attitudes in imagination".[37] This might mean two distinct things: that one *imagines* taking up a moral attitude towards some state of affairs, or that one *actually* takes up an attitude directed towards an *imagined* state of affairs. At various points in Kieran's paper, one notion or the other seems to be

[35] Kieran, "Forbidden Knowledge".

[36] Kieran also claims that a primary way, or perhaps even a necessary way, in which to understand morally good experiences is by having morally bad ones. He expends some effort on arguing for this, but it is not in fact necessary for him to do so, since the cognitivist should acknowledge the cognitive value of understanding bad experiences as well as good ones. Besides removing this "Primacy Claim", I have also reduced the steps in his argument but have not omitted anything essential to it.

[37] Kieran, "Forbidden Knowledge", p. 68.

in play.[38] On the first construal of the idea, it is perfectly possible for someone to imagine having an immoral attitude, and to be invited by a work to do so, without the imaginer doing anything immoral or the work being immoral. A detective might imagine having the attitude of finding murder wonderfully enjoyable, the better to understand the mind of a murderer whom he is trying to catch, without being in any way morally compromised by his imagining. It is the purpose of the imagining that determines its moral status here. So the first sense of 'taking up an attitude in imagination' does not show that a work teaches us something by getting us to respond in an immoral way. Hence a cognitivist argument for contextualism gets no grip on this construal. (And it is possible to learn by imagining having immoral attitudes, so it would also be false to claim that it is only by the actual having of such attitudes that one can learn about immoral attitudes or feelings.) In the second disambiguation of the term, there is an actual attitude directed towards merely imagined states of affairs—for example, the detective would come to feel real delight and approval of his imagined murderous actions. If an artwork asks the reader to respond with an actual immoral attitude directed towards imagined states of affairs, then the work has indeed invited us to take up an immoral attitude. In this case, the work is immoral in this respect, but does it teach us anything about immorality? Since it presents an immoral state of affairs as morally good, then it does not, since one cannot (successfully) teach someone something false. So, again, cognitivist contextualism fails, this time because the cognitive aspect lapses. So on the first disambiguation, taking up an attitude in imagination teaches us something, but the imagined attitude need not be immoral, and on the second disambiguation, the attitude is immoral, but it does not *ipso facto* teach us, since it falsely represents what is immoral as being morally permissible.

Now it may be protested that this last point fails to specify adequately the content of what is being taught. For instance, in the Greene example, what is being taught is that bullying can be enjoyed (and that is true), not that bullying is morally good. Suppose that is so; then now the content of what is taught is true, but the attitude invited by the work is not *ipso facto* immoral: the work is inviting us to contemplate this (morally neutral) truth, by making it vivid to us.[39]

Suppose instead that the work actually invites an immoral attitude of enjoyment to the imagined events, and thereby implicitly endorses such attitudes. One could still come to learn something from such attitudes—for instance, that bullying can be enjoyed. And this is perhaps the situation that Kieran has in

[38] For instance, at ibid., pp. 68–9, in discussing "The Destructors", it seems to be actual attitudes, such as desiring things, directed towards imagined states of affairs that is meant; but at other places, such as on p. 71, where he says that one may "imaginatively explore different possible attitudes", it seems to be the sense of imagining having an attitude that is meant.

[39] Another possibility that does not morally taint the work, but rather can give it moral value, is where the work only *appears* to adopt an immoral attitude, which it in fact condemns, with a view to showing us our moral fallibility; this is the seduction strategy, to be discussed in the next section.

mind. But note that now one has learned something distinct from what the work is trying to teach one (that is, that bullying is morally fine, whereas what one has learned is that it can be enjoyed—a different content). But, if this is the claim, then we should recall that cognitivism (in its full version) is a thesis about what a work teaches us (see Section 7.1). It is perfectly possible to learn a lot from people with false or even deluded views. Recall the incompetent plumber: the fact that I have learned from him does not reflect any cognitive or epistemic merit in him—rather, I learned from him because he was so misinformed. Similarly, I may learn from a Flat-Earther, who accosts me on my doorstep with his crazy views; but what I learn is not what he is trying to teach me, that the earth is flat, but, rather, something about the ability of humans to produce elaborate cognitive fantasies. Learning this from him does not require me to impute any cognitive virtue to him—on the contrary, he lacks basic cognitive virtues, such as having a grip on reality, and that is why I have learned something from him about the power that epistemic delusions can have on people. If he had written a novel expressing his views, rather than berating me personally, then I could come to learn the same things from it, but the novel would not thereby manifest any understanding or cognitive merit. Since it lacked cognitive merit, it would on an aesthetic cognitivist view also lack any aesthetic merit in that respect. Rather, it would be both cognitively and aesthetically flawed by virtue of seriously advocating flagrantly false views. For reasons we have seen, one ought not to formulate cognitivism in terms of learning something, where this is not correlative to the work teaching us that thing. And this argument for cognitivist contextualism nicely illustrates why, unless we are careful about how we understand cognitivism, we will be led to false conclusions.

8.3. TECHNIQUES AND STRATEGIES

I have argued that artworks can teach us, and that this capacity is under certain conditions an aesthetic merit in works. The current section investigates some of the methods that art employs to do this, and illustrates their aesthetic relevance. Its point is both to show the richness of the resources that art has in its cognitive employment, and also, by providing detailed discussion of how artworks can teach us, to show that there is nothing alien or anti-aesthetic about these techniques and strategies. On the contrary, they lie at the heart of much narrative art.

I am going to focus on representational, narrative works, for these are central for moral learning; but it should be noted that even abstract works can teach us, particularly about sensory matters, for they can get us to see things and to notice visual and acoustic subtleties that we might otherwise have missed. Josef Albers's series of paintings *Homage to the Square* consists in variations of colours within a common format of one square set within another. Albers thought of himself as a colour-theorist as well as a painter, and wanted to discover what

subtle phenomenal and affective results could be obtained by juxtaposition of different colours. He, and his audience, can learn about the phenomenal features of colours by viewing these works. And this general point about sensory learning is true also of representational art, which by highlighting often subtle visual features of form or colour can enhance our sensitivity towards and appreciation of the visual world.

Representational artworks have a number of resources that can be employed to guide us to greater moral sensitivity and awareness. Several of these are quite straightforward and are widely available to many kinds of representations, not just artworks. First, most works are other-centred—that is, they deal with people other than the reader or viewer; the audience can more easily take up an unbiased view of others' conduct than they can of their own actions; and they can then see their own actions and characteristics in those of others. Recall the encounter between King David and Nathan in the Bathsheba Bible story: David is led to see the wrongness of what he has done by Nathan's parable of the poor man with his beloved ewe. What this simple story makes explicit, good artworks tend to accomplish implicitly and more subtly: a reader may recognise some of her character traits or actions in Emma's interference in Harriet's love life, for instance, without it being explicitly signalled that the reader should ponder whether there is any relation between fictional events and her own life. Second, representational works are public objects, so they allow the coordination of imaginings: most evidently, the artist's imagining that has produced the work is coordinated with that of the reader, but also the imaginings of members of the audience are coordinated with the imaginings of other members of the audience.[40] One of the roles of criticism is to allow readers and viewers to imagine together, and to discover more in the work than they could have done separately. This feature can also mitigate the biases of one's own imagination, for one tests one's reactions against those of others. Third, artworks are usually non-interactive—that is, the audience cannot intervene in the world represented in the work; so they are encouraged to scrutinise the represented world in a way that is sometimes not possible in life, with its call for action. Since the audience cannot act towards the represented world, they have the time to assess the details of the situation, imagine what it would be like to be in it, to think about its rights and wrongs, and to consider the various ways in which one should act towards it, if this were possible. This is particularly fruitful as far as the representation of moral dilemmas is concerned, since in such cases there is no right action and the situation is standardly complex, so it merits lengthy consideration. Fourth, those representational works that are fictions can help us better understand others' moral situations. Our knowledge of real-life people is often severely circumscribed, even when they are friends; even more so when they are strangers or merely historical figures. We often know little about what they were thinking

[40] On coordinating imaginings, see Kendall Walton, *Mimesis as Make-Believe*, ch. 1.

or feeling at crucial points in their lives, so we are deprived of much of the material we would need for successful imaginative understanding of them and of what they should have done. This is not so in the case of fictional representations (which includes the fictionalising of real events): the author can give us as much material as we need to engage in this kind of understanding. Experiences, feelings, emotions and the most intimate thoughts can be laid out for us, so that we can better imagine what it is like to undergo those events and be that kind of character, and therefore we can adopt the kind of imaginative acquaintance that we saw in the previous chapter is so important for ethical understanding.

So far we have considered some general features of representations; but there are also features of artworks that, though not unique to them, are nevertheless characteristic of them, and that can be deployed to enhance moral and psychological understanding. As we suggested earlier, it is the way that cognitive insights are presented, by artistic methods (for instance, focusing on particulars of the situation and character, presented in an affectively forceful manner) that tends to make them of aesthetic relevance. This locates a further set of resources for conveying ethical understanding: these include artistic techniques such as the use of imagery and the nuanced presentation of characters and situations; and artistic strategies, such as the ethical journey and seduction strategies discussed below.

The deployment of literary devices such as imagery and repetition can bring home forcefully a moral aspect of the situation. There are innumerable pat descriptions of murder in popular literature and films, descriptions that allow us to close our eyes to the horrors of violent death. But in the following description of a murder scene, Ruth Rendell subverts this kind of approach and makes sure that we cannot take such an easy view of murder:

Blood had splashed the dark-green papered walls, the green and gold lampshades in which the bulbs remained alight, had stained the dark-green carpet in black blotches. A drop of blood had struck a picture on the wall, trickled down the pale thick oil-paint and dried there.

On the table were three plates with food on them. On two of them the food remained there, cold and congealing, but recognisably food. The third was drenched with blood, as if sauce had been poured liberally over it, as if a bottle of sauce had been emptied on to it for some horror meal.[41]

This passage deploys some powerful imagery to bring home the horror of the murder it describes. The stark colour contrasts between the red of the blood, and the gold and green of the decor; the mixing of types of fluid—blood, oil paint, sauce; the violation of the normal boundaries between ourselves and what we eat, the insistent repetition of the word 'blood' throughout, and the repetition of the image of blood as sauce at the end, all contribute to a powerful image of

[41] Ruth Rendell, *Kissing the Gunner's Daughter*, pp. 28–9.

carnage, an evocation of disgust that is both visceral and moral. This is an image of murder that gives full weight to the moral horror that it describes. It shows how, by deploying artistic devices, one can forcefully bring home a moral point of view.[42] Besides illustrating how aesthetic presentation can contribute to the power of moral teaching, it also exemplifies our main aesthetic claim that a moral merit, when aesthetically relevant, is an aesthetic merit; for without the moral point, the passage would lose much of its aesthetic weight (imagine, for instance, that the context were different and Rendell were simply using her description to secure a nauseous reaction from the reader, rather than also employing it to make a serious point about murder).

A different way of developing our moral capacities is by creating characters and situations of sufficient complexity that we are challenged to refine and elaborate our moral judgements and discriminations. We have already remarked on how the moral dilemmas described in literature, from *Antigone* to *Sophie's Choice*, invite us to consider what those imprisoned in them should do. But the point applies more generally: readers regularly reflect on whether or not a character made a correct choice—indeed, it is striking that readers treat characters as if they were real people in discussing their actions, despite the best efforts of literary (post-)structuralists to disabuse them of this tendency. And readers react in this manner in part because works often invite them to engage in such speculations. The rightness of Emma's interference with Harriet's marriage plans is something we ponder in part because Emma herself reflects on it, and changes her mind, and because what is reflected in that change of mind is so important to her growth in self-awareness that is the central theme of the novel. Relatedly, complexity of character allows or even challenges us to make finer and better moral and psychological discriminations in judgement and feeling. Because Emma is initially such a mix of appealing and unappealing characteristics, we are asked to sort out where sympathy is due, and where moral anxiety is appropriate. This complexity of character is a major source of aesthetic richness and moral insight in many artworks. In Hitchcock's *Vertigo*, for instance, Scottie, played by Jimmy Stewart, is an upright holder of the law, the dupe of a cruel crime, a sensitively vulnerable character, and a dangerous and possibly insane obsessive; and the film guides us to see different aspects of his character through its narrative structure. It is through sorting out our reactions that we are encouraged to think harder and deeper about our moral reactions to him. And, as we shall shortly see in discussing Humbert Humbert in *Lolita*, this mixture can reach even more combustible proportions, where it can remain highly controversial as to how to judge a character, and where the novel itself may encourage certain misconstruals, only to undermine them on a more careful reading.

[42] Consider too Marcia Eaton's nice account of how lists, rhythm and repetition are used to drive home a message about the importance of trying in her discussion of the children's book *The Little Engine that Could*. See her *Merit, Aesthetic and Ethical*, pp. 139–41.

This point about the complexity and specificity of the descriptions of characters and situations fits smoothly with the cognitive importance of the mechanism of 'seeing-as', which we noted in the previous section. In seeing real people and situations in terms of fictional ones, we can learn about the real cases in so far as the fictional characters have depth and plausibility, and the fictional situations capture real points of conflict between our principles or central aspects of the choices that people have to make in their lives. In applying fictional characters and situations to the real world as kinds of concepts, we can make further discriminations and gain greater insights, psychological or moral, than we could have achieved without them. In an interesting extension of this sort of view, Noël Carroll has argued for the existence of virtue wheels in literature—that is, for sets of characters who exemplify virtues (or the corresponding vices) to varying degrees, whose presence allows the reader to learn about the virtues. For instance, *Great Expectations*, he argues, has several characters who demonstrate the virtues or defects of parenting to differing degrees.[43] This network of related characters thus allows for much greater conceptual discrimination and comparison.

Our relation to fictional characters is sometimes that of identification, which, I have argued elsewhere, has many aspects, taking fuller or more attenuated forms, involving possible combinations of imagining perceptually, epistemically and affectively from the character's point of view, and also empathising with the character.[44] When we identify with a character, we thus come, in various ways, to view the world from her point of view, and thus can try on the perspective that she adopts. This can play an important role in the ethical journey strategy that I discuss below. However, our relations with characters can be different from that of identification. On Bertolt Brecht's notion of the alienation effect, which he explicitly opposes to character identification, one is encouraged to maintain a critical distance from the character, studying her from the outside. Brecht's reason for encouraging his actors to create this effect in the theatre was explicitly cognitivist: "Even if he [the actor] plays a man possessed he must not seem to be possessed himself, for how is the spectator to discover what possessed him if he does?"[45] And he suggests that a play or the way it is presented should treat incidents simply as illustrations of moral or other general principles, and so encourage critical reflection on those principles.[46] However, because Brecht treats identification as a simple, homogenous notion, he develops a notion of its opposite as similarly simple and homogenous. But, if one can identify with a character in several respects, then one may refuse to identify with

[43] Carroll, "The Wheel of Virtue", p. 12. He also stresses the importance of clarifying concepts and knowing the application conditions of principles in "Art, Narrative, and Moral Understanding".

[44] My "Identification and Emotion in Narrative Film".

[45] Brecht, "A Short Organum for the Theatre", para. 47, in John Willett (ed.), *Brecht on Theatre*, p. 193.

[46] Brecht, "A Short Organum for the Theatre", para. 67, in Willett (ed.), *Brecht on Theatre*, p. 201.

her, that is, one may be alienated from her, in several respects too, the most telling of which is a refusal of empathy. Though it is overly simple, Brecht's account does signal the possibility of modes of relation to characters that are more critical than the standard notion of identification allows.[47] And it is in this range of possibilities that one can locate the unreliable narrator, a figure whose pronouncements one should refuse to take as true in the fiction, and an understanding of whose role (as we shall see in discussing *Lolita*) can be crucial to learning from literature.

Besides the use of imagery, and complex descriptions of characters and situations, time-based arts can deploy dynamic cognitive devices, which I will call *strategies*, to guide the reader to greater understanding in some domain. It is often crucial to understand such strategies if one is correctly to grasp a work of literature and what it has to tell us. There are at least two strategies that are important for moral teaching: the ethical journey strategy and the seduction strategy.

The notion of an ethical journey concerns the actions of a character who comes to learn something of ethical significance, normally about herself, during the events described by the work. Emma comes to learn that she has been shallow and manipulative in her relations to others and ignorant about what is good for herself. Lear learns that he has had a woefully distorted conception of the nature and demands of family love. In Harold Ramis's film *Groundhog Day*, Phil Connors (Bill Murray) gets some much-needed practice in how to behave decently and joyously by reliving the same day again and again until he gets it right. In the course of an ethical journey, the characters learn something of central significance about themselves or the world, and the audience can learn this too, or have its previous understanding affectively presented and so rendered more salient. The ethical journey may be characterised by 'poetic justice'—that is, virtue is rewarded, vice punished, as is the case with both Emma and Phil Connors (Andie MacDowell being Connors's ample reward), and in a great deal of popular fiction. But the strategy can work as well or better without poetic justice, since in this case there is no requirement to distort events to secure the desired 'happy ending'. The genre of tragedy avoids this trap—Lear's final, agonised achievement of moral knowledge is accompanied by the ruin of all his desires. An ethical journey ends with knowledge, not necessarily happiness. The ethical journey strategy also characteristically has the audience identify with the characters concerned. But identification is not a necessary feature: one could in principle learn from a character's journey while refusing all kinds of identification with him or her.

The seduction strategy also plays an important role in ethical learning, but it has a very different structure. It does not require any change in the characters' conception of the world (though it may be accompanied by such a change);

[47] For a discussion of some of these complexities, see Murray Smith, *Engaging Characters*.

rather, its aim is to show the audience how easily it can be seduced into false, idealising, morally tainted, or even plain evil views of what is going on in the work. But, together with this aimed-at seduction, the work also provides the evidence to undermine the proffered view, so that the audience can learn both the wrongness of the view, as well as how easily they can be led to adopt it. The seduction strategy can be enormously effective in providing us with an insight into ourselves and our moral position, because it undercuts our often-assumed superiority (which the ethical journey strategy can actually reinforce), by showing that we are prone to adopt attitudes that we may consciously abhor or dismiss. (And note that what is meant here is not merely that we *imagine* adopting the attitude, which can be entirely ethically innocent, but rather that we *actually* adopt the attitude towards the fictional events.) It can thus bring home lessons to us very powerfully in a way that displays an interesting complexity. In many examples of the seduction strategy one can identify the view that we are apparently being encouraged to adopt with that of the narrator. But this is not always so: the general distinction is between two epistemic levels in relation to the work. On a superficial understanding of the work, it invites us to adopt and endorse some attitude, which we may then go on to adopt. On a deeper understanding of the work, it provides evidence to show us that this adopted attitude is mistaken or distorted, and should be abandoned. So, on the deeper understanding of the work, we can see that the work's invitation to adopt the attitude was only apparent: it really invites us to adopt a quite different attitude, one involving the disavowal or questioning of the apparent attitude. It thus teaches us about our propensity to be seduced into problematic views and responses, including morally problematic views and responses. In these latter cases, far from being itself morally problematic, the artwork possesses moral, as well as cognitive, value in vividly displaying to us our moral frailty.

Because detecting the seduction strategy requires careful attention to the full range of evidence provided by the work, it is easily missed, and there are several 'immoral' works that are not so when correctly construed. Accepting this point is not, of course, to deny that there are morally tainted works that wholeheartedly endorse the immoral attitudes they encourage their readers to adopt (no one will plausibly ascribe a seduction strategy, in the sense intended here, to the works of the Marquis de Sade).

Consider as an example of the seduction strategy Max Ophuls's film *Letter from an Unknown Woman*. Narrated in voice-over by Lisa, it describes her boundless love from adolescence onwards for a gifted pianist; though she spends only one night with him, from which she gains a son, she has no doubt of the pure perfection of her love, and that if only he could reciprocate it, he would find his true muse, fulfilling his happiness and perfecting his musical gifts. The film was made in 1948, and is generically a 'woman's film' or a 'weepy', and these attitudes would have probably found a ready assent from the film's target audience. Yet, according to a compelling interpretation due to George Wilson, careful attention

to the film shows that it aims at least partly to undercut this attitude, by showing that it can be viewed as a kind of obsessive mania, a projection of romantic fantasies onto a person in whom little genuinely answers to them.[48] As such, it can educate its audience about the dangers of romantic fantasy, by getting them to adopt an attitude it then implicitly questions: the trap is set, and then the jaws spring shut. The film's apparent attitude to romantic love turns out to be significantly different from its real attitude to it.

Another example of the seduction strategy is "The Destructors", the story that Kieran cites.[49] In discussing Kieran's contextualist cognitivism, I adopted for ease of exposition his interpretation of the story, as inviting immoral attitudes. Though his general argument does not depend on the accuracy of his reading of the story, there is nevertheless something very odd about Kieran's apparent interpretation of it. For Graham Greene is hardly a likely candidate for an immoral novelist: indeed, one of his abiding concerns was with how pervasive is evil, and how easily we can be corrupted. What is actually going on in this story is something more complex. We are, indeed, *apparently* invited by the story to take up an immoral attitude, but a more careful reading reveals that this attitude is undercut, and that the *real* attitude manifested in the story is that we are easily seduced into cruel ways, that we are fallen creatures. Nothing about the seduction strategy requires a work employing it to be immoral; on the contrary, the work lays a moral trap for us, into which we may stumble, and then shows us what this fall reveals about our fallibility and corruptibility.

The story is set in the present of its time of publication (1954) and is about how a gang of London boys systematically destroys the house of an old man who has shown them nothing but kindness. We are encouraged to adopt an attitude of enjoying the destruction by a number of devices: during the two-day destruction of the house, we are confined to the boys' perspective, so we experience the suspense of not knowing whether they will succeed; the lorry driver at the end of the story, the traditionally privileged point, laughs and says "you got to admit it's funny"; we are given the seductive idea that the destruction is a form of creation, and so forth. So we are shown just how we can be attracted to calculatedly cruel destruction. But, at the same time, there is abundant evidence in the story to show that it condemns that attitude and provides a diagnosis of its sources. What the boys destroy is a beautiful house, the last on its block; the others have been destroyed in the Blitz, the Nazi bombing of London in the Second World War. On the start of the day on which the house's destruction occurs, thunder rolls in the sky, like the bombs falling in the Blitz. T., the leader of the gang, is 15 at the time of the story, and so would have been born in 1939, the start of the war; he never, we are told, had a real childhood, and his father (an architect) has seen little of him. The house he destroys is said to have been built by Wren—the

[48] George M. Wilson, *Narration in Light*, ch. 6.
[49] Graham Greene, "The Destructors".

architect, we are reminded, of St Paul's cathedral. Now St Paul's is not just a magnificent example of religious architecture; its survival during the Blitz was taken by Londoners as a great sign of hope that goodness would prevail against evil. The symbolism here is clear: brutalised by the war and its long, impoverished and depressing aftermath, T. and his gang carry to completion what the Nazis had begun. T. is a nihilist; he announces that love and hatred are not real, and only "things" are—and things are what he then proceeds systematically to destroy. We are thus shown not only how systematic cruelty can attract, but also that attitude is undermined by the work, and Greene suggests that it is rooted in a kind of nihilism, born in the case of T. from a brutalising environment and parental neglect. All this fits smoothly with Greene's bleak vision of a fallen world, in his own variant of Catholicism, where the struggle of good and evil is rarely conducted with pure goodness on one side, and where he and his readers participate in that tainted and flawed world.

There is, then, a rich array of techniques and dynamic devices (strategies) available to artworks, which can be employed to convey moral or psychological understanding to their audiences.[50] What the use of these techniques and strategies grounds is an implicit commentary by the artwork on the events depicted, a point of view that guides the audience towards a favoured conclusion. There are many other devices that can be employed—perhaps most obviously that of explicit commentary by the author (in a simple case the 'moral' of Aesop's fables), or the use of an authorial 'tone of voice' to give a perspective on the events recounted. But, though the above account is not intended to be exhaustive, it should provide some evidence that the cognitive resources available to artworks are rich and varied, and are not to be thought of as an alien addition to artworks required to deliver a 'message', but are, rather, integral to the artistic structure of the works. And we have also seen that what we are encouraged to learn from the works may not be anything simple and statable in short, general propositions (though that is sometimes so, especially when the work is a condemnation of certain ossified moral conventions). Rather, it may be a matter of inviting finer discriminations in both moral judgements and moral feelings. Just how rich the aesthetic results can be is best illustrated by considering in detail an example of the employment of these techniques and devices.

8.4. *LOLITA*

Vladimir Nabokov's great novel *Lolita* is at first sight a challenge to the ethicist cognitivist, rather than promising material for an illustration of the view. Indeed, it has often been held up as a counter-example to moralism about aesthetics. The

[50] These devices can misfire: as we noted in Ch. 6, Sam Peckinpah's *The Wild Bunch* is plausibly a case where the seduction strategy has gone awry.

novel has been viewed as a morally subversive work, great in part because of its immorality, and thus fodder for the contextualist. The novelist Martin Amis has hailed it as a "comedy, subversive yet divine . . . You read *Lolita* sprawling limply in your chair, ravished, overcome, nodding scandalized assent".[51] Anderson and Dean, in their defence of moderate autonomism, regard the novel as deriving its power in part from the tensions between its disturbingly alien moral perspective, with "much sympathy and rather little apology for Humbert", and its aesthetic excellence.[52] And Nabokov himself in a postscript to the novel appears to adopt a staunchly autonomist and anti-cognitivist line: "I am neither a reader nor a writer of didactic fiction . . . *Lolita* has no moral in tow. For me a work of fiction exists only insofar as it affords me what I shall bluntly call aesthetic bliss . . .".[53] But, besides showing how the novel employs several of the techniques and strategies explored in the last section, and thus illustrating how these can contribute to aesthetic excellence, I will also argue that the novel conforms well to the cognitivist and ethicist view. The point, of course, is not to defend ethicism in its full generality by appeal to an example (which in itself could not bear so heavy a load), but to illustrate that ethicism can cope even with some apparently recalcitrant cases and that it can throw light on aesthetic features of works that morally neutral critical methods discern only dimly, if at all.

The first *canard* to pot is the supposed immorality of the work. Nabokov recounts how four American publishers were so shocked at the manuscript that they refused to publish it; and he denounces "the idiotic accusation of immorality".[54] One might wonder how the accusation of immorality could be avoided. *Lolita* is, after all, fictionally a memoir written by Humbert Humbert, paedophile and murderer, explaining and in certain respects attempting to justify his actions. It is entirely recounted from Humbert's point of view in the first person. This first-person narratorial role by a character might seem to leave no room for an independent authorial perspective on the character's actions. But that is not so. *Gulliver's Travels* is fictionally written by Lemuel Gulliver, sailor, faithfully recounting his adventures; yet Swift, the manifested author, employs these adventures for a completely different purpose, satirising much of contemporary society, without deviating from Gulliver's narratorial role. The moral point of view of a work is that of the manifested author, not that of his or her characters, including narrators; and the author, as Swift's novel illustrates, can manifest himself even when first-person narration is continuous. The character's credulity or corruption may be something commented on and condemned by the author, not something that must be identified with the authorial point of view. As Nabokov remarks of Humbert, "there are many things, besides nymphets, in which I disagree with him".[55]

[51] Quoted on the back cover of the Penguin edition of *Lolita*.
[52] Anderson and Dean, "Moderate Autonomism", pp. 162, 165.
[53] Vladimir Nabokov, *Lolita*, p. 314. [54] Ibid., p. 315. [55] Ibid.

There is another reason why the accusation of immorality is "idiotic", and it illustrates the idea of an ethical journey in a complex form. For Humbert's tone and attitude to Lolita shift both in the five years in which he knows her and also in the fifty-six days in which he pens his memoir. Recounting his early days with her, he celebrates his sexual feelings and activities with her, albeit with a dull, background throb of guilt; but, as their story progresses, he gradually succumbs to devastating remorse that she "had been deprived of her childhood by a maniac".[56] And midway through the writing of the memoir, which he has been prompted to compose by his lawyer for use at his trial, he decides that it will be published only after her death, so as to protect her. Humbert's remorse about Lolita is, I believe, genuine (though it is not, as we shall see, simple). In so far as the reader is encouraged to identify with him, one is thus also lead through an ethical journey, and the emotional impact of the moral enormity of what Humbert has done is considerable.

Yet in this complex masterpiece there is much more going on than this. Central to the working of the book is a deployment of the seduction strategy, and the success and power of Nabokov's use of it go some way to explaining why this has seemed to many a work complicit with Humbert's appetites. With his full access to the scintillating array of Nabokovian prose, there has never been a proponent of child sex with such majestic powers of literary persuasion as Humbert. His narration in the early parts of the novel is a constant teasing play of imagery, designed in part to distance himself from what he is doing and to draw the reader into complicity with his actions. The reader is addressed in a variety of flattering ways: he or she is seen as a member of the jury that will judge Humbert, a position requiring serious and "impartial sympathy", and Humbert talks of "my learned readers".[57] The reader is invited to sympathise, to understand and at least in part to forgive in these early pages; Humbert insists that his first use of Lolita in masturbation is properly viewed as "chaste" and "wine-sweet". He also deploys a menagerie of animal imagery, designed in part to distance his deeds from human and moral appraisal; Humbert has an "ape-ear", he draws Lolita into a "web", she has "monkeyish feet" and a "little hot paw".[58] His depravity is acknowledged, for he cannot deny it, but it is treated humorously, joltingly distanced into the third person, and presented in a context flattering to him, with more animal imagery: "I am lanky, big-boned, wooly-chested Humbert Humbert, with thick black eyebrows and a queer accent, and a cesspoolful of rotting monsters behind his slow boyish smile."[59]

Humour is indeed central to the reader's attempted seduction by Humbert, and is pivotal to the two scenes in which he first achieves sexual satisfaction with Lolita. In the first, she places her legs on his lap and together they sing a popular song; unbeknownst to her, he uses the movement of her legs to achieve a climax:

[56] Vladimir Nabokov, *Lolita*, p. 283. [57] Ibid., p. 57.
[58] Ibid., pt I, ch. 11. [59] Ibid., p. 44.

"I crushed out against her left buttock the last throb of the longest ecstasy man or monster had ever known."[60] In the second, when he first penetrates her, he endures a long night of indecision lying next to her in the Enchanted Hunters motel, until Lolita wakes up, and he claims, seduces *him*. She has previously had sex with Charlie Holmes, a young boy; Humbert persuades her that not only did he not have sex as a boy, but that adults do not do that sort of thing. So she instructs him in sexual technique: "She saw the stark act merely as part of a youngster's furtive world, unknown to adults. What adults did for purposes of procreation was no business of hers."[61] These scenes undoubtedly display a kind of humour, resting largely on the incongruity between Lolita's innocent perception of the situation and its black reality in the first case, and in her misperception that adults never have sex in the second. The humour is deployed as part of Humbert's armoury in disarming his reader. Yet this is, of course, a nasty, sick kind of humour, for a child is being sexually abused—and, as Craig Raine points out, Lolita's innocence is displayed in the very fact that she believes Humbert's claims about adult sex.[62] So here the seduction strategy at the moment of its deployment shows itself for what it is: the reader is invited to be amused by Humbert and is also appalled by the nature of what is going on (as indeed is Humbert's later self). So the strategy works in these and other scenes not only because the invited responses are undermined by Humbert's anguished remorse, most explicitly later in the book. It also works at the very moment of its deployment, in the disgust we are invited to feel at Humbert's actions and responses. There is a characteristic pattern of enjoyment and recoil in this first part of the book: we are shown that we can be seduced to take a kind of enjoyment in something that we simultaneously abhor.

In part II of the book, Humbert's nagging guilt engorges to agonised proportions. After their two years together, largely spent in an endless blur of motels, Lolita vanishes from her hospital sickbed, and he loses her for three years. But her reappearance leads him to a fruitless declaration of love, which is apparently a love no longer merely for the child, but also for the grown woman: "I insist the world know how much I loved my Lolita, *this* Lolita, pale and polluted, and big with another's child . . .".[63] And he learns at last the name of the man, Clare Quilty, for whom Lolita had abandoned him three years previously, a man he has long wanted to kill. Quilty he views not just as a rival, but also as a kind of dark alter ego—paedophile, drug-taker, organiser of orgies—a man with Humbert's sexual tastes but none of his redeeming love for Lolita. In a scene of grim farce, Humbert shoots Quilty repeatedly in his house, finally killing him; and he then surrenders himself to the law through a spectacular piece of dangerous driving. The novel thus ends with the symbolic destruction through Quilty's murder of Humbert's desire for child sex, his stark awareness of the evil that he has inflicted

[60] Ibid., p. 61. [61] Ibid., p. 133.
[62] Craig Raine, "Afterword", in ibid., p. 327. [63] Nabokov, *Lolita*, p. 278.

on a child, his mature love for the adult Lolita, and a paean to the power of art, as represented by his memoir, to immortalise her: "I am thinking of aurochs and angels, the secret of durable pigments, prophetic sonnets, the refuge of art. And this is the only immortality you and I may share, my Lolita."[64]

On this reading of the novel both the ethical journey and the seduction strategy are in play; we are made to understand and even to feel something of how it is possible to be sexually attracted to children, yet the evil of that urge is exploded; and the full force of its viciousness is brought home emotionally in the powerful ending of the novel. We achieve insight into something that should be totally alien to us, the mind of a paedophile, and we have the sickness of this view affectively presented to us. And no part of this interpretation is false. But I want to suggest that the novel is richer than this reading allows, and that this richer understanding is best captured by ethical criticism. For a second seduction strategy is in play in the latter part of the work, and the reader who thinks that Humbert has reached a mature and sane grip on reality has fallen victim to Nabokov's ploy.

The place to begin is with the question of whether or not Humbert is a reliable narrator. Some have argued that he is: Craig Raine, for instance, holds that he is "a paragon of exactitude".[65] But there are good reasons to number Humbert amongst Nabokov's spacious gallery of unreliable narrators. In the chapter before he meets Lolita, Humbert recounts how he spent twenty months in arctic Canada (sandwiched between two bouts of insanity), as a "recorder of psychic reactions", and how he "concocted a perfectly spurious and very racy report" of what went on, which he published in two journals.[66] Given the importance of establishing how people react in judging the events of *Lolita*, this is a clear signal that we should not take Humbert's account at face value. He also tells us that he has a "photographic memory", thus bolstering the accuracy of his account. But then we later hear of his "sensational but incomplete and unorthodox memory", and that he has somehow mixed up two events, but that "such suffusions of swimming colors are not to be disdained by the artist in recollection".[67] And then there are blatant contradictions: at one point he is "no poet. I am only a very conscientious recorder"; a few pages later we are told that he is no killer, since "Poets never kill".[68] And this is penned by a man who begins his memoir by admitting that he is a murderer. One can hardly rely on the accuracy of a memoir by a man on trial for murder, who, even at the end, is still contemplating using parts of the memoir in his trial. As he remarks: "You can always count on a murderer for a fancy prose style."[69] And for "fancy", read "lying".

There are two ways of being an unreliable narrator: either the narrator may be lying to his reader, knowing the truth himself; or he may be self-deceived, so that

64 Nabokov, p. 309. 65 Craig Raine, "Afterword", in ibid., p. 322.
66 Nabokov, *Lolita*, pp. 33–4. 67 Ibid., pp. 40, 217, 263.
68 Ibid., pp. 72, 88. 69 Ibid., p. 9.

he is deceiving himself as well as his reader. Humbert manages to be unreliable in both ways at various points.

Unreliability seems to infect his account of his seduction of Lolita. At first, Lolita, as we saw, is represented as sexually experienced, someone who seduces him; towards the end, in his full flow of contrition, she is represented as an innocent, corrupted by him. (Such a change may admittedly represent his remorse, marking his ethical journey.) More striking is the way his actions and feelings are presented from the time of his final meeting with her onwards; and it is here that we come to the second seduction strategy that I mentioned earlier. If one takes Humbert's view of matters at the end, he is someone who has grievously sinned against Lolita, but who is now wholly penitent, having found the capacity to form a mature relationship with her, even if she will not accept him as a lover, and who has symbolically killed his dark side, as represented by Quilty. He writes: "Had I come before myself, I would have given Humbert at least thirty-five years for rape, and dismissed the rest of the charges."[70] But note what is happening here—Humbert has just claimed that his killing of Quilty was justified; and murder is the capital charge on which he is to stand trial. His memoir ends, then, as a justification of murder and a claim that he truly and maturely loves Lolita. Given the power of his rhetoric, it is easy for the unwary reader to be seduced into accepting both; and, in accomplishing this, Nabokov shows both the power of art to deceive, and how difficult it can be to determine human motivations.

Nabokov provides several clues that we should not take Humbert's account at the end at face value, nor endorse his views. Humbert claims to love Lolita truly. Yet his arrogance is such that he cannot take account of her interests. He asks her to abandon her husband, "her incidental Dick", as he calls him, within a few minutes of meeting her again. Her response is pithy and accurate: "You're crazy."[71] She tells him that Quilty "was the only man she had ever been crazy about", and that she would rather go back to him than return to Humbert.[72] And shortly afterwards, Humbert kills Quilty. What sort of love is it that so totally disregards the interests of the beloved? It is that of the egomaniac, someone to whom Lolita is only a projection of his fantasies; Lolita is never fully regarded as a real human being with her own interests and point of view. Reflecting on the early carefully calibrated masturbation scene with Lolita, Humbert writes: "What I had madly possessed was not she, but my own creation, another, fanciful Lolita—perhaps, more real than Lolita . . . indeed, [with] no life of her own."[73] What he says here is true of his relations to her even at the end. This is the sinister undercurrent of his repeated use of "my Lolita".

And what of Clare Quilty? At the end, Humbert asks Lolita: "do not pity C. Q. One had to choose between him and H. H., and one wanted H. H. to exist

[70] Ibid., p. 308. [71] Ibid., p. 278.
[72] Ibid., pp. 272, 279. [73] Ibid., p. 62.

at least a couple of months longer, so as to have him make you live in the minds of later generations."[74] The arrogance is breathtaking and the logic fallacious. Quilty did not have to die in order for Humbert to write the memoir. Quilty has been reduced here to a mere symbol, eviscerated of all independent reality, in the same way as has happened to Lolita. Extremely nasty though he is, and with his undoubted taste for child sex, there is, ironically, no clear evidence that Quilty ever had sex with Lolita. He claims that he had "no fun" with Lolita, being practically impotent; and Lolita says that she left him because he wanted her to have sex with other men.[75] Quilty has not done anything as bad to Lolita as Humbert has. After Humbert accuses Quilty of having kidnapped Lolita, Quilty points out in a startling understatement that, "my dear Mr. Humbert, you were not an ideal stepfather, and I did not force your little protégée to join me. It was she who made me remove her to a happier home."[76] And Humbert's egocentric motive for murder is stated in his poem: Quilty is being killed "Because you cheated me of my redemption".[77] The 'symbolic' murder is of someone who is less guilty of doing harm to Lolita than Humbert is; and it is a murder of a man whom Lolita loves more than she loves Humbert.

Consider too the overtly manipulative way in which Quilty's murder is described. It is distanced and made funny, in the same way that the early sexual episodes with Lolita are made funny, so as to absolve Humbert of guilt. It is set up as a fairy tale: Quilty's house is on Grimm Road, the front door swings open, "as in a medieval fairy tale".[78] Humbert is drunk, Quilty is drugged and for most of the time has no idea of to whom he is talking. Humbert's poem justifying the murder is read out by Quilty, and it is comically awful. Humbert shoots Quilty repeatedly, but he refuses to die easily:

he shivered every time a bullet hit him as if I were tickling him, and every time I got him with those slow, clumsy, blind bullets of mine, he would say under his breath, with a phoney British accent—all the while dreadfully twitching, shivering, smirking, but withal talking in a curiously detached and even amiable manner: "Ah that hurts, sir, enough! Ah, that hurts atrociously, my dear fellow. I pray you, desist."[79]

How could someone being methodically shot to death in this way possibly react in such a manner (and why, come to that, with a phoney British accent)? The narration becomes overtly unreliable here—it is clearly signalled that Humbert cannot be trusted as to what happened, and that he is trying for a distancing, comic effect, so as to seduce us, cast as the notional jury, into accepting the murder for which he is to stand trial.

I have argued, then, that there is a second use of the seduction strategy in the novel, designed to get us to accept the maturity of Humbert's love for Lolita and the rightness of his murder of Quilty. Unlike the first use, which tries to justify

[74] Nabokov, *Lolita*, p. 309. [75] Ibid., pp. 298, 277. [76] Ibid., p. 301.
[77] Ibid., p. 300. [78] Ibid., pp. 293–4. [79] Ibid., p. 303.

Humbert's sex with a child, the actions involved are not disavowed by Humbert. The strategy is thus left as a trap in which to catch the heedless reader; but the clues are planted in the novel to signal that it is indeed a trap, and that we are not supposed simply to accept Humbert's actions and apparent redemption at the end at face value. Nabokov thus implicitly comments on Humbert's delusions and vanities and on the ease with which we can be seduced by his character. Humbert is manipulating us, partly consciously, partly out of the self-deception grounded on his vast egoism. And that view of what is happening fits neatly with Nabokov's own verdict on Humbert: "a vain and cruel wretch who manages to appear 'touching'."[80]

What is the point of this second seduction strategy? The answer is partly the generic one outlined earlier: we are shown how easily we can be moved to take up attitudes we would reject if we thought more carefully, and are shown the manipulative power of rhetoric in general and of art in particular. But the strategy also adds to the complexity of the Humbert character and demands a nuanced set of discriminations from us as to how to judge and respond to it. Humbert's remorse is, I think, genuinely felt, and so he demands sympathy from us. On the other hand, he also deserves our disdain: not just for what he did to Lolita (he disdains himself for that) but also because his remorse is that of someone so bloated with self-regard that he never manages fully to respond to the real Lolita; and of someone with an egoism so vast that he can regard a brutal murder as a mere symbolic side-event, part of his bid for psychological quiescence and literary immortality. We are also encouraged to ponder on just how sure we can be of the motivations of anyone with any psychological complexity and intellectual gifts.

So the novel's deployment of these strategies does teach us, via a particularly rich example, something about the complexity of moral and psychological judgements, of the need for fine discriminations of feeling and judgement, and of the seductive powers of art. And, by giving us a rich imaginative and affective experience, it brings these things home to us. This may seem to sit ill at ease with Nabokov's remarks quoted earlier that he is not a writer of didactic fiction and that the novel has no moral in tow. But the remarks are best construed as an attack on simplistic readings of the novel. The Foreword to the novel is by John Ray, Jr, Ph.D., a psychoanalyst who tells us that *Lolita* "should make us all—parents, social workers, educators—apply ourselves with still greater vigilance and vision to the task of bringing up a better generation in a safer world".[81] It is Ray's views that Nabokov explicitly attacks in the passage where he declares himself not to be a didactic writer. John Ray is a fictional character, invented by Nabokov, and psychoanalysts are the great object of Nabokov's (and Humbert's) scorn, precisely because they simplify and distort human motivations. What Nabokov is against is pat, simplistic judgements; what he shows us in *Lolita* is that moral and psychological judgements need to be sensitive to the complexities of character,

[80] Quoted in Craig Raine, "Afterword", in ibid., p. 319. [81] Nabokov, *Lolita*, p. 6.

that we are prone to great simplifications and strangely biased judgements. And when he writes that a novel exists only in so far as it affords aesthetic bliss, it turns out that he is no autonomist; for by "aesthetic bliss" he says that he means "a sense of being somehow, somewhere, connected with other states of being where art (curiosity, tenderness, kindness, ecstasy) is the norm".[82] The aesthetic for Nabokov includes the ethical; and, as we have seen, the aesthetic experience of this novel should embrace the ethical realm, if it is to be properly sensitive to the full richness of this wonderful work.

[82] Nabokov, *Lolita*, pp. 314–15.

9

Emotion and Imagination

That our response to art centrally involves emotions is a commonplace, albeit a true and very important one. It is particularly germane to the theme of this book, for, as the previous chapter noted, art deploys a cognitive–affective perspective on its represented events, a perspective that invites the audience to react emotionally to the scenes and characters it describes. And, given the importance of emotions to ethical education as well, emotional responses to represented events form a powerful means of ethical illumination in art. The next chapter will also argue that our affective responses to events are subject to ethical criteria, and that this forms the basis for a further argument for ethicism, the merited response argument.

Both the cognitive and the merited response arguments for ethicism, then, employ the claim that we can feel real emotions towards represented events. But this claim, apparently so uncontentious, has in fact been powerfully contested. Several philosophers, whom I will dub *emotional irrealists* have denied that one can feel real emotions towards fictional events, and others have held that, though this is possible, it is irrational to do so. Given that so much of art is fictional, the truth of these claims would threaten some of the central positions defended in this book, at least in the formulations employed here. The goal of the present chapter, then, is to defend what I term *emotional realism*—the common-sense view that one can feel real emotions towards fictional events and be rational when one does so.

9.1. THE IMPORTANCE OF EMOTIONAL REALISM

One might wonder whether it matters whether emotional realism is true or not for our present purposes. For could not the cognitivist and merited response arguments be defended without recourse to emotional realism? Emotional irrealists could note that, when one learns through fictional art, one may learn by *imagining* having certain emotions (imagining pity or scorn for Humbert Humbert, say), and that imagined emotions are as powerfully educative of how we ought to feel as are actual emotions. Likewise, the irrealist could hold that whether or not an affective response is unmerited because unethical (which is a crucial premiss of the merited response argument) should be understood as

whether or not *imagining* having that response is unmerited because unethical. On such a conception, the arguments for ethicism, suitably recast, could go through.

To address this question of the importance of emotional realism, we need first to get clearer about what an emotion is. In one broad, but legitimate, sense of the term, an emotion is a state that is characteristically felt, a state that characteristically has a phenomenology (unlike, say, a belief, which has none). In this sense, we may say that someone is very emotional, and simply mean that he is prone to swings of mood or tends to feel things deeply. It is this broad sense of the term that figures in the title of this book. In a narrower sense of the notion, an emotion is just one of the various kinds of state that are characteristically felt. It is hard precisely to delineate emotions in this narrower sense from other affective states—indeed, it has been plausibly suggested that emotions do not form a natural class at all.[1] But it is useful at least to distinguish emotions from moods. A mood, such as happiness or sadness, need not have an intentional object: someone can simply be happy or sad, without being happy or sad *about* anything. An emotion in contrast has an intentional object: I am afraid of something, I pity someone. According to the dominant (and I would argue correct) cognitive–evaluative theory of the emotions, an emotion not only has an intentional object, but also essentially incorporates an evaluation of that object. So to be afraid of something essentially involves evaluating that thing as dangerous; to pity someone essentially involves evaluating her suffering as a bad thing; to be angry with someone essentially involves thinking of that person as having wronged someone about whom one cares.[2] Finally, an emotion is a state that characteristically can motivate actions: I run away because I am afraid, I help someone because I pity her, I strike someone because I am angry with him.

There are, then, three main characteristic aspects to an emotion: the affective, the cognitive–evaluative and the motivational. In most fully fledged occurrent emotions all three are present, but it is not necessary that all three be present for an emotion to exist. Not all the characteristic features of an emotion are essential to it. In particular, many emotional episodes are non-occurrent: one can be angry with someone for a long time, even when he is absent and one is not thinking about him. One need not have any feeling of anger during these long periods. Nevertheless, if one's anger does become occurrent, perhaps because the person is present, characteristically one will experience a feeling of anger. According to the cognitive–evaluative theory, an emotion is not, however, individuated by its particular feeling. The feelings that we experience when we are ashamed and

[1] A. O. Rorty (ed.), *Explaining Emotions*, p. 1.

[2] Cognitive-evaluative theories in various forms are defended by Ronald de Sousa, *The Rationality of Emotion*; Patricia Greenspan, *Emotions and Reasons*; William Lyons, *Emotion*; Robert C. Roberts, "What An Emotion Is". The particular evaluations mentioned as being essentially connected with each emotion are used for illustrative purposes only; in fact, they may be more complex than is commonly suggested, but that does not matter for the purposes of this chapter.

when we feel guilty, for instance, might well be identical. What individuates the emotions is the content of the respective evaluative thoughts—of having done something shameful, as opposed to having done something morally wrong. For instance, Lyons holds that an occurrent emotion involves bodily sensations of felt disturbance caused by certain evaluations; but he does not maintain that each emotion has a unique feeling associated with it by which we individuate the emotion.[3] A feeling will characteristically be present in occurrent emotion, but what feeling it is might vary from occasion to occasion, or from person to person.

If one takes the notion of an emotion in the broadest sense, as an affective response, there is one kind of response that both sides to the realist dispute can agree to be real. It is evident that one can actually enjoy or be displeased by fictional events: one can actually enjoy a fictional state of affairs, such as a beloved character's happiness. And ethicism can be defended by appeal to those responses, the reality of which is fairly uncontentious. Pleasure and displeasure are pervasive in our responses to fictions; and, as we noted in Section 2.3, a person can be ethically criticised for what she feels; and this includes what she takes pleasure or displeasure in. Someone can be criticised for enjoying the suffering of others; and likewise someone who actually enjoys the imagined suffering of others can properly be condemned for this response. Moreover, one can learn from the pleasure or displeasure that one takes in merely imagined events: the pleasure that I feel in imagining going on holiday shows me that going on holiday is a worthwhile thing for me to do. So merely by appeal to the reality of pleasure and displeasure felt towards fictions, one can defend versions of the cognitivist and merited response arguments for ethicism.

This still leaves open the question of the reality of fiction-directed emotional responses in the narrower sense of the notion of an emotion, the issue that we will address from now on; and the arguments for ethicism would have less scope if they were formulated in terms merely of pleasure and displeasure.

However, I do not wish to deny that the irrealist can help herself to suitably adapted versions of the arguments defended here even for emotions in the narrower sense. One might hold that one can learn merely from imagining feeling pity towards a fictional scenario; and that what one imagines feeling can be ethically criticised as well, if it is imagined in a way that expresses a morally bad character. So, though I have formulated the claims of this book in realist terminology and will defend that formulation here, someone need not be driven to deny ethicism or to abjure variants of the arguments, if she is unconvinced by realism.[4] But to say this much is not to say that the truth of emotional realism has no implications for our understanding of the ethical criticism of art. On the

[3] Lyons, *Emotion*.
[4] This is a point to which we will return in Ch. 10 in more detail, after the merited response argument has been developed.

contrary, the truth of realism matters in at least three respects for ethical criticism and for closely related issues: the issues of responsibility, of learning and of the value of fictions.

Richard Moran has noted that, if we have real emotions toward fictions, we are responsible for them, and cannot disavow them, in a way that we can if we only imagine having these emotions.[5] I can imagine anything (say, that I am filled with loathing at gays) without that reflecting on my character; but if I feel the same, real, emotion, I cannot similarly disavow it—it reflects on my character. This evidently has powerful implications for ethical criticism, for my actual character is revealed in a direct way that it is not with merely imagined emotions.

However, Walton has pointed out that Moran's position is too simple as it stands: if, to take Walton's example, every time I hear the word 'kittens', I think of torturing them, then that might well reveal something gruesome about my character, and I could not simply disavow the response.[6] Walton's point here is true and important: what I imagine can indeed reveal things about my character, and I cannot simply disavow my imaginings. But to acknowledge this much is not thereby to show that there is not an even more intimate relation between character and actual emotions. Suppose that, to extend Walton's scenario, when I imagine torturing kittens, I immediately feel ashamed, and contrast this with when I feel joy at what I am doing in imagination. These have very different implications for the sort of person I am, and I cannot disavow these implications on the realist account by claiming that I did not really feel shame or joy.

The irrealist can, of course, respond that what is actually going on here is that I am *imagining* feeling shame or joy, and that I am responsible for what I imagine. But, again, I am more responsible for what I feel than for what I imagine feeling. Consider another example. Suppose that I am contemplating a change of career, and wonder whether to become an investment banker. As part of my imaginings, I imagine my character changing in various ways, as I adapt to my work environment. So, for instance, I imagine feeling great pride in the deals I put together, even though I am currently indifferent to such matters. In order to discover whether I should change career, I ask myself how I now actually feel about this imagined scenario—does it fill me with joy or trepidation? Here it is essential to my imaginative project that I take what I now feel towards imagined events as revelatory of my actual character, and how I imagine feeling when I am a banker as revelatory of a character I would possess, but do not currently have. So the imagined emotions fit together as a part of a possible, imagined, character, which I might come to possess, depending on my future actions; and my current, actual emotions are directed towards the imagined scenario and are ones that are revelatory of my current, real character. So we take our actual feelings in

[5] Richard Moran, "The Expression of Feeling in Imagination".
[6] Walton, "Spelunking, Simulation, and Slime", p. 45.

such cases as ones that are not so easily disavowed, as opposed to imagined feelings, that may represent only a possible character I could possess. And what characteristics it is possible for me to possess may indeed reveal something about my actual character, but they are still distinct from it.

Secondly, the realist view offers a robust account of an aspect of how one can learn through imagination by responding to fictions. As we noted in Chapter 7, how one can learn from imagination involves several factors. Discovering what are one's dispositions to imagine various things is one way that one can learn about oneself—think of Walton's kittens example again. But the realist can add an extra and evidentially more robust dimension to this route for learning through imagination. For a better source of evidence is based on one's actually having an experience, since no one doubts that experience is a source of knowledge. On the realist view, one does have a kind of experience in engaging with fictions—one has emotional experience, and by means of it, one can learn about oneself, about others, and about what ought to be done in a situation. And we noted in Chapter 7 that the validity of the claim that one can learn ethically from imagining various scenarios rests in part on the view that one can have real affective experiences towards merely imagined events.

Finally, the view that we experience real emotions towards fictions helps explain part of the value of fictions. People often have a hunger for broadening their experience, whether it be by travel, by experimentation with new ways of living, by interaction with new friends or by engaging with fictions. An advantage of the latter on the realist view is that emotions can be felt towards merely imagined objects and events, so that one does not have to undergo the sometimes painful or brutal events that would be necessary if one were to experience these emotions by actually living through the events. The point is well put by de Sousa: "at least one component of the need for art is the desire to experience the emotions called forth by death, by sexual thrall, by revenge, or by painful or ridiculous alienation, by evoking the relevant paradigm scenarios without needing to live through the actual events and their natural causes."[7] On the realist view, this is *bona fide* emotional experience; on the irrealist view, it is at most fictional or simulated emotions that one feels in this way towards the imagined events. The realist account can thus wholeheartedly respect the observation that it is the broadening of emotional experience (not the having of mere quasi-emotions) that is part of the value of those fictions that are works of art. Since affective responses include emotional ones, this observation fits neatly with the claim that a significant part of the value of art lies in its development of an illuminating cognitive–affective perspective on the world.

Emotional realism has, then, several interesting consequences for ethical criticism and for related issues in aesthetics. The remainder of this chapter will argue for its truth.

[7] De Sousa, *The Rationality of Emotion*, pp. 320–1.

9.2. THE POSSIBILITY OF FICTION-DIRECTED
EMOTIONS

Generally the question concerning emotional realism has been put like this: is it *possible* to feel real emotions towards events and situations known to be fictional, and if so, how? The so-called 'paradox of fiction' is then construed as the problem of how there can be real emotions directed towards known fictions. On the face of it, such emotions are puzzling: when we are afraid of something, for instance, it seems that we must believe that the feared object exists and is dangerous, and also be disposed to remove ourselves from its dangers. Yet, watching a horror film, we do not believe that the depicted monsters actually exist or are really dangerous, and far from rushing in terror from the cinema, we stay and watch with enjoyment.

Some aestheticians, including Kendall Walton and Jerrold Levinson, have tried to dissolve the paradox by arguing that (with various nuances and qualifications) it is not in fact possible to feel real emotions towards known fictional events: very broadly, what is happening is that the spectator is imagining feeling these emotions.[8] These theorists do not deny that spectators may feel real emotions towards real-world analogues of fictional events, nor do they deny that there is something emotion-like going on in spectators when they are moved by fictions: it is simply not real fear, pity, disgust and so forth that they are feeling towards the fictional events. These are the irrealists.

Realists include Noël Carroll, Richard Joyce, Peter Lamarque, Derek Matravers, Richard Moran and John Morreall, who argue that the phenomenology of spectatorship supports the claim that spectators can feel real emotions towards fictions, and that there are no good philosophical reasons for holding that the phenomenology is non-veridical in such cases.[9]

[8] Walton, *Mimesis as Make-Believe*, esp. pp. 195–204, 241–55, and, "Spelunking, Simulation, and Slime"; Jerrold Levinson, "Emotion in Response to Art". In *The Nature of Fiction*, ch. 5, Currie offers what appears to be an irrealist account in terms of states of make-belief and "make-desire" causing quasi-emotions, as distinct from genuine emotions. The account is initially motivated by the view that real emotions must be caused by appropriate beliefs, rather than make-beliefs. However, in sect. 5.7 he suggests that one can acceptably talk of a category of "broad emotions", which includes what we feel towards fictions, and that this broad notion of emotions does not require beliefs: only "paradigm emotions" do so. If broad emotions are genuine emotions, then Currie, despite appearances, a realist. (Indeed, Currie's more recent position is explicitly realist: see Currie and Ravenscroft, *Recreative Minds*, pp. 96, 159, and ch. 9.) If, on the other hand, we construe his account as irrealist, and not all broad emotions are genuine, then the objections to judgementalism, which we will make later, undermine his account too.

[9] Noël Carroll, *The Philosophy of Horror or Paradoxes of the Heart*, pp. 60–88; Richard Joyce, "Rational Fear of Monsters"; Peter Lamarque, "How Can We Fear and Pity Fictions?"; Derek Matravers, *Art and Emotion*, chs 3, 4; Moran, "The Expression of Feeling in Imagination"; John Morreall, "Fear without Belief".

I am going to argue for the claim not just of the possibility but also the *rationality* of fiction-directed emotions. The latter has sometimes not been as sharply separated from the former issue as it ought to be. For instance, Colin Radford in one of the earliest papers in the debate addressed the question of the rationality of fiction-directed emotions, but his position encouraged a conflation of this with the distinct question of their possibility.[10] Though distinct, there is nevertheless an important connection between the two issues: it will turn out that the strongest arguments for emotional irrealism stem from arguments based on rationality considerations, so that the puzzle about the rationality of fiction-directed emotions needs to be solved or dissolved in order to resolve the issue of realism.

The question of the possibility of emotional responses to fictions has been discussed chiefly in terms of the emotions of pity and fear, the emotions aroused by tragic representations. But, as foreshadowed in the previous section, if we cast our net wider, the irrealist case becomes less compelling. Disgust, for instance, is an emotion; but it is odd to say that one has to know whether something really occurred if one is to be disgusted at the thought of it. If I describe in vivid and detailed fashion the jam-and-live-mouse sandwich that I breakfasted on the other day, you might well be disgusted, without supposing that I am telling the truth. And if I tell you a joke, you don't have to wait to find out whether the events I describe really happened before you can find the joke funny. I can also be awed by or feel wonder at a depicted landscape, even though I know that the artist invented it. Nor does there seem to be anything problematic about the possibility of admiring a fictional character, such as Superman.[11]

Stronger, though, are the intuitions supporting the irrealist case in respect of fear and pity. How can one really fear something, or fear for someone, if one does not believe that the thing is dangerous or the person endangered? And how can one not be motivated to flee if danger really threatens one? Indeed, how could one enjoy these states if one really were afraid? Similar considerations apply to pitying someone.

If the irrealist is right about these matters, he or she owes an account of what is going on in such cases. Perhaps the most developed version of such an account is due to Kendall Walton. Walton holds that it is only fictional that Charles, the spectator of a horror movie, is afraid of the green slime that features in it, and what makes this the case is that Charles "experiences quasi fear [the sensations and physiological reactions normally associated with fear] as a result of realizing that fictionally the slime threatens him. This makes it fictional that his quasi fear is caused by a belief that the slime poses a danger, and hence that he fears the slime."[12] According to this analysis, spectators actually experience the sensations and physiological reactions normally associated with fear; these reactions do not,

[10] Colin Radford, "How Can We Be Moved by the Fate of Anna Karenina?".
[11] *Pace* Walton, *Mimesis as Make-Believe*, p. 203. [12] Ibid., p. 245.

however, constitute fear when directed towards fictions. The account thus readily provides an error theory for why spectators might falsely conclude that they really are afraid, even though they are only make-believedly afraid.

One evident disadvantage that such an account has over realism is its far greater complexity: whereas the realist holds simply that Charles is afraid of the Green Slime, the irrealist holds that he is in the complex state described above, which would involve his possession of concepts such as quasi-fear. We can indeed ascribe such concepts to spectators if they are necessary to explain the phenomena, even if spectators are not explicitly aware of possessing the concepts (think of how Chomskyans ascribe knowledge of deep grammatical structures to competent speakers, though such speakers have no explicit knowledge of them). But, if there is a simpler account available, which adequately explains the phenomena, we ought on general heuristic grounds to adopt that. And this means that, unless the irrealist has good grounds for showing that realism is inadequate, then realism ought to be the preferred account.

We have already adverted to the kinds of considerations to which irrealists can appeal; they can be organised around the three aspects of an emotion: the affective, the cognitive-evaluative and the motivational.

First, if a fiction-directed emotion is genuine, how could one enjoy feeling it? After all, real fear is intrinsically unpleasant, and people go out of their way to avoid it. But spectators enjoy horror films, and also a wide variety of other fictions in which they fear for characters. That strongly suggests that such spectators are only make-believedly afraid, not really so. However, this argument fails. For one of the many merits of Walton's account is that it allows for make-believe fear to have exactly the same phenomenology as real fear—that is what quasi-fear is. And any adequate account of make-believe fear must keep its phenomenology the same as that of fear, because it is a truth of introspection that one can be in a state that *feels* like fear when watching a horror film. But, if one insists that one cannot enjoy fear, because the feel of fear is unpleasant, then one must equally insist that one cannot enjoy make-believe fear, since, sharing the same phenomenology, that too must be unpleasant. Moreover, as I have argued elsewhere, it is a mistake to hold that fear is intrinsically unpleasant.[13] According to the cognitive-evaluative theory it is not the feeling that individuates the emotion, but the cognitive content; and this allows for at least some cases where fear can be felt as pleasant (perhaps because of its associated 'arousal jag'). Bungee-jumpers, mountaineers and many others who are confronted with real danger can seek out and enjoy fear; the cognitive theory shows how this is possible.

The second, cognitive–evaluative, aspect of an emotion seems to provide a stronger ground for the irrealist case. Real emotions require their subjects to have appropriate beliefs: real fear requires one to believe that someone about whom one cares is threatened. If a man in a pub tells you a harrowing story about his

[13] See my "The Paradox of Horror".

sister, then you will cease to be harrowed if the man then admits that he made the story up, and does not have a sister.[14] However, the example does not prove that an emotion requires a belief: if one's emotion does evaporate on being told that the sister is an invention, that merely shows that, *if* an emotion is grounded on a belief, removal of that belief tends to remove the emotion grounded on it. It does not support the more general claim that having an appropriate belief is a necessary condition for the existence of an emotion.

The claim that to have an emotion a person must have the appropriate evaluative belief might seem to follow from the cognitive–evaluative theory of the emotions. But in fact cognition is a broader category than belief, including imaginings in a broad sense—unasserted thoughts, construals, seeings-as and so on. The more restricted version of cognitivism, which holds that emotions require *beliefs* about their objects, has been dubbed *judgementalism*, and there are good reasons to reject it, as Patricia Greenspan has argued. Consider Fido, an old and harmless dog. Because of a traumatic childhood incident, Fred has a neurotic fear of dogs, and Fred fears Fido. Fred does not believe that Fido is dangerous: Fred has, for instance, no tendency to warn others about him. Fred simply cannot help seeing Fido as dangerous, and he responds to Fido with fear. So it is possible to feel fear while not possessing a belief that the object of one's fear is dangerous.[15] Or consider cases when I vividly imagine my hand being mangled by a machine, and I feel fear, though I firmly believe that my hand is not caught in the machine;[16] or when I vividly imagine plunging to my death on the rocks below, though I believe that I am safely behind the parapet on the cliff top. It is also possible to fear merely counterfactual cases.[17] For instance, it makes sense to be afraid of what would have happened if Hitler had won the Second World War. And a visitor to the CN Tower in Toronto can have the experience of walking on a glass floor several hundred feet up on the observation deck of the tower, seeing the ground far below his feet. As one edges gingerly across the floor, one certainly believes that it is safe to do so (otherwise it would be madness to walk across), but the experience of fear is perfectly genuine: the appearance of extreme danger is a very vivid one, and explains one's fear of falling.

The irrealist will deny the possibility of these cases. First, it will be objected that all these examples are ones in which one does have a belief, albeit an irrational and probably subconscious one. Several phobic fears may be like this: someone who fears flying may well have an irrational belief that flying is dangerous. However, while this may be true of some phobias, it fails as a plausible explanation for the full range of cases considered above: I do not, for instance, have a subconscious and irrational belief that Hitler really did win the Second World War, or that I will fall to my death when I walk across the glass floor—if I did have the latter

14 Radford, "How Can We Be Moved by the Fate of Anna Karenina?".

15 Greenspan, *Emotions and Reasons*, ch. 2.

16 Carroll, *The Philosophy of Horror or Paradoxes of the Heart*, pp. 78–9.

17 See also Moran, "The Expression of Feeling in Imagination".

belief, I would not walk across. The better explanation is that the vivid imagining or appearance of danger is sufficient to ground real fear.

Secondly, it has been objected that anti-judgementalist accounts mistake the intentional object of emotions. Carroll dubs his version of the anti-judgementalist view the *Thought Theory*, and holds that Charles fears the thought of the Green Slime, and this thought need not be asserted;[18] and a related position is defended by Lamarque.[19] Walton has objected to the latter that one does not fear the thought, but the *object* of the thought—the Green Slime.[20] The anti-judgementalist should simply agree: the theory should hold that one fears not the act of *thinking* of the Green Slime, but the *thought-content*: that is, the Green Slime. Judgementalism holds that asserted thoughts (beliefs) are necessary for emotions; and that the intentional object of the fear is the belief-content—that is, what the belief is about. Anti-judgementalism holds that unasserted thoughts are all that may be required for an emotion, and should relatedly hold that the object of fear is the thought-content—that is, what the thought is about.

Finally, an irrealist can object that the Fido case and its ilk show only that it is not necessary to believe that an object is dangerous to fear it; but it is compatible with this that one must believe that the object exists in order to fear it. So fear does not require *characterising* beliefs that something is dangerous, but it does require *existential* beliefs, and hence the paradox of fiction is not solved by the anti-judgementalist stratagem. Something like this suggestion is made by Levinson.[21] However, such a halfway position lacks motivation: fear has as its formal object the dangerous, so the fact that one believes that the object of fear exists, even though it lacks the property of being dangerous, would be no less puzzling than the case where one does not believe that object of fear exists at all. And far from it being the case that fear must be directed to what one believes exists, fear is often felt towards what *may* happen in the future, not what one believes is presently so.

The third, motivational, aspect of emotions grounds what some irrealists see as their most powerful argument. Walton remains neutral on Greenspan's anti-judgementalism, but holds that there are nevertheless good reasons for thinking that Charles, unlike Fred who fears Fido, is not really afraid, for Charles is not motivated to flee, and "Fear emasculated by subtracting its distinctive motivational force is not fear at all".[22] Similarly, the irrealist can hold that I am not motivated to help Anna Karenina, and that this undermines the claim that I pity her.

In reply, the realist needs to get clearer about what the motivational aspect of an emotion involves. For consider a parallel argument to the above in respect

18 Carroll, *The Philosophy of Horror or Paradoxes of the Heart*, pp. 60–88.
19 Lamarque, "How Can We Fear and Pity Fictions?".
20 Walton, *Mimesis as Make-Believe*, p. 203.
21 Levinson, "Emotion in Response to Art". 22 Walton, *Mimesis as Make-Believe*, p. 102.

of historical victims: it might be claimed that I do not really pity Anne Boleyn, since I am not motivated to help her in any way. But I really can pity Anne Boleyn; and this is so by virtue of the fact that I have a genuine desire or wish that she did not suffer as she did. It is the presence of such a desire or wish that constitutes the motivational aspect of the emotion of pity. If, for instance, I said that I pitied Anne, but had no desire at all that she did not suffer as she did, there would be defeasible grounds for questioning whether I really did pity her. But I do not try to help Anne, since I lack the belief that there is something I can do to help her. It is absence of this belief, not of the desire (or therefore of the emotion), that explains why I do not act. So the absence of motivated action does not prove that I do not pity Anne; rather, I lack the appropriate beliefs about being able to help her. In the same way, I may genuinely pity Anna Karenina, since I wish that she had not suffered as she did, but I lack the belief about being able to help her in any way; so I do not try to do so. The point applies not just to historical cases, but also to anyone whom I believe I cannot help. If I watch a live television broadcast of a hurricane sweeping through a small Florida town, I can genuinely pity the inhabitants, though I do not try to get them out of the way of the hurricane, since I know that there is nothing I can do to prevent it from engulfing them.[23]

A parallel argument applies to the case of fear. It is not the case that the desire criterial for fear is a desire to flee, since, in the case of certain fears, fleeing is not appropriate—as in the case of my fear that I will lose my job. Rather, the desire is not to be threatened or endangered. And, here again, spectators do not flee, since they lack the appropriate beliefs to motivate flight. Charles does not *believe* that he is endangered, but only *imagines* it; and, given this, his desire not to be threatened does not motivate flight. However, this desire, imagined to be frustrated, may express itself in his reactions: covering his eyes, flinching, moaning and so forth. Charles may in addition desire to flee the Green Slime, but even then he is not motivated to flee it, since he knows that no action available to him could count as fleeing it, since he cannot physically remove himself from the Slime: it occupies a fictional space, distinct from the physical space he occupies, and no point of this physical space is closer or more distant from the Slime than any other. (He may, of course, flee the cinema, but this action counts as fleeing the image of the Slime, not the Slime itself.) So, again, the motivational aspect of fear is constituted by the presence of a desire or wish; lack of the motivated

[23] For a similar set of considerations about motivation, see Derek Matravers, "Who's Afraid of Virginia Woolf?", and his *Art and Emotion*, chs 3, 4; Matravers also endorses anti-judgementalism. These are, as noted, central parts of the solution to the paradox of fiction. But as a core part of his solution he also embraces the report model for fiction—the claim that the appropriate game we play with a work of fiction is to imagine it as a narrated documentary representation, which is non-transparent (i.e. whose function is not solely to produce belief in its audience). But the report model is unnecessary, since anti-judgementalism and the motivational point are all that are required to defend realism. The report model is also deeply problematic, and false of many fictions, particularly cinematic ones: see my "Philosophy of the Movies: Cinematic Narration".

action of flight may be explained by the absence of appropriate beliefs, not by the absence of the emotion.[24]

The irrealist may object that we do not genuinely pity fictional characters, for we have desires that require them to suffer. I do not genuinely pity Anna, since I want to read *Anna Karenina* because it is a great tragic novel, and Anna's suffering is necessary to its being a tragedy. If someone produced a sanitised version of the novel, in which Anna goes off to live happily ever after with Vronsky, I would not want to read it. So my feeling of pity is illusory: I really do want Anna to suffer.

We can again help ourselves to the idea of *pro tanto* judgements. One can in general desire that some state of affairs occur, in so far as it has some property, and also desire that the same state of affairs not occur, in so far as it has a different property. I want to eat this chocolate cake in so far as it will taste delectable; I also want not to eat the chocolate cake in so far as it will make me fat. Having such conflicting desires is possible, indeed common, and not in the least irrational. Moreover, if I decide overall that the latter desire is the stronger, and I do not eat the cake, that does not show that the desire to eat the cake is not real or strong—it is, as witnessed by my pangs of regret as I reluctantly refuse a slice. In the same way, I may genuinely desire that Anna not suffer, in so far as she is loveable and her suffering is overall undeserved, while also desiring that Anna suffer, in so far as her suffering is a necessary constituent of a great novel. The greater strength of the latter desire does not prove that the former does not exist. So my desire that she not suffer and my pity for her are indeed genuine.[25]

So irrealist arguments drawing on each of the three aspects of an emotion fail to show that we cannot have fiction-directed emotions. The realist replies in each case drew not just on discussion of fictional cases, but also crucially on non-fictional cases, such as emotions felt towards counterfactual cases, or to real-life cases, and on emotions felt towards historical personages or towards contemporaries whom one cannot help. It emerged that it is not a requirement that one has an appropriate belief for one to have a genuine emotion, a mere imagining may suffice; and we also saw that the motivational aspect of an emotion can involve merely the presence of a wish or desire. And, as we noted, the greater complexity of Walton's make-believe account gives reason to prefer the realist account, if realism is at least as adequate an account of the phenomena.

[24] It should be noted that I have not maintained that motivated action invariably requires an appropriate belief as well as a desire—for Fred only imagines Fido to be dangerous, and this imagining, combined with his desire not to be endangered, is sufficient to motivate him to flee Fido. An imagining here takes the role of a belief in motivation; but—to anticipate the later discussion—this is an aspect of Fred's irrationality, and, in rational persons, an appropriate belief is required together with a desire to motivate action. Since the present section discusses the *possibility* of fiction-directed emotions, I am assuming here that spectators of fictions are rational, so that, if they lack the appropriate belief, they will not be motivated to act. The rationality claim will be defended later.

[25] Alex Neill in "Fiction and the Emotions" discusses this kind of objection, and responds in a way that is related to but somewhat different from that given above.

Realism is, in fact, a better account of these phenomena, being grounded on an anti-judgementalist theory of the cognitive aspect of emotions, and a superior understanding of the motivational aspect of emotions.

Finally, consider a mixed position, which holds that, while one should be a realist about pity and fear for fictional characters, one cannot feel fear *for oneself* in fictional contexts. This view has been defended by Alex Neill, who adopts a judgementalist version of the cognitive–evaluative theory of the emotions.[26] However, he maintains that the belief necessary for the existence of the emotion need not be a belief that its object has the appropriate evaluative property, but may instead be a belief that it is *fictional* that its object has that property.[27] The latter condition allows it to be possible to fear for or pity a fictional character. But fear for oneself is not possible, since one neither believes, for instance, that one is threatened by Dracula, nor does one believe that it is fictional that one is so threatened, since one knows that nothing fictional can threaten a real person (there is an "ontological gap" between fiction and reality, preventing cross-world action). Moreover, the reason that one does not flee Dracula is that the desire to flee from something requires either that one believe that one is threatened by it, or that one believe that it is fictional that one is threatened by it; but neither of these is the case. Hence Charles can stay firmly in his seat, despite the marauding Green Slime. He never fears for himself.

We have already seen that one should reject the judgementalist account of the emotions. As Fido and the other cases demonstrate, it is not necessary for an emotion to exist that one have the relevant belief—Fred does not believe that Fido is dangerous; nor does he believe that it is a fiction that Fido is dangerous (indeed, that thought would be a source of comfort to him). Also, Fred has a desire to flee Fido, and indeed may act on that desire, even though he lacks both of the beliefs just mentioned. It is possible for action to be motivated by a desire and an imagining, not a desire and a belief—the latter, as we shall see, is a condition for the rationality of the motivation, not for its possibility. So these claims of the mixed account are flawed.

And there is in fact no good reason to deny the possibility of fear for oneself in certain fictional contexts. When the Slime stares out of the screen at Charles, it is fictional that the Slime threatens him (this is akin to a theatrical aside). The case is unusual, since fictional characters do not generally perform such asides, but when they do so, imagining that one is threatened is prescribed, and hence it is fictional that one is threatened. So it is correct to believe that it is fictional that one is threatened, and hence, even on Neill's account, it should be appropriate to feel fear for oneself. And on an anti-judgementalist view it is also clearly possible to feel afraid in this situation.

[26] Ibid.

[27] In ibid., p. 4, however, Neill says that emotions require one to adopt a perspective on something, which may be a concession to the anti-judgementalist view.

However, Neill also advances a subtler worry: in such cases, it seems that it cannot be myself for whom I fear, since it is not true that the Slime threatens me, but at most it threatens my fictional or possible counterpart (I, as I exist in the fictional world).[28] But this is in fact sufficient for fear for oneself. For consider a case where I narrowly avoid skidding in my car, and afterwards fear what might have happened to me, had I hit that tree. Here, one might insist that, strictly speaking, it is a possible counterpart of myself for whom I fear (myself when I hit the tree), rather than myself as I actually am (unharmed). But nevertheless we speak quite naturally and appropriately of such a case as one in which I fear for myself. My concern for myself includes not just myself as I am, but also myself under various possible circumstances. I do not cease to care for myself merely because certain of my properties alter—for example, I get older. Hence when we talk of self-concern, this includes concern for possible counterparts of ourselves, and so there is no reason to deny that I am afraid for myself when I contemplate myself in various possible situations. So not only should one be a realist about fear for fictional characters, but one should also be a realist about fear for oneself in these kinds of fictional contexts.

9.3. THE RATIONALITY OF FICTION-DIRECTED EMOTIONS

There is a related problem for realism that is at least as pressing as that considered above. Suppose that the anti-judgementalist is right about the nature of emotions, and that beliefs are not required for emotions to exist. Nevertheless, it looks plausible to hold that appropriate beliefs are required for emotions to be *rational*. Even if I can fear Fido without believing that he really is dangerous, it seems that, for my fear of him to be rational, I must believe that he is dangerous. (I may have an irrational belief that he is dangerous, but, if so, this is a case of theoretical irrationality, and the emotion itself is derivatively irrational by virtue of this theoretical irrationality.) If I say 'I'm afraid of Fido, though he's perfectly harmless', this may describe a possible state, but it also seems to be a self-conviction of irrationality. Yet, in the case of fiction-directed emotions, we do not believe that fictional entities exist, or are suffering, or are dangerous; and that seems to render these emotions irrational. For anyone who believes that our emotional engagement with fictions is valuable, this is not a welcome result. Moreover, though we argued against irrealist accounts, if it transpired that the cost of rejecting them were that spectators were systematically irrational, then a principle of charity in interpretation would come to bear. If we had to conclude that emotional responses to fictions were irrational, there would be a

[28] Alex Neill, "Who's *Afraid* of Virginia Woolf?", p. 96.

strong reason, given the pervasive nature and importance of such responses, to reinterpret them so that they were only imagined emotions, and hence to preserve the rationality of spectators' responses to fictions. This would put pressure on the arguments of the last section, and it might be better to conclude that fiction-directed emotions are make-believe.

We need first to say a little about what rationality is. In its most general characterisation, rationality is a matter of sensitivity to reasons; specifically, it is a matter of being able to recognise reasons and respond appropriately to them. It covers reasons to believe (theoretical rationality), reasons for action (practical rationality) and reasons to feel (affective rationality), the latter being our particular concern. There is a distinction between two standards of demandingness of rationality. Sometimes when we wonder what rational persons would believe, do or feel, we wonder what they have *most reason* to believe, do or feel. This requires the deliberator to bring to bear all relevant reasons in the appropriate domain, and this can be a very demanding task, far beyond the capacity of an ordinary person. If one wonders what one has most reason to believe about the truth of a particular mathematical proposition, one may have to engage in mathematical reasoning of a complexity that few can follow. Call this notion *maximal rationality*. When we call someone irrational, on the other hand, the accusation cannot be of failing to be maximally rational, for this would be an extremely demanding standard, given all the reasons that are potentially relevant in any particular domain, and most people on most occasions might well be judged to be irrational by this standard. Rather, we must be adopting a lower standard in making this accusation: the irrational person is a person who fails to achieve some *minimal* standard of rationality. The reasons that he or she fails to recognise or to respond to appropriately would be those that are readily graspable, being clear and evident. How to specify this notion more exactly is a moot issue, but for our present purposes, we need not attempt to do so. The main point is to distinguish these two standards of rationality, and relatedly to note that not all failures to grasp reasons are instances of irrationality.

How is the realist to respond to the claim that fiction-directed emotions are irrational? The most straightforward realist position is simply to embrace the objection, and to be an *irrationalist* about fiction-directed emotions. Emotional responses towards fictions are irrational, and charity should not lead us to deny that they occur. There are, after all, natural responses that are irrational: people tend to be systematically more optimistic about how well their lives will go than is epistemically warranted. And love, as Proust and Stendhal have made us well aware, can have many irrational aspects to it, involving projections of one's hopes and fantasies onto the loved one that may have little foundation in reality. But that is simply how love is, and it would be wrong to try to interpret away these features of our lives in the interest of ascribing greater rationality to ourselves. Similarly, perhaps we have a natural tendency to respond to fictions with real emotions, but this is nevertheless irrational.

Something like this seems to have been Plato's view in the *Ion*. To recall the passage quoted in Chapter 1, Socrates says of the recitor of verses:

> There he is, at a sacrifice or festival, got up in holiday attire, adorned with golden chaplets, and he weeps, though he has lost nothing of his finery. Or he recoils with fear, standing in the presence of more than twenty thousand friendly people, though nobody is stripping him or doing him damage. Shall we say that the man is in his senses?
>
> ION: Never, Socrates, upon my word. That is strictly true.
>
> SOCRATES: Now, then, are you aware that you produce the same effects in most of the spectators too?
>
> ION: Yes, indeed, I know it very well. As I look down at them from the stage above, I see them, every time, weeping, casting terrible glances, stricken with amazement at the deeds recounted.[29]

Socrates, then, does not doubt the reality of fear and sorrow in these cases: he simply thinks that they are irrational. Radford's preferred response to the problem also seems to be a version of irrationalism.[30]

So the emotional realist can hold that fiction-directed emotions are real, but irrational, and fall into a class of other real but frequently irrational emotions or attitudes. However, this response is not very plausible. First, the claim is extremely counter-intuitive, since all instances of emotions directed towards fiction would have to be held to be irrational, for we always lack the requisite evaluative and existential beliefs about fictions. It is not that the responses *sometimes* err in being irrational (as is the case with optimism and love); they *always* so err. And these responses are a core part of our general response to fictions, so almost every response to fiction would probably be tainted with irrationality. This is hard to accept.

Secondly, the objection from the principle of charity cannot easily be evaded. For emotional irrealism, as we have seen, has a story to tell about how imagined emotions have affective features that explain why we confuse them with real emotions; the account provides an error theory of why a spectator might falsely conclude that he really is afraid. And, since that error theory is not wildly implausible, a principle of charity points towards the conclusion that emotional irrealism is correct. In contrast, it is much more implausible to interpret away the irrational aspects of optimism and love—wild optimists are not experiencing quasi-optimism, and people irrationally in love are not experiencing quasi-love. The pressure exerted by charity in favour of reinterpretation is much greater in the fiction case, so irrationalism should not seek shelter in the occurrence of irrational responses in real life.

A final problem with irrationalism is that holding fiction-directed emotions to be irrational undermines some of the discriminations required in assessing viewers' responses to works. Suppose you fear some dreadful monster in a horror

[29] Plato, *Ion*, 535 d–e.
[30] Radford, "How Can We Be Moved by the Fate of Anna Karenina?".

film, while Bertie fears an innocent victim in that film. Bertie's fear is irrational, your fear is not. But, if all emotions directed towards fictions were irrational, this sort of discrimination could not be made. Yet we clearly can, do and ought to make such discriminations, so we are not and ought not to be irrationalists.

A different response to the puzzle about the rationality of fiction-directed responses employs the notion of control. The realist might hold that the reason why fear of Fido is irrational has nothing to do with the absence of an evaluative belief, so the absence of this belief does not tend to show that fear of Dracula is also irrational. Rather, the crucial difference between the two cases lies in relation to the degree of control that subjects have over the respective emotions. Fred's neurotic fear of Fido is something he cannot control: he sees Fido and is consumed with fear. But Charles, watching the Green Slime, can control his fear: he can turn his attention away from it, thus abolishing his fear; nor does the fear overwhelm him. It is lack of emotional control that makes Fred's fear irrational, not lack of an evaluative belief.

However, it cannot be lack of control that makes an emotion irrational. For consider my terror of the pit-bull terrier that is howling ravenously and unrestrainedly in front of me. My fear is out of my control, but it is also completely rational: I may be about to be viciously attacked. Moreover, the control criterion will not invariably separate fictional from non-fictional cases, since emotions felt towards real situations can sometimes be as much under our control as are emotions felt towards fictions. Fred may well be able to control his fear of Fido by avoiding Fido and not thinking about him. In just the same way, Charles may decide that the horror film has got too grisly, close his eyes and think of something pleasantly soothing. Strategies for coping with fear, by diverting one's attention and dwelling on pleasant thoughts, are equally available in both cases. Still, Fred's controlled fear is irrational, while Charles's controlled fear is not. Lack of control is in fact more likely to be explained by experiencing an extremely powerful emotion, whether produced by a fictional or a non-fictional situation—the power of the response temporarily robs one of one's ordinary coping abilities for dealing with emotions.

A third solution, which employs the idea of control, though in more sophisticated fashion, is that of instrumentalism. Richard Joyce distinguishes clearly between the problems of the possibility of fiction-directed emotions and their rationality.[31] He solves the former by adopting an anti-judgementalist view (though he does not confront the problems due to lack of motivated actions). The rationality puzzle he addresses by distinguishing between emotions that we do not control, which if counter-productive are phobias, and emotions that are under our control, and these he holds are common in the case of fiction-directed emotions. Emotions under our control are subject to the norms of instrumental

[31] Joyce, "Rational Fear of Monsters".

rationality, so they are rational if subjects are justified in believing that having them serves their interests. Since fiction provides valuable experiences in respect both of pleasure and of providing us with opportunities to learn, having fiction-directed emotions can be rational.

Joyce's criterion is related in part to the affective criterion to be developed later, since it is sensitive to the question of whether an emotion is in a certain way counter-productive. And his argument that it is not necessarily absence of belief that makes something a phobia (since phobias can be founded on irrational beliefs as well) is well taken. But his instrumentalist solution fails. Suppose that you offer me a large sum of money, in order that (via the processes of active imagination) I induce in myself a serious fear of doorknobs. I succeed in doing this, and will not touch doorknobs, shrink away when I see one and so on. My production of the emotion in myself was instrumentally rational (I gained something to my benefit), but the emotion itself is still irrational. It violates, for instance, the motivational criterion (to be developed shortly)—I am motivated to avoid doorknobs, even though I do not believe they are dangerous (or, if I do believe they are dangerous, my fear is derivatively irrational, as being founded on an irrational belief). So it can be instrumentally rational to induce in oneself an emotion that is irrational. Joyce's account suffers from the same general defect as the other two just examined—it seeks to provide one simple criterion for a complex phenomenon, and so ends up in oversimplifying the rationality constraints to which emotions are subject.

The correct solution to the problem, I propose, begins by acknowledging the complexity of emotional states, with their three aspects of the motivational, cognitive and affective. Given this complexity, it would be surprising if the criteria for rationality (in the minimal sense of not being irrational) were not similarly complex, and related to these three aspects of an emotion.

First, consider the cognitive aspect of an emotion. There is a salient difference between Fred's fear of Fido and Charles's fear of the Green Slime—Fred believes that Fido exists (even though he does not believe that he is dangerous), but Charles does not believe in the existence of the Green Slime. This difference looks like a plausible reason for why Charles's fear is rational, and Fred's is not. So consider this criterion:

(C1) The rationality of fear of objects believed to exist requires one to believe that they are dangerous; and the rationality of fear of objects merely imagined to exist requires one (correctly) to imagine that they are dangerous.[32]

[32] The proposal, of course, generalises: for each emotion, one should substitute in the formula the evaluative property that individuates that emotion—for pity, suffering; for anger, having been wronged, and so on. Note that in some instances of phobias the subject may have irrational beliefs about the feared object, which he believes to exist; in these cases, the phobic fear would pass the cognitive criterion, but the emotion would be *derivatively* irrational; i.e. the fear would be irrational

Fred believes that Fido exists, but he does not believe that he is dangerous, hence his fear is irrational. Charles only imagines that the Green Slime exists, but he correctly imagines it as dangerous, hence his fear of it is rational in this respect. And the criterion is not *ad hoc*: the distinction in the rationality criterion derives from the difference in the cognitive states of imagination and belief.

The criterion also gives the correct answer about Bertie, who fears not the evidently vicious monster, but the evidently harmless victim in a horror film (she bears a strong resemblance to his aged aunt, of whom he is terrified). In the case of fictions, a large part of what makes it correct to imagine that someone is the victim, and not the monster, is laid down by the internal norms of the fiction—by what the artists made fictional by their actions. Given these norms, Bertie has imagined incorrectly.

The criterion is general in the correct way: it draws the distinction, not between fictional and real-life cases, but between cognitive states that are imaginings, whether or not they are associated with fictions, and cognitive states that are beliefs. Incorrectness in imagining is possible, not just for fictions that are generated by an author independently of the audience, but also for self-generated imaginings, because incorrectness can be fixed by the implicit prescriptions governing such imaginings. Imagining a calm and peaceful scene on a beach, I am suddenly struck by fear of the passing shadows of children, even though these children are in no way dangerous in my imagined scenario. That counts as an irrational fear. And contrast the rational fear of what might have happened had Hitler won the Second World War with the fear of what would have happened had Italy won the 1974 Football World Cup. The latter fear is not rational, unless I have ancillary imaginings that would make the team dangerous—such as that they were really a terrorist organisation planning to blow up the stadium after they had won.

The criterion thus yields intuitively correct results; but it may seem vulnerable to objections. First, consider Frank, who has no neurotic fears of Fido, but instead decides to play a game of make-believe featuring the trusty old dog, in which he imagines Fido to have the temperament of a maddened Rottweiler on speed, and to possess not his actual toothless old gums, but glinting dental machinery with which to effect his murderous dispositions on the hapless Frank. Frank, imagining Fido thus, is terrified. On the cognitive criterion, since Frank believes that Fido exists, for his fear of Fido to be rational, he should believe that Fido is dangerous. But he doesn't. So his fear of Fido counts as irrational. But surely his fear may be perfectly rational: perhaps Frank is a psychotherapist, and is trying to figure out what it is like to be gripped by fear.

by virtue of being grounded on an irrational belief. A related criterion has also been suggested by Eva Dadlez in "Fiction, Emotion, and Rationality". However, she holds that it is a necessary condition for an emotion to be irrational that it be directed at a real object; but this is not correct, as the cases of Bertie and of the fear of ghosts (to be discussed shortly) show.

In this scenario, what is the intentional object of Frank's fear? Not Fido as he actually is: for, knowing that he is playing a game of make-believe, Frank's feelings about the real Fido may (and should) not have changed in the least: Frank may pat and stroke Fido without the slightest tremor when he steps out of his game. Rather, it is the make-believe Fido that he fears, he of the terrible temperament and the deadly fangs. Since this Fido is a merely imagined being, he can rationally fear him according to the cognitive criterion. Contrast this with Fred's neurotic fear of Fido. What makes it possible for Fred to fear Fido is that he imagines the dog to be dangerous, even though he does not believe that he is. In seeing him as dangerous, he may imagine him as having the vicious temperament and deadly capacities that Frank imagines him to possess in the game. But the difference in the case of the phobia is that Fred fears the actual Fido: he shrinks from his touch, he goes clammy at the sight of him. The intentional object of Fred's neurotic fear is actual-Fido, whom he believes to exist: but the intentional object of Frank's rational fear in the game is imagined-Fido.[33]

There is a close connection to another case here. Suppose I meet Tom Cruise, who plays Dracula in a film, at a party, and, on seeing his warm smile and outstretched hand, I cringe with fear and shrink from his touch. What I have reason to fear is Dracula, not Cruise—Dracula is imaginary, and, given the properties ascribed to him in the film, it is correct to imagine him as dangerous. If the intentional object of my fear is, however, Cruise, my fear is irrational, for I believe that Cruise exists and is not dangerous. I am irrational because I have confused fictional persons with real ones, and the responses appropriate towards fiction are in this case inappropriate when directed at reality. A similar scenario can be constructed for pity: I may irrationally pity an actress who played the part of Tess of the D'Urbervilles.

Secondly, it may be objected that this solution actually shows that we are no longer dealing with the same emotion directed towards objects imagined to exist and believed to exist, and therefore in the former case perhaps the emotion itself is only imagined. For, if the rationality-conditions differ in the two cases, then the emotions must differ too: since mental states are normative, any mental state is constituted by a specification of those conditions under which it is rational.

However, consider the case of belief: belief is rational (justified) with respect to mathematical statements only when these are proved a priori; but for statements about the number of chairs in a room, attempting to ground them a priori would be irrational. So the rationality-conditions for belief are distinct in the two kinds of cases. Nevertheless, 'belief' means just the same when belief is about a priori propositions as when it is about a posteriori ones. So the distinction in the rationality-conditions between emotions directed towards entities only

[33] It is possible, of course, that, as a causal consequence of his imaginings, Frank might come to fear the actual Fido, for instance, fearing him outside the game; he is then irrational on the cognitive criterion; and that is correct, for in this case he has induced Fred's irrational phobia in himself.

imagined to exist and towards entities believed to exist does not show that there are two different kinds of emotions involved. Moreover, the difference in the rationality-conditions need not be traced to a difference in the emotion: the difference can be traced to a difference in the mode of cognition of their objects—that is, to whether they are imagined or believed to exist.

The second aspect of an emotion is the motivational aspect. Suppose that you imagine ghosts to exist, you imagine them as dangerous (correctly, given their well-known propensities), and you fear them. You don't believe that the ghosts exist or are dangerous; so, in respect of the cognitive criterion, your fear is rational (that is, not irrational). But are you really rational? You might be—like Frank, you might be engaged in a project of imaginative understanding, and want to grasp what is going on in the minds of the ghost-fearing tribe that you are currently living with and studying, without irrationally holding their beliefs. But suppose that you are so caught up in this imaginative project that you start looking in the dark corners of your room for signs of ghostly inhabitancy, huddle under your bed when you hear rumbling noises from outside and so on. At that point, you have slipped into irrationality, because you are now engaged in trying to avoid those non-existent ghosts; but you have not violated the cognitive criterion. (In respect of the two ways in which you were fearing ghosts, before you were like Charles, watching the horror film, and you were rational; now you are like a spectator who flees screaming from the cinema, trying to get away from the Slime.)

So there must be a further criterion for rationality, concerning motivations. If you actually believed that ghosts exist and are dangerous, your glances under the bed would not count as irrational (though your beliefs probably would). So your fear counts as irrational by virtue of its motivating actions to avoid ghosts, even though you have no motivation-relevant beliefs—in this case, that ghosts exist and are dangerous. And this suggests a motivational criterion:

(C2) An emotion is irrational if it motivates action, though its subject lacks motivation-relevant beliefs.[34]

This criterion also picks out a further aspect of Fred's irrationality. Fred is motivated to flee Fido, though he lacks the belief that Fido endangers him. So he is motivated to act by his desire not to be endangered and his vivid *imagining* that he is endangered. As noted earlier, motivated action requires not necessarily desire and belief, but desire and some cognitive state, which may be an imagining, that ascribes the evaluative property to an object. And I also suggested that, if the motivation to flee in the case of fear were present, though the belief about being

[34] Motivation-relevant beliefs are those that ascribe the relevant evaluative property to the object of the emotion (e.g. believing that something is dangerous, in the case of fear) or those that concern the possibility of the subject acting towards the evaluated object (e.g. believing that one can do something to help, in the case of pity).

endangered were not, then that would show that the motivation is irrational. So it is with Fred: his motivation is irrational, since he lacks the belief (about being endangered) that would rationalise it. His fear violates the motivational criterion. Frank's emotion in contrast is not irrational, since he also lacks the belief and is not motivated to flee Fido.

Is the motivational criterion tenable? First, it may seem that it sits badly with the cognitive criterion, since it renders it otiose. What makes Fred's response to Fido irrational is not his emotions, it might be objected, but what he is motivated to do: run away from him. If like Charles in the fiction case, Fred were not motivated to flee, then whatever his emotional state, he would be rational. Appeal to the cognitive criterion is unnecessary.

But, even if Fred were not motivated to flee by his fear of Fido, his fear would still be irrational, since he has no reason to fear the dog. Emotions involve evaluative thoughts, and the rationality of these thoughts can be assessed independently of the motivations which they ground in certain circumstances. This can also be true of responses to non-fictions: if I pity the Nazis, and not their victims, while knowing that it is the victims, not the Nazis, who suffered, then my pity is irrational, even though I am not motivated to help either group, since I know they are beyond the reach of my actions. The motivational criterion cannot do all the work.

Secondly, people watching a horror film may flinch, moan, go pale, shiver and so on; these are actions motivated by fear. Since spectators do not believe that they are threatened, these motivated actions will count as irrational on the motivational criterion. But they are the natural accompaniments of fear, and hard to suppress. So almost all fiction-directed fear would count as irrational on this criterion—and the same will apply *mutatis mutandis* to other fiction-directed emotions by virtue of their natural accompaniments.

We should distinguish between expressive and goal-directed actions. The activity just mentioned, in so far as it involves actions and not merely involuntary behaviour, is expressive activity, the natural bodily and behavioural tendencies of the emotion. Goal-directed actions in contrast aim at some end cognised by the agent, and the actions seek to achieve that end. So contrast the case of blanching and shivering at the Green Slime, with the case where I carefully check under my cinema seat for signs of ectoplasmic goo adhering to it. The latter action is irrational, the former not. The motivational criterion should be understood to govern actions in so far as they are goal-directed, and not in so far as they are simply expressive.

Finally, the third aspect of an emotion is the affective aspect, which grounds a third criterion. Suppose that I believe (correctly) that I am in great danger of losing my job; this motivates me to do what I can to avoid losing it. Cognitively and motivationally, my fear is rational. But I am tormented by the prospect of losing my job, I brood on it and suffer immensely, though none of this affects my job performance. I am suffering to no point, and the emotion is irrational,

yet it passes the cognitive and motivational tests. So we need a further criterion, which governs the affective dimension of an emotion:

(C3) An occurrence of an emotion is irrational if experiencing it involves suffering to no point.

This criterion is supported by a wide range of cases. It governs not just actual, but also imagined situations, or what we might call 'negative fantasies'. Suppose that I am very prone to torment myself with fear and dread by imagining myself being roundly humiliated whenever I meet people for the first time. I imagine suitably luridly embarrassing and humiliating scenarios, though I am not motivated to avoid meeting people because of this. On the cognitive and motivational criteria, my fear is rational. Yet it is in fact irrational: there is no point to this self-torment, and I ought to stop it. So the affective criterion correctly governs these kinds of cases. Note in contrast that, if I am prone instead to engage in positive, pleasant fantasies, the warm feelings that I have towards them do not seem irrational at all.

The affective criterion also explains an aspect of the irrationality of phobias: one reason we hold them to be irrational is because they are disabling in various ways—the person in the grip of the phobia suffers, and he or she is prevented from performing otherwise worthwhile activities (such as going outside, or meeting people, or enjoying the pleasures of canine company). Some instances of suffering are worthwhile because they have a point (one may believe them to be character-improving, for instance). But these cases are not like that: this is suffering without a point. And the affective criterion provides yet another reason why we deem Frank's encounters with Fido to be rational and Fred's not. Frank, if he feels intense fear, may suffer; but his suffering has a point, for it allows him to understand his patients better; Fred's suffering in contrast has no point—indeed, it prevents him from enjoying time with that loveable old hound.

One might suppose that some kind of proportionality criterion would do the job better here—a criterion that holds, for instance, that one ought to feel greater fear the more in danger one is in. But that is too crude. If I am climbing an extremely dangerous mountain, I have reason not to feel a very high degree of fear, since that might be so distracting that my climb is rendered even more dangerous. Fear presumably has as its point the preservation of the subject who fears; yet in this case, feeling it in proportion to the danger might well make my preservation less likely. This fear not only has no point; it undermines the point of having fear itself. We should understand the 'to no point' criterion as also including the case where the suffering undermines the point of the emotion itself.

Finally, note that the pointlessness must, according to the general constraint on minimal rationality stated earlier, be clear and evident. If it transpired, for instance, that feeling certain emotions, such as jealousy, were always prone to produce psychic damage with no compensating advantage, then it would not necessarily follow that feeling jealous is always irrational—the invariably

damaging nature of jealousy might not be clear and evident, but might be discoverable only via complex empirical work. In such cases, the ability to see this would be more like the ability to grasp complex mathematical reasons; and failure to recognise them would not count as an instance of irrationality.

I have argued that there are at least three criteria for emotional rationality, each associated with a particular aspect of what it is to be an emotion. Violation of any of them grounds a charge of irrationality, in the sense of a failure to be even minimally rational. Perhaps this is not a complete list of criteria; for, even if each is associated with an aspect of an emotion, it does not follow that each aspect has only one criterion associated with it. And there may be ways to finesse and refine the particular criteria that I have offered. Recall too that these criteria are only meant to capture minimal rationality: if one asks what a maximally rational emotional response requires, then that will require a different and more demanding answer (quite plausibly appealing to something like Aristotle's *phronimos*). Nevertheless, these three criteria do capture, at least in outline, a large part of our reasons for holding occurrences of emotions to be irrational. And it is clear that fiction-directed emotions can be rational according to each of these criteria. Charles can really feel fear: he correctly imagines the Slime as dangerous; he is not motivated to flee the Slime, since he does not believe that it is dangerous; and he is not suffering to no point (indeed he is likely to be enjoying the experience). Fiction-directed emotions can be rational according to a general set of criteria that govern the rationality conditions of emotions both towards situations believed to exist and towards situations that are merely imagined. That being so, we have shown that realism is correct, and that an assumption employed by the cognitivist and merited response arguments in the formulations defended here is correct.

10

The Merited Response Argument

We have now developed two a priori arguments in favour of ethicism. The first, the moral beauty argument, holds that moral excellence is a kind of beauty of character; thus the beauty of the manifested author's moral character partly constitutes the beauty of the work. The second argument is a cognitivist one, holding that a work's capacity to teach us (including about moral matters) is, under certain conditions, an aesthetic merit in the work.

However, there is still a dimension lacking in our defence of ethicism. People often say that they are emotionally moved when experiencing art. We have already started to address this aspect of aesthetic experience in the previous chapter in arguing for the reality and rationality of emotional responses towards fictions. Responses, emotions in the broad sense of the term, are central to our interactions with artworks. And, as we will see, the notion of a response plays an important role in the final argument for ethicism.

10.1. VERSIONS OF THE ARGUMENT

The third argument for ethicism, which I term the *merited response argument*, has been mooted in various forms in philosophy. Hume glanced in its direction, and a fuller version has been developed by Noël Carroll. As we saw in Section 2.3, ethics governs our feelings as well as our actions, and it is a common observation that art can affectively move us. This encourages the thought that the connection between aesthetics and ethics also holds in the realm of feeling.

Hume, in "Of the Standard of Taste", is an ethicist about art, but not it seems a cognitivist. He remarks that, "where vicious manners are described, without being marked with the proper characters of blame and disapprobation; this must be allowed to disfigure the poem, and to be a real deformity. I cannot, nor is it proper I should, enter into such sentiments."[1] The core of this argument rests on an appeal to affective responses ("sentiments"), and Hume claims that we cannot enter into the immoral sentiments that the work asks us to feel. This seems (unhappily) false, for an evil person might be able to enter into such sentiments

[1] Hume, "Of the Standard of Taste", p. 282.

with gusto, and applied to his case the argument might conclude in establishing contextualism (at least relative to certain audiences). Nazi supporters would have been able to enter into the Fascist sentiments of *Triumph of the Will*, not just easily, but with conviction and enjoyment. However, there is something else that Hume adds to his empirical, psychological claim: he says "nor is it proper that I should" enter into these sentiments; and that ought to be the core claim: the responses must be *merited*, not simply the ones we actually have.

Noël Carroll has developed a fuller version of a merited response argument. Carroll is also a cognitivist about the value of art, and his argument partly rests on the notion that narrative artworks can deepen moral understanding. Leaving aside the cognitivist claim, which we have already discussed, we can represent Carroll's argument in broad outline as follows. First, narrative artworks have as an aesthetic aim the production of certain responses in their audiences: generally, they aim to absorb their audiences, commanding their attention and interest; and specific genres of narrative artworks may also aim at more specific responses, such as the aim of tragedy to get its audience to feel pity for the hero, and the aim of satire to amuse. Second, moral defects in a work result in morally sensitive audiences being unable to experience the aimed-at response—that is, the work will not secure psychological uptake of the aimed-at responses in this audience. The argument concludes that moral defects in works of art, when they result in audiences being unable to secure psychological uptake of the aimed-at responses, are aesthetic defects in those works. Conversely, moral merits, when they enhance uptake of the works' aimed-at responses, such as when the moral merits of a work increase one's absorption in it, are aesthetic merits of these works.[2]

Though much here is on the right lines, the argument also has a number of problems. Most striking is the appeal to a morally sensitive audience. Carroll introduces this notion, having earlier discussed audiences' responses without this restriction, in order to meet a potential counter-example: a propaganda film that treats the enemy as sub-human and to which most of its wartime audience has no problem in reacting as invited. More generally, we can add, evil audiences might very easily be able to secure uptake of the responses invited by evil works (such as the Nazis watching *Triumph of the Will*). Appeal to a morally sensitive audience solves the problem, but no reason is provided for why this kind of audience is the appropriate one against which to measure the value of artworks. Indeed, the relevance of an appeal to such an audience is just what the autonomist would deny. So the crucial appeal to a morally sensitive audience simply begs the question in favour of some version of moralism.

Second, even if some supporting argument for the introduction of a morally sensitive audience were provided, there is still something structurally wrong with the argument. What matters aesthetically on this argument is whether or not the audience is deterred from psychological uptake—that is, experiencing

[2] Noël Carroll, "Moderate Moralism", pp. 231–7.

the aimed-at response. A moral defect counts as aesthetic for Carroll when "it actually deters the response to which the work aspires".[3] But then what is aesthetically wrong with the work is that it fails to secure psychological uptake in its audience, not that it is morally defective. Carroll counters that what explains its inability to secure uptake is its moral defect. Yet that cannot always be true, given his own account. For Carroll holds that the most general aimed-at response in art is absorption; yet a morally sensitive audience could be absorbed in a work precisely because the work is evil. One may be appalled by a work on moral grounds, and for this reason be absorbed by it, having it command one's attention and interest. One could be absorbed in *Triumph of the Will* precisely because it is so morally repellent and one wants to understand how anyone could have been led to embrace the Fascist views endorsed in it. Moral disapproval is compatible with close attention to evil works (and indeed to evil people).

Finally, the argument assumes that a general goal of art is absorption and that this is invariably a positive aesthetic value. But it is very doubtful whether all art aims at this response, or, indeed, whether it is a central aesthetic value. Brecht's 'alienation effect' was self-consciously designed to avoid absorption in the standard sense; and, while John Grisham is an excellent writer of page-turning popular fiction, one would not want him to count as one of the greatest of novelists.[4] More importantly, the capacity of a work to absorb one is not always an aesthetic merit in it. For the question needs to be asked of *why* one is absorbed in the work. It is quite possible for a work to be absorbing because it is aesthetically bad: any reader of the examples cited in Monroe Beardsley's "Bad Poetry" can attest that one can be absorbed in a work precisely because it is so bad, and one is trying to figure out why it is so awful.[5]

The version of the merited response argument I will now develop attempts to avoid the problems of Hume's and Carroll's versions. Ethicism holds that a work is aesthetically flawed in so far as it possesses an aesthetically relevant ethical flaw and aesthetically meritorious in so far as it possesses an aesthetically relevant ethical merit. The ethical flaws referred to are intrinsic ethical flaws, not the ethically bad effects that works may have on actual audiences. Intrinsic ethical flaws are ethical flaws in the attitudes that works manifest towards their subjects. So ethicism holds that works are aesthetically flawed in so far as they exhibit aesthetically relevant ethical flaws in their manifested attitudes.

We can now establish a connection between the attitudes manifested and the responses that a work prescribes. It is obvious that works prescribe the imagining

[3] Ibid., p. 234.
[4] For further, partly related, criticisms of Carroll's argument, see Oliver Conolly, "Ethicism and Moderate Moralism", and Anderson and Dean, "Moderate Autonomism". Carroll replies to the latter in "Moderate Moralism versus Moderate Autonomism".
[5] See Monroe C. Beardsley, "Bad Poetry".

of certain events: a horror film may prescribe imagining teenagers being assaulted by a monster; *The 120 Days of Sodom* prescribes imagining that acts of sexual torture occur. But, perhaps less obviously, works also prescribe certain responses to these fictional events: the loud, atonal music of the horror film prescribes us to react to the represented events with fear; *The 120 Days of Sodom* invites the reader to find sexual torture erotically attractive, to be aroused by it, to be amused by the contortions described, to admire the intricacy of their implementation and so forth.[6] The approbatory attitude that *The 120 Days of Sodom* exhibits towards sexual torture, then, is manifested in the responses it prescribes its readers to have towards such torture. The point is quite general: the attitudes of works are manifested in the responses they prescribe to their audiences.

It is important to construe this claim correctly to avoid an objection. Consider an instance of the seduction strategy—a novel that apparently prescribes its readers to be amused at a character's undeserved suffering, but that does so in order to show up the ease with which the reader can be seduced into callous responses. Then one response (amusement) is apparently prescribed, but a very different attitude is really manifested by the work (disapproval of the ease with which we can be morally seduced). Hence it may seem that the manifestation of attitudes is wholly distinct from and independent of the prescription of responses. What this objection reveals is that prescriptions, like attitudes, come in a hierarchy, with higher-order prescriptions taking lower-order ones as their objects. Thus my amusement at the character's suffering is apparently prescribed, but there is a higher-order prescription that this amusement itself be regarded as callous, and therefore as unmerited. So the complete set of prescriptions that a work makes must be examined in order to discover what attitudes it really manifests: taking individual prescriptions out of context may mislead us about the work's attitudes. Here again, the application of the ethicist principle requires a grasp of interpretative subtleties and context. Talk of prescriptions from now on should be construed as involving the complete set of relevant prescriptions that a work makes towards fictional events.

The claim that works prescribe certain responses to the events described is widely applicable: *Jane Eyre*, for instance, prescribes the imagining of the course of a love affair between Jane and Rochester, and also prescribes us to admire Jane's fortitude, to want things to turn out well for her, to be moved by her plight, to be attracted to this relationship as an ideal of love and so forth. Similar remarks apply to paintings, films and other representational arts. Music without a text is also subject to ethical criticism if we can properly ascribe to the music a presented situation and a prescribed response to it. If Shostakovich's symphonies are a musical protest against the Stalinist regime, we can ethically assess them.

[6] The notion of prescribing imagined feelings is to be found in Walton, *Mimesis as Make-Believe*, Sect. 7.2. The possibility of prescribing real emotional responses towards fictions follows from the argument that I developed in Ch. 9.

The notion of a response is to be understood broadly, covering a wide range of states directed at represented events and characters, including being pleased at something, feeling an emotion towards it, being amused about it, approving of it and desiring something with respect to it—wanting it to continue or stop, wanting to know what happens next. Such states are characteristically affective, some essentially so, such as pleasure, while in the case of others, such as desires, there is no necessity that they be felt, although they generally are.

The responses are not simply imagined: we are prescribed by *The 120 Days of Sodom* actually to find erotically attractive the fictional events, to be amused by them, to enjoy them, to admire this kind of activity. So the novel does not just present imagined events; it also presents a point of view on them, a perspective constituted in part by actual feelings, emotions and desires that the reader is prescribed to have towards the merely imagined events. Given that the notion of a response covers such things as enjoyment and amusement, it is evident that some kinds of response are actual, not just imagined. Irrealists deny that we feel actual emotions towards fictional events; but there are, as I have argued, good reasons for holding this to be possible.

Though a work may prescribe a response, it does not follow that it succeeds in making this response merited: horror fictions may be unfrightening, comedies unamusing, thrillers unthrilling. This is not to say that fear, amusement and thrills are not produced in the audience: for people may respond in a way that is inappropriate. Rather, the question is whether the prescribed response is merited: whether it is appropriate or inappropriate to respond in the way the work prescribes. If I am afraid of a harmless victim in a horror movie, because of her passing resemblance to an old tormentor of mine, my fear is inappropriate. And my admiration for a character in a novel can be criticised for being based on a misunderstanding of what he did in the story. So prescribed responses are subject to evaluative criteria.

Some of these criteria are ethical ones. As we saw in Section 2.3, responses outside the context of art are subject to ethical evaluation. I can criticise someone for taking pleasure in others' pain, for being amused by sadistic cruelty, for being angry at someone who has done no wrong, for desiring the bad. The same is true when responses are directed at fictional events, for these responses are actual, not just imagined ones. If we actually enjoy or are amused by some exhibition of sadistic cruelty in a novel, that shows us in a bad light, reflects ill on our ethical character, and we can properly be criticised for responding in this fashion.

If a work prescribes a response that is unmerited, then it has failed in an aim internal to it, and that is a defect. But not all defects in works of art are aesthetic ones. From the point of view of shipping them to art exhibitions, many of Tintoretto's paintings are very bad, since they are so large and fragile that they can be moved only at great risk. But that is not an aesthetic defect. Is the failure of a prescribed response to be merited an *aesthetic* defect (that is, is it a defect in the work qua work of art)?

As noted in Section 4.3, prescribed responses, when presented through labels or bare lists, may not be aesthetically relevant. Attaching a label inviting a response (for instance, to feel sympathy for a woman) to a neutrally painted portrait of her may not make that prescribed response aesthetically relevant. But when prescribed responses are presented through an artistic mode of expression, involving, for instance, painting the woman in such a way as to invite sympathy for her, they are clearly of aesthetic relevance. And it is as presented through an artistic mode of expression, as described in Section 4.3, that we will understand the notion of a prescribed response from now on. That prescribed responses in this sense are of aesthetic relevance is evidently true of many artistic genres: thrillers that do not merit the audience being thrilled, tragedies that do not merit fear and pity for their protagonists, comedies that are not amusing, melodramas that do not merit sadness and pity, are all aesthetic failures in these respects. Such genres standardly prescribe their responses by deploying an artistic mode of expression, employing narrative, symbols, metaphors, the presentation of universals in particulars, bringing their points home affectively, and so on. They do not employ bare labels or lists, enjoining their audience to laugh, or weep, or pity the characters. Works outside these genres, which similarly prescribe a range of responses, are likewise aesthetic failures if the responses are unmerited. And in general it is a bad work of art that leaves us bored and offers no enjoyment at all. We are also concerned not just with whether a response occurs, but with the quality of that response: humour may be crude, unimaginative or flat, or it may be revelatory, profound or inspirational. And the aesthetic criticism of a work as being manipulative, sentimental, insensible or crude is founded on a mismatch between the response the work prescribes the reader to feel and the response actually merited by the work's presentation of the fictional situation.

The aesthetic relevance of prescribed responses wins further support from the fact that the value of art in part derives from its deployment of an affective mode of cognition, as we argued in Chapters 7 and 8—derives from the way works teach us, not by giving us merely intellectual knowledge, but by bringing that knowledge home to us, embodying it in particular characters and events, and so on. As we noted, this teaching is not just about how the world is, but can reveal new conceptions of the world in the light of which we can experience our situation, can teach us new ideals, can impart new concepts and discriminatory skills—having read Dickens, we can recognise the Micawbers of the world. And the way knowledge is brought home to us is characteristically by making it vividly present, so disposing us to reorder our thoughts, feelings and motivations in the light of it. We all know we will die, but it may take a great work of art to drive that point fully home, to make it vividly present. We may think of the universe as devoid of transcendent meaning, but it may take *Waiting for Godot* to make that thought concrete and real. We may believe in the value of love, but it may take *Jane Eyre* to render that ideal unforgettably alluring. On

the cognitive–affective view of the value of art, whether prescribed responses are merited will be of aesthetic significance, since such responses constitute a cognitive–affective perspective onto the events recounted. Such responses are not merely affective, but include a cognitive component, being directed towards some state of affairs or thing, and bring it under evaluative concepts. For instance, by prescribing us to be amused, to enjoy, to be aroused by scenes of sexual torture, through its presentation of realised scenarios, *The 120 Days of Sodom* aims to get us to approve of the imagined events, to think of them as in some way desirable, and so to endorse an evaluation about events of that kind.

These points can be assembled into an argument for ethicism. Ethicism concerns the intrinsic ethical defects of an artwork; these are ethical defects in the attitude that a work manifests. A work's attitude is standardly manifested in prescribing certain responses towards the events it describes. Prescribed responses are not always merited. One way in which they can be unmerited is in being unethical. If the prescribed responses are unmerited, that is a failure of the work; so, if the prescribed responses are unmerited, because unethical, that is a failure in the work. What responses the work prescribes is of aesthetic relevance. So, if the prescribed responses are unmerited because unethical, that is an *aesthetic* failure of the work—that is to say, is an aesthetic defect in it. So a work's manifestation of ethically bad attitudes in its prescribed responses is an aesthetic defect in it. *Mutatis mutandis*, a parallel argument shows that a work's manifestation of ethically commendable attitudes in its prescribed responses is an aesthetic merit in it.

To illustrate: a comedy presents certain events as funny (prescribes a humorous response to them), but, if this involves being amused at heartless cruelty, then the work is not funny or at least its humour is flawed, and that is an aesthetic defect in it. If a work prescribes our enjoyment (as almost all art does to some extent), but if we are supposed to enjoy, say, gratuitous suffering, then it is not enjoyable in that respect (it does not merit enjoyment), and hence the work fails aesthetically. If a work invites us to pity some characters, but they are unworthy of pity because of their vicious actions, then they are not pitiable, and hence the work is aesthetically flawed. Conversely, if the comedy's humour is revelatory, free from the narrow bonds of prejudice, showing a situation in a different and better moral light with an appropriate invited response, then its humour is ethically merited, we have reason to adopt the response, and the work succeeds aesthetically in this respect. If a work asks us to enjoy the deserved triumph of a character, then we have reason to find it enjoyable, insofar as that triumph is deserved, and the work succeeds in that way. And, if a work prescribes pity towards characters who suffer unfairly and through no fault of their own, they are pitiable (pity is merited), and the work succeeds aesthetically in this way. Similar remarks apply to the range of other responses prescribed by works, such as admiring characters, being angry on their behalf, wanting things for them and so forth.

10.2. OBJECTIONS AND REPLIES

The argument advanced in the previous section has met with several criticisms.[7] I turn now to consider some of these objections, as well as others that it might encounter.

First, it may be objected that the argument does not support ethicism, since to say that a prescribed response is unmerited is to say that the work is emotionally unengaging: but then the work's failure is a result of its failure to engage, and not of its ethical corruption. Indeed, if, despite its ethical corruption, the work does emotionally engage, its ethical badness is not an aesthetic defect in it. (This objection is similar to one that we directed against Carroll's version of the merited response argument.)

However, this objection misconstrues the version of the argument developed here, even in respect of those responses that are emotions in the narrow sense of the term. First, a work may engage an emotion even when it does not merit it (it may, for instance, manipulate us into feeling a sort of pity we know is merely sentimental), but only *merited* emotions are relevant to the argument. Second, it is important to note that the claim for which we have argued is not that the ethical demerits of works *bring about*, through their presence, some aesthetic demerits in works, such as their being emotionally unengaging, which are distinct from their ethical demerits. The claim is, rather, that ethical demerits *are*, when manifested in prescribed responses, aesthetic demerits in works. We have seen that a work's prescribing an unmerited response is an aesthetic defect in the work. A prescribed response can be unmerited because unethical: being unethical is one way of being unmerited. Hence a work's prescribing an unethical response is an aesthetic defect in the work. Ethical defects in works are under these conditions aesthetic defects in them.

Second, it may be held that works may prescribe responses that are not aesthetically relevant, because of the kinds or uses of the responses prescribed. For instance, a royal portrait may be designed to impart a sense of awe and respect towards the king depicted, and a religious work may aim at enhancing the viewer's sense of religious reverence, but such responses are aesthetically irrelevant. So ethicism rests on a false premiss.

Yet this is not so. A painting is not just (or even) a beautiful object: it aims to convey complex thoughts and feelings about its subject, providing an individual perspective on the object represented. Thus it is that a painting can be not just a representation, but can embody a way of seeing, thinking and feeling about its subject; and it is this latter area that is often at the centre of our aesthetic interest

[7] A version of the argument was first published in "The Ethical Criticism of Art".

in it. So, if a painting does not succeed in meriting the responses prescribed, it fails on a dimension of aesthetic excellence.

Third, it may be held that the argument rests on a claim that real responses, not merely imagined ones, can be had towards fictions, a claim for which I argued in the previous chapter. Does that mean that the merited response argument requires the truth of emotional realism? If so, then emotional irrealists will reject it.

We have already explored in Section 9.1 some of the implications of emotional realism. As noted there, it is not *essential* to the merited response argument to appeal to fiction-directed real emotions. To expand on the points made, there is a class of responses towards fictions—responses of pleasure and displeasure—that both sides to the dispute can agree to be real. It is evident that one can actually enjoy or be displeased by fictional events: one can actually enjoy Jane Eyre's (fictional) happiness at the end of the novel. Scarcely more contentious is the thought that there are many other fiction-directed responses that are real: I do not have to check to see whether a story is fictional or not in order to know whether I am really amused by it or only imagining that I am so. I don't have to know whether described events really occurred to know whether I am disgusted by them. The battleground between realists and irrealists is, as we saw, over the reality of those specific kinds of responses that are emotions in the narrow sense, and indeed chiefly over the reality of pity and fear directed at fictions.

Ethicism could be defended by appeal to those responses the reality of which is relatively uncontentious. For these include pleasure and displeasure, which are pervasive in our responses to fictions; and a person can be ethically criticised for what she takes pleasure or displeasure in. Someone who actually enjoys imagined suffering can properly be condemned for this response. Hence pleasure and displeasure felt towards fictions are the only kinds of responses the reality of which one needs to appeal to in order successfully to defend ethicism.

Further, the appeal to actual responses was made in order to avoid a possible objection that the audience's responses are only imagined, and the audience is not ethically at fault if it only imagines a response, as opposed actually to possessing it. But the claim that imagined responses are not ethically assessable can be denied in its full generality. Some kinds of imagined responses, particularly when they are compulsive, vivid or ones that in various ways fully engage their imaginers, may ground ethical condemnation, since they too may be deeply expressive of the imaginer's moral character; for instance, a rape fantasist may be ethically criticised, even if he only imagines, vividly and compulsively, being aroused by the imagined scenarios. Hence emotional irrealists can support ethicism on the grounds that people can be ethically condemned for *some* of their merely imagined responses.[8] However, it is important to see that this point is compatible with holding that

[8] This is a point that I owe to Kendall Walton: see his "Morals in Fiction and Fictional Morality" for an irrealist discussion of the ethical criticism of art.

imagining having a morally bad response is very often not morally condemnable, since it does not express a moral defect in the imaginer's character, but may be engaged in for a variety of legitimate purposes, such as helping one to understand how the world looks from an immoral perspective, without oneself embracing that perspective.

Also, works that manifest certain attitudes towards fictional entities implicitly manifest the same attitudes to real entities of that kind. Reading this in terms of prescribed imagined responses, the irrealist can hold that works prescribing an imagined response towards fictional entities implicitly prescribe the counterpart real response to real entities of that kind. Since no one denies that real emotional responses can be directed at real entities, the irrealist can hold that artworks are aesthetically flawed by virtue of the moral reprehensibility of the implied emotions directed at real states of affairs.[9] Thus, it is not essential to the success of the merited response argument that emotional realism is true: emotional irrealists can and should sign up to it as well. Nevertheless, I have argued that realism is true, so the merited response argument is best defended in the way laid out above.

A fourth objection, due to Eddy Zemach, holds that the argument fails because, when generalised, it suffers obvious counter-examples. An artwork is an artefact, and it is true of all artefacts that there is something specific you must do to appreciate them properly: you cannot appreciate nails if you try to cook them, rather than drive them into a wall. An artefact is good of its kind just in case, when performing these prescribed actions, it performs them effectively. Some of these actions may be immoral, but that does not show that the artefact is not good of its kind. For instance, a handgun is designed to kill people, and it is a good handgun if it does so effectively; but the action required to appreciate it properly—namely, killing people—is an immoral one. The fact that you have moral reason not to kill people, though, does not show that the handgun is a bad one. In just the same way, the fact that you have to engage in some immoral actions (experiencing immoral feelings with pleasure, for instance) in order to appreciate certain artworks does not show that the artworks are bad qua artworks.[10]

The represented argument is indeed woefully fallacious; but that is hardly surprising, since it rests on overgeneralising the argument for ethicism. Ethicism makes a claim about the ethical attitudes manifested by works of art. Only a sub-set of artefacts manifests certain attitudes: guns do not, except in peculiar contexts when employed for communicative purposes. The objection rests on conflating the notion of a work prescribing a certain attitude with the distinct claim that there are certain things I must do in order to appreciate a work.

[9] I owe this point to Jerrold Levinson.

[10] Eddy Zemach, "Review of Jerrold Levinson (ed.), *Aesthetics and Ethics: Essays at the Intersection*", pp. 162–4.

But these are clearly different matters: to appreciate a painting properly, I must perform the action of looking at it; but that has nothing to do with attitudes, if any, manifested by it.

However, one might recast this objection in terms of a more straightforward and familiar claim that a good artefact is simply one that performs its function well. So a gun is a good gun just in case it kills people effectively. And the morality or immorality of the function may, as the example illustrates, have nothing at all to do with whether it is a good artefact.

This version avoids the fallacy of the earlier objection, but now encounters the problem of whether art has a function, and, if so, whether that function has nothing to do with morality. I have argued elsewhere that one cannot define art in terms of functions, and that the purposes that art serves have been historically diverse.[11] But, even if one believed that art were constituted by its function, the objection would have to assume what it is seeking to prove—that the function of art has nothing to do with morality. Support for this view would then require the adoption of some version of the radical or moderate autonomist positions against which we have already argued.

A fifth objection holds that the argument is structurally unsound for a different reason: there is a crucial ambiguity in the notions of merit and associated types of reason, which the argument exploits. The most sophisticated version of this objection is due to Daniel Jacobson.[12] Jacobson distinguishes between three different kinds of reasons for having a response. The first are reasons of warrant: a response is warranted just in case the object towards which it is directed has the appropriate evaluative property, so that the response 'fits' the object. For instance, anger is warranted if someone has done something outrageous; amusement is warranted if something is funny. The second kind of reasons are strategic ones, to do with the effects of having the response. You may make a witty remark at a tiresome public lecture, and the remark may be funny, yet I may have strategic reasons not to be amused, since the natural expression of my amusement is laughter, and laughing might call embarrassing attention to myself (prudential strategic reasons), or perhaps humiliate the speaker (moral strategic reasons). The third kind of reasons are non-strategic reasons (which he sometimes calls intrinsic reasons) for having a response. If it is wrong to be amused at certain jokes (racist or sexist ones, for instance), because this would require adopting a vicious attitude, then there are moral reasons, independent of the consequences of amusement, for not being amused. But this does not show that the jokes are not funny, only that it is wrong to be amused by them. Given these distinctions, we can see that the merited response argument needs to conclude that unethical

[11] See my " 'Art' as a Cluster Concept".

[12] Jacobson, "In Praise of Immoral Art", especially pp. 170–9; and his "Ethical Criticism and the Vice of Moderation", pp. 349–51. Compare too Jenefer Robinson, "Review of *Aesthetics and Ethics: Essays at the Intersection*", p. 692.

responses are not *warranted* — that is, that immoral works of art do not have the evaluative properties, such as being funny, at which they aim. But the argument appeals to the fact that certain responses are *unethical*; yet they could be unethical because of strategic or intrinsic reasons, and these would not at all impugn the warrant of the response. It may be wrong for strategic or intrinsic reasons to be amused by some joke, yet the joke can still be funny (that is, amusement can still be warranted). So there is a glaring equivocation in the argument. The point can also be put this way: 'unmerited' must mean 'unethical' (rather than 'unwarranted') when the ethicist says that a prescribed response is unmerited because unethical, for that claim to be (now trivially) true; but, when she says that it is an aesthetic flaw in a work when a prescribed response is unmerited, 'unmerited' must mean 'unwarranted' for the claim to be plausible (if 'unmerited' meant 'unethical' here, the claim would be question-begging). So there is a fatal ambiguity in the argument.[13]

I am going to argue that there is no non sequitur or ambiguity in the argument. However, Jacobson's probing objection does give us the opportunity to clarify and defend further the argument given in the previous section. Jacobson's objection has in effect two strands. The first is the general claim about ambiguity; the second is the more specific claim about humour, which he uses as an example of the ambiguity. Since the issue of humour will raise issues more complex than the ambiguity point, I will defer most of the discussion of humour to the next section.

Jacobson is right, of course, to call attention to the different types of reasons that bear on responses. Indeed, some of his distinctions are the same as those drawn in the previous chapter. His notion of warrant corresponds with the cognitive–evaluative aspect of reasons to feel: as we noted, we can criticise someone's response because it does not correspond with the evaluative property ascribed to the object by an imagining or belief about it. His notion of strategic reasons is simply that of reasons based on the consequences of a feeling — that is, instrumental reasons; and we objected to Joyce's solution to the rationality problem because it would render responses rational simply on the basis of their consequences — for instance, it would be rational actually to fear doorknobs because someone bribed one to do so.

However, drawing attention to these, or other, distinctions does not show that the argument trades on an ambiguity between them. In noting that responses can be unmerited because unethical we used examples such as being angry at someone who has done no wrong, taking pleasure in others' pain, being amused at sadistic cruelty and desiring the bad. What sort of ethical reasons are involved here? They are not instrumental (strategic) reasons: they are not to do with the bad effects of, say, being amused at sadistic cruelty (perhaps making it more likely that one will start being sadistic oneself). Rather, someone can be ethically criticised for

<hr />

[13] Jacobson, "In Praise of Immoral Art", pp. 177–8.

these responses, even if it were shown that they had no such bad effects. And we have emphasised throughout that we are concerned with the intrinsic moral properties of works, not with any bad empirical consequences they may have on one's own character or on anything else. Nor are the criticisms mentioned based on the affective aspect of rationality: the criticism is not that one is feeling, say, amusement too strongly, nor that one's feeling amused is suffering to no point. Nor clearly are the criticisms based on the motivational aspect of rationality: it is not that a deluded person is, say, trying to prevent something happening that is recounted in the joke, not realising that it is a fictional situation. Rather, the criticisms are based on the cognitive–evaluative aspect of emotional rationality: they are content-directed, to do with the intentional content of the response. What is wrong (rationally and morally) with being angry at someone who has done no wrong is that the formal object of the emotion of anger (someone having done something wrong) does not correspond to the intentional content of the thought, that they have done no wrong. What is wrong in taking pleasure in others' pain is that this is not pleasurable, in the proper, normative sense of that in which we ought to take pleasure. Those people who took pleasure in watching public decapitations during the French Revolution enjoyed what was going on, but that is not to say that they ought to have done so—that is, it is not to say that they were taking pleasure in what is pleasurable. Likewise, someone who desires the bad is someone who desires what is not desirable. And to be amused by sadistic cruelty is to be amused by something that is not, in so far as it is sadistically cruel, amusing. And it is not plausible to hold in these examples that all we are entitled to claim is that we ought not to have the response, because to do so would reveal a vicious attitude, but that the object does have the relevant evaluative property. Such a view would hold, for instance, that it would be wrong to take pleasure in public executions, even though they might still be pleasurable. For the intuition against this is clear: it is not just that it would be wrong to take this kind of pleasure, but that to do so would be to take pleasure in what is not pleasurable, but is, rather, foul and disgusting.

So in all cases the point appealed to is that the response prescribed does not cor-respond to the evaluative properties of the object—it is the cognitive–evaluative aspect of rationality that in each case is impugned by its immorality. That is, in Jacobson's terms, these responses are not *warranted* in so far as they are unethical, and the argument would go through with 'warrant' substituted for 'merit' throughout; and, likewise, the reasons appealed to are those concerned with warrant, not with any other kind of reasons. Hence there is no ambiguity or non sequitur in the argument: rather, there is appeal to a substantive claim that a range of responses has ethical criteria among their warrant conditions. So, while Jacobson is correct that saying a response is unethical does not *entail* that it is unwarranted, since for instance instrumental reasons may bear on the response but not the warrant, the kinds of examples appealed to show that

warrant conditions of responses very often are sensitive to ethical concerns, and this is all that the argument requires.

Jacobson has, however, claimed that reformulating the merited response argument in terms of warrant would not work. For he holds that not all unethical responses are unwarranted, in particular because strategic considerations are relevant to the propriety (that is, morality) of the responses, but not to their warrant.[14] That is, a response might have morally bad consequences, even though it would be warranted (for instance, my pitying someone who is suffering might so enrage that person's assailant that he redoubles his assault). This is correct, but the only point the merited response argument requires is that warrant conditions of a range of responses are sensitive to ethical considerations, not that every ethically bad feature (such as its having bad consequences) of a response concerns its warrant.

This claim about the ethical sensitivity of warrant conditions could be denied. If no response's warrant were subject to ethical criteria, then ethicism, in so far as responses were concerned, would simply lapse, as having no application. Yet it is wildly implausible to take such a line. Some so-called moral emotions have ethical concepts built in as part of their evaluative content: the difference between guilt and shame, as we noted in the previous chapter, is that the former involves the evaluative thought of oneself having done something wrong. Likewise, anger or indignation involves the evaluative thought of someone else having done something wrong (including morally wrong).[15] But the role of ethical criteria extends further than this. Plausibly, fear, pity, pleasure and being thrilled do not have moral concepts analytically as part of their evaluative content, yet the having of these responses can be unwarranted on moral grounds. If I fear for someone, my emotion may be criticised because that person is someone who does not deserve my concern for the discomfort or danger he is undergoing: perhaps I am fearing for someone who is being justly punished. My pity for someone may also be criticised on the grounds that he deserves his suffering (perhaps again because he is being justly punished). As already noted, one may criticise someone's taking pleasure in something that is evil, such as public executions, because of what it is that this person is enjoying. And even being thrilled by something can be criticised on moral grounds: someone who found it thrilling to watch a child being tortured to death might properly be criticised, in part because what he is watching is not thrilling, but deeply morally disgusting. In fact, there are good reasons to believe that the ethical must have a purchase on whether a wide range of responses is merited (warranted) or not. For, as I argued in Section 2.3, the ethical is centrally concerned with the quality of our relations with others, and this governs not just how we act, but how we feel. So, in so far as a response manifests some attitude towards others, it is potentially subject to ethical scrutiny.

[14] Jacobson, p. 178.
[15] Jacobson would not deny this; see ibid., p. 197 n. 61.

The standard point of resistance to the latter thought concerns humour. Some of what Jacobson says supports the thought that the warrant of the amusing is not subject to ethical criteria: for instance, he holds that, even if it is wrong to be amused by racist or sexist jokes, that does not mean that they are not funny.[16] Now suppose that this position (call it 'comic autonomism') were right; what would follow? First, this view would not in fact undermine ethicism, but only restrict its scope. For the merited response argument holds that, where prescribed responses are unmerited (unwarranted) because they are unethical, then that is an aesthetic flaw in the work. On the comic autonomist view, humorous responses are never unwarranted because they are unethical (it is only wrong to be amused in such cases). Rather, the funny falls entirely outside the domain of the ethical. That restricts what aspects of the work we can ethically assess, but does not show that, for those aspects that we *can* ethically assess, ethicism is false. (The point generalises, of course, to any other responses, the warrant conditions of which are not subject to ethical criteria.) Hence there is a scope restriction on the application of ethicism, but ethicism itself is not undermined. A second consequence of the view, though, actually causes a problem for the comic autonomist who rejects ethicism, but who believes that it is wrong to be amused by a vicious joke, even though it is funny. Imagine a comedy full of hilarious jokes, all of which were so vicious and cruel that audiences watched in stony silence, without being amused at all, since they correctly thought that it would be wrong to feel amusement. Would this play count as an aesthetic success? Clearly not: we value art in part because of the quality of the responses it properly calls forth, and *ex hypothesi* the audience of this play is morally cut off from responding to it. That looks like a serious aesthetic defect in the play, even though, according to the comic autonomist, the play is still hilarious. So all that would happen if comic autonomism were true is that what is identified as the relevant aesthetic defect would change: the defect would not be that the work is flawed in its humour, but that the work is (to use Jacobson's nice phrase) morally inaccessible in respect of its humour. And that means that comic autonomism does not undermine ethicism, but merely changes *which* aesthetic features are identified as defects by virtue of being morally problematic.[17]

[16] Ibid., p. 172. Note that, though some of the observations he makes can ground comic autonomism, Jacobson's favoured position seems to be contextualism about humour, as we shall see in the next section.

[17] Jacobson denies that moral inaccessibility is an aesthetic defect, since merely instrumental (strategic) considerations can make a work's aesthetic value morally inaccessible, but purely instrumental effects of art do not contribute to its aesthetic value. An example is Monty Python's wonderful conceit of a joke that is so funny that it kills all who hear it: the joke is funny, albeit inaccessible to anyone who is morally, or indeed, prudentially sensitive ("In Praise of Immoral Art", p. 190). Again this is true, but it is beside the point: in the case of the hilarious but vicious play, it is not moral considerations about the effects of amusement that holds the audience back from amusement, but, according to the comic autonomist, their perception that it would be wrong to be

10.3. HUMOUR

I have argued, then, that several objections to the merited response argument fail. However, there is one sort of objection yet to be considered, and it is of sufficient interest to merit detailed investigation. The idea that humour is unaffected by moral considerations poses no threat to ethicism, but only limits its scope, as we have seen. Sometimes, however, it is held that artworks are funny and thereby aesthetically successful partly because of the wicked, cruel or vicious attitudes that they display. Jacobson appeals to a parallel with jokes: "the fact that a joke unjustly slights someone, and portrays this slight as amusing, just doesn't look like a reason to deny that it is funny. To the contrary, that is, intuitively, *just what is funny about it*: the panache with which this is done."[18] Very few jokes are works of art, and our question concerns artworks, so discussion of jokes and morality will not be of direct help in the present context. Indeed, the almost exclusive focus on jokes of the philosophical literature about humour is extremely surprising, since most jokes in their shortness and relative simplicity are likely to be of far less interest to the aesthetician than are the many complex and rich works of art that are comedies, including most notably Shakespeare's comedies. The philosophical situation with respect to humour is akin to a situation in which, through some post-structuralist literary holocaust, literary studies departments had completely abandoned the study of literature and now studied only advertising slogans. The object of study would have become unbearably impoverished.

So, turning to what are undoubtedly works of art, the contextualist can more promisingly appeal to the great swathes of successful art that seem to feature vicious, cruel humour, which has been a staple of satire throughout the ages; and satire is a major, if surprisingly under-discussed, artistic genre, as well as being a recurrent trait of many extra-generic artworks. Think of the great eighteenth-century English visual satirists, Thomas Rowlandson, James Gillray and William Hogarth, excoriating their political masters and lampooning their fellow subjects. Think, in more sedate form, of the tart wit of Jane Austen, of how the lesser characters in her novels have their failings satirised, with a particularly barbed wit reserved for hypochondriacs such as Mrs Bennet and Mr Woodhouse. Or think of Joe Orton's hilarious broadsides launched against the mindless conformity of 1950s and 1960s Britain; or the lampooning to which Stanley Kubrick subjects the armed forces and governing powers in *Dr Strangelove*; or the systematic ridicule that Ethan and Joel Coen heap on virtually all the characters in *Fargo*. Satire and the nearly coextensive genre of black comedy, then, seem to show that, at least for much of our comedic art, contextualism is correct: artworks can be

amused, since amusement would manifest a vicious attitude. So it is, in Jacobson's terms, an intrinsic reason not to be amused, and falls outside his ban on instrumental reasons being aesthetic ones.

[18] Jacobson, "In Praise of Immoral Art", p. 175.

aesthetically good in so far as they manifest aesthetically relevant vicious attitudes, where the vicious attitudes are rendered aesthetically relevant by virtue of being displayed through the humour of the works. So the most intuitively plausible case where ethicism fails is this case of dark humour; indeed, it is striking how often objections to ethicism turn on an appeal to it.

Let us first suppose that the contextualist is right about humour. The question would then be whether the features of humour that render it putatively inconsistent with ethicism are special to it, or whether they generalise across a range of affective and cognitive states. If not, and assuming that the other arguments for ethicism are sound, we should adopt what we identified in Section 3.1 as ethicist contextualism: that is, the general valence of the relation between the ethical and the aesthetic would be positive, so that the character of the relation would be ethicist, but in the case of humour there would be a reversing explanation for why ethical flaws count as aesthetic merits. Now humour is undoubtedly an odd kind of beast compared to other responses that roam the world. And, given the peculiarities of humour, it would be plausible that this kind of reversing explanation would be specific to humour, so that the explanation would be self-limiting. For example, the most influential theory of humour holds that it involves the enjoyment of incongruities, where these are understood in terms of absurdities or violations of norms, and these can be held to include moral norms. Thus the standard normative 'fit' between response and evaluative property is disrupted or undermined in the case of humour. This sort of explanation would be specific to the case of humour, and would be consistent with the truth of ethicism for other kinds of response, since they lack this feature of absurdity or norm-violation that undermines ethicism specifically in the case of humour. The adoption of ethicist contextualism would undoubtedly be an important modification of the theory, but it would not undermine its general character, precisely because the reversing explanation is self-limiting, and the general character of the ethical–aesthetic relation would be positive. Ethicist contextualism would be, if adopted only for the case of humour, more ethicist than contextualist, and the basic tenor of the ethicist relation would be preserved.

However, I am going to argue that ethicism *simpliciter* is correct even for dark humour. We can start by asking whether a reversing explanation would be plausible in such cases. As just noted, incongruity theory is the most influential theory of humour, and seems to lend itself naturally to explaining why something can be funny in part because it is vicious, as Noël Carroll has observed. For "incongruity involves deviations from a background of norms—conceptual, logical, linguistic, stereotypical, and so forth. These can also include moral and prudential norms."[19] Since immorality is a deviation from or violation of a moral norm, and thus an incongruity, it seems to follow that a work could be funny by virtue of being immoral.

[19] Noël Carroll, "Humour", p. 348.

There is reason to deny the correctness of the incongruity theory of humour (as indeed of all other general theories of humour). There are plenty of incongruities, even pleasant ones, that are not funny—for instance, as Carroll notes, some of the incongruities found in Surrealist paintings.[20] And, conversely, much humour depends on following norms, not violating them—stereotypes, for instance, are the backbone of a great deal of humour, so it is not the case that norms constituting stereotypes are violated. And sometimes we are amused by a surprising and genuine insight into some matter, which couples together domains that we have never connected before; in such a case it is congruity, not incongruity, that we appreciate. However, the difficulty for ethicism would arise even if incongruities, in the sense of norm-violations, are sometimes the objects of amusement (which is plausible), even if one cannot define the formal object of humour in terms of them.

So in what sense are norms violated in humour? One possibility is that we are asked by a work to imagine norms being violated, to imagine someone (standardly a character in the comedy) violating norms, say, of good taste, logic, morality and so forth. But it does not follow from the fact that the comedy asks us to imagine this that it is endorsing the violation of these norms—that is, inviting us to adopt these norm-violations ourselves. For instance, if a character is amusing because he is making terrible errors in reasoning, it is not generally the case that the audience are themselves invited to reason in the same logically mistaken way. Indeed, they could not find the character amusing if they were to do so, since they would cease to recognise the incongruity if they themselves engaged in that mistaken process of reasoning. Likewise, in the case of violating moral norms, it does not follow from the fact that a character is amusing because he violates some moral norms (Carroll's nice example is of Charlie Chaplin using a person as an armrest) that the artwork is inviting the audience to adopt the violation of those norms. Indeed, a crazed reactionary portrayed in a comedy can be amusing by virtue of the extremity of his views, but he himself may be satirised by the work, so in such cases the audience is certainly not invited to adopt his attitudes.[21] A comedy can thus invite its audience to imagine the violation of norms without inviting them to adopt those norm-violations; so the comedy can be amusing by virtue of the first feature, without being immoral by virtue of the second. (We shall explore some examples of this phenomenon shortly.) In short, incongruities, including moral ones, are sometimes amusing, but it does not follow that the artwork is itself manifesting an immoral attitude. And the latter, of course, is the object of ethical criticism. Hence the incongruity theory does not entail the truth of contextualism about humour. The doctrine would have to be argued for on other grounds.

[20] Noël Carroll, p. 351; Carroll cites M. W. Martin, "Humour and the Aesthetic Enjoyment of Incongruity".

[21] The point is in fact noted by Carroll, "Humour", p. 361.

There are other influential theories of humour, such as the superiority theory, which highlights the fact that much comedy involves ridicule. But ridicule is not always undeserved (as we shall see when we look at satire), so again this theory does not entail contextualism about humour. But, rather than continuing to explore dubious theories of humour, let us address the question of immoral humour directly.

The most promising way to approach the issue is in heuristic terms: what is the best account of people's sometimes conflicting or uncertain intuitions about humour—that is, what is the account that makes best sense of the phenomena? One option is autonomism about humour, or comic autonomism, the view that humour is never subject to ethical criteria. This runs into problems with the fact that many people think that sexist or racist works that try to be funny are not funny, or at least are flawed in their humour. And this need not be a partisanly political view: if one keeps ratcheting up the sheer cruelty manifested in a work, it is hard to see how there could not come a point at which any humour that the work might otherwise have had is dispelled or at least severely compromised. And the same phenomenon causes problems for the comic contextualist, who holds that works are sometimes amusing by virtue of the immoral attitudes they manifest; for, if that were so, how does one explain the kinds of intuitions just noted? One response would be to explain them away. Jacobson claims that "people say 'That's not funny' even when they don't really mean it, simply because they don't want to endorse the joke *in any way*".[22] Doubtless this is sometimes true, but what of those cases where people clearly do mean it, and react in a way that makes it clear that they really don't think these jokes (or comedies) are funny? Plenty of feminists react in this fashion. And Wayne Booth writes that, since he came to see Rabelais as grossly sexist, his pleasure in Rabelais's jokes has diminished.[23]

Ethicism about humour, of course, also has to explain away those opposing intuitions that support the view that we sometimes find something funny precisely because it is so vicious. But it has plenty of resources to do so. Ethicism does not entail that a work cannot be funny because it manifests immoral attitudes. For one can apply the *pro tanto* structure of ethicism to particular aesthetic values, such as humour, as well as to aesthetic value in general. What makes something funny is a complex and multifarious matter, which resists capture in terms of necessary and sufficient conditions for something to be funny. Word play and puns; zaniness; unexpected twists of the plot; incongruities of various kinds; sudden, surprising insights (perceptions of *congruities*); and an innumerable host of other matters can contribute towards a successful comedy. So a comedy's humour can be flawed by virtue of manifesting vicious attitudes through its

[22] Jacobson, "In Praise of Immoral Art", p. 177.
[23] Booth, "Why Banning Ethical Criticism is a Serious Mistake", p. 369; see also Booth, *The Company We Keep*, ch. 12.

humour, yet still be amusing in respect of some of the features just mentioned, as well as many others. So ethicism is not left morosely intoning 'that's not funny' to every instance of immoral comedy. Given its *pro tanto* structure, it is not even an implication of ethicism that removing the viciousness of a comedy will make it, all things considered, funnier. This is for the same reason that this is not true for aesthetic value in general, as we saw in Section 3.2—namely, because of the possibility of value-interaction. Maybe removing that piece of vicious word play removes the cleverness and subtlety of the pun as well as its viciousness, and the work is overall less funny. Rather, the ethicist claim is that the humour is aesthetically flawed in so far as it is vicious, not that there is no humour at all (though, of course, in extreme cases this may also be true). Further, the notion of flawed humour is to be understood partly in terms of the qualitative aspect of humour: humour can be coarse, crude or sick in virtue of the immoral attitudes manifested through it; conversely, humour can be touching, warm-hearted, even revelatory in virtue of the moral attitudes it evinces. There are plenty of aesthetic terms applying to humour that are ethically sensitive. And it is important to recall that the notion of the amusing or funny is a normative one: what is amusing is not what *causes* amusement, but what *merits* amusement. So one can be amused by what is not amusing and not amused by what is amusing (uncontentious examples include where one has failed to grasp what is going on in the comedy, or is in a foul mood in which nothing seems funny). So the mere propensity of some people to laugh at cruel jibes does not show that these are amusing: ethicism is not subject to simple empirical counter-exampling.

Hence ethicism about humour is a subtle position, capable of capturing divergent intuitions about humour; in particular, it does not require one to believe that genuinely immoral works cannot be funny, nor that one can always overall improve a comedy's humour by removing its immorality. Further, the ethicist should deploy several distinctions, to some of which we have already adverted. The most important of these is that between whether we are invited by a work merely to imagine an evil attitude (something that it need not be morally dubious to do) or whether we are invited actually to adopt this evil attitude. Much of the support for the view that works are funny by virtue of vicious attitudes rests on a confusion between these two cases, as we shall see when we look at black comedies. Likewise, it is easy to confuse the notion of ridicule with immoral ridicule (some ridicule is well deserved); and to elide the significance of differences between fictional and actual people.

We can now examine some of these heuristic points and distinctions in more detail in their application to satire and black comedies.[24] Though the case of satiric comedy is interestingly complex, appeal to it does not support

[24] My "Just Joking", also develops some of these heuristic points in reference to ethicism about jokes. Though jokes differ importantly from comic artworks, as noted above, analogues of the strategies employed in discussing jokes apply to artworks too.

contextualism. Edward Lucie-Smith, in an introduction to a collection of satiric poetry, writes:

Satire, despite its mixed motives, always does have some general aim, a moral centre—otherwise it is not really satire at all. When satire concerns itself with individuals (as it so often does) these are being measured against an abstract thing, a standard of conduct. And it is this which gives force and resonance to the condemnations heaped upon the victims. Without some kind of moral code being implied by the poem, satire is helpless. It becomes merely abuse.[25]

While it is unclear whether Lucie-Smith is right in holding that there is a necessary connection between satire and moral intent, it is certainly the case that satirists almost invariably have such an intent (though of course we may disagree with the content of their moral outlook). Rowlandson, Gillray and Hogarth were attacking what they saw as the vices of their day—the corruption and self-serving incompetence of the ruling classes (as in Rowlandson's political caricatures); the drunkenness, dissoluteness and moral emptiness of the lower classes (as in Hogarth's *The Rake's Progress*); and the emptiness of the marriage of convenience (as in Hogarth's *Marriage à la Mode*). Molière, through Tartuffe, lambastes hypocrisy and creates a byword for it. Austen reserves her pointed humour for those characters who are egocentric and oblivious to the needs of others. And Kubrick in *Dr Strangelove* gives the weightiest moral warning of all—that we are living in an insane political and military system, and, unless something is done to curtail it, there will be a nuclear holocaust. In all these cases the lampooning is effected in order to drive home a moral point. Indeed, in Austen's hands dry wit is a seamless part of her endeavour to refine the ethical sensibilities of her readers, and in this she is following the traditional understanding of the use of satire, articulated by Sir Philip Sidney: "comedy is an imitation of the common errors of our life, which he [the comic writer] representeth in the most ridiculous and scornful sort that may be, so as it is impossible that any beholder can be content to be such a one."[26]

The contextualist may object that, while the intent of many satirists may be moral, we nevertheless relish the viciousness and cruelty with which they accomplish this intent. It is the overt cruelty and nastiness of Gillray that we enjoy, or its more decorous and lady-like counterpart in Austen. Now this may indeed be true for some viewers and readers, but it does not establish contextualism; for that is a thesis about aesthetic *value*, not about what audiences happen to enjoy. And what is enjoyed is distinct from what is enjoyable, the latter alone being a general value and a possible ground of aesthetic value. The

[25] Edward Lucie-Smith, "Introduction", to *The Penguin Book of Satirical Verse*, p. 14. On p. 22 he goes on to say that he thinks that it is "axiomatic" that morality lies at the very heart of satire.
[26] Sidney, "An Apology for Poetry", p. 165. It is quite likely that this was also Aristotle's understanding of the use of comedy, given his passing remarks on comedy in bk I of the *Poetics*; but we cannot be sure, since bk II is lost to us.

enjoyable or pleasurable is a normative notion, being what merits pleasure, and is subject to ethical criteria, as we earlier noted. So we cannot conclude that, if audiences enjoy the display of cruelty in a work, the cause of their enjoyment is therefore a merit, still less an aesthetic merit, of the work. Moreover, as Sidney reminds us, satire works by representing things in a ridiculous or scornful way. The ridiculous is the feature of something that warrants ridicule, the scornful is that which merits scorn; and it is not vicious, cruel or otherwise immoral to ridicule what is worthy of ridicule (the ridiculous) and to scorn what is worthy of scorn (the scornful). Condemnation of what is condemnable is not a vice.

The latter point introduces one of the interesting complexities of satiric comedy, which I earlier mentioned. For satire generally has a double object. The intentional object of satire is the object as it is represented by the work to be—for instance, in Hogarth's *Gin Alley*, the drunken, helpless gin addicts with all their characteristics as displayed there. The actual object (which we will call the model) is the real people or the type intended—for instance, those people in the eighteenth century who were heavy gin drinkers. Satire generally employs a method of exaggeration and distortion so as to heighten or highlight the vices of its subject; hence the intentional object is constructed with those properties that make it worthy of ridicule, and these are generally not exactly the same as the actual object's properties. But the actual object is the ultimate object of satiric abuse: Hogarth is (perhaps) exaggerating to make a point about the perils and vices of drunkenness, but it is the drunkenness of real people that he is ultimately condemning. Given the likely difference between the intentional object and the real object's properties, it may be that the intentional object is worthy of ridicule and the real object is not. Perhaps the satirist is fair to people as he has represented them, but unfair to their actual models. That is not uncommon in satire of named individuals, where the satirist scores a merited hit in ridiculing the political man as represented, but may be unfair to the actual man. And this can happen with types too: most of the characters represented in *Fargo* deserve the scorn the film joyously ladles over them, but many Minnesotans understandably felt that the film was unfair to them in the regional stereotypes employed. A satire can thus be merited in its attack on its intentional object, but unmerited in its attack on the model; having a double object, a satire can be in respect of one object an aesthetic success, and in respect of the other an aesthetic failure.[27] It is sometimes said that a satire was a success, but that it was also unfair; this judgement is, of course, compatible with ethicism, but it may in many cases be put more perspicuously by saying that the satire was fair and a success directed towards one object, but unfair and a failure directed towards another. However, a satire can be successful in both respects, if the model does

[27] The existence of an actual object of satire also raises the issue of whether it is fair to ridicule those who are its actual object, if they will get to know about the ridicule, and will perhaps be deeply hurt by it. That, however, is a distinct question from whether the ridicule is merited.

indeed have, albeit probably in a lesser form, the failings that the intentional object possesses.

The contextualist may take a slightly different line at this point, and focus on the notion of black comedy as opposed to satire. The concepts of the two genres are almost co-extensive, but their intensions are different. The difference between white comedies and black comedies, one might suppose, is a bit like the difference between white magic and black magic—the former has a good end and the latter an evil end. In black comedies, the contextualist may claim, the artist invites us to be deeply implicated in characteristically vicious, cruel and even sadistic attitudes. The classic Ealing comedy *Kind Hearts and Coronets* invites the audience to take delight in murder, presenting the murders of eight members of the d'Ascoyne family (each wonderfully played by Alec Guinness) as a source of amusement. The film critic Geoff Andrew has celebrated Robert Hamer's direction of this film for its "use of typically English *sang froid* to express outrageous moral values".[28] And *Fargo* drives black comedy towards almost nightmarish limits, most strikingly in the scene in which one of the crooks minces the body of the other in a woodchipping machine; the heavily pregnant police officer played by Frances McDormand comes across the carnage, blood spattering wildly from the woodchipper across the snowy landscape, a single leg of the dismembered crook poking up and out from the machine. This seemingly Satanic humour is what, surely, helps to make the film the success that it is.

The examples undoubtedly highlight an intriguing phenomenon, but is it something that supports the contextualist case? One reply would be to employ the distinction just made between intentional objects and actual objects. Consider, for instance, a cartoon where Jerry puts Tom through a mincer in the course of one of their incessant battles. One would not want to say that this involved inviting the audience to enjoy acts of physical mutilation: cartoon characters do not suffer even fictionally, and instantly after his shredding Tom will re-form into one whole and very annoyed pussy cat. By moving the fictional world far enough away from the actual world in its basic properties, actions that would be morally wrong if done to real beings would not be wrong if done to their fictional counterparts, because of the morally salient differences between the properties of real beings and those that fictional objects are represented to have in these worlds.[29] Now this point might save a person from some bizarrely censorious attitudes towards cartoons and live but cartoon-like films (think of Laurel and Hardy's wonderful ability to emerge whole and ultimately unharmed from whatever scrape they get into). But it will not help us in the case of the black comedies mentioned: the d'Ascoyne family and the Fargo crooks do not miraculously re-form after their deaths and they do fictionally suffer.

[28] Geoff Andrew, *The Film Handbook*, p. 125.
[29] Paisley Livingston and Alfred R. Mele in "Evaluating Emotional Responses to Fiction", n. 30, make a related point about lack of genuine violence in some comedies.

There is, however, another distinction that deserves attention. What, exactly, is the attitude that the black comedies are manifesting towards murder and thereby inviting us to take towards it? One option is that we are being invited actually to adopt the attitude of finding murder permissible and indeed enjoyable, an undoubtedly evil attitude. Another option is that they are inviting us to *imagine* adopting this attitude, as part of our imaginative task in appreciating the film. The distinction between having an attitude and imagining having an attitude is, as we have seen, an important one. In coming to understand another person, for instance, I may have to imagine adopting her attitudes, but I need not thereby myself adopt them. To understand a staunch reactionary's views, I may have to imagine approving of flogging miscreants and hanging criminals; I may succeed in imagining what it would be like to approve of these things, but I may not be in the least disposed actually to approve of them. Likewise, in imagining what it would be like to change career, I may have to imagine having attitudes completely different from those that I currently have.[30] Related to this distinction, there is an ambiguity in the notion of the serious. In one sense, a comic writer is never serious, since he is aiming to amuse; this is the usage in which one can remark that a man is not serious in what he says, since he is joking. But in another sense a comic writer can be serious, in that he is indeed endorsing a particular attitude towards some subject, rather than merely asking us to imagine it. In this second sense, then, a comedy may be either serious (inviting us to adopt certain attitudes) or not serious (inviting us only to imagine adopting those attitudes).

So, to return to the case of black comedy, the question is, are these works inviting us actually to find murder permissible, or are they asking us to imagine finding it permissible? It is certainly hard to believe that *Kind Hearts and Coronets* is aiming at the former attitude. The tone of the film is light, ironic, tongue-in-cheek; and, given the buttoned-up nature of English society in 1949, it would have been incredible for that film to have been so well received by its initial audience were it taken to be an incitement to murder. Andrew is in a way correct in his critical judgement that the film expresses outrageous moral values, but it does this only in the sense that it asks us to imagine adopting them, to play with them in imagination, to imagine the world from their perspective; it does not ask us actually to adopt those values or endorse them. *Fargo* is more complex, since at certain key points in the film it seems appropriate to be simultaneously both amused and appalled. But, on the key point of the attitude manifested by the film towards murder, the point just made applies. For, suppose that we had some evidence that the film did invite us actually to adopt (as opposed merely to imagine adopting) an attitude of finding murder permissible and fun. Suppose, for instance, that it emerged that the Coen brothers had engaged on a

[30] De Sousa, in *The Rationality of Emotion*, pp. 290–2, holds in the course of discussing humour that it is impossible to adopt attitudes merely hypothetically. However, as the examples illustrate, this is not so.

secret spree of serial killings around the time of filming the movie, employing similar mechanisms of death to those in the film. We might justifiably take this as evidence that the film did actually advocate murder. (Recall that attitudes manifested in works can have evidential links to those possessed by their makers.) Would we then correctly view the woodchipper scene as wonderfully funny? It would be like laughing at child-abuse jokes told by a convicted paedophile. Or, suppose that the means of death and dismemberment were dwelled on lovingly by the film, so that we were invited to relish the minutiae of agony and death; and we therefore had reason to think that the film wanted us actually to view murder as fun. Here again, we would have reason to be simply sickened by the scene, not to feel the complex mix of humour and disquiet that we actually do feel towards it.[31]

So the dark humour of satires and black comedies does not support contextualism. The satirist's intent is generally a moral one; the success of satire depends in part on the object as represented meriting the ridicule heaped upon it, and there need be nothing morally wrong in our enjoyment of ridicule in such cases. And the aesthetic success of humour in black comedies depends on the works' inviting us only to imagine adopting an immoral perspective, not inviting us actually to adopt it. We have also seen that the key notion of the enjoyable or pleasurable is a normative one, and is partly answerable to ethical considerations. The merited response argument thus withstands the objections raised against it from dark humour.

10.4. CONCLUSION

We have now developed all the considerations in favour of ethicism. Three philosophical arguments were deployed to defend it: the moral beauty argument, the cognitivist argument and the merited response argument. We have also shown that ethicism is consistent with critical practices; and the comparison of Rembrandt's *Bathsheba* with Drost's painting of the same name, together with the discussion of Nabokov's *Lolita*, have given grounds to think that ethical criticism is not to be dismissed on the grounds that it must inevitably be unsubtle and insensitive to the nuances of particular artworks. Ethicism is not the crude view that many have supposed, a view that reduces to a moralistic or didactic account. The distinction between *pro tanto* and overall principles has also been vital in showing that ethicism is not committed to holding that any improvement

[31] Noël Carroll is correct, I think, in holding that *American Psycho* is such a real-life case. Carroll says that the novel fails as satire because "the serial killings depicted in the novel are so graphically brutal that readers are not able morally to get past the gore in order to savour the parody" ("Moderate Moralism", p. 232). In my terms, the novel's savouring of graphically described dismemberments gives reason to ascribe to the novel and therefore to the manifested author (though not necessarily of course to the author in real-life contexts) an attitude of finding murder permissible and enjoyable.

in a work's moral character must improve its overall aesthetic merit, a claim that contextualists are perfectly correct in rejecting.

There is also a sense in which the ethicist position is inescapable. Each of the three philosophical arguments developed drew on central aspects of our experience of artworks. The traditional account of the value of artworks is that they have their value through their beauty, and the experience of a work's beauty is still a prime determinant of our valuing it. We showed that the notion of beauty is not to be construed merely in terms of pleasure in sensory presentations, but has to allow for the possibility of the beauty of objects and traits, such as moral ones, which cannot be perceived directly. The existence of moral beauty means that a work's moral character can be a beauty in the work. One of the most influential modern accounts of the value of art is the cognitivist one, which holds that works of art have their artistic value in part through their cognitive merits. We defended this account, and showed how, through linking cognition to imagination, art can teach us about ethical values, as well as about other matters; and we saw how this cognitive merit can be an aesthetic merit too. Finally, an important aspect of our valuing of works of art is the way that they move us emotionally, and this aspect of our experience of art is drawn on by the merited response argument, since the question of value rests on the issue, not of whether certain responses were caused to occur in us, but whether the responses prescribed are merited. And this notion of merit, we have just argued, is sensitive to moral considerations. Thus, if one examines some of the central grounds on which art is valued—its beauty, its cognitive role, its affective dimension—each of them involves an ethical aspect. It is in this sense that the ethical evaluation of art is inescapable, since it is inextricably intertwined with some of the central grounds on which we value art. And it is therefore no surprise that, as we saw, even autonomists, who in their theoretical pronouncements hold that art has nothing to do with ethical evaluation, sometimes turn in their practical criticism to the very evaluations that they officially eschew.

The long tradition of maintaining that ethical evaluations and aesthetic evaluations are intimately interlinked is thus, I have argued, correct. Ethical evaluation of artworks is not only coherent and correct, but is also in a way unavoidable. It is, then, no surprise that it has played such a dominant role in shaping our understanding and evaluation of art in the Western tradition. In the long and intermittently strident debate over the relation of art to ethics, a debate stretching back to Plato, ethicism, I have argued, emerges victorious.

Bibliography

Ackroyd, Peter, *Dickens*, abridged edition, London: Vintage, 2002.

Adorno, Theodor, "Trying to Understand *Endgame*", in Brian O'Connor (ed.), *The Adorno Reader*, Oxford: Blackwell, 2000.

Allott, Miriam (ed.), *Novelists on the Novel*, London: Routledge, 1959.

Alpers, Svetlana, "Not Bathsheba: The Painter and the Model", in Ann Jensen Adams (ed.), *Rembrandt's Bathsheba Reading King David's Letter*, Cambridge: Cambridge University Press, 1998.

Anderson, James C. and Dean, Jeffrey T., "Moderate Autonomism", *British Journal of Aesthetics*, 38, 1998, pp. 150–66.

Andrew, Geoff, *The Film Handbook*, Harlow: Longman, 1989.

Aristotle, *The Complete Works of Aristotle: The Revised Oxford Translation*, ed. Jonathan Barnes, Princeton: Princeton University Press, 1984.

—— *Nicomachean Ethics*, trans. Terence Irwin, Indianapolis: Hackett, 1985.

Audi, Robert, *Epistemology: A Contemporary Introduction to the Theory of Knowledge*, London: Routledge, 1998.

Bailey, Anthony, *A View of Delft: Vermeer Then and Now*, London: Pimlico, 2002.

Barish, Jonas, *The Antitheatrical Prejudice*, Berkeley and Los Angeles: University of California Press, 1981.

Baron, Marcia W., *Kantian Ethics almost without Apology*, Ithaca, NY: Cornell University Press, 1996.

Baxandall, Michael, *Painting and Experience in Fifteenth-Century Italy*, Oxford: Oxford University Press, 1972.

Beardsley, Monroe C., "On the Generality of Critical Reasons", *Journal of Philosophy*, 59, 1962, pp. 477–86.

—— "Bad Poetry", in his *The Possibility of Criticism*, Detroit: Wayne State University Press, 1970.

—— *Aesthetics: Problems in the Philosophy of Criticism*, 2nd edn., Indianapolis: Hackett, 1981.

—— "The Aesthetic Point of View", in Joseph Margolis (ed.), *Philosophy Looks at the Arts: Contemporary Readings in Aesthetics*, 3rd edn., Philadelphia: Temple University Press, 1987.

Beardsmore, R. W., *Art and Morality*, London: Macmillan, 1971.

—— "Learning from a Novel", in Godfrey Vesey (ed.), *Philosophy and the Arts: Royal Institute of Philosophy Lectures, Vol. VI, 1971–72*, London: Macmillan, 1973.

Beauvoir, Simone de, "Must We Burn Sade?", in Marquis de Sade, *The 120 Days of Sodom and Other Writings*, trans. Austryn Wainhouse and Richard Seaver, London: Arrow Books, 1990.

Bell, Clive, *Art*, ed. J. B. Bullen, Oxford: Oxford University Press, 1987.

Bloom, Allan, *The Closing of the American Mind*, New York: Simon & Schuster, 1987.

Booth, Wayne, *The Rhetoric of Fiction*, 2nd edn., Chicago: University of Chicago Press, 1983.

Booth, Wayne, *The Company We Keep: An Ethics of Fiction*, Berkeley and Los Angeles: University of California Press, 1988.

—— "Why Banning Ethical Criticism is a Serious Mistake", *Philosophy and Literature*, 22, 1998, pp. 366–93.

Brooks, Cleanth, "Irony as a Principle of Structure", in Hazard Adams (ed.), *Critical Theory since Plato*, San Diego: Harcourt Brace Jovanovich, 1971.

Carroll, Noël, *The Philosophy of Horror or Paradoxes of the Heart*, London: Routledge, 1990.

—— "Moderate Moralism", *British Journal of Aesthetics*, 36, 1996, pp. 223–38.

—— "Art, Narrative, and Moral Understanding", in Jerrold Levinson (ed.), *Aesthetics and Ethics: Essays at the Intersection*, Cambridge: Cambridge University Press, 1998.

—— "Moderate Moralism versus Moderate Autonomism", *British Journal of Aesthetics*, 38, 1998, pp. 419–24.

—— "Art and Ethical Criticism: An Overview of Recent Directions of Research", *Ethics*, 2000, pp. 350–87.

—— "The Wheel of Virtue: Art, Literature, and Moral Knowledge", *Journal of Aesthetics and Art Criticism*, 60, 2002, pp. 3–26.

—— "Humour", in Jerrold Levinson (ed.), *The Oxford Handbook of Aesthetics*, New York: Oxford University Press, 2003.

—— "Aesthetic Experience: A Question of Content", in Matthew Kieran (ed.), *Contemporary Debates in Aesthetics and the Philosophy of Art*, Oxford: Blackwell, 2006.

Coady, C. A. J., *Testimony: A Philosophical Study*, Oxford: Clarendon Press, 1992.

Cohen, Ted, "Aesthetics/Non-Aesthetics and the Concept of Taste", *Theoria*, 39, 1973, pp. 113–52.

Conolly, Oliver, "Ethicism and Moderate Moralism", *British Journal of Aesthetics*, 40, 2000, pp. 302–16.

Currie, Gregory, *The Nature of Fiction*, Cambridge: Cambridge University Press, 1990.

—— *Image and Mind: Film, Philosophy, and Cognitive Science*, Cambridge: Cambridge University Press, 1995.

—— "Review of *Truth, Fiction, and Literature*", *Mind*, 104, 1995, pp. 911–13.

—— "The Moral Psychology of Fiction", in Stephen Davies (ed.), *Art and its Messages: Meaning, Morality, and Society*, University Park, Pa.: Pennsylvania University Press, 1997.

—— "Realism of Character and the Value of Fiction", in Jerrold Levinson (ed.), *Aesthetics and Ethics: Essays at the Intersection*, Cambridge: Cambridge University Press, 1998.

—— and Ravenscroft, Ian, *Recreative Minds: Imagination in Philosophy and Psychology*, Oxford: Clarendon Press, 2002.

Dadlez, Eva, "Fiction, Emotion, and Rationality", *British Journal of Aesthetics*, 36, 1996, pp. 290–304.

Dancy, Jonathan, *Moral Reasons*, Oxford: Blackwell, 1993.

Daniels, Norman, *Justice and Justification: Reflective Equilibrium in Theory and Practice*, Cambridge: Cambridge University Press, 1996.

Davies, Martin and Stone, Tony (eds.), *Folk Psychology: The Theory of Mind Debate*, Oxford: Blackwell, 1995.

De Sousa, Ronald, *The Rationality of Emotion*, Cambridge, Mass.: MIT Press, 1987.

Devereaux, Mary, "Beauty and Evil: The Case of Leni Riefenstahl's *Triumph of the Will*", in Jerrold Levinson (ed.), *Aesthetics and Ethics: Essays at the Intersection*, Cambridge: Cambridge University Press, 1998.

____ "Moral Judgments and Works of Art: The Case of Narrative Literature", *Journal of Aesthetics and Art Criticism*, 62, 2004, pp. 3–11.

Dickie, George, "The Myth of the Aesthetic Attitude", in Joseph Margolis (ed.), *Philosophy Looks at the Arts: Contemporary Readings in Aesthetics*, 3rd edn., Philadelphia: Temple University Press, 1987.

____ *Evaluating Art*, Philadelphia: Temple University Press, 1988.

____ "The New Institutional Theory of Art", in George Dickie, Richard Sclafani and Ronald Roblin (eds.), *Aesthetics: A Critical Anthology*, 2nd edn., New York: St Martin's Press, 1989.

____ "The Triumph in *Triumph of the Will*", *British Journal of Aesthetics*, 45, 2005, pp. 151–6.

Diffey, T. J., "What Can We Learn from Art?", in Stephen Davies (ed.), *Art and its Messages: Meaning, Morality, and Society*, University Park, Pa.: Pennsylvania State University Press, 1997.

Dunn, Douglas, *Elegies*, London: Faber, 1985.

Eagleton, Terry, *Literary Theory: An Introduction*, Oxford: Basil Blackwell, 1983.

Eaton, Marcia Muelder, *Merit, Aesthetic and Ethical*, Oxford: Oxford University Press, 2001.

Eliot, George, *Middlemarch*, Harmondsworth: Penguin, 1965.

Eliot, T. S., "Matthew Arnold" in his *The Use of Poetry and the Use of Criticism*, London: Faber & Faber, 1964.

Foot, Philippa, "Morality and Art", in Ted Honderich and Miles Burnyeat (eds.), *Philosophy As It Is*, London: Allen Lane, 1979.

Foucault, Michel, *Madness and Civilization: A History of Insanity in the Age of Reason*, trans. Richard Howard, London: Routledge, 1989.

Franklin, Benjamin, *Autobiography* and "The Way to Wealth", both in *Autobiography and Other Writings*, ed. Ormond Seavey, Oxford: Oxford University Press, 1993.

Fry, Roger, *Vision and Design*, ed. J. B. Bullen, Oxford: Oxford University Press, 1981.

Gabler, Neal, *An Empire of their Own: How the Jews Invented Hollywood*, New York: Doubleday, 1988.

Gass, William, "Goodness Knows Nothing of Beauty: On the Distance between Morality and Art", *Harper's Magazine*, 274, 1987, pp. 37–44.

Gates, Jnr., Henry Louis, "Whose Canon Is It Anyway?", *New York Times Book Review*, 26 Feb. 1989.

Gaut, Berys, "Interpreting the Arts: The Patchwork Theory", *Journal of Aesthetics and Art Criticism*, 51, 1993, pp. 597–609.

____ "Moral Pluralism", *Philosophical Papers*, 22, 1993, pp. 17–40.

____ "The Paradox of Horror", *British Journal of Aesthetics*, 1993, 33, pp. 333–45.

____ "Metaphor and the Understanding of Art", *Proceedings of the Aristotelian Society*, 97, 1997, pp. 223–41.

____ "The Ethical Criticism of Art", in Jerrold Levinson (ed.), *Aesthetics and Ethics: Essays at the Intersection*, Cambridge: Cambridge University Press, 1998.

____ "Imagination, Interpretation, and Film", *Philosophical Studies*, 89, 1998, pp. 331–41.

Gaut, Berys, "Just Joking: The Ethics and Aesthetics of Humor", *Philosophy and Literature*, 22, 1998, pp. 51–68.

―――― "Identification and Emotion in Narrative Film", in Carl Plantinga and Greg M. Smith (eds.), *Passionate Views: Film, Cognition, and Emotion*, Baltimore: Johns Hopkins University Press, 1999, pp. 200–16.

―――― " 'Art' as a Cluster Concept", in Noël Carroll (ed.), *Theories of Art Today*, Madison: University of Wisconsin Press, 2000, pp. 25–44.

―――― "Creativity and Imagination", in Berys Gaut and Paisley Livingston (eds.), *The Creation of Art: New Essays in Philosophical Aesthetics*, Cambridge: Cambridge University Press, 2003.

―――― "Philosophy of the Movies: Cinematic Narration", in Peter Kivy (ed.), *The Blackwell Guide to Aesthetics*, Oxford: Blackwell, 2004.

―――― "The Cluster Account of Art Defended", *British Journal of Aesthetics*, 45, 2005, pp. 273–88.

Gilbert, Sandra M. and Gubar, Susan, *The Madwoman in the Attic: The Woman Writer and the Nineteenth-Century Literary Imagination*, London: Yale University Press, 1979.

Goldman, Alan, "Aesthetic Qualities and Aesthetic Value", *Journal of Philosophy*, 87, 1990, pp. 23–37.

―――― *Aesthetic Value*, Boulder: Westview Press, 1995.

Goodman, Nelson, *Languages of Art: An Approach to the Theory of Symbols*, Indianapolis: Hackett, 1976.

Gracyk, Theodore, *Rhythm and Noise: An Aesthetics of Rock*, Durham, NC: Duke University Press, 1996.

Graham, Gordon, "Learning from Art", *British Journal of Aesthetics*, 35, 1995, pp. 26–37.

Greene, Graham, "The Destructors", in his *Twenty-One Stories*, London: Vintage, 2001.

Greenspan, Patricia, *Emotions and Reasons: An Inquiry into Emotional Justification*, London: Routledge, 1988.

Guyer, Paul, *Kant and the Experience of Freedom: Essays on Aesthetics and Morality*, Cambridge: Cambridge University Press, 1993.

―――― "Baumgarten", in Michael Kelly (ed.), *Encyclopedia of Aesthetics*, vol. 1, Oxford: Oxford University Press, 1998.

Hanslick, Eduard, *On the Musically Beautiful*, trans. Geoffrey Payzant, Indianapolis: Hackett, 1986.

Hare, R. M., *Freedom and Reason*, Oxford: Oxford University Press, 1963.

―――― *Moral Thinking: Its Levels, Method, and Point*, Oxford: Clarendon Press, 1981.

Hegel, G. W. F. *Introductory Lectures on Aesthetics*, trans. Bernard Bosenquet, Harmondsworth: Penguin, 1993.

Horace, "Art of Poetry", in Hazard Adams (ed.), *Critical Theory since Plato*, San Diego: Harcourt Brace Jovanovich, 1971.

Hornby, Nick, *How to be Good*, London: Penguin, 2001.

Hughes, Robert, *Goya*, London: Harvill Press, 2003.

Hume, David, "Of the Standard of Taste", in Hazard Adams (ed.), *Critical Theory since Plato*, San Diego: Harcourt Brace Jovanovich, 1971.

―――― *A Treatise of Human Nature*, ed. L. A. Selby-Bigge, rev. P. H. Nidditch, 2nd edn., Oxford: Clarendon Press, 1978.

―――― *An Enquiry Concerning the Principles of Morals*, ed. J. B. Schneewind, Indianapolis: Hackett, 1983.

Hutcheson, Francis, *An Inquiry into the Original of our Ideas of Beauty and Virtue*, Indianapolis: Liberty Fund, Inc., 2004.

Hyman, Lawrence W., "Morality and Literature—The Necessary Conflict", *British Journal of Aesthetics*, 24, 1984, pp. 149–55.

Iseminger, Gary, "The Aesthetic State of Mind", in Matthew Kieran (ed.), *Contemporary Debates in Aesthetics and the Philosophy of Art*, Oxford: Blackwell, 2006.

Isenberg, Arnold, "The Problem of Belief", *Journal of Aesthetics and Art Criticism*, 13, 1955, pp. 395–407.

—— "Ethical and Aesthetic Criticism", in his *Aesthetics and the Theory of Criticism: Selected Essays of Arnold Isenberg*, ed. William Callaghan *et al.*, Chicago: University of Chicago Press, 1973.

Jacobson, Daniel, "In Praise of Immoral Art", *Philosophical Topics*, 25, 1997, pp. 155–99.

—— "Ethical Criticism and the Vice of Moderation", in Matthew Kieran (ed.), *Contemporary Debates in Aesthetics and the Philosophy of Art*, Oxford: Blackwell, 2006.

James, Henry, *Literary Criticism: French Writers, Other European Writers, The Prefaces to the New York Edition*, New York: Library of America, 1984.

Janaway, Christopher, *Images of Excellence: Plato's Critique of the Arts*, Oxford: Oxford University Press, 1995.

Jauss, Hans Robert, "Literary History as a Challenge to Literary Theory", in Hazard Adams and Leroy Searle (eds.), *Critical Theory since 1965*, Tallahassee: University Presses of Florida, 1986.

Johnston, Mark, "Dispositional Theories of Value III", *Proceedings of the Aristotelian Society*, supp. vol. 63, 1989, pp. 139–74.

Joyce, Richard, "Rational Fear of Monsters", *British Journal of Aesthetics*, 40, 2000, pp. 209–224.

Kant, Immanuel, *Grounding for the Metaphysics of Morals*, trans. James W. Ellington, 2nd edn., Indianapolis: Hackett, 1981.

—— *Critique of Judgment*, trans. Werner S. Pluhar, Indianapolis: Hackett, 1987.

Kieran, Matthew, "Art, Imagination, and the Cultivation of Morals", *Journal of Aesthetics and Art Criticism*, 54, 1996, pp. 337–51.

—— "Art and Morality", in Jerrold Levinson (ed.), *The Oxford Handbook of Aesthetics*, New York: Oxford University Press, 2003.

—— "Forbidden Knowledge: The Challenge of Immoralism", in José Luis Bermúdez and Sebastian Gardner (eds.), *Art and Morality*, London: Routledge, 2003.

Kivy, Peter, "The Laboratory of Fictional Truth", in his *Philosophies of Arts: An Essay in Differences*, Cambridge: Cambridge University Press, 1997.

Kolodny, Annette, "Dancing through the Minefield: Some Observations on the Theory, Practice, and Politics of a Feminist Literary Criticism", in Elaine Showalter (ed.), *The New Feminist Criticism: Essays on Women, Literature, and Theory*, New York: Pantheon Books, 1985.

Kripke, Saul, *Naming and Necessity*, Cambridge, Mass.: Harvard University Press, 1980.

Kundera, Milan, *The Unbearable Lightness of Being*, trans. M. H. Heim, London: Faber & Faber, 1984.

Lamarque, Peter, "How Can We Fear and Pity Fictions?", *British Journal of Aesthetics*, 21, 1981, pp. 291–304.

Lamarque, Peter, "Tragedy and Moral Value", in his *Fictional Points of View*, Ithaca, NY: Cornell University Press, 1996.

_____ "Learning from Literature", *Dalhousie Review*, 77, 1997, pp. 7–21.

_____ "Cognitive Values in the Arts: Marking the Boundaries", in Matthew Kieran (ed.), *Contemporary Debates in Aesthetics and the Philosophy of Art*, Oxford: Blackwell, 2006.

_____ and Olsen, Stein Haugom, *Truth, Fiction, and Literature: A Philosophical Perspective*, Oxford: Clarendon Press, 1994.

Leavis, F. R., *Revaluation: Tradition and Development in English Poetry*, Harmondsworth: Penguin, 1964.

Le Carré John, *The Constant Gardener*, London: Hodder & Stoughton, 2001.

LeGuin, Ursula, *The Left Hand of Darkness*, London: Orbit, 1992.

Leitch, Vincent B., *American Literary Criticism from the Thirties to the Eighties*, New York: Columbia University Press, 1988.

Levinson, Jerrold, "Artworks and the Future", in his *Music, Art, and Metaphysics: Essays in Philosophical Aesthetics*, Ithaca, NY: Cornell University Press, 1990.

_____ "Intention and Interpretation in Literature", in his *The Pleasures of Aesthetics: Philosophical Essays*, Ithaca, NY: Cornell University Press, 1996.

_____ "Emotion in Response to Art: A Survey of the Terrain", in Mette Hjort and Sue Laver (eds.), *Emotion and the Arts*, New York: Oxford University Press, 1997.

Lewis, David, "Truth in Fiction", *American Philosophical Quarterly*, 15, 1978, pp. 37–46.

_____ "Dispositional Theories of Value II", *Proceedings of the Aristotelian Society*, supp. vol. 63, 1989, pp. 113–37.

Livingston, Paisley, "Pentimento", in Berys Gaut and Paisley Livingston (eds.), *The Creation of Art: New Essays in Philosophical Aesthetics*, Cambridge: Cambridge University Press, 2003.

_____ and Mele, Alfred R., "Evaluating Emotional Responses to Fiction", in Mette Hjort and Sue Laver (eds.), *Emotion and the Arts*, New York: Oxford University Press, 1997.

Lopes, Dominic McIver, *Sight and Sensibility: Evaluating Pictures*, Oxford: Oxford University Press, 2005.

Lucie-Smith, Edward (ed.), *The Penguin Book of Satirical Verse*, Harmondsworth: Penguin, 1967.

Lyas, Colin, "Sibley", in Berys Gaut and Dominic McIver Lopes (eds.), *The Routledge Companion to Aesthetics*, 2nd edn., London: Routledge, 2005.

Lyons, William, *Emotion*, Cambridge: Cambridge University Press, 1980.

MacCarthy, Fiona, *Eric Gill*, London: Faber, 1989.

McConnell, Terrance, "Moral Residue and Dilemmas", in H. E. Mason (ed.), *Moral Dilemmas and Moral Theory*, New York: Oxford University Press, 1992.

McDowell, John, "Aesthetic Value, Objectivity and the Fabric of the World", in Eva Schaper (ed.), *Pleasure, Preference and Value*, Cambridge: Cambridge University Press, 1983.

McGinn, Colin, *Ethics, Evil, and Fiction*, Oxford: Oxford University Press, 1997.

Mackie, John, *Ethics: Inventing Right and Wrong*, Harmondsworth: Penguin, 1977.

Martin, M. W., "Humour and the Aesthetic Enjoyment of Incongruity", *British Journal of Aesthetics*, 23, 1983, pp. 74–84.

Matisse, Henri, "Notes of a Painter", in Herschel B. Chipp (ed.), *Theories of Modern Art: A Source Book by Artists and Critics*, Berkeley and Los Angeles: University of California Press, 1968.

Matravers, Derek, "Who's Afraid of Virginia Woolf?", *Ratio*, N.S. 4, 1991, pp. 25–37.

_____ *Art and Emotion*, Oxford: Oxford University Press, 1998.

Medved, Michael, *Hollywood vs. America: Popular Culture and the War on Traditional Values*, New York: HarperCollins, 1992.

Miller, Richard W., "Truth in Beauty", *American Philosophical Quarterly*, 16, 1979, pp. 317–25.

Moran, Richard, "The Expression of Feeling in Imagination", *Philosophical Review*, 103, 1994, pp. 75–106.

Morreall, John, "Fear without Belief", *Journal of Philosophy*, 90, 1993, pp. 359–66.

Murdoch, Iris, *The Sovereignty of Good*, London: Routledge, 1970.

_____ *The Fire and the Sun: Why Plato Banished the Artists*, Oxford: Oxford University Press, 1977.

Nabokov, Vladimir, *Lolita*, London: Weidenfeld & Nicolson, 1959; reprinted Penguin Classics, 2000.

Nehamas, Alexander, "The Postulated Author: Critical Monism as a Regulative Ideal", *Critical Inquiry*, 8, 1981, pp. 133–49.

_____ "Plato and the Mass Media", *Monist*, 71, 1988, pp. 214–34.

Neill, Alex, "Who's *Afraid* of Virginia Woolf?", *Ratio*, N.S. 5, 1992, pp. 94–7.

_____ "Fiction and the Emotions", *American Philosophical Quarterly*, 30, 1993, pp. 1–13.

Netta, Irene, "The Phenomenon of Time in the Art of Vermeer", in Ivan Gaskell and Michiel Jonker (eds), *Vermeer Studies*, Washington: National Gallery of Art, 1998.

Newton, Adam Zachary, *Narrative Ethics*, Cambridge, Mass.: Harvard University Press, 1995.

Norton, Robert E., *The Beautiful Soul: Aesthetic Morality in the Eighteenth Century*, Ithaca, NY: Cornell University Press, 1995.

Novitz, David, *Knowledge, Fiction and Imagination*, Philadelphia: Temple University Press, 1987.

Nussbaum, Martha, *Love's Knowledge: Essays on Philosophy and Literature*, New York: Oxford University Press, 1990.

_____ *Poetic Justice: The Literary Imagination and Public Life*, Boston: Beacon Press, 1995.

Parker, David, *Ethics, Theory and the Novel*, Cambridge: Cambridge University Press, 1994.

Plato, *The Collected Dialogues*, ed. Edith Hamilton and Huntington Cairns, Princeton: Princeton University Press, 1961.

Plotinus, *The Enneads*, trans. Stephen MacKenna, rev. B. S. Page, London: Faber & Faber, 1956.

Posner, Richard, "Against Ethical Criticism", *Philosophy and Literature*, 21, 1997, pp. 1–27.

_____ "Against Ethical Criticism: Part Two", *Philosophy and Literature*, 22, 1998, pp. 394–412.

Prince, Stephen, "Introduction: Sam Peckinpah, Savage Poet of American Cinema", in Stephen Prince (ed.), *Sam Peckinpah's The Wild Bunch*, Cambridge: Cambridge University Press, 1999.

Putnam, Hilary, "The Meaning of 'Meaning'", in his *Mind, Language and Reality: Philosophical Papers*, vol. II, Cambridge: Cambridge University Press, 1975.

Radford, Colin, "How Can We Be Moved by the Fate of Anna Karenina?", *Proceedings of the Aristotelian Society*, supp. vol. 49, 1975, pp. 67–80.

Rawls, John, "Outline for a Decision Procedure for Ethics", *Philosophical Review*, 60, 1951, pp. 177–97.

Rendell, Ruth, *Kissing the Gunner's Daughter*, London: Arrow Books, 1991.

Robbe-Grillet, Alain, *Jealousy*, trans. Richard Howard, London: Calder Publications, 1995.

Roberts, Robert C., "What An Emotion Is: A Sketch", *Philosophical Review*, 97, 1988, pp. 183–209.

Robinson, Jenefer, "Review of *Aesthetics and Ethics: Essays at the Intersection*", *Mind*, 441, 2002, pp. 687–93.

Robinson, Lillian S., "Treason Our Text: Feminist Challenges to the Literary Canon", in Elaine Showalter (ed.), *The New Feminist Criticism: Essays on Women, Literature, and Theory*, New York: Pantheon Books, 1985.

Rorty, A. O. (ed.), *Explaining Emotions*, Berkeley and Los Angeles: University of California Press, 1980.

Rothko, Mark, "The Romantics Were Prompted", in Herschel B. Chipp (ed.), *Theories of Modern Art: A Source Book by Artists and Critics*, Berkeley and Los Angeles: University of California Press, 1968.

Rowe, M. W., "Lamarque and Olsen on Literature and Truth", *Philosophical Quarterly*, 47, 1997, pp. 322–41.

Sade, Marquis de, *The 120 Days of Sodom and Other Writings*, trans. Austryn Wainhouse and Richard Seaver, London: Arrow Books, 1990.

Savile, Anthony, *The Test of Time: An Essay in Philosophical Aesthetics*, Oxford: Oxford University Press, 1982.

Schama, Simon, *Rembrandt's Eyes*, London: Penguin, 1999.

Schiller, Friedrich, *On the Aesthetic Education of Man in a Series of Letters*, ed. and trans. Elizabeth M. Wilkinson and L. A. Willoughby, Oxford: Clarendon Press, 1967.

Schwartz, Gary, "'Though Deficient in Beauty': A Documentary History and Interpretation of Rembrandt's 1654 Painting of Bathsheba", in Ann Jensen Adams (ed.), *Rembrandt's Bathsheba Reading King David's Letter*, Cambridge: Cambridge University Press, 1998.

Scruton, Roger, *Art and Imagination: A Study in the Philosophy of Mind*, London: Routledge & Kegan Paul, 1974.

―――― "Fantasy, Imagination and the Screen", in his *The Aesthetic Understanding*, London: Methuen, 1983.

Sharpe, Robert, "Moral Tales", *Philosophy*, 67, 1992, pp. 155–68.

Shelley, Percy Bysshe, "A Defense of Poetry", in Hazard Adams (ed.), *Critical Theory since Plato*, San Diego: Harcourt Brace Jovanovich, 1971.

Sheppard, Anne, *Aesthetics: An Introduction to the Philosophy of Art*, Oxford: Oxford University Press, 1987.

Showalter, Elaine (ed.), *The New Feminist Criticism: Essays on Women, Literature, and Theory*, New York: Pantheon, 1985.

Sibley, Frank, "Aesthetic Concepts", in his *Approach to Aesthetics: Collected Papers on Philosophical Aesthetics*, ed. John Benson, Betty Redfern and Jeremy Roxbee Cox, Oxford: Clarendon Press, 2001.

––––– "Arts or the Aesthetic—Which Comes First?", in his *Approach to Aesthetics: Collected Papers on Philosophical Aesthetics*, ed. John Benson, Betty Redfern and Jeremy Roxbee Cox, Oxford: Clarendon Press, 2001.

––––– "General Criteria and Reasons in Aesthetics", in his *Approach to Aesthetics: Collected Papers on Philosophical Aesthetics*, ed. John Benson, Betty Redfern and Jeremy Roxbee Cox, Oxford: Clarendon Press, 2001.

––––– "Tastes, Smells, and Aesthetics", in his *Approach to Aesthetics: Collected Papers on Philosophical Aesthetics*, ed John Benson, Betty Redfern and Jeremy Roxbee Cox, Oxford: Clarendon Press, 2001.

Sidney, Sir Philip, "An Apology for Poetry", in Hazard Adams (ed.), *Critical Theory since Plato*, San Diego: Harcourt Brace Jovanovich, 1971.

Siebers, Tobin, *The Ethics of Criticism*, Ithaca, NY: Cornell University Press, 1988.

Sircello, Guy, "Expressive Properties of Art", in Joseph Margolis (ed.), *Philosophy Looks at the Arts: Contemporary Readings in Aesthetics*, 3rd edn., Philadelphia: Temple University Press, 1987.

Skorupski, John, "The Definition of Morality", in A. Phillips Griffiths (ed.), *Ethics: Royal Institute of Philosophy Supplement: 35*, Cambridge: Cambridge University Press, 1993.

Slote, Michael, "Morality and Self-Other Asymmetry", *Journal of Philosophy*, 81, 1984, pp. 179–92.

Sluijter, Eric Jan, "Rembrandt's Bathsheba and the Conventions of a Seductive Theme", in Ann Jensen Adams (ed.), *Rembrandt's Bathsheba Reading King David's Letter*, Cambridge: Cambridge University Press, 1998.

Smith, Murray, *Engaging Characters: Fiction, Emotion, and the Cinema*, Oxford: Clarendon Press, 1995.

Snow, C. P., *The Realists: Portraits of Eight Novelists*, London: Macmillan, 1978.

Stecker, Robert, *Artworks: Definition, Meaning, Value*, University Park, Pa.: Pennsylvania State University Press, 1997.

––––– "The Interaction of Ethical and Aesthetic Value", *British Journal of Aesthetics*, 45, 2005, pp. 138–50.

Steinberg, Leo, "An Incomparable Bathsheba", in Ann Jensen Adams (ed.), *Rembrandt's Bathsheba Reading King David's Letter*, Cambridge: Cambridge University Press, 1998.

Stolnitz, Jerome, "The Aesthetic Attitude", in George Dickie, Richard Sclafani and Ronald Roblin (eds.), *Aesthetics: A Critical Anthology*, 2nd edn., New York: St Martin's Press, 1989.

––––– "On the Cognitive Triviality of Art", *British Journal of Aesthetics*, 32, 1992, pp. 191–200.

Styron, William, *Sophie's Choice*, London: Jonathan Cape, 1979; reprinted Vintage, 2000.

Tolstoy, Leo, *What is Art?*, trans. A. Maude, Oxford: Oxford University Press, 1930.

Townsend, Dabney, "Taste: Early History", in Michael Kelly (ed.), *Encyclopedia of Aesthetics*, vol. 4, Oxford: Oxford University Press, 1998.

Trilling, Lionel, "What is Criticism?" in his *The Last Decade: Essays and Reviews, 1965–1975*, ed. Diana Trilling, New York: Harcourt, Brace, Jovanovich, 1979.

Trollope, Anthony, *An Autobiography*, Oxford: Oxford University Press, 1999.

Vasari, Giorgio, *Lives of the Artists*, trans. George Bull, Harmondsworth: Penguin, 1965.

Vermazen, Bruce, "Expression as Expression", *Pacific Philosophical Quarterly*, 67, 1986, pp. 196–234.

Wallace, G. and Walker, A. D. M., *The Definition of Morality*, London: Methuen, 1970.

Walsh, Dorothy, *Literature and Knowledge*, Middletown, Conn: Wesleyan University Press, 1969.

Walton, Kendall, *Mimesis as Make-Believe: On the Foundations of the Representational Arts*, Cambridge, Mass.: Harvard University Press, 1990.

_____ "Morals in Fiction and Fictional Morality", *Proceedings of the Aristotelian Society*, supp. vol. 68, 1994, pp. 27–50.

_____ "Spelunking, Simulation, and Slime: On Being Moved by Fiction", in Mette Hjort and Sue Laver (eds.), *Emotion and the Arts*, New York: Oxford University Press, 1997.

Warnock, G. J., *The Object of Morality*, London: Methuen, 1971.

Wetering, Ernst van de, "Rembrandt's Bathsheba: The Object and its Transformations", in Ann Jensen Adams (ed.), *Rembrandt's Bathsheba Reading King David's Letter*, Cambridge: Cambridge University Press, 1998.

Wilde, Oscar, "The Decay of Lying", in Hazard Adams (ed.), *Critical Theory since Plato*, San Diego: Harcourt Brace Jovanovich, 1971.

_____ *The Picture of Dorian Gray*, Ware: Wordsworth, 1992.

Willett, John (ed. and trans.), *Brecht on Theatre*, 2nd edn., London: Eyre Methuen, 1974.

Williams, Bernard, "A Critique of Utilitarianism", in J. J. C. Smart and Bernard Williams, *Utilitarianism: For and Against*, Cambridge: Cambridge University Press, 1973.

_____ *Ethics and the Limits of Philosophy*, London: Fontana, 1985.

Willingham, John R., "The New Criticism: Then and Now", in G. Douglas Atkins and Laura Morrow (eds.), *Contemporary Literary Theory*, Amherst, Mass.: University of Massachusetts Press, 1989.

Wilson, George M., *Narration in Light: Studies in Cinematic Point of View*, Baltimore and London: Johns Hopkins University Press, 1986.

Wolf, Susan, "Moral Saints", *Journal of Philosophy*, 79, 1982, pp. 419–39.

Zangwill, Nick, *The Metaphysics of Beauty*, Ithaca, NY: Cornell University Press, 2001.

Zemach, Eddy, "Review of Jerrold Levinson ed., *Aesthetics and Ethics: Essays at the Intersection*", *Literature and Aesthetics*, 12, 2002, pp. 152–64.

Index

Ackroyd, Peter 93 n. 5
Adorno, Theodor 97 n. 25
The Adventures of Huckleberry Finn 78, 80
Aesop 85–6, 194
aesthetic 13
 artistic theory of 34–41, 83
 attitude 28–31, 35, 81–2, 177–8
 broad (wide) sense of 27, 40
 contemplation vs. practical 29, 30–1, 32
 n. 12, 81–2
 disinterest 28–9, 81, 118, 123
 evaluation 34–40
 experience 28 n. 3, 125
 intrinsic vs. instrumental interest 29–30
 merits enhance moral teaching 165, 188–9
 and metaphors 35, 38, 70–1
 narrow sense of 26–7
 and phenomenal properties 33
 pleasure (and enjoyment) 27, 29
 pluralism 64, 66, 79, 110, 175
 point of view 26
 principles 60, 62–3
 properties 28, 31–3, 34–40
 properties of nature 35–9, 70
 taste 28
 value 35
 see also artistic (aesthetic) and ethical value,
 general relation of
aesthetic anti-cognitivism 76, 77, 82, 141,
 166, 195
 objections to aesthetic claim 172–83
 objections to critical vocabulary
 argument 168–72
 objections to epistemic claim 141–2, 144
aesthetic cognitivism 82
 aesthetic claim 137–8, 165–86
 epistemic claim 137, 141–63
 essentialism 180
 formulation of 76 n., 136–40, 186
 and institutional guarantee 144–5
 purely learning version 139–40
 teaching (stronger) version 138–9, 140,
 142, 166
 understanding (minimal) version 138,
 141–2, 165–6
 see also cognitive argument; imagination;
 knowledge
aestheticism 4, 7
aesthetic relevance of ethical properties 50, 83,
 234–5

criterion for 84–9, 129, 170–1, 232
"afterlife" of a work 142, 182
Albers, Josef 186–7
alienation effect 190–1, 229
Allott, Miriam 93 n. 4, 95 n. 15, 102 n. 39
Alpers, Svetlana 23 n. 34, 24 n. 36
American Psycho 251 n.
Amis, Martin 195
Anderson, James C. 80–1, 195, 229 n. 4
Andrew, Geoff 249
Anna Karenina 24, 65, 69, 74–5, 107–8, 110,
 126, 146, 173, 182, 214
anti-cognitivism; *see* aesthetic anti-cognitivism
Antigone 173, 175, 189
Aristotle 3, 41, 48, 127, 146, 226, 247 n. 26
Arnold, Matthew 4, 10–11, 95–6, 98–9
art
 abstract 67–9, 186–7
 cluster account of 39
 and fear of ethical corruption 1–3
 function of 237
 Institutional Theory of 39
 power of 1, 5–6, 201
 religious 92, 176
 and self-understanding 5–6
 as transgression 4–5, 8, 11, 56–7, 90,
 100–2
artist
 actual 73, 75, 110
 aims of 92–5, 181
 implied 13, 74–6, 107, 109–12, 130
 manifested 72, 76, 80, 108–9, 114–15,
 127–9, 177, 195
 persona of 73–75
 postulated 110–11
artistic
 acts 71–4, 77
 evaluation; *see* aesthetic evaluation
 strategies 191–4, 196–201
 techniques 188–91
artistic (aesthetic) and ethical value, general
 relation of
 causal issue 6–7
 conceptual question 7
 intrinsic issue 8, 9–12, 26, 34, 49, 58, 67
 public policy 7
 structural symmetry 8, 12
 on wide conception of aesthetic 40
 see also autonomism, contextualism,
 ethicism, immoralism, moralism

artistic mode of expression criterion 85–9, 129, 232
 see also aesthetic relevance of ethical properties, criterion for
attitudes
 actual vs. imagined 184–5, 244, 246, 250
 manifested 9–10, 68, 107–8, 115, 229–30, 250–1
Audi, Robert 142
Austen, Jane 6, 85, 93, 172, 179, 242, 247
author; *see* artist
autonomism 10–11, 49, 50, 54, 67–82, 228, 237
 and artistic aims and critical practice 91, 95, 97–100
 characterised 51–2
 moderate 10, 13, 51–2, 76–82, 83, 177, 183, 195
 and objections to cognitivism 168–83
 and objections to ethicism 77–82, 127–129
 radical 10, 13, 51, 67–73, 76, 107
 as threat to contextualism 55, 57
 see also aestheticism

Bailey, Anthony 105 n. 43
Barish, Jonas 3 n. 5
Barna da Siena 133, 135
Baron, Marcia 47 n.
Bathsheba (Drost) 15–16, 18–25, 71–2, 87, 251
Bathsheba (Rembrandt) 15, 18, 20–5, 69, 71–2, 86, 87–8, 105, 115, 129 n. 41, 251
Baumgarten, Alexander 38
Baxandall, Michael 92
Beardsley, Monroe C. 4, 128, 229
 on the aesthetic 31–2, 48
 as autonomist 77, 83, 97–8, 100
 on principles 60, 63 n. 21
Beardsmore, R. W. 84–5, 88, 136 n., 174 n. 16
beauty 26–8
 and disinterest 118
 and sensory pleasure 124–6
 see also moral beauty
Beauvoir, Simone de 101–2
Beethoven, Ludwig van 68
Bell, Clive 4
Billy Liar 151
Blake, William 176–7
Bleak House 141
Bloom, Allan 2
Booth, Wayne 13, 85 n., 93 n. 8, 245
 on the ethical 42–3, 48
 and ethical criticism 42, 78, 96, 97

and friendship argument 107, 108–12
 on implied author 74–6
Brecht, Bertolt 190–1, 229
Brooks, Cleanth 98–9
Burke, Edmund 122–3, 124

Cantos 65, 77, 100
Caravaggio 92, 133–6, 141, 166
Carroll, Noël 14
 on the aesthetic 28 n. 3
 on cognitivism 136 n., 148 n. 14, 181 n. 30, 190 n. 43
 on emotional realism 208, 211 n. 16, 212
 on humour 243–4, 251 n.
 and merited response argument 227, 228–9, 234
 and moderate moralism 49–51, 54–5
censorship 7, 12
Chadwick, Helen 37
Chekhov, Anton 102 n. 39
Un Chien andalou 32
Christie, Agatha 166
Coady, C. A. J. 143 n. 7
Coen, Ethan and Joel 242, 250–1
cognitive-affective perspective 170–1, 203, 207, 233
cognitive argument 11, 13–14, 83, 141, 205, 251
 and aesthetic claim 165–86
 and componential argument 166–7
 and criterion for aesthetic relevance 84–9, 170–1
 and critical vocabulary argument 167–72
 and epistemic claim 141–63
 and relation to wide notion of the aesthetic 40
 see also knowledge
cognitivism; *see* aesthetic cognitivism
Cohen, Ted 27–8 n. 2
comedy; *see* humour
complexity
 of characters 189–90, 201
 as a formal value 60, 77, 83, 126
confirmation problem 141–2, 165
 see also knowledge
Conolly, Oliver 229 n. 4
Constable, John 121
The Constant Gardener 144 n.
contextualism 13, 53–7, 64, 195, 228
 cognitivist argument for 184–6
 and critical practice 92, 100–5
 and humour 241 n. 16, 242–5, 249
 and objections to ethicism 58–64, 100–5, 129–32, 184–6, 237–51
 see also autonomism, ethicism, immoralism

critical practices 34, 37, 82, 90–1
 feminist 96
 New Criticism 97–100
 political 96–7, 181
 post-structuralist 100–5
 see also ethical criticism
Currie, Gregory 75 n. 18
 on cognitivism 136 n., 146 n. 10, 156, 180
 n. 28, 183 n. 33
 on emotional realism 208 n. 8
 on simulation theory 149 n.

Dadlez, Eva 220–1 n.
Danaë 21
Dancy, Jonathan 43 n. 34
Daniels, Norman 157 n.
Dante 174–5
Davies, David 37 n. 18
Davies, Martin 149 n.
Davies, Stephen 122 n. 30
Dean, Jeffrey T. 80–1, 195, 229 n. 4
Defoe, Daniel 93
Déjeuner sur l'herbe 4
Les Demoiselles d'Avignon 62, 131
De Sousa, Ronald 204 n. 2, 207, 250 n.
"The Destructors" 184–5, 193–4
Devereaux, Mary 69 n. 5, 74 n., 96 n. 20
Dickens, Charles 78–9, 93, 141, 182, 232
Dickie, George 30 n. 9, 35 n. 16
'didactic' as a critical term 103–6, 121, 171,
 195, 201
Diffey, T. J. 141 n. 2, 167 n. 2, 177
Dircx, Geertje 69, 74, 88, 114–5
*The Disasters of War (Desastres de la
 Guerra)* 29, 100–1
Dostoevsky, Fyodor 6
droit de suite 7
Drost, Willem 15–16, 18–25, 71–2, 87, 251
Dr Strangelove 242, 247
Duchamp, Marcel 5
Duff, Antony 112 n. 13
Dunn, Douglas 152–3

Eagleton, Terry 97
Eaton, Marcia Muelder 42 n. 31, 189 n.
effects of art 6–7, 8, 9
 on actual audiences 9–10, 11, 67, 69, 229
 on normatively specified audiences 11–12
 and strategic reasons 237, 238–9, 241 n. 17
Eliot, George 59, 69, 78, 93, 178, 181, 182
Eliot, T. S. 10–11, 99
Emma 141, 151, 153, 171, 189
emotional irrealism 203, 208
 arguments for 209–12, 214, 216–7
 importance of 205–7, 231, 235–6
 see also emotional realism

emotional realism 14
 argument for possibility 208–16
 argument for rationality 209, 220–6
 and control 219
 importance of 203–7
 and instrumentalism 219–20
 and irrationalism 217–9
 and maximal rationality 217, 226
 and merited response argument 231, 235–6
 and minimal rationality 217, 220, 225–6
 and mixed theory 215–6
emotions
 in broad vs. narrow sense 204–5
 cognitive-evaluative theory of 204, 210, 211
 and enjoyment 210
 and imagination 211–14
 and judgementalism 210–12, 215
 and motivation 212–14
 see also emotional realism
ethical
 affective-practical conception of 47–8
 and blame 44–5
 broad sense of 41–3, 48, 109 n. 5, 110
 dilemmas 162–4
 and feelings 47–8, 159, 160, 205, 231
 function 44
 intrinsic value 9
 learning 157–64, 173
 motivation 122–3
 narrow sense of 43–8
 and other-regarding feelings 45–47
 and overridingness 43–4
 and particularities 161
 purely practical conception of 47
 see also moral pluralism, pleasure, reflective
 equilibrium, universalisability
ethical criticism (as a critical practice) 90–1,
 106, 198, 230, 244, 251
 and artist 72, 74–5, 109
 autonomist rejection of 67–8, 78, 97–100
 and discussion of *Bathsheba* 13, 15, 25, 78
 dominance of 95–7
 and emotional realism and irrealism 205–6,
 207, 235 n.
 and notion of ethical 42, 45
 see also ethicism
ethical journey 191, 196, 198, 199
ethicism 10, 66, 89, 195
 aesthetic relevance condition of 49–50,
 51–2
 autonomist objections to 77–82, 127–9
 contextualist objections to 58–64, 100–5,
 129–32, 184–6, 237–51
 and critical practice 91, 103–6
 full-blooded vs. weak 52–3
 as inescapable 252
 relation to moderate moralism 49–50, 54

value-relation condition of 52–3
see also aesthetic relevance of ethical
 properties, cognitive argument,
 friendship argument, humour, merited
 response argument, moral beauty,
 moralism, *pro tanto* principles and
 judgements
ethicist contextualism 57, 67, 92, 243
expression 70–4

fantasy 152, 153, 154, 160, 199, 225
Fargo 242, 248, 249, 250–1
Fielding, Henry 93
Flaubert, Gustave 102
Fleming, Ian 152, 153
Foot, Philippa 9
Ford, Ford Madox 75, 95
formalism 11, 32, 34, 176
Foucault, Michel 100–1, 102
Fountain 5
Franklin, Benjamin 41
friendship argument 107, 109–14
Fry, Roger 4
Fuller, Peter 4

Gabler, Neal 5 n. 15
Gass, William 77–8, 80, 174, 176
Gates, Jnr, Henry Louis 2
Gaut, Berys 35 n. 15, 190 n. 44, 210, 213,
 234 n.
 on 'art' as a cluster concept 39 n. 24, 180
 n. 27, 237 n. 11
 on imagination 152 n. 18
 on interpretation 73 n. 15, 75 n. 18
 on jokes 246
 on moral pluralism 61 n., 157 n., 173 n. 14
Gibbon, Edward 111–2, 178
Gilbert and George 57
Gilbert, Sandra M. 96
Gill, Eric 1
Gillray, James 242, 247
Gin Alley 248
Giuliani, Rudolph 1
Goldman, Alan 32–3
Goodman, Nelson 70–1, 143
Goya, Francisco 29, 100–1
Gracyk, Theodore 2 n. 4
Graham, Gordon 174 n. 16
Greene, Graham 184–5, 193–4
Greenspan, Patricia 204 n. 2, 211–12
Grisham, John 229
Groundhog Day 191
Gubar, Susan 96
Gulliver's Travels 195
Guyer, Paul 9 n. 22, 38 n. 22, 81 n. 34

Hanslick, Eduard 68
Hare, R. M. 43–4, 130 n. 42, 162 n.
Harvey, Marcus 1
Hegel, G. W. F. 6
Helms, Jesse 1, 5
Herbert, George 175–6
Hindley, Myra 1
Hirst, Damien 37
Hitchcock, Alfred 189
Hogarth, William 242, 247, 248
Homer 3, 92
Horace 3–4, 93
Hornby, Nick 111, 131 n. 44
Hughes, Robert 101
humanism 3–4, 6–7, 8, 14, 96
Hume, David 7, 8, 14, 175
 on friendship 109, 113
 and merited response argument 227–8
 on moral beauty 116–7
 on morality 44
humour 14, 56, 63, 106, 118, 131–2
 autonomism about (comic
 autonomism) 241, 245
 black 249–51
 contextualism about (comic
 contextualism) 241 n. 16, 242–5, 249
 ethicism about 245–51
 incongruity theory of 243–4
 and jokes 242
 in *Lolita* 196–7, 200
 and objections to ethicism 241–51
 and satire 246–9
Hutcheson, Francis 116, 124, 127
Hyman, Lawrence W. 57 n.

identification 190–1
imagination
 affective 154–5, 156, 159, 164, 171
 aims of 152
 coordinated 187
 disciplines of 154–6
 and emotion 211–14, 221
 and ethical learning 157–64
 experiential 151, 155, 159, 164
 learning from 145–63, 205, 207
 minimal 151
 and morality 145, 148
 and possibility 147–8
 and responsibility 206–7
 and role of art in aiding 145–7
 and vividness 155, 162, 164
 see also attitudes, emotional realism, fantasy,
 simulation theory
imaginative acquaintance 155, 159–60,
 188

immoralism 11, 184
 better called 'contextualism' 13, 49–51, 53,
 54–5, 57
 see also contextualism
implied author; *see* artist, implied
intentionalism 73, 75
intentionality 71, 80
Iseminger, Gary 28 n. 3
Isenberg, Arnold 77, 83, 168 n. 7, 176

Jacobson, Daniel 50, 51 n. 7, 53 n., 54–5, 57
 n.
 and objections to ethicism 58–60, 64
 and objections to merited response
 argument 237–42, 245
La Jalousie 170–1 n. 11
James, Henry 4, 77–8, 93
Janaway, Christopher 3
Jane Eyre 230, 231
Jarrell, Randall 98
Jauss, Hans Robert 102–3, 139
Johnston, Mark 154 n. 23
Joyce, Richard 208, 219–20, 238

Kant, Immanuel 7, 8–9, 94, 175
 on the aesthetic 28–30, 81, 118, 123
 on morality 46, 47 n., 81, 123, 164
Karr, Mary 178
Kieran, Matthew 58
 and cognitivist argument 55, 136 n., 184–6
 on immoralism 50 n. 4, 51 n. 6, 53 n.,
 54–5, 57, 64, 184–6
The Killing Fields 29
Kind Hearts and Coronets 249, 250
King Lear 191
Kissing the Gunner's Daughter 188–9
Kivy, Peter 142, 181–2
knowledge
 and confirmation 141–2, 147
 and defeasibility 156
 and experience 142–3, 148
 and reasoning 142
 and testimony 143–5, 148
 sources of 142–7
 varieties of 136, 141
 see also aesthetic cognitivism, cognitive
 argument, imagination
Kolodny, Annette 96
Kripke, Saul 119 n. 26
Kubrick, Stanley 242, 247
Kundera, Milan 146–7, 172

Lamarque, Peter 37 n. 19
 and anti-cognitivism 168–7, 173 n. 15,
 174, 178–83
 and emotional realism 208, 212

The Last Judgement 112–13
Laurel and Hardy 249
learning from art; *see* aesthetic cognitivism,
 cognitive argument
Leavis, F. R. 4, 96
Le Carré, John 144 n.
LeGuin, Ursula 153
Leitch, Vincent B. 98 n. 29, n. 30
Letter from an Unknown Woman 192–3
Levinson, Jerrold 75 n. 18, 124 n. 35, 208,
 212, 236 n. 9
Lewis, David 147
Lichtenstein, Roy 6
Livingston, Paisley 75 n. 18, 104 n., 105, 249
 n. 29
Locke, John 79
Lolita 14, 80, 189, 191, 194–202, 251
Lopes, Dominic McIver 54 n.
Lucie-Smith, Edward 247
Lyas, Colin 27 n. 2, 34, 34
Lynes, George Platt 5
Lyons, William 204 n. 2, 205

MacCarthy, Fiona 1 n. 2
McConnell, Terrance 163
McDowell, John 9
McGinn, Colin 7, 95 n. 15, 117, 119–20,
 122 n. 32, 132
Mackie, John 44, 158–9, 168
Madame Bovary 102–3, 139
The Magic Mountain 142
Manet, Edouard 5
Mann, Thomas 142
Mapplethorpe, Robert 1, 5
Marriage of Figaro 6
Martin, M. W. 244 n. 20
Matisse, Henri 1
Matravers, Derek 208, 213 n.
Medved, Michael 1–2
Mele, Alfred R. 249 n. 29
The Merchant of Venice 79, 80
merited response argument 11–12, 14, 83,
 203, 205, 229–33
 objections to 234–51
 and warrant 237–41, 252
 see also ethicism
Michelangelo 92, 112–13
Middlemarch 59, 69, 78, 86–7, 178
Miller, J. Hillis 182
Miller, Richard W. 167 n. 3
Milton, John 68, 174–6
Moby Dick 84
Molière 247
moral; *see* ethical
moral beauty argument 83, 115–27
 autonomist objections to 127–9
 contextualist objections to 129–32

moral beauty view 7, 13, 27, 114–32
 identity vs. predicative version of 123–4
 strong vs. weaker version of 120, 122–3
moralism 10, 13, 49
 defined 66
 moderate 49–51, 54, 57
 see also ethicism
'moralistic' as a critical term 103–6, 121
moral pluralism 61, 173 n. 14
moral saints 131
Moran, Richard 206, 208, 211 n. 17
Morreall, John 208
Murdoch, Iris 3, 153 n. 20
music 67–9, 168, 230

Nabokov, Vladimir 14, 194–202
narrator, unreliable (in *Lolita*) 198–9, 200
Nash, John 120
Nathan's parable 17, 86, 187
Natural Born Killers 2
Nehamas, Alexander 6 n. 17, 75 n. 18, 110
 n. 9
Neill, Alex 214 n. 25, 215–6
Netta, Irene 104–5
Newton, Adam Zachary 93–4
Newton, Isaac 170 n. 10
Norton, Robert E. 117 n. 23, 122 n. 31, n. 33
no-truth theory 178–83
Novitz, David 136 n.
Nussbaum, Martha 7, 42, 77, 111 n., 136 n.

Ofili, Chris 1
Olsen, Stein Haugom 169 n. 9, 173 n. 15,
 178–9, 180 n. 28, 181
The 120 Days of Sodom 60, 79, 95, 175, 230,
 231, 233
Ophuls, Max 192
Orton, Joe 242
Our Mutual Friend 182
Owen, Wilfred 174

Paradise Lost 68, 175
Parker, David 78, 97 n. 24
Pat Garrett and Billy the Kid 130
Peckinpah, Sam 129–31, 194 n.
Picasso, Pablo 62, 74
The Picture of Dorian Gray 5 n. 14, 69 n. 4,
 94–5
Piss Christ 1, 5
Plato 2–3, 4, 6, 7, 14, 92, 116, 131, 218,
 252
pleasure
 and ethical blame 205, 231, 239, 240
 see also aesthetic pleasure
Plotinus 7, 116, 120
Posner, Richard 42–3, 78–9

Pound, Ezra 65, 77, 100
prescribed responses 83, 231–4, 234
Presley, Elvis 2
Prince, Stephen 130 n. 43
profundity 32, 96, 166, 168–9, 170 n. 171,
 232
pro tanto principles and judgements
 and emotional realism 214
 and ethicism 60–5, 78–9, 103, 121, 128,
 131, 245
 and morality 61–2
 vs. overall principles 58–9, 64, 131
Pulp Fiction 2
Putnam, Hilary 119 n. 26

Radford, Colin 209, 211 n. 14, 218
Raine, Craig 197, 198, 201 n. 80
Ramis, Harold 191
Ravenscroft, Ian 149 n.
Rawls, John 157 n.
reflective equilibrium 40, 157, 159
Rembrandt 15, 18, 20–5, 80, 173, 251
 and Geertje Dircx 69, 73–4, 114–5
 see also Bathsheba (Rembrandt)
Rendell, Ruth 188
Richardson, Samuel 93
Riefenstahl, Leni 65
Rite of Spring 5
Robbe-Grillet, Alain 170–1 n. 11
Roberts, Robert C. 204 n. 2
Robinson, Jenefer 237 n. 12
Robinson, Lillian S. 96
Rorty, A. O. 204 n. 1
Rothko, Mark 6, 68
Rowe, M. W. 181 n. 30, 183 n. 33
Rowlandson, Thomas 242, 247
Rubens, Peter Paul 92
Ruskin, John 4

Sade, Marquis de 5, 10, 59, 95, 100–2, 192
Sassoon, Siegfried 174
Savile, Anthony 7, 154 n. 24, 167 n. 4
Schama, Simon 69 n. 6, 86, 114
Schiller, Friedrich 94, 117
Schwartz, Gary 21 n. 32; 24 n. 36, n. 37.
Scruton, Roger 29, 151
seduction strategy 130 n. 43, 191–4,
 196–201, 230
'seeing-as' 173–4, 179
Sensation exhibition 1
sentimentality 152–3, 154, 155, 160, 167,
 169
Serrano, Andres 1, 5
Shaftesbury 7, 116, 122
Shakespeare, William 78–9, 92, 145–6, 169,
 173, 242

Sharpe, Robert 17, 136 n.
Shelley, Percy Bysshe 94
Sheppard, Anne 7
Shostakovich 69 n. 3, 230
Sibley, Frank
 on the aesthetic 27–8, 34, 37, 38
 on principles 60, 63 n. 22
Sidney, Sir Philip 3, 4, 93, 247, 248
Siebers, Tobin 97
simulation theory 148–51, 153
Sircello, Guy 71–3
Skorupski, John 44
Slote, Michael 46 n. 41
Sluijter, Eric Jan 18 n. 29, 21 n. 33,
 23 n. 34
Smith, Murray 191 n.
Snow, C. P. 69 n. 7
Sophie's Choice 140, 162–4, 172–3,
 189
Sophocles, 174–5
Stations of the Cross 1
St Augustine 7, 116
Stecker, Robert 36 n., 54 n., 75 n. 18
Steinberg, Leo 23
Stoics 7, 116
Stoffels, Hendrickje 24, 74
Stolnitz, Jerome
 on the aesthetic 29–30
 and anti-cognitivism 141, 172
Stone, Tony 149 n.
Stravinsky 5
Styron, William 140, 162–4, 166
supervenience 43, 119–20
Swift, Jonathan 195

The Taking of Christ 92, 133–6, 141–2,
 166
teaching; *see* aesthetic cognitivism; cognitive
 argument
Tess of the d'Urbervilles 29, 32
thought-experiments 119, 127, 183
 about morality 161–2, 164
Tintoretto 231
Toilet of Bathsheba 20–1
Tolstoy, Leo
 as novelist 24, 65, 69, 108, 110, 146, 171,
 173
 as theorist 4, 10, 51, 65
Tom and Jerry 249
Townsend, Dabney 39 n. 23
Trilling, Lionel 96
Tristan and Isolde 6
Triumph of the Will 58–9, 64, 65, 79, 80,
 228, 229
Trollope, Anthony 93

truth, aesthetic relevance of 168–9,
 178–83

ugliness; *see* beauty
The Unbearable Lightness of Being 146–7, 172
Uncle Tom's Cabin 65, 128
universalisability 43, 148, 157–9, 161, 164,
 182
Updike, John 93
utilitarianism 160–62

value of art 3, 8, 9, 228, 252
 as cognitive-affective 40–1, 170–1, 207,
 232–3
 relation to aesthetic 34–5, 37, 39–41
 see also aesthetic cognitivism,
 cognitive-affective perspective,
 ethicism, moral beauty
Vasari, Giorgio 38–9, 112–13
Vermazen, Bruce 71 n. 10
Vermeer, Johannes 103–5
Vertigo 189
Vico, Giambattista 151
Vlieger, Simon 137

Wagner, Richard 6, 65, 77
Waiting for Godot 232
Walker, A. D. M. 45 n.
Wallace, G. 45 n.
Walsh, Dorothy 155
Walton, Kendall 153 n. 22, 187 n., 206
 and emotional irrealism 208, 209–10, 212,
 214, 230 n., 235 n.
War and Peace 65, 171
Warnock, G. J. 44, 46
The Waste Land 126
Weber, Max 151
Wetering, Ernst van de 21 n. 31
Whistler, James McNeill 4
The Wild Bunch 129–30, 194 n.
Wilde, Oscar 4–5, 11, 69, 94–5
Willett, John 190 n. 45, n. 46
Williams, Bernard 41, 44, 46, 160–2
Willingham, John R. 97
Wilson, George M. 192–3
Wolf, Susan 131

*Young Woman Reading a Letter at an Open
 Window* 104–5

Zangwill, Nick 124–6
Zemach, Eddy 236
Zola, Émile 144 n.